GEORGES BRAQUE

Recent Titles in
Bio-Bibliographies in Art and Architecture

Paul Gauguin: A Bio-Bibliography
Russell T. Clement

Henri Matisse: A Bio-Bibliography
Russell T. Clement

GEORGES BRAQUE

A Bio-Bibliography

Russell T. Clement

Bio-Bibliographies in Art and Architecture, Number 3

GREENWOOD PRESS
Westport, Connecticut • London

Library of Congress Cataloging-in-Publication Data

Clement, Russell T.
 Georges Braque : a bio-bibliography / Russell T. Clement.
 p. cm. – (Bio-bibliographies in art and architecture, ISSN
 1055-6826 ; no. 3)
 Includes indexes.
 ISBN 0-313-29235-3
 1. Braque, Georges, 1882-1963 – Bibliography. I. Title.
 II. Series.
 Z8115.66.C57 1994
 [N6853.B7]
 016.7'092 – dc20 93-45310

British Library Cataloguing in Publication Data is available.

Library of Congress Catalog Card Number: 93-45310
ISBN: 0-313-29235-3
ISSN: 1055-6826

First published in 1994

Greenwood Press, 88 Post Road West, Westport, CT 06881
An imprint of Greenwood Publishing Group, Inc.

Printed in the United States of America

The paper used in this book complies with the
Permanent Paper Standard issued by the National
Information Standards Organization (Z39.48-1984).

10 9 8 7 6 5 4 3 2 1

Contents

Preface . vii
Acknowledgments . ix
Biographical Sketch . xi
Chronology . 1
Bibliographic Overview . 11
Common Abbreviations . 15
Primary Bibliography . 17
 I. Archival Materials . 17
 II. Correspondence, Writings, Statements, and Interviews 17
 III. Sketchbooks . 22
Secondary Bibliography: Biography, Career and Picasso 23
 I. Biography and Career Development . 23
 Books . 23
 Articles . 26
 II. Braque and Picasso . 34
 Books . 34
 Articles . 36
Secondary Bibliography: Works (Œuvre) . 47
 I. Catalogues Raisonnés . 47
 II. Œuvre in General . 49
 Books . 49
 Articles . 53
 III. Individual Paintings . 63
 Books . 63
 Articles . 63
 IV. Drawings . 72
 Books . 72
 Articles . 72
 V. Graphic Works and Prints . 73
 Books . 73
 Articles . 73
 VI. Illustrated Books and Portfolios . 78
 VII. Papiers découpés (Cutouts) . 84
 Book . 84
 Articles . 84

VIII. Sculpture .85
 Books .85
 Articles .85
IX. Jewelry .86
 Books .86
 Articles .86
X. Theatre Designs .86
 Articles .86
XI. Special Issues of Journals Devoted to Georges Braque 87
XII. Audiovisual Materials .89
Influence and Mentions .93
 I. Influence on Other Artists .93
 Books .93
 Articles .97
 II. Mentions of Georges Braque . 101
 Books . 101
 Articles . 124
Exhibitions . 143
 I. Individual Exhibitions . 143
 II. Group Exhibitions . 162
Art Works Index . 213
Personal Names Index . 215
Subject Index . 229

Preface

An interesting anecdote about Georges Braque was recorded by his friend the poet Pierre Reverdy: "In 1917 I went to join him in the Midi, near Avignon. One day, while we were walking from Sorgues through the fields to the hamlet where I was staying, Braque carried one of his pictures at the end of a stick over his shoulder. We stopped and Braque put the canvas on the ground, among the grass and stones. I was struck by something and told him about it: 'It's amazing how it holds up against the actual colors and the stones.' Afterwards, I learned that it was above all a matter of whether it would hold up against hunger. Today I can answer. Yes, it has held, and against much more, for the paintings are afraid of nothing." Georges Braque has stood the test of time. His paintings are an invitation to accompany him along his creative journey, along his path as an artist and as a human being.

Braque is one of the best-known and least-understood painters of our century, a paradigmatic modernist who only now, three decades after his death, is beginning to be evaluated with the scholarly attention accorded a major figure. Characterized variously as a radical innovator or an elegant stylist, as a serene classicist or a temperamental individualist, as Picasso's sidekick or the grand old man of French painting, Braque lacks neither attention nor admiration. Since the 1920s he has been regarded as an essential figure in the evolution of modern art. Art history texts and museum installations have underlined his role as a vital collaborator in the modernist adventure, stressing in particular his intimate relationship with Picasso during the formative years of Cubism. The two artists' works are often hung side by side and the phrase "Picasso and Braque" is mentioned as though it refers to a single artist. While Cubism assured Braque's place in the history of twentieth-century art, his close association with Picasso has made him seem less interesting and less important in his own right, and his individuality and strengths have not always been fully appreciated.

This bio-bibliography/research guide compiles and organizes the considerable literature surrounding this seminal artist whose career appears to be undergoing a radical reevaluation since the centennial of his birth in 1982.

From 1990 to 1993 relevant literature was gleaned from computer and card catalogues and from printed indexes and guides to the library and archival collections of major art museums, universities, and scholarly and artistic institutes in the United States and Western Europe. Standard art indexes and abstracting services, such as *Bibliography of the History of Art; Art Index; ARTbibliographies MODERN; International Repertory of the Literature of Art; Répertoire d'art et d'archéologie;* Chicago Art Institute, Ryerson Library's *Index to Art Periodicals; Frick Art Reference Library Original Index to Art*

Periodicals; Arts and Humanities Citation Index; Humanities Index; Religion Index; MLA Bibliography; Worldwide Art Catalogue Bulletin; and *Répertoire des catalogues de ventes* were consulted, along with pertinent bibliographic databases such as RLIN, SCIPIO, Carl UnCover, First Search, and OCLC. The bio-bibliography attempts to be as comprehensive as possible within time, travel, budget, and length constraints. It should not, however, be construed as exhaustive.

This guide is intended as a briefly and partially annotated bibliography, not as a critical one. Annotations are provided for entries where titles give incomplete or unclear information about works and their content. Monographs and dissertations are annotated with more regularity than periodical articles. Annotations are of necessity brief and are intended only to note the subject matter discussed, the general orientation, or the conclusion of the study. Obviously, a few sentences can hardly hope to represent fairly and adequately even a short article, to say nothing of a major book.

My apologies to authors who may feel that the annotations have misrepresented, misconstrued, misunderstood, or even distorted their work in this process of radical condensation. My own opinion and critical judgment have in no case been conscious criteria for inclusion or exclusion. Foreign language titles abound, particularly in French. Since a reading knowledge of French is essential for serious Braque research, with few exceptions, only titles in other foreign languages are occasionally translated.

How to Use the Secondary Bibliography

The Secondary Bibliography is divided into sections, accessible by the Contents and the Subject Index. Entries are numbered consecutively throughout. In every section, monographs are listed first, followed by periodical articles. Within each section, citations are listed alphabetically by author or chronologically, when noted. Anonymous works are alphabetized by title. When several entries are credited to the same author, they are arranged chronologically. Authors whose surnames have changed and those who have rearranged their given names or initials are generally listed as they appear in print. They may, therefore, be found in the Personal Names Index in more than one location.

To some degree any system of classification is arbitrary, and this one is no exception. I have attempted to organize a great variety of material under headings most useful for art historical study rather than placing them in what at first may have seemed a most appropriate place. This arrangement is not always satisfactory. Hopefully, users perplexed by omissions in certain sections will be compensated by finding titles that they were unaware of in other sections.

Ideally, some titles should be listed in more than one section. In most instances, however, this was not practical. The division of the Secondary Bibliography into many categories is intended to serve as a simple subject index. Citations in the "Mentions of Georges Braque" section concentrate on major sources deemed historically significant. These entries are interesting as a reflection of the critical evaluation of Braque at the time of publication. The Exhibitions section contains information and publications about Braque exhibitions, including a few sales catalogues, arranged chronologically in individual and group exhibition categories.

The most effective use of the Secondary Bibliography is by means of the Contents and the Art Works, Personal Names, and Subject Indexes. Entries are indexed with reference to their citation numbers. Particular publications may be located in the Personal Names Index under the author or any other persons associated with the work.

Acknowledgments

In late 1990, work commenced on a research guide, sourcebook, and bibliography of the major French Fauve artists. As sources multiplied and the database grew, it became apparent that the Fauve literature was far too extensive for one or two books. Certain Fauve painters merited individual treatment, particularly after the decision was reached to detail entire careers and œuvres. A separate work on Henri Matisse was issued earlier in 1993. A general guide to Fauvism and individual Fauve painters is slated to appear later this year. The present work on Braque reached fruition only through the gracious assistance and generous support of many individuals. Numerous library colleagues, art historians, and Braque specialists provided encouragement and invaluable assistance in identifying, correcting, and organizing sources. Brigham Young University and the Harold B. Lee Library in particular rendered exceptional institutional support. Profound gratitude is expressed to A. Dean Larsen, Martha M. Peacock, and Madison U. Sowell, BYU colleagues who critiqued the expository sections and provided helpful suggestions about overall organization. Also at BYU, Annick Houzé proofread and edited the French citations and Richard D. Hacken edited the German, Italian, and Scandinavian entries. Kathleen Hansen and her able Interlibrary Loan staff procured important books and journals essential to the project. Katherine Bond, Kelly Hong, and Gretchen Cederlof performed the laborious tasks of data entry, word processing, correcting, and formatting. Without their cheerful assistance and dogged persistence, this work would never have been realized. Funding of three research trips to Europe was supplied by Brigham Young University and by the National Endowment for the Humanities Travel to Collections Program. On a personal level, father's apology for family hours spent elsewhere go to Esther, Jon, Sam, and Ben.

Biographical Sketch

Georges Braque was born on May 13, 1882 at Argenteuil, a Parisian suburb on the Seine made famous by the Impressionists. At that time Argenteuil was a pleasant riverside village outside the city and a haunt of painters, boating, enthusiasts, and holiday makers. Claude Monet had lived at Argenteuil from 1872 to 1878 in the glory days of Impressionism and Gustave Caillebotte's villa stood just across the river. Natives of Argenteuil, Braque's father and grandfather owned and managed a small housepainting and decorating business. In their spare time, and for their own pleasure, they painted landscape studies in the open air. When Georges was eight the family moved to Le Havre on the Normandy coast, where they prospered. An indifferent pupil undistinguished even in drawing classes and described as reserved and thoughtful, Braque left school at seventeen though he continued to attend evening classes at the local art school. On Sundays he and his father would drive into the country in the family buggy to sketch. Georges was fascinated by the sights of the busy harbor. At the local museum he discovered canvases by Boudin and Corot. Already a music lover, he learned to play the flute from Gaston Dufy (Raoul's brother), who later gave lessons to Jean Dubuffet. He also met Havrais artists Raoul Dufy and Othon Friesz. Following the family's livelihood, Braque served as an apprentice to a local decorator.

In the fall of 1900—at the very time when Picasso, his senior by six months, was paying his first visit to the city—Braque's parents sent him to Paris to finish his apprenticeship under one of their former employees and to take his diploma as a house painter. According to French law at the time, once he had become a qualified craftsman his period of obligatory military service would be reduced from three years to one. This stratagem worked. Besides the immediate benefit and the livelihood it produced, Braque's intense early training was to have far-reaching effects not only on his art but on the evolution of Cubism. Perhaps it also accounts for the domestic orientation of his work (in which landscapes and figures are rare) which is concerned, as befits a highly skilled house decorator, with interiors, objects, and wall decoration.

During his apprenticeship Braque learned special decorating techniques that would be useful to the family firm and enhance his standing as an artisan—how to paint imitation marble, exotic wood grains, mosaics, cornices, moldings, paneling—in short, how to render all the expensive embellishments of turn-of-the-century interiors as relatively inexpensive two dimensional illusions. The economy and precision of a skilled workman were thus instilled at an early age.

During his first year in Paris he lived in Montmartre, rue des Trois-Frères, and in the evenings attended drawing classes at the Cours Municipal des Batignolles. In October,

1901, Braque was called up and spent a year in the army, stationed near Le Havre. Serving in the same regiment were the art dealer Jean Dieterle and the collector Albert Henraux. Neither seemed to have had any inkling of Braque's vocation and remembered him only as a strapping young man with a zest for boxing who played the accordion, sang, and danced better than his comrades.

After his discharge from the army he obtained his father's permission to study art in Paris. Braque was granted a monthly allowance and settled again in Montmartre late in 1902, this time in the rue Lepic where van Gogh had lived fifteen years before. Except for a few months in 1903 in the studio of Léon Bonnat, whose rigid academicism Braque found unbearable, he spent the next two years studying at l'Académie Humbert in the boulevard Rochechouart, where a more amiable discipline reigned. There he met Marie Laurencin and Francis Picabia. During the summer holidays he painted in Normandy and Brittany. He later destroyed nearly all of these early neo-impressionistic efforts. Returning to Paris in 1904 after the summer holidays, Braque rented a studio of his own on rue d'Orsel, across from the Théâtre Montmartre and, feeling that there was nothing more to be gained from the art schools, began to work independently.

Familiar with the Louvre since childhood, Braque was particularly impressed by Poussin and Corot and by Egyptian art and ancient Greek sculpture. He studied the Impressionists at Durand-Ruel's and Vollard's galleries and in the rooms containing the Caillebotte Bequest at the Musée du Luxembourg. Unattracted by Manet and Degas, his preferences went to Renoir and Monet and, a little later, to Cézanne and Seurat, who both made a powerful impression on him. Braque spent the summer of 1905 at Honfleur and Le Havre and, on returning to Paris in the company of the Spanish sculptor Manolo and the fledgling critic Maurice Raynal, was dazzled by the famous *salle fauve* at the Salon d'Automne. This paroxysmal movement was based on simplification of technique and the excited handling of pure flat colors used expressively as the equivalent of light and the principle of composition.

Braque's boyhood friends, Raoul Dufy and Othon Friesz, probably introduced him to the Fauves—a loosely organized group of a dozen or so artists welded together by the tireless efforts of Henri Matisse, eldest of them all and the acknowledged leader. The sight of Matisse's work in the fall of 1904 converted Friesz to Fauvism; in the spring of 1905 it won over Dufy. In March, 1906, seven of Braque's paintings were accepted for the Salon des Indépendants. That summer he accompanied Friesz to Antwerp, where he worked with him and adopted the Fauvist technique. Braque's views looking down on the Scheldt River and the Antwerp harbor were, as he recognized, the beginning of his truly creative work. He spent the following winter at L'Estaque near Marseille, a site painted by Cézanne. In the Provençal light his colors flared into a swirl of lines. In February, 1907, Braque returned to Paris and exhibited six landscapes at the Salon des Indépendants. All sold—five were purchased by the German art critic and collector Wilhelm Unde. At the opening of the exhibition Braque met Matisse, Derain, Maurice de Vlaminck, and other members of the artistic avant-garde.

Braque's Fauvism was not the robust variety based on violent tonal contrasts of Derain and Vlaminck, but was more meditative and lyrical with luminous bright colors, a strong constructive element, and vibrant pointillist brushwork. Braque continued to be closely associated with the Fauves through 1907, exhibiting with them in Le Havre and submitting Fauve paintings to the Salon d'Automne of that year. In contrast to his previous successes, however, all but *Red Rocks* were refused. By then Braque seems to have been losing faith in Fauvism and Cézanne's influence was becoming increasingly important to him. Braque may have seen a large exhibition of Cézanne's watercolors at the Bernheim-Jeune gallery in Paris in the spring of 1907. There is no doubt that when Braque went south for the third time to spend October and November 1907 in L'Estaque,

he did so with new aspirations and a radically changed approach intensified by his having seen, just before leaving, yet another large retrospective exhibition honoring Cézanne, who had died the previous year.

When Braque returned to Paris in late 1907, he continued to revise and work from the canvases that he had brought back from the south. There is a new clarity and angularity of structure in these pictures and a new sonority of color quite different from the traditional Fauve palette. Braque later maintained that abandoning Fauvism had been inevitable: "I knew the paroxysm it contained could not last forever. How? When I returned to the south of France for the third time, I noticed that the exaltation that had filled me during my first stay there and that I transmitted to my paintings, was not the same any more. I saw that there was something else."[1]

The "something else" was, in part, his emulation of Cézanne's composition and choice of viewpoint. Besides toning down his colors, Braque would often forgo the naturalistic long views of his Fauve paintings for layered arrangements of clearly bounded planes pulled parallel to the surface of the canvas. In Cézanne's minutely adjusted nuances of color and intuitive sense of order, Braque found clues to a new approach that gave his own pictures an unprecedented lucidity and logic. This new perspective led Braque in a direction that not only transformed his own art but altered the way almost everyone since Braque has thought about pictorial space and illusion. What is perhaps most fascinating is that this major change came about not only because of Braque's own explorations, but because of a concentrated collaboration with one of his peers, Pablo Picasso.

In March or April, 1907, about the time of the Salon des Indépendants, Braque paid his first visit to the studio of a Montmartre neighbor—the young Spanish painter Pablo Picasso. Finding him out, he left a calling card on which he wrote "Anticipated memories." The two painters had friends and acquaintances in common before 1907, but nothing confirms that they were particularly aware of each other. Braque probably had his first view of Picasso's startling *Les Demoiselles d'Avignon* and a related painting, *Three Women,* in late November or early December 1907 when he and Guillaume Apollinaire visited Picasso's studio. The aggressive African primitivism and deliberate incoherence of *Les Demoiselles* disturbed him greatly. Nevertheless, Braque began to paint a few nudes of his own with very compact volumes that confirmed his change of orientation. The monumental *Nude* on which he concentrated during the winter of 1907-08, with its raised planes, concentrated light, multiple viewpoints, and circling space was, even more than Picasso's *Demoiselles*, the beginning of what was to become Cubism.

Thus began the greatest adventure of Braque's life—the six-year exchange with Picasso called Cubism which generated some of modernism's most innovative and beautiful paintings. Largely because of the superb exhibition *Picasso and Braque: Pioneering Cubism,* organized by The Museum of Modern Art, New York, in 1989, there has been a good deal of new discussion about the role of each artist in Cubism. As the MOMA exhibition made clear, the popular notion that Picasso was the innovator in whose shadow Braque labored is not true—something that was usually evident to anyone close to them during the years they worked together. André Salmon, part of the Montmartre "inner circle" and an early supporter of Cubism, provided an illuminating description of the relationship: "Georges Braque didn't need to be anyone's disciple. His friend's audacity simply persuaded him of the truth, the health of everything to which he had been impelled for a long time."[2] Daniel-Henry Kahnweiler explained further: "People tended to identify Cubism with Picasso. Braque was very wrongly considered to be a plagiarist. . . . Picasso always defended him with great generosity, and said: 'Not at all, he's an absolutely authentic creator who paints in his own style'."[3]

It is hardly surprisingly that Picasso should be assumed to have been the dominant figure, even in so patently cooperative an effort as the development of Cubism. His

charisma, his dazzling virtuosity, his productivity, and his lightning changes of style have combined to make his name synonymous with modern art. Braque has remained in another category, admired by his peers rather than adulated by the public. If one judges by the art and not by the anecdotes, Braque's intelligence and importance as an equal partner in the Cubist venture are immediately apparent. So are his originality and ability to invent. Since there are no undisputed proofs of sequence for Cubism, and no firm chronology that allows unquestionable priority to either artist, questions of who did what first are almost beside the point. What is far more compelling is the extraordinary symbiosis between the two artists, the way each responded to pressures exerted by the other, and the way limits were expanded and tenuous suggestions carried to full realization.

During his stay at L'Estaque with Dufy in spring and summer 1908, Braque continued his volumetric structuring along decidedly Cézannian lines in the "cubist style," avoiding the pitfalls of Expressionism and the temptations of primitivism to which some of his friends were succumbing. Refused by the Salon d'Automne, his canvases were exhibited that November in the gallery of the young dealer David-Henry Kahnweiler, soon to become the hotbed of Cubism. Braque's L'Estaque landscapes and early Cubist still lifes of musical instruments soon caught the eye of the art critics. Louis Vauxcelles, the critic for *Gil Blas* who had earlier coined the moniker Fauvism, noted that everything was reduced "to geometric cubes." The preface to Braque's first individual show was written by Apollinaire: "Here is Georges Braque. He leads an admirable life . . . he expresses a beauty full of tenderness and the nacre of his painting iridesces our understanding."

Still life, which had made its appearance with his *Jugs and Pipe* (Josefowitz Collection) of 1906 and would become his enduring specialty, was developed in the second half of 1908. After some compositions with typically Cézannesque motifs of pitchers and fruit bowls, Braque suddenly painted *Musical Instruments* (1908), which he considered his first work in the Cubist mode, in that it created space and volume while negating perspective and showing different angles. Musical instruments would become a common subject during his Cubist period.

Ties between Braque and Picasso became closer as they worked along parallel lines. Their new vision reached full affirmation in the canvases completed by Braque at L'Estaque in 1908 and La Roche-Guyon in 1909, works corresponding exactly to those painted in the same period by Picasso at La-Rue-des-Bois (Oise) and Horta de Ebro (Spain). The fecundity of Cubism stems from this particular association of two complementary artists, shortly afterward to be joined by Juan Gris and Fernand Léger. Until 1914 Braque and Picasso were inseparable. They spent the summer of 1911 at Céret in the Pyrennées and that of 1912 at Sorgues-sur-l'Ouveze, near Avignon. Braque married Marcelle Lapré in 1912. They remained together, childless, until his death more than half a century later. With Picasso, the Braques spent the summer of 1913 at Sorgues and he stayed there again in 1914 until the outbreak of World War I.

Braque's contributions to Cubism were considerable. He was responsible for the development of overlapping planes that created the new Cubist space; he first used letters as part of a composition (*Le Portugais*, 1911, Öffentliches Kunstsammlung, Kunstmuseum Basel); and soon after Picasso created the first *collage*, Braque made the first *papier collé* (*Fruit Dish and Glass*, September 1912). Braque's analytic-cubist compositions of 1910-11 are among the most cogent examples of the style. In 1911 Braque gave up landscape painting—to which he did not return until 1928—for figure painting, characterized by the same multi-faceted fragmentation as his paintings of objects and still lifes, which would remain his specialty.

In Cubism, Braque and Picasso rejected all accidents of appearance and atmospheric distortion and tried to define, by a geometric crystallization inspired by Cézanne, the permanent reality of objects and, simultaneously, their appearance in a closed space

without perspective or special lighting. The actual pioneers of Cubism did not, however, participate in the controversial exhibitions of 1911-13, arranged by their followers. Nevertheless, Cubism soon won international recognition if not popular acceptance. Through exposure in Berlin, New York, London, Russia and elsewhere, Braque was famous among avant-garde artists everywhere before World War I.

The so-called "synthetic" phase of Cubism began with Braque and Picasso's invention of *papiers collés* and collages, canvases that combine painted forms with added shapes of paper and other decorative substances. Imitation wood graining and veneers of imitation wallpaper and marble reminiscent of Braque's decorating apprenticeship began to appear in the still lifes of 1912-14. Letters and numerals cut from journals were often pasted into context with painted shapes.

Braque's Cubist progress was cut short by World War I, which scattered the Cubists. Many of them, like Braque, went to the front lines. Seriously wounded in 1915 at Artois, Braque did not paint again until 1917. In 1920 he returned to Paris. By then Picasso had moved on to new beginnings and only Juan Gris seemed to be continuing the Cubist ways. Braque's work had changed too. Suppleness prevailed over stiffness as Braque began searching for a more languid rhythm. The decade of 1918-28 produced long, narrow still lifes arranged either in width or in depth possessing a deep resonance of color often reinforced by a black background. The monumental classicism of his *Canephorae* (1922-26) marks the humanization of Cubism and its harmonious expansion in volumes and planes. Instantly personal with their massive forms and small breasts, these *canephorae* have a sensual nervous touch, indicating a light-hearted period away from investigation and experiment. During the following decade, however—in seascapes, bathers, heads facing two ways, interiors with figures, still lifes with rose tonalities—linear cadences, arabesques, curves, and decorative rhythms predominate with far less succulent colors.

In 1922 the forty-year-old Braque was honored at the Salon d'Automne and moved from Montmartre to Montparnasse. Three years later Braque moved into a calm and well-lit house built to his specifications near the Parc Montsouris. In 1928, instead of going to Sorgues and Provence as usual, he returned to the Normandy of his boyhood days and soon acquired and renovated a house at Varengeville-sur-mer, near Dieppe, which became his summer quarters away from Paris, complete with a studio and garden. He also returned to landscape and painted sensitive and luminous naturalistic seascapes. In 1931 his illustrations for Hesiod's *Theogony* and plaster panels incised with mythological scenes led to a group of simple still lifes on which fine white lines were delicately scratched into thin layers of predominately brown and Indian red paint.

Braque painted several series of works on similar themes, which enabled him to build up slowly to complex themes. His "studio" series, for instance, began in the mid 1930s and reached its first climax in 1939 with *The Painter and his Model* (Walter P. Chrysler Collection). From 1933 to 1938 Braque abandoned himself to luxuriant decorative pieces, painting a series of horizontal still lifes set on round or rectangular tabletops and designated by the color of the tablecloth. Between 1936 and 1939, and occasionally until 1944, Braque painted compositions with figures, or rather interiors in which humans play an important but not dominant role in the articulation of space. The notion of portraiture, of individual characterization so essential to Picasso, was foreign to Braque's painting. His figures, mostly female, alone or in pairs, symbolize two main pursuits, painting and music. Internationally recognized, Braque received first prize at the Carnegie International Exhibition of 1937 and at the Venice Biennale of 1948. He was honored with a special exhibit at the Salon d'Automne of 1943.

Braque's awareness of "Art" as the subject of art is increasingly apparent throughout the 1940s. Palettes, easels, and pictures within pictures appear regularly,

culminating in a series of five paintings each called *The Studio* in 1949. In numbers I-IV of these the bird motif, which had occurred earlier in his work, takes on a metaphysical function as a symbol for aspiration. The dynamic theme of the flight of a bird, metaphor of a palette with its winged contours, would later inspire his great mural compositions for the Louvre ceiling and for a private villa at Saint-Paul-de-Vence.

During the German occupation of Paris, Braque mainly produced still lifes in his studio. He continued in Paris the experiments with sculpture begun at Varengeville in the summer of 1939. They are the sculptures of a painter, done in low relief, with subjects like Faces, Horses, Fish, Birds, Plants, Vases, and Plows, presented both as concrete objects and as spiritual emblems and combining reminiscences of forms from archaic Greece and China. In addition to sculpture, Braque worked in many media—book illustrations which include drawings for Paul Reverdy's *The Roof Slates* (1918), etchings for Hesiod's *Theogony* published by Ambrose Vollard (1931), lithographs for Reverdy's *Liberty of Seas* (1959), and engravings for *The Order of Birds* with poems by Saint-John Perse (1962). He also designed sets for Diaghilev's ballets *The Bores* (1923) and *Zephyrus and Flora* (1925), as well as sets and costumes for the ballet *Salade* with music by Milhaud (1924) and the sets for Molière's *Tartuffe* (1949).

Major exhibitions of Braque's work toured Europe and the United States during his lifetime and a retrospective exhibition even went to Tokyo in 1952, long before the Japanese became significant consumers of modernist French art. Special issues of important art magazines were devoted to his work. Sculpture, lithographs, stained-glass windows, and murals held an increasing place in Braque's later work—work of a decorative trend yet suffused with an intense spirituality. In 1952-53 he was invited to decorate the ceiling of the Louvre's Salle Henri II, where the Etruscan collection was then displayed. In 1961, at seventy-nine, Braque became the first living artist ever accorded an individual exhibition at the museum. In 1954 he produced mural decorations for the Mas Bernard at St-Paul-de-Vence and stained-glass windows for the small church at Varengeville, the village in Normandy where he had spent nearly every summer beginning in 1928. In 1962 he made some designs for jewelry. When he died in 1963 at eighty-one, Braque was granted state honors at his funeral. André Malraux, the minister of culture, delivered the funeral oration in the Cour Carrée of the Louvre.

The art of Braque was a sixty-year process of continual renewal. His forms, first stripped of their peculiar attributes, are then recomposed by the skillful play of ellipses and allusions which, despite the displacement of their axes and contours, find their equilibrium. His delineations are vague yet definite, his lines of a feline elegance, his drawings inflected with alliterations—all executed with a grace and elegance that belie calculation. His works display the achievement of perfect equilibrium through informed deliberation, a meditated boldness, a subtle mixture of clairvoyance and instinct, a strict focusing of finesse and taste.

In Braque's hands the dimmest and most over-used colors—blacks, grays, beiges, dull greens, faded reds—reveal unsuspected resonances and affinities that delight the eye and discourage analysis. He achieves luminosity less through contrast of light and dark than by the juxtaposition of cool and warm tones. A careful worker, attentive to quality of technique, sensitive to the physical components of the medium, and always choosing the simplest, most economical tools for the most delicate executions, Braque may rightly be called one of the last master artisans.

Although Braque thought long and hard about his art and about art in general, his writings seem to conceal more than they reveal. His introspective notebooks, with their epigrammatic texts and shorthand drawings, are notorious for their economy. When the first section was published in 1948, editor Rebecca West commented, "Nothing in these notebooks, however, sheds the slightest light on Braque's private life, his passions, his

ideas, his fantasies."[4] There are no heartfelt letters available to outsiders and no private journals that reveal hidden agonies.

Interviews prove only slightly more illuminating, yielding provocative but often tantalizingly oblique replies. Speaking of the time he and Picasso reintroduced color into Cubism, after years of working in near monochrome, Braque said: "I don't want to pretend that this was a discovery: on the contrary, this independent impact of color had already been sensed by painters, but we gave it all our attention. We made it our point of departure, but as soon we got down to work, all calculation had to cease—and that's the only reason our painting is alive. It ceased being speculative and became real . . . I have often reflected upon all that and I find it very difficult to grasp it all."[5]

Like the best artists of any time, Braque demands to be judged by his art and not by his life or writings. In his single-minded pursuit of excellence he devoted himself to making thoughtful and deeply felt images. He trusted the results to speak for themselves without benefit of theory or explanation. In his notebooks he wrote, "In art, there is only one thing that counts: the thing that you can't explain."[6] Treading the line between the verifiable and the inexplicable, between perception and conception, Braque changed art irrevocably. Under the tutelage of his paintings and those of like-minded colleagues such as Picasso and Matisse, artists and viewers alike came to value invention as highly as they did faithful representation and to accept the reality of the art object as equal to the reality of anything in the existing world. The aesthetic territory that Braque chose to explore was relatively narrow, especially compared to the limitless field claimed by Picasso who restlessly tried and discarded new approaches throughout his career. In terms of materials and techniques Braque was very willing to experiment and test the possibilities of a great variety of media.

Notes

1. As quoted in Dora Vallier, *Braque: l'œuvre gravée—catalogue raisonné* (Paris: Flammarion, 1982), p. 14.

2. *L'Art vivant* in *Cahiers d'art* 8:1-2(1933), p. 28.

3. "When the Cubists Were Young," recorded interview with Georges Bernier in *L'Œil* (1955), p. 122.

4. As quoted in Serge Fauchereau, *Braque* (New York: Rizzoli, 1987), p. 32.

5. As quoted in Vallier, *Braque*, p. 14.

6. *Illustrated Notebooks: 1917-1955* (New York: Dover, 1971), p. 13.

GEORGES BRAQUE

Chronology, 1882–1963

Information for this chronology was gathered primarily from the "Chronology" by Carol Lowrey in Karen Wilkin, *Georges Braque* (New York: Abbeville Press, 1991), pp. 111-15; Bernard Zurcher, *Braque, vie et œuvre* (Fribourg: Office du Livre, 1988), pp. 283-94; and Jean Leymarie, *Georges Braque* [exh. cat., New York, Solomon R. Guggenheim Museum] (Munich: Prestel-Verlag; New York: Te Neues Publishing Co., 1988), among other sources.

1882 May 13—Georges Braque is born in Argenteuil-sur-Seine, son of Charles Braque, a house painter, building contractor, and amateur painter, and Augustine Johannet. The family resides at 40, rue de l'Hôtel. On Sundays, Charles paints landscapes from nature in an Impressionist style.

1890 Family moves to 33, rue Jules Lecesne, Le Havre, on the Normandy coast.

1893 Braque enters the lycée in Le Havre. Develops an interest in drawing and music. Later receives flute lessons from Gaston Dufy, Raoul Dufy's brother. Is fascinated with activities at the Le Havre harbor. Enrolls in evening classes under Monsieur Courchet at the local Ecole des Beaux-arts. Makes drawings after plaster casts of antique sculpture. Meets fellow painters Raoul Dufy and Othon Friesz.

1899 Abandons secondary schooling without taking his final examinations with the intention of joining his father's business. Begins an apprenticeship first with his father and then with Monsieur Roney, a local house painter and decorator.

1900 Travels to Paris at the end of the year to continue his apprenticeship under the painter-decorator Monsieur Laberthe. Learns a number of technical skills including sign paintings, hand lettering, and the art of painting *faux bois* and other types of simulations. Resides at rue des Trois-Frères, Montmartre. Attends evening drawing classes under Eugène Quignolot at the Cours Municipal des Batignolles.

1901 October—returns to Le Havre for a year's military service (reduced term for apprentice craftsmen). Paints portraits and landscapes during his spare time.

1902 October—returns to Paris. With his parent's support, decides to pursue a career as a painter. Settles on rue Lepic in Montmartre. Enrolls at l'Académie Humbert in the boulevard Rochechouart, where he meets Marie Laurencin and Francis Picabia. Continues his association with Dufy and Friesz. Makes regular visits to the Louvre where he is attracted to Greek and Egyptian art, as well as the work of Jean-Baptiste-Camille Corot and Nicolas Poussin. Sees Impressionist paintings at the Musée du Luxembourg and at the galleries of Durand-Ruel and Vollard.

1903 Fall—spends two months studying at l'Ecole Nationale des Beaux-arts under Léon Bonnat, where he meets Othon Friesz and Raoul Dufy. Dissatisfied with Bonnat's academic approach, he resumes training at l'Académie Humbert. Studies the Impressionists in the Musée du Luxembourg (Caillebotte Bequest) and in the Durand-Ruel and Vollard galleries.

1904 Summer—paints in Brittany and Normandy. Fall—returns to Paris and rents a studio on rue d'Orsel, opposite the Théâtre Montmartre. His work becomes brighter and more colorful. Begins painting in an Impressionist manner directly from nature.

1905 Spring—at the Salon des Indépendants he examines closely the retrospective exhibition of Seurat's work. Summer—paints in Honfleur and Le Havre, accompanied by the sculptor Manolo (Manolo Martinez Hugué) and the art critic Maurice Raynal (both members of the so-called "Picasso gang"). Fall—visits the Salon d'Automne and is deeply inspired by the pure-color Fauve paintings of Henri Matisse and André Derain. Dufy and Friesz also exhibit at the Salon.

1906 March 20-April 30—exhibits seven works (later destroyed) at the Salon des Indépendants. Spring—the Cercle de l'Art Moderne is founded at Le Havre by Charles Braque and others. Georges Braque, Friesz, and Dufy are appointed to the committee on paintings. May 26-June 30—Braque exhibits two paintings at the inaugural exhibition of the Cercle de l'Art moderne. June 12-July 12 and August 14-September 11—paints in Antwerp with Friesz. Produces his earliest Fauve works, including *Landscape near Antwerp*. September—returns to Paris. October—first visits L'Estaque, a little harbor town near Marseille, where he stays at Maurin's boardinghouse.

1907 February—returns to Paris. March 20-April 30—exhibits six landscapes brought back from L'Estaque at the Salon des Indépendants. All sell, five are purchased by the German art critic and collector Wilhelm Uhde. The sixth painting is believed to have been sold to Daniel-Henry Kahnweiler. At the opening of the exhibition Braque meets Matisse, Derain, Maurice de Vlaminck, and other members of

the artistic vanguard. March or April—Braque leaves Pablo Picasso his calling card with the message "Anticipated memories." Spring—Braque exhibits two paintings at the second exhibition of the Cercle de l'Art moderne. Probably sees the exhibition of watercolors by Paul Cézanne at Galerie Bernheim-Jeune in Paris before traveling to the south of France with Friesz. Summer—the young dealer Daniel-Henry Kahnweiler, who has just opened a tiny gallery at 28, rue Vignon in a tailor's shop, buys more of Braque's paintings and becomes his dealer. Late summer—Braque paints at La Ciotat, a resort town near Marseille. His work begins to be influenced by Cézanne's structural principles. September—visits L'Estaque, remaining until late October when he returns to Paris. Exhibits *Red Rocks* at the Salon d'Automne (the rest of his submissions are rejected). Sees the important Cézanne retrospective at the Salon and at Galerie Bernheim-Jeune. Returns to L'Estaque by early November and goes back to Paris by about November 16. Late November—visits Picasso's studio in the Bateau Lavoir, accompanied by the poet Guillaume Apollinaire. Sees Picasso's *Les Demoiselles d'Avignon* (Museum of Modern Art, New York). December—begins to focus on figural themes. Abandons Fauvism for good and moves even closer to a Cézannesque manner. Produces an etching, *Standing Nude*.

1908 Mid-March—completes *Woman* (begun December 1907). Spends spring and summer at L'Estaque with Dufy. Produces a series of proto-Cubist landscapes. Cézanne's influence leads him to limit his palette to greens and ochers, and also to bind planes into volumes. March 20-May 2—exhibits four works at the Salon des Indépendants. Apollinaire, writing in the May 1 issue of *Revue des lettres et des arts*, claims that Braque's work represents the "most original effort of the Salon." Braque spends spring and summer at L'Estaque with Dufy. Produces a number of Cubist landscapes. Submits a number of these new pieces to the Salon d'Automne. The jury, consisting of Matisse, Georges Rouault, and Albert Marquet, rejects all but one, which Braque withdraws. Upon viewing Braque's work, Matisse is the first to make a reference to "cubes." November 9-28—Braque's first one-artist exhibition, held at Galerie Kahnweiler, includes several L'Estaque landscapes as well as Braque's first Cubist still lifes of musical instruments. In his preface to the catalogue, Apollinaire states that each of Braque's paintings "is a monument to an endeavor which nobody before him had ever attempted." In *Gil Blas* of November 14, critic Louis Vauxcelles notes Braque's reduction of forms to "geometric patterns, to cubes." Late November—Braque visits Le Havre but returns to Paris in late November-early December. Attends the banquet given by Picasso at the Bateau Lavoir in honor of the painter Henri Rousseau, a former customs officer nicknamed "Le Douanier."

1909 January 24-February 28—sends four paintings to the second exhibition of the Toison d'Or in Moscow. March 25-May 2—exhibits two works at the Salon des Indépendants. In an article in *Mercure de France*, critic Charles Morice uses the term "Cubism" in print for the first time. June—Braque travels to La Roche-Guyon, in the Seine Valley, near

Mantes, where Cézanne painted in 1885. Paints views of the medieval castle and surrounding forest using a palette dominated by grays and greens. September 7-October 6—puts in another period of military service at Le Havre. Early October—joins Derain at Carrières-Saint-Denis, near Chatou. Late October—returns to Paris. Produces a series of large still lifes based on musical themes including *Guitar and Fruit Dish*. Paints *Lighter and Newspaper: "Gil Blas"* (private collection), the first Cubist painting to feature lettering. Begins a period of close collaboration with Picasso that will last until 1914.

1910 Establishes a new studio on the rue Caulaincourt, on the top floor of the Roma Hotel. Spring—his *Woman with a Mandolin* (Bayerische Staatsgemäldesammlungen, Munich) uses an oval canvas for the first time. July 27—goes to Saint-Aquilin-de-Pacy, near Mantes. Returns to Paris by August 16. Arrives in L'Estaque by early September (fourth visit). September 1-15—exhibits with Picasso at the Thannhauser Gallery in Munich. Late November—spends a few days at Le Havre before returning to Paris about December 1.

1911 March 27-April 12—performs military service at Saint-Mars-la-Brière. July 10—Picasso goes to live at Céret, a charming village in Roussillon which plays the same role for Cubism as nearby Collioure had for Fauvism. About August 17—Braque joins Picasso at Céret in the Pyrenées, after visiting Orléans, Guéret, and Limoges. Incorporates typographic elements into paintings. September—visits Figueras and Collioure. Develops friendships with the sculptor Henri Laurens and the poet Pierre Reverdy. Abandons landscape and turns increasingly to still-life and, following Picasso's example, does several works with human subjects. Visits Collioure, where Matisse shows him his *Interior with Aubergines*. Late fall—begins working on *Le Portugais (The Emigrant)*, the first Cubist painting to feature stenciled lettering, and *Homage to J. S. Bach* (Carroll and Conrad Janis), the earliest example of Braque's use of imitation wood grain.

1912 January 19—returns to Paris after living at Céret since October, 1911. Begins to employ the comb used by decorators to give the impression of wood grain. Exhibits in the Cologne Sonderbund and with the Blaue Reiter in Munich. Marries Marcelle Lapré. They remain together, childless, until his death more than half a century later. April 26-28—visits Le Havre with Picasso. Back in Paris, Picasso executes the first collage, a *Still Life with Chair Caning* (Musée Picasso, Paris), in which a piece of waxed cloth is stuck on the canvas. Picasso returns to Céret with Eva from May 18 to June 21. On the 24th the couple set up house in the Villa Les Clochettes at Sorgues-sur-l'Ouveze near Avignon. Late July—joins Picasso and Reverdy at Sorgues-sur-l'Ouveze. August 9—Braque and Picasso purchase African masks and statuettes in Marseille. Braque begins to add sand and sawdust to his pigment (*Still Life with Cluster of Grapes*). Also makes several paper sculptures-in this he is soon followed by Picasso. September—uses simulated wood-grain wallpaper (purchase in a shop in Avignon) in *Fruit Dish and Glass*, his first *papier collé*. October 9—Picasso writes

to Braque: "I am using your latest paper and powdery procedures. I am imagining a guitar and putting a little dust on our horrible canvas . . ." Picasso produces many collages, which become increasingly complex until they turn into veritable "assemblages." November 29—Braque signs an exclusive one-year contract with Daniel-Henry Kahnweiler.

1913 February 17-March 15—exhibits three works in the *International Exhibition of Modern Art* (the Armory Show) in New York. June—visits Sorgues; makes brief visits to Avignon, Martigues, Marseille, Nîmes, and Arles in the ensuing months. July—spends a few days at Céret with Picasso, Juan Gris, and Max Jacob. Returns to Paris from Sorgues in early December.

1914 June—takes a bicycle trip to the Midi, visiting Sens, Avallon, Dijon, and other cities; arrives in Sorgues by July 5. Pays frequent visits to Picasso. August—called up for military duty. Assigned to the 224th Infantry Regiment, based in Le Havre, with rank of sergeant; promoted to first lieutenant in December for his bravery in action. December 9-January 11, 1915—joint exhibition with Picasso held at Alfred Stieglitz's gallery "291" in New York. The two artists never see each other again after 1914.

1915 Kahnweiler, living in Switzerland, begins writing *Der Weg zum Kubismus (The Rise of Cubism)*, identifying Braque and Picasso as the founders of Cubism. May 11—Braque receives a serious head wound at Carency and undergoes a trepanation; convalesces in Sorgues.

1916 Mid-April—Braque is assigned to Bernay, in the Eure region. Later receives a medical discharge. In recognition of his bravery at the front, he is decorated with the Croix de Guerre and the Légion d'Honneur.

1917 January 15—friends and colleagues in Paris organize a banquet to celebrate Braque's recovery. Summer—resumes painting and continues his association with Gris, Reverdy, and Laurens. He works together with Gris, who imparts to him a taste for choice textures and planes reduced to geometrical shapes. Begins to edit his *Cahier*. December—Braque's article, "Pensées et réflexions sur la peinture" appears in his friend Pierre Reverdy's review, *Nord-sud*. Léonce Rosenberg becomes Braque's new dealer.

1918 Returns to still lifes with pedestal tables and clarinets. Rosenberg opens Galerie de l'Effort moderne, exhibiting the work of many Cubist painters. Braque starts jotting down his drawings in notebooks. They constitute a veritable diary that the painter keeps up all his life.

1919 March—second individual exhibition held in Rosenberg's Galerie de l'Effort moderne, rue de la Beaume.

1920 January—displays four works at the Salon des Indépendants. Executes his first plaster sculpture, *Standing Nude*. Renews his contract with

Léonce Rosenberg. September 1—Kahnweiler opens Galerie Simon, 29 bis, rue d'Astorg, and becomes Braque's dealer again. October—Braque exhibits three works at the Salon d'Automne. Roger Bissière publishes the first monograph on Braque as part of the series "Les Maîtres du Cubisme" (Masters of Cubism). Attends the first performance of Erik Satie's *Socrate*, a dramatic symphony which reflects his own taste for ancient Greek poetry. First sculpture, a *Standing Nude*.

1921 Produces three woodcuts for Satie's comedy, *Le Piège de Méduse* (Medusa's Trap), of which 112 copies are published by the Galerie Simon press. June 13-14—first sale, at the Hôtel Drouot, of the Galerie Kahnweiler Collection, which had been sequestered as a war-time measure. Guy Mounereau gives an account of the sale in the *Echo de Paris*: "An incident took place at the exhibition of the Galerie Kahnweiler.... An incident occurred as a result of fierce argument. The painter Braque, who had a number of canvases in the collection that was to be sold off, had an argument with M. Rosenberg, the organizer of the sale. After exchanging some strong words, Messrs. Braque and Rosenberg came to blows. The quarrel was patched up before the police commandant of the district. No charges were laid. Now we are waiting for what will come out of the sale." November 17-18—second Kahnweiler sale, at the Hôtel Drouot, includes thirty-eight works by Braque. At the second Kahnweiler sale the atmosphere was just as tumultuous as on the first occasion, as is clear from the account published in *Comœdia* (18 November): "Yesterday Room 6 of the sale-rooms was invaded by a noisy group of people—rather too noisy, in fact: French and foreign art lovers, dealers, and art critics. When M. Zapp and M. Léonce Rosenberg, the experts, began the sale people stamped their feet and struck the ground with their walking sticks as if we were at a play The Braque paintings, all earlier works which showed a surprising degree of eclecticism, did not fetch a very good price. Some art lovers did not hesitate too say that they were worth more. Why did they not fetch a higher price than they did?"

1922 Displays eighteen works, including the *Canephorae*, in the room of honor at the Salon d'Automne. Leaves Montmartre for good and settles on avenue Reille in Montparnasse. July 4—third Kahnweiler sale includes three of Braque's *papiers collés*. Begins work on the *Fireplace* series.

1923 Produces sets and costumes for Boris Kochno's ballet, *Les Facheux* (The Bones) with music by Georges Auric, staged by Sergei Diaghilev in January, 1924 at Monte Carlo and in Paris in May. Paul Rosenberg becomes Braque's new dealer. Fourth Kahnweiler sale features fifty-six works by Braque.

1924 Count Etienne de Beaumont persuades Braque to produce the sets for *Les Soirées de Paris* (Paris Evenings) and the costumes for *Salade*, a ballet by Léonide Massine with music by Darius Milhaud.

1925 Moves to a new house built for him by the architect Auguste Perret at 6, rue du Douanier (now rue Georges Braque). The studio, which has a vast window, is on the top floor. Designs the sets for *Zéphyr et Flore*, a ballet by Diaghilev. Visits Rome.

1928 *Pedestal Table* series. During a summer at Dieppe, Braque decides to leave the south of France and return to the Normandy coast where he grew up. He has a house and studio fitted up at Varengeville-sur-mer, where he will come to live each summer from now on. First appearance of the theme of boats on the beach in his work.

1931 Moves into his new home at Varengeville. Travels to Florence and Venice. Produces his first engraved plaster casts featuring heroic figures from Greek mythology—Zao, Nike, Herakles—featured in the black-etched engravings of Hesiod's *Theogony*, which he did for Vollard (1932) and has published by Maeght in 1955.

1932 Produces sixteen etchings as illustrations for Hesiod's *Théogonie*, published by Ambroise Vollard.

1933 April 9-May 14—his first major retrospective exhibition is held at the Kunsthalle, Basel, Switzerland. *Cahiers d'art* devotes an entire issue to Braque in commemoration of the exhibition. Contributors include Apollinaire, André Breton, André Salmon, Christian Zervos, and others.

1934 Produces the illustrations for Carl Einstein's monograph, *Georges Braque*.

1936 January 8-31—Braque's most recent works are exhibited at the Galerie Paul Rosenberg. November-December—exhibition at the Palais des Beaux-arts in Brussels. Begins a magisterial set of compositions on the topic of interiors with human subjects (1936-39). At the same time the theme of the pedestal table returns. Takes a trip to Germany.

1937 Awarded first prize at the Carnegie International Exhibition in Pittsburgh for *The Yellow Tablecloth* (1935). April 3-30—among recent works exhibited at the Galerie Paul Rosenberg, *The Duet* is noted by Louis Hautecoeur, Curator of the Musée du Luxembourg, who after some difficulty acquires it at the end of 1938.

1938 *Studio with Skull* marks the beginning of the appearance of the studio theme, together with his first vanitas. November 16-December 10—exhibition at the Galerie Paul Rosenberg.

1939 Begins sculpting in stone. Spends the winter at Varengeville. Devotes the majority of his time to sculpture (*Hymen, Hesperis, The Little Horse*). November 2-27—first important retrospective exhibition of Braque's work in the United States is held at the Arts Club of Chicago and tours to Washington, D.C., and San Francisco.

1940	June—Braque goes to Limousin and later to the Pyrenees as a result of the German invasion. Fall—returns to Paris. Leads a reclusive existence in his studio until the end of the war.
1942	Completes a number of *Interiors* that exude a spirit of deprivation and harshness, with much use of black as in 1917 and 1918.
1943	September 25-October 31—displays twenty-six paintings and nine sculptures in a special room at the Salon d'Automne.
1944	September—Paris is liberated and Braque returns to Varengeville, where he finishes *The Drawing Room*, the largest of his *Interiors*. This completes his *Washstand* series (1942-44). Begins billiard-table series (seven known canvases, 1944-49).
1945	Summer—undergoes a stomach operation, which interrupts his artistic activity for several months. Fall—retrospective exhibitions of his work are held at the Stedelijk Museum in Amsterdam and at the Palais des Beaux-arts in Brussels. Produces lithographs for Jean Paulhan's book *Braque, le patron* and for Antoine Tudal's *Soupente* (The Garret). He also does lithographs on mythological subjects and still lifes. Becomes an officer of the Légion d'Honneur.
1947	Spring—develops pneumonia. June—Aimé Maeght becomes his new dealer. First exhibition May 30-June 30.
1948	At the 24th Venice Biennale, where a room is devoted to his works, Braque receives the Grand Prize for Painting for *The Billiard Table* (1944). The Maeght publishing house brings out *Le Cahier de Georges Braque, 1917-1947*. Begins working on his series of *Terraces*.
1949	January-June—a major retrospective exhibition of his work is held at the Cleveland Museum of Art and at The Museum of Modern Art, New York. Produces his first *Studios* (*I, II, IV*, and the first version of *Studios II* and *V*, on which he resumes work later), focusing on the image of the bird.
1950	January—exhibits five works from the *Studio* series at Galerie Maeght. Pierre Reverdy publishes *Une Aventure méthodique* with Maeght. Execution of *Studio VI*, finished the following year.
1951	Works on a series of small-scale pastoral landscapes (*Wheatfield*). Becomes a commander of the Légion d'Honneur.
1952	September-October—retrospective exhibition in Tokyo organized by the National Museum and the review *Yomiuri*. Begins *Studios VII* and *VIII*.
1953	At the invitation of Georges Salles, director of the Museums of France, Braque decorates three coffers in the ceiling of the Salle Henri II in the Louvre (Etruscan Room) with an ornithological motif already apparent in his *Studios*. Spring and summer—solo exhibitions of his work are

held at the Kunstmuseum in Bern and at the Kunsthaus, Zurich. Signs *Studio VII* (first version of *Studio IX*, before work is resumed in 1956).

1954 Continues work on Normandy rural landscapes. Designs a set of stained-glass windows for the church at Varengeville. Produces decorations for the Mas Bernard at Saint-Paul-de-Vence.

1955 Finishes *Studio VIII* and his first large canvas on an ornithological theme, *The Bird and its Nest*.

1956 First version of *In Full Flight* (resumed work on it in 1961). Transformation of *Studio VII* into *Studio IX*. April-May—recent works exhibited at the Galerie Maeght. The Arts Council of Great Britain organizes an exhibition of Braque's paintings, which is shown at the Scottish Royal Academy in Edinburgh and at the Tate Gallery in London. He receives an honorary doctorate from Oxford University. Experiences a serious decline in health. December-January 1957—*The Sculpture of Georges Braque* opens at the Contemporary Arts Center in Cincinnati.

1958 Two rooms (XLI and XLII) are devoted to Braque's work at the 29th Venice Biennale. November-January 1959—solo exhibition is held at the Palazzo Barberini in Rome, where he is awarded the Feltrinelli Prize by the Accademia di Belle Arti.

1959 Braque's continuing ill health forces him to curtail his activities, although he does complete a number of drawings and engravings. He continues to illustrate books by his friends who are poets: *La Résurrection de l'oiseau* by Frank Elgar and *La Liberté des mers* by Pierre Reverdy (published by Maeght). Later he does *L'Ordre des oiseaux* by Saint-John Perse (published by Au Vent d'Arles, 1962) and *Lettera amorosa* by René Char (Engelberts, Geneva, 1963). June—exhibition at the Galerie Maeght.

1960 June 24—exhibition of Braque's graphic work opens at the Bibliothèque nationale, Paris. Produces twelve lithographs for Reverdy's *La Liberté des mers* (Open Sea).

1961 November—Jean Cassou, chief curator at the Musée National d'Art moderne in Paris, organizes the exhibition *L'Atelier de Braque* is held at the Louvre. Poor health continues to disrupt Braque's painting activity, although he designs a number of pieces of jewelry, especially onyx cameos. He gives one of these to his wife: it shows in profile Hecate, goddess of riches. He wears another one on a signet-ring during the last year of his life: *The Metamorphosis of Eos*—a white bird representing Aurora.

1963 March 22-May 14—exhibition of Braque's jewelry at the Musée des Arts décoratifs, Paris. June 12-October 6—retrospective exhibition at the Haus der Kunst, Munich. August 31—Braque dies in Paris, leaving *The Weeding Machine* unfinished. A state funeral is held in his honor.

André Malraux delivers a eulogy in the Cour Carrée of the Louvre. Braque is buried in the little cemetery at Varengeville, on a cliff top overlooking the sea, where his wife will join him two years later.

Bibliographic Overview

Until Braque began exhibiting at the Salon des Indépendants in 1906 and at the Salon d'Automne in 1907, there are few contemporary sources that mention him or trace his activities. During the years 1900-06, Braque was a soldier, an apprentice decorator, and an art student. Although apparently no primary documents tell of his activities at this time, published secondary sources such as Henry R. Hope's *Georges Braque* (New York: The Museum of Modern Art, 1949), relied on Braque himself for details of this part of his life and one may accept them as reasonably accurate.

Between 1906 and 1909, the most important primary sources are the paintings themselves. Contemporary publications referring to Braque specifically include the exhibition catalogues of the Salon des Indépendants of 1906-09 and the Salon d'Automne of 1907, which are useful in locating Braque in his travels and charting his progress as an artist. In addition to these public exhibitions, he exhibited in a number of smaller shows. Those with catalogues that mention Braque include Cercle de l'Art moderne, Le Havre (1906-09)—the 1908 exhibition included an essay by Guillaume Apollinaire; *Exposition Georges Braque*, Braque's first individual show with a catalogue introduction by Apollinaire (Galerie Kahnweiler, November 9-18, 1908); continuous showings in group expositions at 28, rue Vignon with other Kahnweiler artists between 1907-14; and group exhibitions at the Galerie Nôtre-Dame-des-Champs in December, 1908 and at Galerie Berthe Weill in March, 1909. Outside France, Braque received mention at the Toison d'Or exhibitions in Moscow in April, 1908 and in February, 1909.

Critical mention of Braque during these years includes reviews by Apollinaire in *Je dis tout*, October, 1907, and *La Revue des lettres et des arts*, May, 1908; Louis Vauxcelles in *Gil Blas*, November, 1908 and April, 1909; Karl Max, *Le Télégramme* (Toulouse), December, 1908; Charles Morice, *Mercure de France*, January and April, 1909; and Gelett Burgess, *Architectural Record*, May, 1910. In addition to specific references to Braque's own work, he is mentioned twice in the context of the Fauves by Michel Puy, *La Phalange*, November, 1906, and by André Pératé in *Gazette des Beaux-arts*, 1907.

While the writings listed above are the only published sources relating directly to Braque during this period, they are not the only means of understanding the artist in the context of the time. Numerous other articles and reviews in the broader context of both Fauvism and Cubism cast light on the subject. Newspapers and little magazines, as well as more prestigious journals such as *Mercure de France*, were all engaged in the controversies surrounding the art of the avant-garde in the Belle Epoque.

For references to Braque's Fauvist period, see Ellen C. Oppler's well-documented and meticulously researched Ph.D. dissertation (Colombia University, 1969), published as *Fauvism Reexamined* (New York: Garland Publishing, 1976). John Elderfield, in his catalogue for the 1976 Museum of Modern Art's (New York) *The 'Wild Beasts': Fauvism and its Affinities* exhibition, concentrates on the stylistic evolution of each member of the group, provides insightful comparisons, and summarizes past scholarship. Research on the Le Havre Fauves—Braque, Dufy, and Friesz—was initiated by Kim Youngna in his 1980 Ph.D. dissertation (Ohio State University). The most significant recent work on Fauvism is Judi Freeman's authoritative catalogue for the 1990-91 traveling exhibition *The Fauve Landscape: Matisse, Derain, Braque and Their Circle, 1904-08* (Los Angeles County Museum of Art). One of the largest international loan shows of Fauve art ever assembled (175 works) and the first to concentrate on outdoor vistas, Freeman surveys the landscapes of eleven Fauves.

The literature on Cubism is vast and well beyond the scope of this research guide/bibliography. Seminal studies include John Golding, *Cubism: A History and An Analysis, 1907-1914* (3rd ed., London and Boston: Faber and Faber, 1988); Robert Rosenblum, *Cubism and Twentieth Century Art* (rev. ed., New York: H. N. Abrams, 1976); and Edward Fry, *Cubism* (New York and London: Oxford University Press, 1978). These works represent very different approaches to the subject. Golding's work is a systematic formal and procedural analysis of the early years (to 1914 only), along with extensive quotations from early writing and reviews. It also pays considerable attention to the secondary strands and offshoots of Cubism in those years, included in a separate chapter. Rosenblum's book uses a representative selection of plates as the basis for enlarging upon the character of Cubism. It introduces parallels to the other arts, especially literature and music, and extends in its later chapters to developments in other countries and the part played by Cubism there. Fry's publication is a carefully compiled anthology of theoretical and historical texts, many of them inaccessible, with valuable notes on each. Its introduction is, as the book's title implies, about the development of Cubism rather than the development of its theory. It includes new photographic comparisons, digests of the known factual details, and some brief comparisons with philosophy of the time.

Other important works on Cubism include Douglas Cooper's *The Cubist Epoch* (New York and London, 1970); Douglas Cooper and Gary Tinterow's *The Essential Cubism: Braque, Picasso & Their Friends, 1907-1920* (London: Tate Gallery, 1983); Lynn Gamwell, *Cubist Criticism* (Ann Arbor, MI: UMI Research Press, 1980); Pierre Daix, *Cubist and Cubism* (Geneva: Skira; New York: Rizzoli, 1982); Mark Roskill, *The Interpretation of Cubism* (Philadelphia: The Art Alliance Press, 1985); Christopher Green, *Cubism and its Enemies: Modern Movements and Reaction in French Art, 1916-1928* (New Haven and London: Yale University Press, 1987); and R. Stanley Johnson, *Cubism & la section d'or: Reflections on the Development of the Cubist Epoch; 1907-1922* (Chicago: Klees/Gustorf, 1991). MOMA's historic 1989 exhibition, *Picasso and Braque: Pioneering Cubism* and the proceedings of its symposium, *Picasso and Braque: A Symposium* (1992), add considerable new research and interpretation to the subject.

Though these books and catalogues provide excellent means of conducting scholarly research into the ideas and attitudes of the time, the researcher should be aware of another valuable avenue of approach to the study of Braque. These are the unpublished private archives that contain documents to which Braque had access or to which he provided insight. The most important of these are at present the collection and archives of Daniel-Henry Kahnweiler (Galerie Louise Leuris, Paris), which includes photographs, contracts, letters, catalogues, press clippings, and paintings from the period, many of which Braque himself must have seen and touched; Braque's own archive, now in the possession of his heir, Claude Laurens, in Paris, containing letters, drawings, paintings,

sculptures, and objects of art, as well as an enormous and unfortunately unedited collection of newspaper clippings dating from the early years of this century. Excellent photographic archives are in the possessions of Mme Mariette Lachaud, Paris, and Mme Nicole Mangin (Worms de Romilly) of the Fondation Maeght, Paris, whose catalogue raisonné of Braque's work is invaluable. The Picasso archive, when available, should also provide much information.

Georges Isarlov's *Œuvres de Georges Braque (1906-1929)* (1932) contains a partial bibliography, a preliminary list of works, an exhibitions list, and a list of collections containing the artist's works current to about 1929. A complete bibliography of Braque to 1949 exists in Hope's *Georges Braque*, and an exhaustive bibliography, prepared by Nadine Pouillon, is contained in Leymarie and Pouillon's *G. Braque*, Musée de l'Orangerie, 1973-74. In addition to the exhibition catalogues mentioned above, Braque's œuvre is treated in the *Catalogue de l'œuvre de Georges Braque* issued by the Galerie Maeght, Paris, includes vol. 7 (1962), covering 1924-27 and vol. 6 (1973) covering 1916-1923, which have no numeration for reference purposes and inadequate comments as to dating; to these has now been added *Braque, Le Cubisme fin 1907-1914* (1982), with numbered entries and revised dates, prepared by Nicole Mangin (Worms de Romilly) and Jean Laude, with an introduction by the latter. Useful also for reference, though incomplete, is Marco Valsecchhi, *L'Opera completa di Braque, della scomposizione cubista al recupero dell'oggetto, 1908-1929* (Milan, 1971). The exhibition catalogue *Georges Braque, les papiers collés,* Center Pompidou (Paris, June-September 1982) includes revisions of chronology, documentation and interpretative essays; the latter appear also, in English, in the version of the exhibition, *Braque, The Papiers Collés,* shown at the National Gallery, Washington, D.C., October 1982-January 1983, with catalogue entries by Isabelle Monod-Fontane and E. A. Carmean, Jr.

Common Abbreviations

cat.	catalogue
col.	color
diss.	dissertation
dist.	distributed
ed(s.)	edition(s) or editor(s)
exh.	exhibition
illus.	illustrations
min.	minutes
no. or nos.	number(s)
p. or pp.	pages(s)
pl.	plate(s)
ser.	series
supp.	supplement
vol(s.)	volume(s)

Primary Bibliography

I. Archival Materials . 17
II. Correspondence, Writings, Statements, and Interviews 17
III. Sketchbooks of Georges Braque . 22

I. Archival Materials

1. BRAQUE, GEORGES. *Georges Braque Archives*. Claude Laurens, Paris.

Includes two letters, drawings, paintings, sculptures, objects of art, and newspaper clippings.

2. BRAQUE, GEORGES. *Illustrated Notebooks, 1917-1955*. Trans. by Stanley Appelbaum. New York: Dover, 1971. 117 p., illus.

3. KAHNWEILER, DANIEL-HENRY. *Daniel-Henry Kahnweiler Archives*. Galerie Louise Leuris, Paris.

Includes photographs, contracts, letters, exhibition catalogues, press clippings, and paintings from Braque's Fauve period. Braque exhibited at Galerie Kahnweiler from 1907-14. His first one-artist show was held there 9-28 November 1908.

II. Correspondence, Writings, Statements, and Interviews

4. BRAQUE, GEORGES. *Correspondance de Georges Braque*. Several letters (or extracts from letters) dating from the Cubist period have recently been published by Isabelle Monod-Fontaine. See the exhibition catalogues at the Musée National d'Art moderne, Centre Georges Pompidou, Paris: *Georges Braque: les papiers collés* (1982):38-42; *Daniel-Henry Kahnweiler* (1984):106-127, and *Donation Louise et Michel Leiris* (1984):24-30.

5. BRAQUE, GEORGES. "Pensées et réflexions sur la peinture." *Nord-sud* 10(Dec. 1917):3-5.

a. Reprints: *Anthologie de la peinture en France* (Paris: Editions Montaigne, 1927):85-92.

b. U.S. eds.: *Artists on Art*, Robert Goldwater and Marco Treves, eds. (New York: Pantheon Books, 1945):421-3; *Art of this Century, 1910 to 1940*, Peggy Guggenheim, ed. (New York, 1942):62-4.

c. German eds.: *Kunstblatt* 4(1920):49-51; *Künstlerbekenntnisse* (Berlin: Propyläen Verlag, n.d.):148-9.

6. BRAQUE, GEORGES. "Pensées." *Valori Plastici* 1:2-3(Feb.-March 1919):2.

Seven epigrams by Braque quoted in a letter about Cubism from Léonce Rosenberg to the editor of *Valori Plastici*.

7. BRAQUE, GEORGES. "Braque." *Le Bulletin de la vie artistique* 21(1924).

8. BRAQUE, GEORGES and EMMANUEL TERIADE (Interviewer). "Confidences d'artistes—Georges Braque." *L'Intransigeant* (3 April 1928). Reprinted in *Montparnasse* 51(May-June 1928):1-2.

9. BRAQUE, GEORGES and EMMANUEL TERIADE (Interviewer). "Emancipation de la peinture." *Le Minotaure* 3-4(1933); pp. 9-20.

10. BRAQUE, GEORGES and GOTTHARD JEDLIKA (Interviewer) "Begegnung mit Georges Braque" in *Begegnungen: Künst-Iernovellen* (Basel: Benno Schwabe, 1933):127-52.

a. 2nd ed.: Erlenbach-Zurich: Eugen Rentsch, 1945, pp. 92-111.

11. BRAQUE, GEORGES. *Testimony Against Gertrude Stein*. The Hague: Service Press, 1935. 16 p. Supplement to *Transition* 23(1934-35):3-8.

Braque's reaction to *The Autobiography of Alice B. Toklas* by Gertrude Stein.

12. BRAQUE, GEORGES and CHRISTIAN ZERVOS (Interviewer). "Réponse à une enquête." *Cahiers d'art* 10:1-4(1935):21-4. 7 illus.

Concerns the revision of plastic values, based on conversations with Braque. The same issue of *Cahiers d'art* reproduces Braque's works on pp. 20, 23, 25-7, 29-30.

13. BRAQUE, GEORGES. "Braque at Varengeville." *Verve* (Spring 1938).

Includes photographs of Braque and his studio.

14. BRAQUE, GEORGES. "Reflections." *Verve* 1:2(Spring 1938):7.

English translation of statements by Braque selected from the artist's notebooks. Includes three color plates of Braque's works on pp. 53, 56.

15. BRAQUE, GEORGES and CHRISTIAN ZERVOS (Interviewer). "Réponse à une enquête." *Cahiers d'art* 14:1-4(1939):65-6.

Based on conversations with Braque.

16. BRAQUE, GEORGES. [Statements by Braque]. *Verve* 2:8(Sept.-Nov. 1940):56-7. 1 col. illus.

Taken from the artist's notebooks.

17. BRAQUE, GEORGES and JEAN PAULHAN. "Georges Braque dans ses propos." *Comœdia* (17 Sept. 1943).

18. BRAQUE, GEORGES and GASTON DIEHL (Interviewer). "L'Univers pictural et son destin: extrait d'une conversation avec Georges Braque" in *Les Problèmes de la peinture* (Paris: Editions Confluences, 1945), pp. 307-9.

19. BRAQUE, GEORGES. [Fragments inédits des] "Cahiers de Braque." *L'Amour de l'art* 26(Jan. 1946):3.

A drawing from Braque's notebook is reproduced on p. 2.

20. BRAQUE, GEORGES and ANDRE WARNOD. "Braque . . . s'est remis au travail." *Arts Magazine* 55(15 Feb. 1946):1,3.

21. BRAQUE, GEORGES. "Réponses à une enquête: à propos de 'l'art et le public.'" *Les Lettres françaises* (15 March 1946).

22. BRAQUE, GEORGES and ANDRE WARNOD (Interviewer). "Tous les *ismes* conduisent au conformisme nous déclare Braque." *Arts Magazine* 146(26 Dec. 1947):1, 5.

23. BRAQUE, GEORGES. "Témoignage." *Revue de la poésie* 1-2(June 1948):11.

24. BRAQUE, GEORGES. "Georges Braque, sa vie racontée par lui-même." *Amis de l'art* 4-8(1949). Propos recueillis par Nicole Montagne.

25. BRAQUE, GEORGES and R. W. HOWE (Interviewer). "Braque, But Only Unawares; Interview." *Apollo* 49(April 1949):104.

26. BRAQUE, GEORGES and PAUL GUTH (Interviewer). "Entretien avec Georges Braque." *Le Figaro littéraire* (13 May 1950).

27. BRAQUE, GEORGES and A. IMAIZUMI (Interviewer). "Georges Braque." *Mizue* (Oct. 1964). Special number devoted to Braque.

28. TERIADE, EMMANUEL. "Propos de Georges Braque." *Verve* 7:27-8(Dec. 1952):71-82.

29. RIBEMONT-DESSAIGNES, GEORGES. "Braque: l'abstrait, c'est de la peinture mondaine, un tableau est fini quand il a effacé l'idée." *Arts* 3(Sept. 1953).

30. LIMBOUR, GEORGES. "Braque à Varengeville." *Le Point* 46(Oct. 1953).

31. BRAQUE, GEORGES. "Sens de l'art moderne." *Zodiaque* 18-19(Jan. 1954):11-7.

"Cahiers de l'atelier du Cœur-Meurtry, Atelier Monastique de Sainte Marie de la Pierre-qui-Vire, Yonne, France."

32. BRAQUE, GEORGES and DORA VALLIER (Interviewer). "Braque, la peinture et nous." *Cahiers d'art* 29:1(1954):13-24. Reprinted in *L'Intérieur de l'art* (Paris: Editions du Seuil, 1982).

33. ROCHE, HENRI-PIERRE. "Souvenirs sur Georges Braque." *La Parisienne* 26(March 1955).

34. BRAQUE, GEORGES and RICHARDSON, JOHN (Interviewer). "Braque Speaks: The Power of Mystery." *The Observer* (London) (1 Dec. 1957).

35. BRAQUE, GEORGES and JOHN RICHARDSON (Interviewer). "Braque Discusses His Art." *Réalités* 93(Aug. 1958):26-31.

36. BRAQUE, GEORGE and DORA VALLIER. *Vom Geheimnis der Kunst. Georges Braque*. Gesammelte Schriften und von Dora Vallier aufgezeichnete Erinnerungen und Gespräche. Mit Photos. Berechtigte Übertragung von Sonja Bütler und Jean-Claude Berger. Zurich: Die Arche, 1958. 96 p. Volume in "Sammlung Horizont" series.

37. BRAQUE, GEORGES and GEORGES CHARBONNIER (Interviewer). "Entretien avec Georges Braque" in *Le Monologue du peintre* (Paris: René Julliard, 1959), vol. 1, pp. 7-18.

38. BRAQUE, GEORGES. *The Power of Mystery*. Edited by John Richardson. Pittsburgh, 1960. 10 p., illus.

39. BRAQUE, GEORGES. "Gedanken zur Kunst." *Das kunstwerk* 13:9(1960):15-6.

40. BRAQUE, GEORGES and DORA VALLIER. *Georges Braque: Ten Works*. With a discussion by the artist: Braque speaks to Dora Vallier. Trans. by Sonia Joyce. London: Oldbourne Press, 1962. 11 p., 10 col. pl.

a. U.S. ed.: A limited edition in facsimile. New York: Harcourt, Brace & World, 1962. 11 p., col. illus., 10 col. pl.

41. GOLDAINE, LOUIS, PIERRE ASTIER, and PIERRE RESTANY. *Ces peintres vous parlent*. Paris: Les Editions du Temps, 1964. 200 p. Volume in "L'Œil du temps" series.

Includes an interview with Braque, pp. 18-21.

42. BRAQUE, GEORGES and PIERRE REVERDY (Interviewer). "Entretien: Pierre Reverdy et Georges Braque, le 10 février 1950." *Derrière le miroir* 144:5(May 1964):74-6.

Special issue devoted to Braque.

43. BRAQUE, GEORGES and DORA VALLIER. *G. Braque*. Textes de Georges Braque et Dora Vallier. Basel: Editions Beyeler, 1968. 109 p., illus., 55 col.

44. COGNIAT, RAYMOND. *Georges Braque*. Paris: Flammarion, 1970.

a. Another ed.: Paris: Nouvelles Editions Françaises, 1976.
b. U.S. eds.: *Georges Braque*. Trans. by Eileen B. Hennessy. New York: Crown, 1970; 1978, 96 p., col. illus. *Georges Braque*. Trans. by I. Mark Paris. New York: Abrams, 1980. 168 p., 118 illus.

45. COOPER, DOUGLAS. *Braque: The Great Years*. Chicago: The Art Institute of Chicago, 1972. Catalogue of an exhibition held at the Art Institute of Chicago (7 Oct.- 3 Dec. 1972).

a. English ed.: London: Weldenfeld, 1973.

46. BRAQUE, GEORGES and JACQUES LASSAIGNE (Interviewer). Un "entretien avec Georges Braque," in catalogue of the exhibition *Les Cubistes*, Bordeaux, Galerie des Beaux-Arts and Paris, Musée d'Art moderne de la Ville de Paris, 1973; reprinted in *XXᵉ siècle* 35:41(1973):3-9. 9 illus. Summary in English.

Braque discusses some of the ideas behind Cubism and how they related to his own work, with particular reference to perspective, space and abstraction.

47. FORTUNESCU, IRINA and DAN GRIGORESCU. *Braque*. Bucharest: Editura Meridiana, 1977.

48. PONGE, FRANCIS. *L'Atelier contemporain*. Paris: Gallimard, 1977.

Texts reprinted include: "Braque le réconciliateur," pp. 58-69; "Braque ou l'art moderne comme événement et plaisir," pp. 70-7; "Braque-Dessins," pp. 102-8; "Braque-Japon," pp. 120-91; "Deux textes sur Braque: Braque lithographe," pp. 237- 46; and "Feuillet votif," pp. 246-50.

49. VERDET, ANDRE. *Entretiens, notes et écrits sur la peinture: Braque, Léger, Matisse, Picasso*. Paris: Editions Galilée, 1978. 211 p.

Includes the following texts on Braque: "Rencontre dans l'atelier parisien," pp. 11-6; "Autour du cubisme," pp. 16-25; "Rencontre à Saint-Paul," pp. 26-34; "Le Sentiment du sacré dans l'œuvre," pp. 35-8; "Dernier entretien," pp. 39-48; "Aux clartés d'un adieu," pp. 49-50.

50. VALLIER, DORA. *L'Intérieur de l'art: entretiens avec Braque, Léger, Villon, Miró, Brancusi (1954-1960)*. Paris: Editions du Seuil, 1982. 152 p., 5 illus. Volume in "Pierres vives" series.

51. LIMBOUR, GEORGES. *Dans le secret des ateliers*. Paris: L'Elocoquent, 1986.

Reprints "Georges Braque à Varengeville," pp. 23-7; "L'Atelier parisien de Braque," pp. 29-33.

52. BRAQUE, GEORGES. "Georges Braque ajatuksia taiteesta" [Georges Braque's Thoughts on Art]. *Taide* (Finland) 28:6(1988):40-5. 4 illus., 3 col.

Selection of Braque's aphorisms on art is presented to show his views on painting, sculpture, artists, aesthetic values, the art world of Paris in his time, and individual painters such as Manet and Cézanne. The comments are illustrated with four examples of Braque's work.

III. Sketchbooks of Georges Braque

53. BRAQUE, GEORGES. *Cahiers de Georges Braque, 1917-1947.* Paris: Fondation Maeght, 1947. 96 p., illus. Sequel: *Cahiers 1947-1955.* Paris: Fondation Maeght, 1956. 117 p., illus.

Includes four color lithographs by Braque.
a. Other eds.: 1948;(unillustrated): *Le Jour et la nuit. Cahiers de Georges Braque, 1917-1952.* Paris: Gallimard, 1952. 56 p., illus.
b. U.S. ed.: *Notebooks of Georges Braque, 1917-1947.* Trans. by Bernard Frechtman. New York: C. Valentin, 1948. 93 p., illus.
c. German ed.: *Der Tag und die Nacht: aus den Aufzeichnungen 1917-1952.* Trans. by Jean-Claude Berger. Zurich: Die Arche, 1953. 46 p., illus.
Review: *Print Collector's Quarterly* 30(March 1950):60.

54. BRAQUE, GEORGES. *The Intimate Sketchbook of G. Braque.* Texts by Will Grohmann and Antoine Tudal. With an appreciation by Rebecca West. English trans. by Stuart Gilbert. New York: Harcourt, Brace, 1955. Distributed in Great Britain and the Dominions by A. Zwemmer. 156 p., illus.

a. Excerpt: *Verve* 8:31-2(1955):1-156.

Secondary Bibliography:
Biography, Career and Picasso

I. Biography and Career Development .23
 Books .23
 Articles .26
II. Braque and Picasso .34
 Books .34
 Articles .36

I. Biography and Career Development

Books

55. BRION, MARCEL. *Georges Braque*. Paris: A. Somogy, 1963. 87 p., col. illus. Volume in "Enchantement de la couleur" series.

a. English ed.: Trans. by A. H. N. Molesworth. London: Oldbourne Press, 1963.
b. U.S. eds.: New York: Abrams, 1963; 1976.

56. CAFRITZ, ROBERT C. *Georges Braque*. With an essay by Duncan Phillips; chronology by Jan Lancaster. Edited by Jan Lancaster. Washington, D. C.: Phillips Collection, 1982. 18 p., illus., 10 pl., some col. Volume in "Medaenas Monographs on the Arts" series.

57. CASSOU, JEAN. *Georges Braque, né en 1882*. Paris: Flammarion, 1956. illus., 30 pl., col. pl. Volume in "Collection le grand art en livre de poche" series.

a. U.S. eds.: *Georges Braque (Born in 1882)*. New York: H. N. Abrams, 1957. 74 p., 31 illus., 1964.
b. Spanish ed.: Trans. by R. S. Torroella. Barcelona: Ed. Timun Mas, 1959.

58. COGNIAT, RAYMOND. *Georges Braque*. Paris: Flammarion, 1970. Volume in "Les Maîtres de la peinture moderne" series.

a. Another ed.: Paris: Nouvelles Editions Françaises, illus., 48 pl., some col.
b. U.S. eds.: *Georges Braque*. Trans. by Eileen B. Hennessy. New York: Crown, 1970; 1978, 96 p., col. illus. *Georges Braque*. Edited by Joanne Greenspan. Trans. by I. Mark Paris. New York: Abrams, 1980. 168 p., 121 illus., 48 col.
c. English ed.: Lugano: Uffici Press, 1970. 96 p., illus.
Review: R. Martin, *ARLIS/NA Newsletter* 8:6(Oct. 1980):186-7.

59. DAMASE, JACQUES. *Georges Braque*. Paris: Marabout, 1963. 90 p., illus., some col. Deventer: De Ijsel.

a. U.S. ed.: Trans. by Tony White. New York: Barnes & Noble 1963. 90 p., illus., some col.
b. English ed.: London: Blandford Press, 1963.

60. DIEHL, GASTON. *Peintres d'aujourd'hui, les maîtres. Témoignages de Georges Braque . . . Raoul Dufy . . . recueillis par Gaston Diehl*. Paris: Les Publications Techniques, 1943. 35 p., illus. Volume in "Collection Comœdia—Charpentier" series.

61. DORIVAL, BERNARD. *Braque*. Paris: Marenod, 1948.

62. FAUCHEREAU, SERGE. *Braque*. Paris: Albin Michel, 1987.

a. U.S. ed.: *Braque*. Trans. by Kenneth Lyons. New York: Rizzoli, 1987. 128 p., illus., some col.

63. HOPE, HENRY RADFORD. *Georges Braque*. The Museum of Modern Art, in collaboration with the Cleveland Museum of Art. Text by Jean Cassou, translated by Monroe Wheeler. New York: Museum of Modern Art; dist. by Simon and Schuster, 1949. 169 p., illus.

Discusses Braque's early years through Fauvism on pp. 11-28. Includes a comprehensive bibliography of Braque to 1949.
Reviews: *Canadian Art* 7:2(1949):80; *Burlington Magazine* 92(Feb. 1950):58.

64. ISARLOV, GEORGES. [*Georges Braque*]. Paris: L'Annonciation, 1925.

a. Another ed.: Paris: Orbes, 1932. 31 p. 200 copies.

65. LAMAC, MIROSLAV. *Georges Braque*. Prague: Odeon, 1982. 94 p., col. illus.

66. LEYMARIE, JEAN. *Braque*. Geneva, London, New York: Skira, 1961. Volume in "Le Goût de notre temps" series.

a. U.S. ed.: *Braque*. Trans. by James Emmons. New York: Skira, dist. by World Publishing Co., Cleveland, 1961. 133 p., col. pl.
b. English ed.: London: Zwemmer, 1961.
Review: G. Habasque, *L'Œil* 84(Dec. 1961):78.

67. LEYMARIE, JEAN, ed. *Georges Braque*. Munich, New York: Prestel, 1992. 280 p., 158 illus., 123 col.

68. LIMBOUR, GEORGES. *Dans le secret des ateliers*. Paris: L'Elocoquent, 1986. 92 p., illus.

Reprints two texts on Braque: "Georges Braque à Varengeville," pp. 23-7; "L'Atelier parisien de Braque," pp. 29-33.

69. MARTIN, ROBERT. *Braque*. Paris: Hachette, 1966. Volume in "Chefs-d'œuvre de l'art, grands peintres" series.

70. MASINI, LARA VINCA. *Braque*. Abrence: Sadea Sansoni, 1969. 96 p., illus., 43 pl. Volume in "Maestri del novecento" series.

a. U.S. ed.: London; New York: Hamlyn; dist. in the U.S. by Crown Publishers, 1971. 95 p., illus., 43 col. pl.

71. MULLINS, EDWIN B. *Braque*. London: Thames & Hudson, 1968. 216 p., 160 illus., 31 col. Volume in "World of Art Library" series.

a. U.S. eds.: *The Art of Georges Braque*. New York: Abrams, 1968. 216 p., illus., some col.; 1971.
Review: J. Cohen, *Art and Artists* 4(March 1969):65.

72. OLIVETTI, CALENDRIER. *G. Braque*. Ivrea: Olivetti, 1958.

73. PALLUCCHINI, RODOLFO. *Braque*. Presentazione di Rodolfo Pallucchini. Rome: De Luca Editore, 1958. 74 p., illus. Volume in "Pittura artista stranieri" series.

74. PONGE, FRANCIS, PIERRE DESCARGUES, and ANDRE MALRAUX. *G. Braque*. Paris: Draeger, 1971. 268 p., illus., some col.

a. U.S. ed.: *G. Braque*. Texts translated by Richard Howard. Biography and captions translated by Lane Dunlop. New York: H. N. Abrams, 1971. 268 p., illus., some col.

75. POUILLON, NADINE. *Braque*. Paris: Nouvelles Éditions Françaises, 1970. Volume in "Le Musée personnel" series.

76. RICHARDSON, JOHN. *Georges Braque*. Harmondsworth, England: Penguin Books, 1959. 31 p., 32 pl., some col. Volume in "Penguin Modern Painters" series.

a. Other eds.: London: Oldbourne Press, 1961. 32 p., 43 illus., 34 col. pl.
b. U.S. eds.: Greenwich, Connecticut: New York Graphic Society, 1961; New York: Public Education Association, 1964. 10 p., 89 pl.
c. Italian ed.: Milan: Silvana Editoriale, 1961.
d. French ed.: Paris: Bibliothèque des arts, 1962.
Reviews: D. Farr, *Burlington Magazine* 102(Feb. 1960):83; *Connoisseur* 148(Oct. 1961):159.

77. WILKIN, KAREN. *Georges Braque*. New York: Abbeville Press, 1991. 127 p., 93 illus., some col. Volume in "Modern Masters" series.

Biographical study and critical assessment. Chapter 2 (pp. 21-27) covers Braque's Fauve period.

78. ZURCHER, BERNARD. *Braque, vie et œuvre*. Fribourg: Office du Livre, 1988. 313 p., illus., some col.

Traces the career and life of Georges Braque, starting from his early work influenced by Cézanne and his involvement with the Fauves and tracing his relationship with Picasso and the development of Cubism. Zurcher considers his innovative work in collage and notes Braque's need to demonstrate the relationships between adjacent objects. He discusses the role of the human figure in Braque's paintings, assessing the significance of the *Canephorae* on his work, considers the importance of his studio as subject matter for his paintings of interiors, and concludes with a chapter on Braque's landscapes and work on the theme of nature.
a. U.S. ed.: *Georges Braque: Life and Work*. Trans. by Simon Nye. New York: Rizzoli, 1988. 319 p., 235 illus., 150 col.

Articles

79. "A Varengeville avec Georges Braque." *France illustration* 417(Dec. 1954):111-8.

80. ALVARD, JULIEN. "Paris: Braque's Studio." *Art News* 66(Oct. 1967):62.

81. ARLAND, MARCEL. "Braque." *L'Age nouveau* 42(1949).

82. BARROWS, CLYDE. "Braque." *Apollo* (April 1931).

83. BAZIN, GERMAIN. "Braque." *Labyrinthe* 4(15 Jan. 1945).

84. BISSIERE, ROGER. "Georges Braque." *L'Art d'aujourd'hui* 2:6(1925):21-5.

85. BONFANTE, EGIDIO and JUTI RAVENNA. "Georges Braque" in *Arte cubista* (Venice: Ateneo, 1945), pp. 107-31. 11 illus., some col.

Brief text with illustrations.

86. BONJEAN, JACQUES. "L'Epoque fauve de Braque." *Les Beaux-arts* (18 Feb. 1938):4.

Review of the Braque exhibition at Galerie Pierre in Paris (Feb. 1938).

87. BOSQUET, ALAIN. "Braque: comme on dit Racine ou Rameau." *Connaissance des arts* 365-6(July-Aug. 1982):38-45.

88. BOVE, E. "Georges Braque: with Biographical Note, Signature, and Palette." *Formes* 3(March 1930):4-5, 26. 9 illus., 1 col.

89. BRANDT, BILL. ["Photograph of Georges Braque and of Braque's Lectern"]. *Verve* 1:2(Spring 1938):52, 55.

90. "Braque: The Cool Fire-Spitter." *Time* 68(29 Oct. 1956):82-3.

91. "Braque: The Great Years." *Connoisseur* 182(Feb. 1973):135-6.

92. "Braque's 80th Birthday: Homage to Braque." *Apollo* 76(May 1962):162-4, 220-1.

93. BRASSAÏ, JULES. "Braque." *Harper's Bazaar* 80:3(March 1946):156-7.

Photographs of Braque in his studio by Brassaï.

94. BROOKNER, ANITA. "L'Atelier de Braque." *Burlington Magazine* 104(Jan. 1962):44.

95. CALVO, SERRALLER F. "En Madrid, antologica de Georges Braque." *Guadalimar* 45(1979).

96. CASSOU, JEAN. "Georges Braque." *Cahiers d'art* 3:1(1928):5-11. 8 illus.

97. CASSOU, JEAN. "Braque, Marcoussis et Juan Gris." *L'Amour de l'art* 14(Nov. 1933):227-33. 8 illus.

98. CASSOU, JEAN. "L'Atelier de Braque." *La Revue du Louvre et des musées de France* 6(1961):279-82.

99. CENDRARS, BLAISE. "Braque." *La Rose rouge* (19 June 1919).

a. Reprint: *Le Centaure* 3:9(June 1929):244.

100. CEPE, P. "Georges Braque." *Paris Journal* (13 April 1923).

101. CHAR, RENE. "Georges Braque." *Cahiers d'art* 22(1947):334.

Reprint of a text first published in *Derrière le miroir* 4(1947).

102. CHAR, RENE, HENRI MALDINEY, and JACQUES GAIGNARI. "G. Braque." *Derrière le miroir* 25-6(Jan.-Feb. 1950).

103. CHAR, RENE. "Songer à ses dettes." *La Nouvelle revue française* (1 Oct. 1963).

104. CHEVALIER, DENYS. "Georges Braque." *Aujourd'hui art et architecture* 34:6(Dec. 1961):4-12. 13 illus., 4 col.

105. "Chroniques—l'atelier parisien de Georges Braque." *Derrière le miroir* 85-6(April-May 1956).

106. COOPER, DOUGLAS. "Georges Braque, l'ordre et le métier." *La France libre* 67(15 May 1946).

107. COOPER, DOUGLAS. "Braque." *Town and Country* 103(March 1949):43, 92, 95-6, 99.

108. COOPER, DOUGLAS. "Georges Braque." *L'Œil* 107(Nov. 1963):26-33. 13 illus., 2 col.

109. DAURIAC, JACQUES-PIERRE. "Centenaire de Georges Braque." *Pantheon* 40(July-Sept. 1982):251-2.

110. DESCARGUES, PIERRE. "Braque à l'Orangerie." *L'Œil* 219(Oct. 1973):32-41. 17 illus.

Contends that Braque was never a public figure like Picasso and never involved himself overtly in politics or signed manifestoes. Yet he was, contrary to general opinion, willing to talk about his work, which is marked by optimism and an interest in the objects of everyday life and of nature; these were his inspiration far more than the art of past ages. His career is traced from his Fauvist period to the period of Cézanne's influence, the Cubist experiments with Picasso, and his independent development thereafter, which was marked by complete indifference to artistic trends around him. Reasons are suggested why his achievement is not usually regarded as comparable to Picasso's. A conversation between Descargues and Claude Laurens is then reproduced in which they discuss Braque's funeral, his relationship with the people of Varengeville, and Lauren's work and his responsibilities in taking charge of Braque's œuvre and preparing it for publication. Braque's destruction of many works and of some of his notebooks is described.

111. DORIVAL, BERNARD. "Braque" in *Les Peintres célèbres* (Paris: Mazenod, 1948), pp. 332-3.

Stylistic analysis, in part chronological. Volume includes frontispiece especially designed by Braque.

112. DUVAL, REMY. "Intimités de Braque." *L'Amour de l'art* 27:5(1947):215-8.

Photographs of Braque, his hand, his studio, his paint pots and brushes.

113. EINSTEIN, CARL. "Braque après la guerre." *Beaux-arts* (6 July 1934):1[+].

114. ELUARD, PAUL. "Georges Braque" in *Capitale de la douleur* (Paris: Gallimard, 1926), p. 128.

Poem by Eluard about Braque.
a. Reprint: *Voir*. Geneva, Paris: Editions des Trois Collines, 1948, pp. 37-9. 1 col. illus.

115. FIERENS, PAUL. "Georges Braque." *Sélection* 3:4(Feb. 1924):360-2, 400.

116. FLAM, JACK DONALD. "Cubiquitous." *Art News* 88:10(Dec. 1989):144-9. 8 illus., 4 col.

Reviews the exhibition at the Museum of Modern Art, New York, *Picasso and Braque: Pioneering Cubism*, which showed nearly 400 works, putting them apart from the so-called "public" Cubists. Although they worked together very closely to forge a new pictorial syntax, Picasso and Braque came from very different viewpoints: Picasso was initially more concerned with sculptural rendering of form and seems to have had the more acute visual intelligence. Flam points out that the term Cubism is imprecise, tracing its origin and concluding that even the "classic" Cubism of Picasso and Braque

..um 1907 to 1914 cannot be covered by a single term, and he outlines their progression during that period.

117. FLANNER, JANET. "Profiles: Master (Georges Braque)." *New Yorker* 32(6 Oct. 1956):49-50+; (13 Oct. 1956):50-2+.

a. Reprint: J. Flanner, *Men and Monuments* (New York: Harper, 1957).

118. "G. Braque." *Life* 26(2 May 1949):80-6. 13 illus.

119. GAUTHIER, MAXIMILIEN. "Georges Braque." *L'Art vivant* 6(15 May 1930):392.

120. "Georges Braque." *Apollo* 61(April 1955):108-9+.

121. "Georges Braque: A Leader of Modern Art." *Picture Post* (London)32:1 (20 July 2946):26-7.

122. GILMOUR, P. "Georges Braque." *Arts Review* 24:22(1972).

123. GIRY, MARCEL. "La Période fauve de Braque." *L'Œil* 323(June 1982):32-9. 10 illus.

124. GOLDING, JOHN. "Braque." *The Masters* (London) 62(1966).

125. GORDON, A. "Braque, 1882-1963, A Tribute." *Connoisseur* 154(Dec. 1963):254+.

126. GOWING, LAWRENCE. "Two Contemporaries, Braque and Ben Nicholson." *New Statesman* (April 1957).

127. GREENBERG, CLEMENT. "Braque" in *Art and Culture: Critical Essays* (Boston: Beacon, 1961), pp. 87-90.

128. GROHMANN, WILL. "Georges Braque." *Cicerone* 21:20(Oct. 1929):576-82.

129. GUEGUEN, PIERRE. "L'Indigence de Braque—à propos d'un entretien." *Art d'aujourd'hui* 4(Aug. 1953):29.

130. HELLERSTEIN, NINA. "The Position of Georges Braque" in "*Quelques reflections sur la peinture cubiste* de Paul Claudel." *Claudel Studies* 10:1(1983):24-31.

131. HERON, PATRICK. "Braque at the Zenith." *Arts* (London) (Feb. 1957).

132. "Homage to Georges Braque." *Arts Magazine* 37(Nov. 1962):22-3.

133. "Hommage à Georges Braque." *Derrière le miroir* (1964).

Special issue devoted to Braque.

134. HUBERT, ETIENNE-ALAIN. "Georges Braque selon Guillaume Apollinaire" in *Mélanges à Michel Décaudin: L'Esprit nouveau dans tous ses états, en hommage à Michel Décaudin* (Paris: Librairie Minard, 1986).

135. HUSER, FRANCE. "Grandeur et décadence d'un peintre." *Le Nouvel observateur* (19-25 July 1980).

136. JAKOVSKI, ANATOLE. "Interviews et opinions: Georges Braque." *Arts de France* 8(1946):31-6.

137. JEDLICKA, GOTTHARD. "Georges Braque." *Universitas* (Stüttgart) 9(1954).

138. JOUFFROY, JEAN-PIERRE. "Et le grand Braque." *L'Humanité Dimanche* (15 Aug. 1980).

139. KAHNWEILER, DANIEL-HENRY. "Werkstätten." *Die Freude* (Burg Lauenstein) 1(1920):153-4.

Brief description of Braque's studio in 1914. Illustrations of Braque's works are on pp. 64-5, 152-3 of the same issue.

140. "Kandinsky et Braque." *XX^e siècle* 25(Dec. 1963):2.

141. KENNER, HUGH. "Brooklyn's Braque: How Max Weber Brought Cubism to America." *Art & Antiques* 9(March 1992):120.

142. KOHLER, A. "En hommage à Braque." *Coopération* (28 Sept. 1963).

143. KRAMER, HILTON A. "Cubism's Conservative Rebel." *New York Times Magazine* (20 May 1962):28, 97-9.

144. KUSPIT, DONALD BURTON. "Cubist Hypochondria; On the Case of Picasso and Braque." *Artforum* 28:1(Sept. 1989):112-6. 4 illus., 2 col.

Detailed discussion of Cubism with reference to the exhibition *Picasso and Braque: Pioneering Cubism* at The Museum of Modern Art, New York (1989). Kuspit suggests that Cubism was more ambivalent about modernity than is often supposed and draws on the ideas of psychoanalysts and psychoanalytic critics to argue that Cubism makes explicit the articulation of bodiliness "as such", Freud's "bodily ego," but with the dramatic twist that it shows it in disintegration. Kuspit looks at it in terms of depersonalization and disembodiment, regression and psychotic tendencies and summarizes its true, morbid message as the impossibility of coherent organization in a world of change that is both emotionally discomforting and physically exhausting. In this it is the archtype of 20th century creativity.

145. LALOY, L. "Braque." *Comœdia* (23 Jan. 1924).

146. LEROY, CLAUDE. "Braque pseudonyme." *Cahiers du Musée National d'art moderne* 11(1983):144-59. 23 illus.

On Braque's maxims as both literary expressions and statements of aesthetic principle and on their relation to his painting.

147. LEVEQUE, JEAN-JACQUES. "Braque." *Galerie-Jardin des arts* 130(Oct. 1973):48-9, 52-4. 17 illus.

On the occasion of the major retrospective exhibition of paintings by Braque held at l'Orangerie, Paris (17 Oct. 1973-14 Jan. 1974), Levêque examines the artist's role in the history of modern painting. He quotes from Jean Paulhan's essay on Braque before analyzing the painter's career, his links to the Fauves, and the judgments of him by Guillaume Apollinaire and Jean Leymarie. He comments that whereas Picasso made a kind of *volte-face* in his reaction to Cubism, Braque followed the lesson of Cézanne in returning figurative solidity to the plastic order. His themes are simple objects, typical of French painting which is unlike Italian in its use of personalities and not marked by the fatality of the Spanish school, nor by the severity of the German. Braque's paintings give the impression of happiness and dignity, order and passion, in the name of a superior harmony.

148. LIBERMAN, ALEXANDER. "Braque." *Vogue* (New York) (1 Oct. 1954):112-9, 173.

149. LIBERMAN, ALEXANDER. "The Artist in His Studio." *Studio* 159(April 1960):115-9.

150. LIMBOUR, GEORGES. "Georges Braque, découvertes et traditions." *L'Œil* 33(Sept. 1957):26-35.

151. MARTIN, ALVIN RANDOLPH III and JUDI FREEMAN. "The Distant Cousins in Normandy" in *The Fauve Landscape*, edited by Judi Freeman [exh. cat. Los Angeles County Museum of Art] (New York: Abbeville Press, 1990), pp. 215-39. 33 illus., 20 col.

152. MASTAI, M. L. D. "Tribute to Georges Braque." *Connoisseur* 154(Dec. 1963):272-3.

153. MONTALE, E. "Visit to Braque." Trans. by J. Galassi. *Paris Review* 23(Fall 1981):51-6.

154. Obituaries: *Kunstwerk* 17(Aug. 1963):82; *Art News* 62(Oct. 1963):21.

155. OCHSE, M. "Georges Braque (1882-1963): la vocation de l'inexplicable." *Jardin des arts* 218(May-June 1973):36-43. 7 illus.

156. PAULHAN, JEAN. "Braque, le patron." *Poésie* 43:13(March-April 1943):2-15.

First edition of *Braque, le patron*, later published in an illustrated edition (Geneva, Paris: Fernand Mourlot; Editions des Trois Collines, 1945).

157. PAULHAN, JEAN. "Georges Braque." *Horizon* 11:65(May 1945):329-39.

English translation of a text which first appeared in *Braque, le patron* (Paris: Mourlot, 1945).

158. PAULHAN, JEAN. ["Georges Braque"]. *Open Oog* (Amsterdam) 1(Sept. 1946):15-6.

Includes texts translated into Danish first published in *Braque, le patron* (Paris: Mourlot, 1945).

159. PAULHAN, JEAN. "Vie imagée de G. Braque." *Arts magazine* (1952).

160. PAULHAN, JEAN. "Peindre en Dieu." *La Nouvelle revue française* (1 Oct. 1963).

161. "Photograph by R. Avedon." *Camera* 38(Nov. 1959):29.

162. PICON, G. "Allocution prononcée à l'église de Varengeville le 4 septembre 1963." *Mercure de France* (Oct. 1963).

163. PONGE, FRANCIS. "Braque, le réconciliateur." *Labyrinthe* 2:22-3(Dec. 146):6-7.

164. "Portrait." *Cahiers d'art* 31-2(1956-57):259; *XX^e siècle* 21(Dec. 1959):6;

165. "Portrait by Bouché." *Museum of Modern Art* 28:2(1961):25.

166. "Portrait by H. Cartier Bresson." *Domus International* 407(Oct. 1963):42-3.

167. PRESLER, G. "Georges Braque und Fernand Léger." *Weltkunst* 51:24(15 Dec. 1981):3814-5. 4 illus.

Traces the careers of Georges Braque and Fernand Léger, with reference to the exhibition in the Staatsgalerie, Stüttgart (Nov. 1981-Jan. 1982), of their collages, prints, drawings and book illustrations, a show which Presler found interesting for the comparisons to be made between their early work and that of Juan Gris and Picasso.

168. "Propos de Georges Braque." *Verve* 7:27-8(1952):71-82. 10 illus., 1 col., 8 col. pl.

169. PUY, MICHEL. *La Phalange* (Nov. 1906).

Exhibition review which mentions Braque in context of the Fauves.

170. "Les 80 ans de Braque." *XX^e siècle* 24(June 1962):2.

171. RAGON, M. "Georges Braque." *Jardin des arts* 148(1967).

172. REUILLARD, GABRIEL. "Braque." *Paris-Normandie* (2 April 1951).

173. REVOL, JEAN. "Braque et Villon: message vivant du cubisme." *La Nouvelle revue française* (Aug.-Sept. 1961).

174. RICHARDSON, JOHN. "The Ateliers of Braque." *Burlington Magazine* 97:627(June 1955):164-70.

175. RICHARDSON, JOHN. "Le Nouvel 'atelier' de Braque." *L'Œil* 6(June 1955):20-5, 39.

176. RICHARDSON, JOHN. "Braque Speaks: The Power of Mystery of Georges Braque." *The Observer* (London) (1 Dec. 1957).

Interview with Braque.

177. RICHARDSON, JOHN. "Pre-Cube to Post-Zen." *Art News* 63:2(April 1964):29-31, 54.

178. SCHNEIDER, PIERRE. "Homage to Braque." *Art News* 60(Feb. 1962):46[+].

179. SCHWABSKY, BARRY. "Georges Braque." *Arts Magazine* 63:1(Sept. 1988):93. 1 col. illus. In English.

With reference to an exhibition of work at the Solomon R. Guggenheim Museum, New York (10 June-11 Sept. 1988), Schwabsky considers briefly the career and work of French painter Georges Braque. The exhibition illustrated clearly Braque's transition from Fauvism to Cubism, and his regretful return in the 1950s to land and seascapes. It is concluded that Braque always found painting hard work because he strove to possess the thing that he painted.

180. STEINBERG, LEO. "The Philosophical Brothel." *Art News* 71:5,6(Sept., Oct. 1972):20-9, 38-47.

181. "Strange Universe of Georges Braque." *Arts & Architecture* 71(July 1954):16-7[+].

182. TERIADE, EMMANUEL. "Propos de Georges Braque." *Verve* 7:28-9(Dec. 1952).

183. USCATESCU, J. "Braque y el Cubismo." *Goyá* 136(Jan. 1977):237-9.

184. VALLIER, DORA. "Braque, la peinture et nous; propos de l'artiste recueillis." *Cahiers d'art* 29:1(1954):13-24.

185. VECCHIS, M. DE. "Caro Braque ci vediamo alla Colombe" [Dear Braque, We See You at La Colombe]. *Bolaffiarte* 8:75(Dec. 1977):24-9. 15 illus.

Brief introduction to the modern art collection at the "La Colombe d'Or" inn at Saint-Paul-de-Vence, near Nice, which first became famous in 1960 with the theft of works by several artists, including Braque and Picasso.

186. VERDET, ANDRE. "Braque le solitaire." *XXe siècle* 20:11(1958):9-17. English synopsis on p. 90.

187. VERDET, ANDRE. "Avec Georges Braque." *XXe siècle* 24:2(Feb. 1962):21-2.

188. VERONESI, GIULIO. "L'Atelier de Georges Braque." *Emporium* 135(Jan. 1962):3-6.

189. VIEIRA, J. G. "Georges Braque." *Habitat* 73(Sept. 1963):38-41.

190. VOLBOUDT, PIERRE. "Braque et le vol poétique." *XXe siècle* 21(1959):42-3.

191. WALLARD, DANIEL. "Braque en 1943" in *Les Problèmes de la peinture* (Paris: Editions Confluences, 1945), pp. 93-8.

192. WARNOD, ANDRE. "Braque s'est remis au travail." *Arts* 55(1946).

193. WARNOD, ANDRE. "Tous les ismes conduisent au conformisme nous déclare Braque." *Arts* 146(26 Dec. 1947):1, 5.

194. WATT, ANDRE. "Paris, Letter, with Braque." *Art in America* 49:3(1961):102-4.

195. WATT, ANDRE. "Visages d'artiste." *Studio* 162(Nov. 1961):169-71.

196. WENTINCK, CHARLES. "Du nouveau sur Braque: un atelier retrouvé." *Jardin des arts* (June 1970):64-7. 4 illus.

197. ZERVOS, CHRISTIAN. "Georges Braque." Trans. by M. Mauthner. *Kunst und Künstler* 27(July 1929):386-9.

Includes biographical information.

II. Braque and Picasso

Books

198. APOLLINAIRE, GUILLAUME. *Les Peintres cubistes. Méditations esthétiques. Première série: Pablo Picasso, Georges Braque* [et al.]. Paris: Eugène Figuière et Cie., 1913. 84 p., pl.

a. 2nd. ed.: Paris: Editions Athena, 1922.
b. Other eds.: Geneva: Pierre Cailler, 1950; Paris: Herman, 1965.
c. U.S. ed.: *The Cubist Painters; Aesthetic Mediations*. New York: Wittenborn, Schultz, 1949.

199. ASHTON, DORE, ed. *Picasso on Art; A Selection of Views*. New York: Viking Press, 1972. 187 p., illus. Volume in "The Documents of 20th Century Art" series.

200. BLUNT, ANTHONY and PHOEBE POOL. *Picasso, The Formative Years: A Study of His Sources*. Greenwich, CT: New York Graphic Society, 1962. 32 p., illus., 63 pl.

201. CHASTEL, ANDRE and YVES BONNEFOY. *Fables, formes, figures*. Paris: Flammarion, 1978. 2 vols., 1085 p., 436 illus., 8 col. Volume in "Idées et recherches" series.

Includes sixty-four articles by the French art historian published in various journals and Festschriften from the 1930s through 1977. One section deals with the reciprocal exchange of ideas between Braque and Picasso.

202. CHIPP, HERSCHEL BROWNING. *Cubism: 1907-1914.* Ph.D. diss., Columbia University, 1955. 172 p.

203. FAUCHEREAU, SERGE. *La Révolution cubiste.* Paris: Denoël, 1982. 223 p., 192 illus., some col.

In this discussion of the Cubist movement, Fauchereau criticizes purist art historians who have tended to discount as peripheral the work of the many artists who interpreted the "analytical" and "synthetic" Cubist paintings by Picasso and Braque from the period 1907-14 in their own ways. He argues that the period from the late 19th century to the 1930s in France was a crucible in which a whole series of revolutionary art movements were created largely due to the formal experiments of the Cubists and the related activities of their followers.

204. INOUE, YASUSHI and SHUJI TAKASHINA. *Braque et le cubisme.* Paris: Editions T. Nishimura, 1973. Volume in "Les Grands maîtres de la peinture moderne" series.

205. MASINI, LARA VINCA. *Picasso e il Cubismo.* Florence: Sadea Sansoni Editori, 1970. 8 p., 32 pl. Volume in "Forma e Colore" series.

Includes seven Braque plates.

206. MOSELE, FRANZ. *Dies kubistische Bildsprache von Georges Braque, Pablo Picasso, und Juan Gris unter besonderer Berücksichtigung der Entwicklung der Farbe* [The Cubist Language of Images by Georges Braque, Pablo Picasso, and Juan Gris, with Special Reference to the Development of Color]. Ph.D. diss. Universität; Zurich: Juris Druck Verlag Zurich, 1973. 317 p., illus.

Investigates the phenomenon of color in art in general and the development of Cubist imagery in the work of Braque, Picasso, and Gris in particular. See *Dissertation Abstracts International: European Abstracts* 38:1(1977).

207. MUNDINGER, HUGO. *Die Landschaft im Kubismus be: Pablo Picasso und Georges Braque.* Tübingen: Fotodruck Prezis; Ludwigsburg: Löchgau, 1963. 161 p., pl.

208. OLIVIER, FERNANDE. *Picasso et ses amis.* Paris: Stock, 1933.

Includes scattered references to Braque.
a. English extract: *Studio* 107(*London Studio* 7) (April 1934):199-203.
b. U.S. ed.: *Picasso and His Friends.* Trans. by Jane Miller. New York: Appleton Century, 1965. 186 p., illus.

209. RUBIN, WILLIAM STANLEY. *Picasso and Braque: Pioneering Cubism*. Catalogue to accompany an exhibition at New York's Museum of Modern Art (1989-1990). New York: Museum of Modern Art; dist. by Boston: Bulfinch Press, 1989. 460 p., illus.

a. French ed.: *Picasso et Braque: l'invention du cubisme*. Suivi d'une chonologie documentaire par Judith Cousins. Paris: Flammarion, 1990. 422 p., illus.
b. German ed.: *Picasso und Braque: die Geburt des Kubsimus*. Mit einer vergleichenden biographischen Chronologie von Judith Cousins. Munich: Prestel-Verlag, 1990. 422 p., illus.
Reviews: J. Flam, *Art Journal* 49(Summer 1990):194-8; W. Rubin, *Gazette des Beaux-arts* ser. 6, 116, *Chronique des arts* (July-Aug. 1990):24-5.

210. RUBIN, WILLIAM STANLEY. *Picasso and Braque: A Symposium*. Moderated by Kirk Varnedoe; proceedings edited by Lynn Zelevansky. New York: The Museum of Modern Art; dist. by H. N. Abrams, 1992. 359 p., illus.

Records meetings of scholars organized at the time of the Museum's 1989-90 exhibition *Picasso and Braque: Pioneering Cubism*. Includes seven papers (including Theodore Reff's "The Reaction Against Fauvism") and transcripts of extended discussions and rebuttals.

211. UHDE, WILHELM. *Picasso et la tradition française: notes sur la peinture actuelle*. Paris: Edition des Quatre Chemins, 1928. 105 p., illus., 48 pl.

Braque is discussed on pp. 37-41.
a. U.S. ed.: *Picasso and the French Tradition: Notes on Contemporary Painting*. Trans. by F. M. Loving. Paris: Edition des Quatre Chemins; New York: E. Weyhe, 1929. 103 p., illus., 48 pl.

212. VERDET, ANDRE. *Entretiens: Notes et écrits sur la peinture: Braque, Léger, Matisse, Picasso*. Paris: Editions Galilée, 1978. 211 p. Volume in "Ecritures" series.

Includes the following texts on Braque: "Rencontre dans l'atelier parisien," pp. 11-6; "Autour du cubisme," pp. 17-25; "Rencontre à Saint-Paul," pp. 26-34; "Le Sentiment du sacré dans l'œuvre," pp. 35-8; "Dernier entretien," pp. 39-48; "Aux clartés d'un adieu," pp. 49-50.

213. WORMS DE ROMILLY, NICOLE and JEAN LAUDE. *Braque: le cubisme fin, 1907-1914*. Paris: Maeght, 1982. 308 p., illus., some col.

a. English ed.: *Braque Cubism: 1907-1914*. Paris: Maeght, 1982. 308 p., illus., some col.

Articles

214. APOLLINAIRE, GUILLAUME. "Cubisme." *Intermédiaire des chercheurs et des curieux* 66(10 Oct. 1912).

215. APOLLINAIRE, GUILLAUME. "Georges Braque" in *Les Peintres cubistes* (Paris: Eugène Figuière et Cie., 1913), pp. 40-2.

a. German ed.: *Querschnitt* 7(March 1927):192-3.

216. BILL, MAX. "Braque, Kandinksy, Picasso." *Arts Magazine* 100(3 Jan. 1947):8.

217. BILLE, EJLER. "Georges Braque" in *Picasso, surrealisme, abstrakt Kunst* (Copenhagen: Helios, 1945), pp. 68-74.

218. BODINO, MARISTELLA. "Douglas Cooper, critico e spia ingelese, scopri perfino un amore segreto di Picasso" [Douglas Cooper, English Spy and Critic, Even Discovered a Secret Love of Picasso's]. *Arte* 19:194(March 1989):119-20, 122, 124. 6 illus.

Profiles the Anglo-Australian collector Douglas Cooper (1911-84) who discovered some letters written by Picasso to Gaby Lespinasse whom he knew between 1915 and 1916. The letters are decorated with delicate watercolors depicting rustic Provençal environments in a vaguely naive style, and accompanied by ardent declarations of love. Cooper was particularly interested in the Cubists: Picasso, Braque, Gris, and Léger. His collection also comprised works by Klee and Miró. Details of the works in the collection are provided, as are the location of his works.

219. BOMPART, MALVINA. "Braque Kai Picasso" [Braque and Picasso]. *Zygos* (Greece) 54(July-Aug. 1982):6-10. 4 illus., 2 col.

With reference to the exhibition *Georges Braque: les papiers collés* at the Centre National d'Art de culture Georges Pompidou, Paris (17 June-27 Sept. 1982), Bompart discusses the relationship of Picasso's and Braque's work, noting the influence of Cézanne. She tries throughout to upset the popular equation of Cubism with Picasso alone, in which Braque plays the part merely of a companion to Picasso.

220. BOUILLON, J.-P. "L'Enigme cubiste: Picasso, Léger, Braque, Gris." *Beaux-arts magazine* 2(May 1983):38-49. 14 illus.

Bouillon, who knew the four cited painters, says that despite the time passed and the fame of the artists, Cubist works remain an enigma for the majority of the public. He divides the movement into three stages: "Cézannian" Cubism (1908-09); analytic Cubism (1910-12) and synthetic Cubism (1913-14), and states that Cubist painting is the practical expression of an essentially theoretical project. There are separate sections devoted to Daniel-Henry Kahnweiler, the first dealer to handle Cubist work; Gertrude Stein; the heritage of Cézanne; disciples and critics; games and trompe-l'œil; and Cubist subversion. The article was occasioned by an exhibition at the Tate Gallery, London (27 April-10 July 1983).

221. CABUTTI, LUCIO. "Quando Picasso ed io inventammo il cubismo" [When Picasso and I Invented Cubism]. *Bolafiarte* 33:4(Oct. 1973):72-5, 32 illus.

Article occasioned by the exhibition of Braque's work at l'Orangerie, Paris, Oct. 1973-Jan. 1974. It consists of a brief introduction to the artist, a list of some of the prices fetched by Braque's works at auctions, and an illustrated account of Braque's career and work which provides details of the development of his style and compares it with that of Picasso.

222. CHASTEL, ANDRE. "Braque et Picasso 1912: la solitude et l'échange." *Mélange Kahnweiler* (Stüttgart) (1954).

a. Reprint: *Pour Daniel-Henry Kahnweiler*, Werner Spies, ed. Stuttgart: Gerd Hatje, 1965.

223. DAIX, PIERRE. "La Révolution du Cubisme." *Connaissance des arts* 375(May 1983):92-7. 7 illus.

With reference to the exhibition of Cubism at the Tate Gallery, London in 1983, Daix states that the movement opened up an autonomous space for paintings and is rightly seen as the most revolutionary movement of the 20th century. He concludes an historical survey of the movement with the suggestion that the pioneers of the Cubist movement, Braque, Léger and Picasso, ended the absolute reign of perspective which had dominated art since the Renaissance. Cubism brought to the visual arts a liberty which allowed them to take up the heritage of all the earlier arts of mankind, and therein lies its own greatest legacy.

224. DAIX, PIERRE. "Les Trois périodes de travail de Picasso sur *Les Trois femmes*: automne 1907-automne 1908, les rapports avec Braque et les débuts du Cubisme." *Gazette des Beaux-arts* ser. 6, 111:1428-0(Jan.-Feb. 1988):141-54, 192. 14 illus. English summary.

This analysis of Picasso's three periods of work on *The Three Women* focuses on the connections between Picasso and Braque during 1907-08. After discovering an earlier version of the painting, William Rubin commented that Picasso's subsequent significant elimination of most of the African attributes of *The Three Women* "coincided with a renewed Cézannism and the adoption of a Cubist syntax linked to that of Braque." Daix author sees this "mountain rope" linking the two artists as having being forged over a long period, through discussion in the Autumn of 1907 on *Les Demoiselles d'Avignon* and through a dialogue between their works evidenced by the long and painstaking alterations of *The Three Women*. An understanding of the complexity of this Picasso-Braque reciprocity lends a new coherence to the course along which Picasso was working during this period as he experimented at greater depth with primitivist and Cézannian means of expression.

225. DAIX, PIERRE. "Le Choc décisif: Picasso—Braque." *Connaissance des arts* 451(Sept. 1989):92-101. 9 col. illus.

Discusses the collaboration in the years 1907-14 of Picasso and Braque, in the context of an exhibition devoted to that subject at The Museum of Modern Art in New York. Daix suggests that the two artists knew one another earlier than has been supposed. He traces the development of their cooperation and their "common discovery" of Cubism. Daix considers various aspects of their mutual influence, noting that the exhibition shows Braque to have been more of an innovator than previously thought and stressing his role as the true "heir" of Cézanne.

226. EINSTEIN, CARL. "La Peinture est sauvée, les pompiers sont déçus." *Das Kunstblatt* 7(1923):47-52.

Extols Cubism (Picasso, Braque, and Gris) as the salvation of painting.
a. Reprint: *Cahiers du Musée National d'Art moderne* 1(July-Sept. 1979):18-21. 3 illus.

227. FEAVIER, W. "By Picasso Out of Braque (or the Other Way Around)." *Art News* 82:8(Oct. 1983):159-60. 2 illus.

Review of *The Essential Cubism* at the Tate Gallery, London (27 April-10 July 1983). Feavier praises the clarification of the movement offered by the singling out of Picasso, Braque, Gris, and Léger, the reduction of academic definitions to friendships, and undertakings involving dealers and collectors. "True" Cubism proceeds not from ideas of modernity but from emulation of masters: Gauguin, Cézanne, Ingres, El Greco, etc. Organizers Douglas Cooper and Gary Tinterow emphasized the personal diary-like notations of the works: chronology rather than genealogy.

228. FERNANDEZ, JUSTINO. "Picasso y Braque" in *Prometeo* (Mexico City: Editorial Porrua, 1945), pp. 25-8.

229. FRANCASTEL, PIERRE. "Braque e il cubismo." *La Biennale di Venezia* 13:30(1958).

230. FUMET, STANISLAS. "Pierre Reverdy. Georges Braque." *Derrière le miroir* 135-6(Dec. 1962-Jan. 1963):1, 28.

231. GIROUD, M. "Les Années vingt: le cubisme en France." *Art Press* 15(Feb. 1978):22-3. 4 illus.

Shows how Fauvism generated the need for another form, one which was denser and more structured—Cubism. The functions of Picasso, Braque, and Gris in articulating the principles of the movement are distinguished and analytic Cubism is compared and contrasted with synthetic.

232. HOFFMANN, GABRIELE. "Intuition, durée, simultanéité—Three Concepts of the Philosophy of Henri Bergson and Their Analogies in the Cubism of Braque and Picasso from 1910-12" in *Das Phänomen Zeit in Kunst und Wissenschaft* [The Phenomenon of Time in Art and Science]. Edited by Hannelore Paflik. Weinheim: VCH, 1987. 157 p., 26 illus. Volume in "Acta Humaniora" series.

Collection of seven essays exploring the fascination of time, focusing on people's experience and understanding of time and its function in art and science.

233. HUBERT, ETIENNE-ALAIN. "Pierre Reverdy et le cubisme en mars 1917." *Revue de l'art* 43(1979):59-66. 8 illus.

Studies the circumstance and range of the essay *On Cubism* published by Reverdy in March, 1917. First evoking the manifestations which attest to the awakening of Cubism, it emphasizes the confusion reigning at the time in this domain of art, which provoked Reverdy's reaction. Without naming friends or foes, *On Cubism* is first of all a recall to the discoveries of Picasso and Braque and at the same time a strong warning addressed to those artists (Lhote, Metzinger, Rivera) who seemed to Reverdy to reduce Cubism to the use of formulas, particularly in portraiture.

234. JAKOVSKI, ANATOLE. "Jakovski commenta Braque attraveso Pablo Picasso." *Arterama* 1(Jan. 1974).

235. JEDLICKA, GOTTHARD. "Matisse-Picasso-Braque." *Werk* 32(April 1945):125-8.

From a speech at the Zurich Kunsthaus in October, 1932.
a. Reprint: Zurich: Oprecht und Helbling, 1934.

236. JULLIAN, RENE. "Les Contacts entre Braque et Picasso et les débuts du cubisme" in *Le Cubisme, Travaux IV* (Saint-Etienne: Université de Saint-Etienne, 1971).

237. KACHUR, LEWIS. "Cubism and Related Movements." *Arts Magazine* 54:5(Jan. 1980):13. 1 illus.

Review of a private exhibition that encapsulates a "Cubist Epoch" with works as late as 1937. Included small-scale works by Picasso, Braque, Carrà, and Gris, among other artists.

238. KAHNWEILER, DANIEL-HENRY. "Du temps que les cubistes étaient jeunes (un entretien au magnétophone avec D.-H. Kahnweiler)." *L'Œil* 1(15 Jan. 1955).

239. KAHNWEILER, DANIEL-HENRY. "Cubism: The Creative Years." *Art News Annual* 24(1955):107-16[+].

240. KAHNWEILER, DANIEL-HENRY and GERHARD WEBER (Interviewer). "Daniel-Henry Kahnweiler: Growing Up with the Cubists." *Art Monthly* 16(May 1978):14-5. 1 illus.

In this interview Kahnweiler, an early supporter of Picasso and Braque, talks about the influences and aims of Cubism.

241. KRAUSS, ROSALIND and FRANÇOIS ROUAN (Interviewer). "Picasso et Braque: l'invention du cubisme." *Art Press* 145(March 1990):12-7. 8 illus., 6 col.

Interview with critic Rosalind Krauss occasioned by the exhibition *Picasso and Braque: Pioneering Cubism*. Rouan sees Picasso as reaching towards something more primitive than Cézanne. Krauss points to features common to Cézanne and Picasso, but not found in Braque. Rouan compares two still lifes of Picasso and Braque to illustrate the closeness of Braque to Cézanne. There is a discussion of paintings by Braque and Picasso from 1908-09. The stimulus to development provided by the close personal relationship, and professional rivalry between Picasso and Braque is stressed.

242. KUSPIT, DONALD BURTON. "Cubist Hypochondria: On the Case of Picasso and Braque." *Artforum* 28:1(Sept. 1989):112-6. 4 illus., 2 col.

Detailed discussion of Cubism with reference to the exhibition *Picasso and Braque: Pioneering Cubism* at The Museum of Modern Art, New York (1989). Kuspit suggests that Cubism was more ambivalent about modernity than is often supposed and draws on the ideas of psychoanalysts and psychoanalytic critics to argue that Cubism makes

explicit the articulation of bodiliness "as such," Freud's "bodily ego," but with the dramatic twist that it shows it in disintegration. Kuspit looks at it in terms of depersonalization and disembodiment, regression and psychotic tendencies and summarizes its true, morbid message as the impossibility of coherent organization in a world of change that is both emotionally discomforting and physically exhausting. In this it is the archtype of 20th century creativity.

243. LOOS, IRMA. "Braque neben Picasso." *Das Kunstwerk* 13:9(March 1960):3-12. 14 illus., 2 col.

244. MATHEY, FRANÇOIS. "La Trinité cubiste: Braque, Picasso, Gris." *L'Arte moderna* 4:31(1968).

245. MATTICK, PAUL. "Picasso & Braque." *Arts Magazine* 64(Jan. 1990):78.

246. MJÖBERG, JÖRAN. "Braque mellan Picasso och Klassiek tradition." *Konstrevy* 3:32(1956):100-4.

247. NASH, JOHN MALCOLM. "The Nature of Cubism: A Study of Conflicting Explanations." *Art History* 3:4(Dec. 1980):435-47. 1 illus.

Although Picasso and Braque never sought to explain Cubism, many others tried to do so. Before 1916, one view predominated that Cubism was about reality, a view held by Léon Werth, Michel Puy, Roger Allard, Olivier Hourcade, Jacques Rivière, Maurice Raynal, and Daniel-Henry Kahnweiler. There was, however, another theory that has received less attention or has been misunderstood. It is found in the essay *Du Cubisme* written in 1912 by Albert Gleizes and Jean Metzinger, both of whom knew Picasso and Braque. Nash states that their view is radically at odds with the "neo-Kantian idealism" of Kahnweiler and those who agreed with him, and argues that it does in fact shed more light on the ambitions of the two artists than those generally accepted accounts.

248. OLIVIER, FERNANDE. "La Naissance du cubisme." *Mercure de France* 15:6(1931):558-65.

249. PARINAUD, ALAIN. "Les Origines du Cubisme." *Galerie-Jardin des arts* 130(March 1974):50-1. 1 illus.

Poses the question "Who invented Cubism? Braque or Picasso?" Braque made the acquaintance of Guillaume Apollinaire in 1906 and was taken by him to Picasso's studio where he saw *Les Demoiselles d'Avignon*, which had a tremendous effect on him. Picasso's portrait of Gertrude Stein, his travels through Spain during which he painted scenes and people from the Andorran country, and his adoption of the mask-like style are all discussed for their relationship to his subsequent researches into the representation of plasticity through new means, and Picasso's subsequent development of the techniques observed in *Les Demoiselles d'Avignon*. Finally, Parinaud quotes Braque himself in a statement made by the painter to the effect that "my Cubism is the means that I have created for my use."

250. "Picasso and Braque." *Kunstforum International* 107(April-May 1990):112-5. 4 col. illus. In German.

Survey of different views from magazines and newspapers on the relationship between Pablo Picasso and Georges Braque, the founding fathers of Cubism. One article speaks of a symbosis between the two artists, the next of the strange dynamics of the partnership between them—after 1914 Picasso never saw Braque again. The third piece relates how the mythical couple Picasso and Braque have become a modern day Castor and Pollux with a difference, while the last article discusses their influence on art later in the 20th century.

251. POOL, PHOEBE. "Sources and Background of Picasso's Art, 1900-06." *Burlington Magazine* (1959).

252. "Portrait by Picasso." *Art Digest* 23(15 April 1949):16; *Magazine of Art* 44(April 1951):148.

253. REGNIER, GERARD. "Picasso and the End of the Avant-Garde." *Journal of Art* 2:4(Jan. 1990):12-3.

Transcript of an interview with Gérard Regnier, new Director of the Picasso Museum in Paris, who explains what he sees as significant in Picasso and Braque's contributions to Cubism and comments on the exhibition at The Museum of Modern Art, New York in 1989. Arguing that the "avant-garde" began in 1860 and ended with the First World War, Regnier relates Marcel Duchamp and Picasso to the movement. He concludes that Duchamp was cerebral, Picasso instinctive. Future projects for the museum are discussed, including a showing of Picasso's writings, photographs of him, and an exposition of his still lifes in 1991.

254. ROBBINS, DANIEL. "Abbreviated Historiography of Cubism." *Art Journal* 47:4(Winter 1988):277-83.

Discusses the historiography of Cubism, analyzing the influential histories of the movement written between the late 1920s and mid-century by Janneau, Kahnweiler, and Barr. Barr's synthesis of Kahnweiler's source materials and the aesthetics of Roger Fry produced a deeply influential history of the movement as basically formalist—unchallenged until Golding's revisionism in 1959. While the Kahnweiler-Barr account with its central dichotomy of Analytical and Synthetic Cubism is an adequate account of Picasso and Braque, it must be rejected as inadequate for the other Cubists: Metzinger, Le Fauconnier, Gleizes, Delaunay, and Léger. The revised history must acknowledge these other artists and the narrative content of the Cubism of Braque and Picasso.

255. RUBIN, WILLIAM STANLEY. "Pablo and Georges and Leo and Bill." *Art in America* 67:2(March-April 1979):128-47. 20 illus., 7 col.

Rebuttal to Leo Steinberg's two-part article, "Resisting Cézanne: Picasso's *Three Women*," published in *Art in America* 66:6(Nov.-Dec. 1978):114-33. Rubin clarifies his own position and defines Picasso's relationship to Braque. Insists that Analytical Cubism was initiated by Braque's response to Cézanne.

256. RUBIN, WILLIAM STANLEY. "From Narrative to Iconic in Picasso: The Buried Allegory in *Bread and Fruit Dish on a Table* and the Role of *Les Demoiselles d'Avignon*." *Art Bulletin* 5:4(Dec. 1983):615-49. 31 illus.

Investigates the crucial two-year interval in Picasso's career between July, 1907 when he completed *Les Demoiselles d'Avignon* and June-July, 1909, which saw the artist's first paintings in a fully realized Analytic Cubist mode. Both *Bread and Fruit Dish on a Table* and *Three Women* reflect the divergent influences the artist was assimilating during the two years in question. These two paintings mark the ascendancy of an early form of Cubism over Picasso's "African" style. Appendices include chronologies of the *Demoiselles, Three Women,* and *Bread and Fruit Dish* as well as analyses of Braque and Cézanne at this period, the *Demoiselles* and Cubism, the left-hand figure in the *Demoiselles,* the masks associated with and the supposed unfinishedness of the *Demoiselles,* Picasso's first tribal objects, Picasso's *Wobe* mask, the sheet-metal *Guitar,* Picasso's equivocations with respect to *art nègre,* and problems of quoting Picasso.

257. RUBIN, WILLIAM STANLEY. "Was Braque Picasso's Best Bride?" *Journal of Art* 2:4(Jan. 1990):10-1.

Transcript of an interview with William Rubin, curator of the exhibition *Picasso and Braque: Pioneering Cubism,* held at The Museum of Modern Art, New York, in 1989, who considers the artistic and stylistic relationship between Picasso and Braque and explains how they both contributed to the discovery of Cubism. Rubin, who has taken great care in dating the paintings correctly, also discusses the two artists' use of color, and the critical and popular reception of the exhibition.

258. SCHÜRER, OSKAR. "Picasso, Laurencin, Braque." *Deutsche Kunst* 55(Jan. 1925):209-16.

259. SOFFICI, ARDENZO. "Picasso e Braque." *La Voce* (Florence) (24 Aug. 1911).

260. SOLOMON, DEBORAH. "Picasso, Braque, and Rubin." *Partisan Review* 62:2(1990):289-93.

Reviews the exhibition *Picasso and Braque: Pioneering Cubism* (1989) then goes on to discuss the role of Juan Gris in the founding of Cubism, the collaboratory relationship of Picasso and Braque, Braque's initial pioneering pieces and Picasso's extensive borrowing from Braque's ideas. Solomon also discusses the use of green in the early Cubist works of both artists and the tension between the intellectually abstract nature of the movement and interesting intrusion of the natural world.

261. STALLER, NATASHA. "Méliès' 'Fantastic' Cinema and the Origins of Cubism." *Art History* 12:2(June 1989):202-32. 12 illus.

At the turn of the century Parisian popular culture was characterized by visual trickery, typified by the films of Georges Méliès. Staller argues that Picasso and Braque adopted many of these anti-naturalistic images, looking to these popular forms as a stimulus for subverting the conventions of high art. She shows how many of Cubism's most radical features—the fragmentation of body parts, the use of conflicting multiple perspectives, and the insertion of letters, numbers, advertising copy and real prosaic objects into artistic contexts—had previously occurred not in high art but in the popular culture of the time. She examines the relationship between cinema and art and Picasso's attitude to the cinema, and analyzes Méliès films in some details, showing how the boundaries between cinema and art were broken down by Cubism.

262. STEINBERG, LEO. "The Polemical Part." *Art in America* 67:2(March-April 1979):114-27. Appendix to "Resisting Cézanne: Picasso's *Three Women*," published in *Art in America* 66:6 (Nov.-Dec. 1978):114-33.
Examines the nature of Cubism and discusses Picsso's contribution to it. Takes issue with William Rubin's thesis that Picasso arrived at early Analytic Cubism through Braque. (Rubin's response appears in the same issue, pp. 128-47).

263. STEMP, ROBIN. "The Vase and the Void: Space, Shape and Composition in Braque's Still Lifes." *The Artist* 106:2(Feb. 1991):25-7. 4 illus., 3 col.

Discusses the still lifes of Georges Braque, focusing on his mastery of the use of space. He notes the artist's preoccupation with music and art and goes on to outlines his background and artistic development. Several of Braque's Cubist paintings are examined and his relationship with Picasso is considered. In conclusion, Stemp briefly comments on the "dignity and tranquility of Braque's work."

264. THORSTENSON, INGER JOHANNE. "André Lhote og den første Kubismen" *Konsthistorisk Tidskrift* 53:3(1984):125-32. 5 illus. In Danish; English summary.

Examines Lhote's Cubist paintings of 1910-20, arguing that these works were the product of Lhote's own theory of Cubism, which differed intentionally from the Cubist theory of Picasso and Braque.

265. "La Trinità Cubista: Braque, Picasso, Gris" in *L'Arte Moderna* 31(Milan: Fratelli Fabbri, 1967), Vol. 4.

266. VERONESI, GIULIO. "Braque, Picasso, Calder." *Emporium* 106:635-6(Nov.-Dec. 1947):121-3.

Article occasioned by an exhibition at Galerie Maeght, Paris (30 May-30 June 1947).

267. WESTHEIM, PAUL. "Kunst in Frankreich." *Kunstblatt* 6(1922):8-25.

Names Braque the leader of Cubism. His style is briefly discussed and compared with that of Gris (see pp. 10-3).

268. WILKIN, KAREN. "O Pioneers!: Picasso & Braque 1907-1914." *New Criterion* 8:4(Dec. 1989):29-35.

Review of the exhibition *Picasso and Braque: Pioneering Cubism* at The Museum of Modern Art, New York. The show revealed the importance of Braque and the dialogue between the two artists. Wilkin describes Braque as the painter and Picasso as the draughtsman. She recounts the early development of Cubism and suggests that neither could have done it alone. She concludes by arguing for the continuing relevance of Cubism.

269. WOLFGANG, MAX FAUST. "Wenn Wörter sich zu Bildern fügen" [When Words Conglomerate into Pictures]. *ART: das Kunstmagazin* 11(Nov. 1990):80-90, 92, 94-5. 31 illus., 22 col.

Analysis of how the written word, even in the form of short texts and slogans, has always been an important part of avant-garde tendencies in 20th century art. Many artists, the latest being the American Jenny Holzer, look back on illustrious predecessors such as the Italian Futurists, Picasso and Braque, Kurt Schwitters and John Heartfield, René Magritte and Jospeh Beuys in that they admit "real life" as an integral part of their creations. Words, written in neon, combined with visual images, stuck together into collages, or combined with art can thus be an epistemological instrument.

270. WOLLHEIM, RICHARD. "The Moment of Cubism Re-Visited." *Modern Painters* 2:4(Winter 1989-90):26-33. 5 illus., 2 col.

With reference to the exhibition *Picasso and Braque: Pioneering Cubism* at The Museum of Modern Art in New York in 1989, Wollheim considers the collaboration between Picasso and Braque in the years 1907-14 and the formation of one style from their two. Before 1907, Picasso was working towards a new means of expressing the human body and its relation to background and foreground. His struggle towards Cubism was harder, less direct and less inevitable than Braque's, and Braque was in some way an agent to Picasso's transition.

271. YAVORSKAYA, N. "Khudozhestvennaya zhizn' vo Frantsii v 1930-kh godakh i dvizhenie Narodnogo fronta" [Artistic Life in France in the 1930s and the Popular Front Movement]. *Iskusstvo* 10(1973):52-61. 14 illus.

Yavorskaya describes how shocked he was by Picasso's harsh and nervous paintings of 1927 and 1928, only to realize with hindsight that these were the artist's response to the impending political crises of Europe, and in particular to the rise of fascism and the resulting formation of the Popular Front in France. He describes how these events similarly affected the work of others, such as Matisse, Léger, Lurçat, Braque, etc. Not only did the artists form specific political organizations but they also made a positive step in returning to more realistic work, a trend extended after the War.

272. ZELEVANSKY, LYNN. "Braque ou Picasso: l'invention du cubisme." *Beaux-arts magazine* 72(Oct. 1989):76-87. 15 illus., 11 col.

Discusses the elaboration of Cubism and the mutual influence on each other of Picasso and Braque, on the occasion of an exhibition entitled *Picasso and Braque: Pioneering Cubism* at The Museum of Modern Art in New York. Zelevansky discusses various aspects of their "collaboration" including the differences between the two men and their work, and notes some of the salient points in the creation of the movement. She stresses the seminal importance of Cubism in the development of 20th century art and considers the possible impact of an exhibition the like of which, she feels, is unlikely to be seen again.

273. ZERVOS, CHRISTIAN. "Georges Braque et la peinture française." *Cahiers d'art* 2:1(1927):5-16. 10 illus.

Comparison of Braque and Picasso. Includes nine illustrations of Braque's paintings, 1925-26, on pp. 7, 9-16.

274. ZERVOS, CHRISTIAN. "Braque et le développement du cubisme." *Cahiers d'art* 4:1(1929) and 7:1-2(1932):13-27. 19 illus.

Discussion of Braque's paintings and drawings, including a biographical note (p. 23) and an extract from the preface to the catalogue of Braque's first individual exhibition at the Kahnweiler Gallery, Paris (9-28 Nov. 1908).

Secondary Bibliography:
Works (Œuvre)

I.	Catalogues Raisonnés	47
II.	Œuvre in General	49
	Books	49
	Articles	53
III.	Individual Paintings	63
	Books	63
	Articles	63
IV.	Drawings	72
	Books	72
	Articles	72
V.	Graphic Works and Prints	73
	Books	73
	Articles	73
VI.	Illustrated Books and Portfolios	78
VII.	*Papiers découpés* (Cutouts)	84
	Book	84
	Articles	84
VIII.	Sculpture	85
	Books	85
	Articles	85
IX.	Jewelry	86
	Books	86
	Articles	86
X.	Theatre Designs	86
	Articles	86
XI.	Special Issues of Journals Devoted to Georges Braque	87
XII.	Audiovisual Materials	89

I. Catalogues Raisonnés

275. ISARLOV, GEORGES. *Œuvres de Georges Braque (1906-1929)*. Paris: José Corti, 1932. 31 p. Also published in *Orbes* 3(Spring 1932):71-97.

Volume in "Collection Orbes" series. Includes biographical notes and a preliminary list of works, 1906-29; list of exhibitions, 1906-26; list of collections containing works by Braque; and a bibliography to 1929.

276. ENGELBERTS, EDWIN. *Georges Braque: œuvre graphique originale.* Précédée de *Cinq Poésies* de René Char en hommage à Georges Braque. Catalogue édité à l'occasion d'une exposition de gravures de Braque à la Galerie Engelberts à Genève. Genève: Cabinet des Estampes du Musée d'Art et d'histoire et Galerie Nicolas Rauch, 1958. 32 p., illus.

277. MANGIN, NICOLE S. (WORMS DE ROMILLY) and JEAN LAUDE (vol. 7). *Braque. Peintures 1916-23, 1924-27, 1928-35, 1936-41, 1942-47, 1948-57.* Paris: Maeght Editeur, 1959-82. 7 vols. Looseleaf for updating.

 1959: *Peintures 1948-57*
 1960: *Peintures 1942-47*
 1961: *Peintures 1936-41*
 1962: *Peintures 1928-35*
 1968: *Peintures 1924-27*
 1973: *Peintures 1916-23*
 1982: *Le Cubisme, fin 1907-1914.* 308 p., 247 illus. Cites 247 Cubist works
 (paintings, drawings, collages).

"Table des expositions pour les œuvres cataloguées" at the end of each volume. Includes bibliographies.
Reviews: *L'Œil* 64(April 1960):63-4; J. Golding, *Burlington Magazine* 126:971(Feb. 1984):97-8.

278. LAUDE, JEAN. *La Stratégie des signes.*

Catalogue raisonné, pp. 11-53.

279. PONGE, FRANCIS and FERNAND MOURLOT. *Georges Braque, lithographe.* Préface de Francis Ponge. Notices et catalogue établis par Fernand Mourlot. Avec cinq lithographies dont deux hors-texte, une pour la couverture, une pour le frontispiece et une pour la page de titre. Monté Carlo, Paris: Sauret, 1963. 184 p., illus. 125 copies.

Préface reprinted in Francis Ponge, *L'Atelier contemporain* (Paris: Gallimard, 1977).

280. VALSECCHI, MARCO and MASSIMO CARRA. *L'Opera completa di Braque: Dalla composizione cubista al recupero dell'oggetto: 1908-1929.* Presentazione di Maro Valsecchi. Apparati critici e filologici di Massimo Carrà. Volume in "Classici dell'arte" series.

a. French ed.: *Toute l'œuvre peinte de Braque, 1908-1929.* Introduction de Pierre Descargues. Traduction de Simone Darses. Paris: Flammarion, 1973. 111 p., illus., some col.

281. POUILLON, NADINE and ISABELLE MONOD-FONTAINE. *Catalogue raisonné de l'œuvre de Braque*. Paris: Centre National d'Art et de culture Georges Pompidou, 1982. 224 p., 312 illus.

Catalogue raisonné of works by Georges Braque in the holdings of the Musée National d'Art moderne, Paris, divided into sections for paintings, drawings, sculptures, theatrical design, and jewelry. Each item is illustrated and accompanied by a detailed commentary as well as annotations listing title, date, size, signature, provenance, exhibitions and bibliographical references. The introductions traces the history of the museum's collection. A concise catalogue raisonné of works by Braque in other public museums in France, a list of Braque's exhibitions, a detailed biography and an extensive bibliography are appended.

282. VALLIER, DORA. *Catalogue raisonné de l'œuvre gravée*. Paris: Flammarion, 1982. 319 p., 192 illus., 40 col.

"Etabli d'après les documents conservés dans les archives de Mme. et M. Claude Laurens." (p. 15).

a. Japanese ed.: *Burakku zen hanga ten*. Tokyo: Yomiuri Shimbun, L'Association japonaise des musées d'art, 1984. 174 p., illus., some col.
b. U.S. ed.: *Braque, the Complete Graphics: Catalogue Raisonné*. Trans. by Robert Bononno and Pamela Barr. New York: Gallery Books, Alpine Fine Arts Collection, 1988. 318 p., illus., some col.

II. Œuvre in General

Books

283. ABTAL, KAMPIS. *Braque*. Budapest: Corvine Kiad'o, 1966.

284. APOLONIO, UMBRO and ALVIN RANDOLPH MARTIN III. *Georges Braque*. Milan: Fratelli Fabbri Editori, 1965. Volume in "Chefs-d'œuvres des grands peintres" series.
a. French ed.: Paris: Hachette, 1966.

285. BENINCASA, CARMINE. *Georges Braque: Opere 1900-1963*. A cura di Carmine Benincasa. Venice: Marsilio, 1982. 94 p., illus., some col.

286. BISSIERE, ROGER. *Georges Braque: vingt tableaux*. Paris: Editions de L'Effort moderne (Léonce Rosenberg), 1920. 6 p., 20 pl. Volume in "Les Maîtres du cubisme" series.

Text reprinted in *Bulletin de l'effort moderne* 3(March 1924):11-4; *L'Art d'aujourd'hui* 2:6(1925):21-5; *Cahiers d'art* (special issue) 8:1-2(1933).

287. BRAQUE, GEORGES. *L'Atelier de Braque*. Paris: Editions des Musées Nationaux, 1961. 52 p., illus., 51 pl.

288. BRAQUE, GEORGES. *Georges Braque.* Testo di Umbro Apollonio. Milan: Fratelli Fabbri Editori, 1963. 7 p., col. illus., 16 pl. Volume in "I Maestri del colore" series.

a. New ed.: 1978.

289. BRAQUE, GEORGES. *Braque: Peintures, 1909-1947.* Préface de Jean Grenier. Paris: Editions du Chêne, 1948. 7 p., 16 pl., some col.

a. English ed.: *Braque: Paintings, 1909-1947.* Introduction by London: Lindsay Drummond, 1948. 11 p., 16 col. pl.
b. German ed.: *Braque: Gemälde 1909-1947.* Einleitung von Franz Roh. Saarbrücken: Saar-Verlag, 1948.

290. BRAQUE, GEORGES. *Espaces.* 13 dessins, lavis, aquarelles. Préface d'André Verdet. Paris: Au Vent d'Arles, 1957. 7 p., col. illus., 13 pl.

291. BRAQUE, GEORGES. *Burakku ten-Georges Braque.* Kanshū Senzoku Nobuyuki. Tokyo: Ato Raifu, 1988. 159 p., illus.

292. BRUNET, CHRISTIAN. *Braque et l'espace; langage et peinture.* Paris: Klincksieck, 1971. 172 p., 8 pl. Volume in "Collection d'esthétique" series.

293. CUTTOLI, RAPHAËL DE. *Métamorphoses de Georges Braque.* Raphaël de Cuttoli, Baron Heger de Loewenfeld; préface de Germain Bazin; textes de Hervé Alphand et André Verdet. Paris; Editions France Art Center; Editions de l'Amateur, 1989. 123 p., col. illus.

294. COOPER, DOUGLAS. *Braque Painting, 1909-1947.* Introduction by Douglas Cooper. London: Lindsay Drummond; Paris: Editions du Chêne, 1948. 11 p., 16 pl. some col.

Reviews: *Burlington Magazine* 91(May 1949):147; *Studio* 138(Aug. 1949):64.

295. ELGAR, FRANK. *Braque: 1906-1920.* Paris: Fernand Hazan, 1958. 25 p., 15 col. pl. Volume in "Collection petite encyclopédie de l'art" series.
a. U.S. ed.: New York: Tudor Publishing Company, 1958. 16 p., illus., 15 pl.
b. English ed.: London: Methuen, 1958.

296. FORTENESCU, IRINA and DAN GRIGORESCU. *Braque.* Bucharest: Editura Meridiana, 1977.

297. FUMET, STANISLAS. *Georges Braque.* Paris, 1941.

298. FUMET, STANISLAS. *Braque.* Introduction de Stanislas Fumet. Paris: Braun, 1944. 60 p., illus. 48 pl. Volume in "Couleurs des maîtres" series.

a. Other eds.: 1945, 1948, 1965(221 p.).
b. U.S. ed.: New York: Tudor, 1946. 17 p., 24 col. pl.
c. English ed.: London: Soho Gallery, 2946. 17 p., illus., 24 col. pl.

299. FUMET, STANISLAS. *Georges Braque.* Paris: Maeght, 1965. 222 p., illus., some col.

300. GALLATIN, ALBERT EUGENE. *Georges Braque: Essay and Bibliography.* New York: Wittenborn, 1943. 57 p., illus., 12 pl. 450 copies.

301. GIEURE, MAURICE. *Georges Braque.* Paris: Editions Pierre Tisné, 1956. 131 p., illus. 136 pl.

a. U.S. ed.: New York: Universe Books, 1956. 128 p., illus. 136 pl.
b. English ed.: London: Zwemmer, 1956.

302. HERON, PATRICK. *Braque.* With an introduction and notes by Patrick Heron. London: Faber and Faber, 1958. 24 p., illus., 10 col. pl. Volume in "The Faber Gallery" series.

303. JUDKINS, WINTHROP. *Fluctuant Representation in Synthetic Cubism: Picasso, Braque, Gris, 1910-1920.* Ph.D. diss., Harvard University, 1954, 526 p.; New York: Garland, 1976. 526 p., 188 illus.

Contends that "fluctuant representation" constitutes the primary objective of the mature, so-called "synthetic" Cubism of Picasso, Braque, and Gris. This term refers to the artist's ability simultaneously to compound the aspects of natural appearances in such a way that the perceiving eye experiences a continuing fluctuation among them.
Review: C. Baldwin, *Art Bulletin* 60:1(March 1978):187-8.

304. KIM, YOUNGNA. *The Early Works of Georges Braque, Raoul Dufy, and Othon Friesz: The Le Havre Group of Fauvist Painters.* Ph.D. diss., Ohio State University, 1980. 434 p.; Ann Arbor, MI: University Microfilms International, 1986. 413 p., 265 illus.

Detailed stylistic examination of the early work of these three artists who grew up together in Le Havre and studied together in Paris, and of their Fauvist works from 1906 to 1907. It is shown that Braque was the more innovative member of the group, his movement towards Cubism being compared with that of Picasso. Youngna concludes that the two artists mutually created the style and that Fauvism and the influence of Cézanne on Braque in 1907 and 1908 played a fundamental role in its formation.

305. LAUFER, FRITZ. *Braque.* Bern: Alfred Scherz-Verlag, 1954. Volume in "Scherz Kunstbücher" series.

a. Italian ed.: *Braque.* Trans. by Ervino Pocar. Milan: A. Martello, 1953. 31 p., illus., 52 pl., some col.
Review: *Werk* 43(April 1956):70.

306. LEJARD, ANDRE. *Georges Braque.* Paris: Fernand Hazan, 1949. 21 p., 24 col. pl. Volume in "Bibliothèque Aldine des arts" series.

307. MARTIN, ALVIN RANDOLPH III. *Georges Braque: Stylistic Formation and Transition, 1900-1909.* Ph.D. diss., Harvard University, 1980. 381 p., illus.

308. PONGE, FRANCIS. *Braque, le réconciliateur.* Geneva: Albert Skira, 1946. 12 p., 17 illus., 15 col. pl. Volume in "Les Trésors de la peinture française" series.

a. Another ed.: 1948.
b. Reprint: *Labyrinthe* (Geneva) 2:22-3(Dec. 146):6-7.

309. PONGE, FRANCIS. *La Peinture à l'étude.* Paris: Gallimard, 1948. 160 p.

Includes two chapters on Braque: "Braque, le réconciliateur," pp. 115-40 (text of 1946) and "Braque, ou l'art moderne comme événement et plaisir," pp. 11-56.

310. PONGE, FRANCIS. *L'Atelier contemporain.* Paris: Gallimard, 1977. 361 p.

Reprints texts on Braque, including: "Braque, le réconciliateur," pp. 58-69; "Braque ou l'art moderne comme événement et plaisir," pp. 70-7; "Braque-Dessins," pp. 102-8; "Braque-Japon," pp. 120-9; "Deux textes sur Braque: Braque lithographe," pp. 237-46; "Feuillet votif," pp. 246-50.

311. POUILLON, NADINE and ISABELLE MONOD-FONTAINE. *Braque: œuvres de Georges Braque (1882-1963).* Catalogue établi par Nadine Pouillon avec le concours de Isabelle Monod-Fontaine. Paris: Musée National d'Art moderne, Centre Georges Pompidou, 1982. 223 p.

312. RAPHAEL, MAX. *Raumgestaltungen: der Beginn der modernen Kunst im Kubismus und im Werk von Georges Braque.* Herausgegeben von Hans-Jürgen Heinrichs. Frankfurt am Main and New York: Suhrkamp, Edition Qumran in Campus-Verlag, 1986. 207 p., illus. Volume in "Suhrkamp Taschenbush Wissenschaft" series.

313. RAYNAL, MAURICE. *Georges Braque.* Avec 32 reproductions en phototypie. Rome: Editions Valori Plastici, 1921. 21 p., 32 illus., pl. Volume in "Collection les artistes nouveaux."

a. 2nd ed.: 1924.
b. Italian excerpts: *Valori Plastici* (Rome) 2:7-8(1920):83-4; 2:9-12(1920):107-8.
c. French excerpts: *Le Néoclassicisme dans l'art contemporain* (Rome: Editions Valori Plastici, 1923):25-6.

314. REVOL, JEAN. *Braque et Villon: message vivant du cubisme.*

315. RUSSELL, JOHN. *Georges Braque.* With eighty illustrations including twenty-four in colour selected by René Ben Sussan. London: Phaidon Press, 1959. 127 p., 80 illus., 24 col.

a. U.S. ed.: New York: Phaidon, dist. by Doubleday, Garden City, NY, 1959. 127 p., illus.
Reviews: *American Institute of Architecture Journal* 33(May 1960):196; *Connoisseur* 145(May 1960):196.

316. SEGUI, SHINICHI. *Braque/Léger*. Tokyo: Schueisha, 1972. Volume in "L'Art moderne du monde" series.

317. SELZ, JEAN. *Braque: 1920-1963*. Paris: Hazan, 1973.

318. TADASHI, MIYAGAWA, et al. *Georges Braque*. Tokyo: Bijutsu Shuppansha, 1963. 70 p., illus., some col.

Reprint of a special issue of *Mizue* (no. 38) devoted to Braque.

319. TONO, YOSHIAKY. *Picasso/Braque*. Tokyo: Zauho Press, 1967. Volume in "Gendai Sekai Bijutsu Zenshu" series.

320. VERDET, ANDRE. *Braque, le solitaire*. Paris: XXe siècle; Greenwich, CT: New York Graphic Society, 1950. 55 p., col. illus.

a. Another ed.: Paris: Fernand Hazan, 1959.
b. English ed.: *Georges Braque*. Ports. by Roger Hauert. Trans. by Frances Richardson. Geneva: R. Kister, 1956. 30 p., illus.

321. VERDET, ANDRE. *Georges Braque*. Images de Roger Hauert. Texte d'André Verdet. Geneva: René Kister; dist. by Union européenne d'éditions, Monaco, 1956. 30 p., illus. Volume in "Les Grands peintres" series.

a. English ed.: Trans. by Roger Hauert. Geneva: R. Kister, 1956. 30 p., illus.

322. WILKIN, KAREN. *Georges Braque*. New York: Abbeville Press, 1991. 127 p., 93 illus., some col. Volume in "Modern Masters" series.

Biographical study and critical assessment. Chapter 2 (pp. 21-27) covers Braque's Fauve period.

323. ZURCHER, BERNARD. *Braque, vie et œuvre*. Fribourg: Office du Livre, 1988. 313 p., illus., some col.

Traces the career and life of Georges Braque, starting from his early work influenced by Cézanne and his involvement with the Fauves and tracing his relationship with Picasso and the development of Cubism. Zurcher considers his innovative work in collage and notes Braque's need to demonstrate the relationships between adjacent objects. He discusses the role of the human figure in Braque's paintings, assessing the significance of the *Canephorae* on his work, considers the importance of his studio as subject matter for his paintings of interiors, and concludes with a chapter on Braque's landscapes and work on the theme of nature.
a. U.S. ed.: *Georges Braque: Life and Work*. Trans. by Simon Nye. New York: Rizzoli, 1988. 319 p., 235 illus., 150 col.

Articles

324. ADRIAN, DENNIS. "Georges Braque's Monumental Still-Lifes." *Art News* 71(Nov. 1972):30-3.

325. APOLLINAIRE, GUILLAUME. "Georges Braque." *Mercure de France* (16 Jan. 1909).

326. APOLLINAIRE, GUILLAUME. "Georges Braque." *La Revue indépendante* (Aug. 1911):166.

327. APOLLINAIRE, GUILLAUME. "Georges Braque." *Cahiers d'art* 7:1-2(1932):23.

Includes, in part, the preface Apollinaire wrote for the Braque exhibition held 9-28 November 1908, Galerie Kahnweiler, Paris.

328. "L'Atelier de Braque au Louvre." *Domus* 389(April 1962):33.

329. AYERS, R. "'The Essential Cubism' at the Tate." *Artscribe* 41(June 1983):59-62. 4 illus.

Review of the exhibition *The Essential Cubism* at the Tate Gallery, London (27 April-10 July 1983). Commenting on the difficulty of "seeing" Cubist paintings in the light of art history's overworking of Cubism, Ayers confirms the established view of the pre-eminence of Braque and Picasso. He considers one of the exhibition's "surprises" to be the importance of linear drawing in Cubism and traces its appearance and development at every stage. Regretting the poor representation of Picasso's constructions in the show, he suggests that among Picasso and Braque's contemporaries, it was sculptors such as Laurens and Lipchitz who made most intelligent use of their experiments. For many contemporary artists, Cubism now seems distant, but, it is concluded, Cubism's intelligent, pictorial, and witty consciousness may once again become more widely respected.

330. BABELON, J. "Braque et la nature morte." *Les Beaux-arts* (30 Sept. 1943).

331. BAKER, SARAH. "Georges Braque." *Right Angle* (Washington, D.C.) 1:5(July 1947):4-5.

332. BARRIERE, GERARD. "Un citron est un citron est un citron." *Connaissance des arts* 261(Nov. 1973):90-9. 7 illus.

Account of Braque's work which briefly summarizes his Cubist work but concentrates on the period from 1918 to 1963. The influence of Taoism and Buddhism on him is considered and his analysis of a subject is seen to be related to the Zen "tatatha" method, in that he reduces it to its intrinsic elements of existence in such a way that it can be seen to exist independent of all outside influences. In order to achieve his aim of "washing" our vision, Braque reduces his palette to a minimum so as not to distract from the importance of the subject. Barrière then relates this presentation of the subject matter to the overall interpretation of the world implied by Braque's work.

333. BAZAINE, JACQUES, BERNARD DORIVAL, and STANISLAS FUMET. "Braque: un enrichissement de l'espace." *La Cité* 19(1964).

334. BAZIN, GERMAIN. "Braque 1939." *Prométhée* 20(June 1939):179-81. 2 illus.

Article occasioned by the Braque exhibition at Galerie Rosenberg, Paris (April 1939).

335. BAZIN, GERMAIN. "Sur l'espace en peinture: la vision de Braque." *Journal de psychologie normale et pathologique* 45(1953):439-48.

336. BISSIERE, ROGER. "Notes sur l'art de Braque." *Bulletin de l'effort moderne* 3(March 1924):11-4.

337. BISSIERE, ROGER. "Georges Braque" in *Cahiers d'art* (special issue)8:1-2(1933).

338. BLÁZQUEZ-MIGUEL, JUAN. "Tema del mundo clásico en la pintura de Kokoschka y Braque" [Classical Themes in the Painting of Kokoschka and Braque] in *Miscelánea de arte* (Madrid: Instituto "Diego Velázquez," Consejo Superior de Investigaciones Científicas, 1982).

339. BOATTO, A. "Braque: il 'laboratorio' del classicismo" [Braque: The 'Laboratory' of Classicism]. *Capitolium* 50:2-3(Feb.-March 1975):59-62. 6 illus.

Discussion of Braque's art occasioned by the recent exhibition of his work at Villa Medici, Rome. Boatto considers the period between his Fauve beginnings and his Cubist maturity, 1907-25. He describes Braque's development of the artisan tradition in painting, his technique of conferring modernity onto the past, and his particular brand of classicism arising out of the confrontation between the ambiguous world of symbols and the harsh world of facts. Finally, the author examines Braque's subsequent Cubist development, comparing the technical, formal, and compositional aspects of his Cubism with those of Picasso.

340. BOSQUET, ALAIN. "La Musique de Braque." *La Nouvelle revue française* 253(Jan. 1974):81-3.

341. BOUILLIER, RENEE. "Braque et l'espace." *La Nouvelle revue française* 253(Jan. 1974):72-4.

342. BOURET, JEAN. "Braque ou l'andante noir et gris." *Arts* (17 Feb. 1950).

343. BRAQUE, GEORGES. [26 reproductions, 1945-47, and an extract from his notebook. Reproduction of a sculpture and note on an exhibition]. *Cahiers d'art* 22(1947):7-36, 309, 320.

344. BRAQUE, GEORGES. "Dix ans d'édition 1946-56." *Derrière le miroir* (suppléments, 1956-62, 1964).

345. "Braque, derniers messages." *Derrière le miroir* 166(1967).

Special issue devoted to Braque.

346. CAFRITZ, ROBERT C. "The Great Late Braque." *Connoisseur* 212:849(Nov. 1982):140-5. 4 illus.

Some critics believe that Georges Braque's paintings after his Cubist period are the work of a basically conservative man, enervated by his experiences in the trenches and compelled to lower his artistic sights. This dismissal of the later works was rectified by an exhibition at the Phillips Collection, Washington, D.C. in 1978—*Georges Braque: The Late Paintings (1940-1963)*, reviewed here. Cafritz feels that Braque, in his old age, "was moved to create more eloquent types of pictorial structures in order to reveal his deeply felt insight into the nature of reality."

347. CAIN, JEAN. "Braque." *Gazette des Beaux-arts* ser. 6, 68(July 1966):13.

348. CARTIER, JEAN-ALBERT. "Poétique de Braque." *Jardin des arts* (Dec. 1956).

349. CASSOU, JEAN. "Œuvres récentes de Braque." *L'Amour de l'art* 11(Feb. 1930):80-90.

350. CASSOU, JEAN. "Le Secret de Braque." *L'Amour de l'art* 26:1(Jan. 1946):4-8.

Includes "Fragments inédits des cahiers de Braque (Pensées et dessins)."
a. Spanish reprint: "El Secreto de Braque." *Cultura Peruana* 8:34-5(1946):10.

351. CHAR, RENE. "Peintures de Georges Braque." *Cahiers d'art* 26(1951):141-55. 17 illus.

352. CHAR, RENE. "Braque, lorsqu'il peignait." *Art de France* 4(1964).

353. CHARBONNIER, GEORGES. "Unterhaltung mit Braque." *Kunstwerk* 13(March 1960):13-4.

354. COGNIAT, RAYMOND. "Braque." *Arts Magazine* 118(6 June 1947):1.

355. COHEN, J. "Art of Georges Braque." *Art and Artists* 3(March 1969):65.

356. DAHLIN, BERNARD. "Georges Braque ou un judicieux usage de la raison." *Tendances* 35(June 1965).

357. DAVAY, P. "Paris: dix ans après sa mort, Braque commence tout à coup à mourir." *Clés pour les arts* 38(Dec. 1973):19-21. 4 illus.

The Braque exhibition at l'Orangerie, Paris (16 Oct. 1973-14 Jan. 1974), demonstrates, in Davay's view, how much of the artist's work has lost its impact since his death. He argues that Braque is ensured an important place in the history of art because of his contribution during the Cubist period, but maintains that after 1914 Braque's work became less powerful and important.

358. DETHLEFS, HANS JOACHIM. "Die Überwindung des Asthetischen: Über Carl Einsteins Braque-Projekt." *Text Kritik: Zeitschrift für Literatur* 95(July 1987):23-43.

359. EINSTEIN, CARL. "Tableaux récents de Georges Braque." *Documents* 1:6(Nov. 1929):289-96. 6 illus.

360. FAGUS, FELICIEN. "Georges Braque." *La Revue blanche* 26(15 July 1901):195.

361. FRIED, ANNY. "Braque." *Forum* (Bratislava)7:6(1937):115-6.

362. FÜGLISTER, ROBERT L. "Les Premiers bateaux de Braque: Schiffmotive im ersten Jahrzehnt seines Schaffens." Manuscript, 1989.

363. FUMET, STANISLAS, GEORGES LIMBOUR, and GEORGES RIBEMONT-DESSAIGNES. "Braque." *Le Point* (Colmar) (1953).

364. GASCH, SEBASTIA. "Georges Braque." *L'Amie des arts* (Sitges) 2:2(April 1927):31-2.

365. GATELLIER, G. "Le Présent perpétuel de Braque." *Galerie des arts* (June 1967).

366. GAVRONSKY, SERGE. "Ponge on Braque: The Visible Object." *Bucknell Review: A Scholarly Journal of Letters, Arts and Sciences* 30:2(1987):168-77.

367. GEORGE, WALDEMAR. "Georges Braque." *L'Esprit nouveau* 6(1921):63-56. illus., some col.

368. GEORGE, WALDEMAR. "Georges Braque." *L'Amour de l'art* (Oct. 1922):298-300.

369. GEORGE, WALDEMAR. "The Artists' Dilemma." *Formes* 17(Sept. 1931):114. 4 illus.

370. "Georges Braque." *Derrière le miroir* 155(1959).

Special issue devoted to Braque.

371. "Georges Braque. Derniers messages." *Derrière le miroir* 166(1967).

Special issue devoted to Braque.

372. "Georges Braque, l'avènement classique du cubisme." *Cahiers d'art* 10(1929):447-53.

373. "Georges Braque, peintre contemplatif." *Le Point* (Souillac) 46(1953):1-48.

Special issue devoted to Braque.

374. GRENIER, JEAN. "Introduction à la peinture de Braque." *Variété* 3(1946).

375. HALVORSEN, WALTHER. "Georges Braque." *Cahiers d'art* 6-7(1937):218-20. 3 illus.

376. "Harmony in Braque." *Country Life* 152(9 Nov. 1972):1233.

377. HERTZ, HENRI. "Georges Braque et le réveil des apparences." *L'Amour de l'art* 7(April 1926):135-40.

378. HOFFMAN, E. "Braque in Paris." *Burlington Magazine* 850(1974).

379. HORTER, EARL. "Abstract Painting, A Visit to Braque." *Pennsylvania Museum Bulletin* 29(March 1934):62-3. Reprinted in *Art Digest* 8(15 April 1934):22.

380. IMDAHL, M. "Cézanne, Braque, Picasso: zum Verhältniszwischen Bildautonomie und Gegenstandssehen." [Cézanne, Braque, Picasso: The Connection Between Pictorial Autonomy and Observation of the Subject].

Discusses paintings by Cézanne, Braque, and Picasso, as examples of a particular type of painting in which pictorial autonomy and subject observation are connected. However, there are divergences in interpretation by the three painters. Cézanne's optical autonomy lies in a reevaluation of the normal relationship between seeing and recognizing objects. Braque's paintings are used to illustrate the characteristics of certain aspects of Cubism, viz. that the painter's intention and what is seen by the observer can diverge. Imdahl believes this may be a reason for the many contradictory statements made about Cubism. Picasso's style of the late 1930s and 1940s is distinctive in that one figure was used to integrate all these aspects. The possibility of a synthesis of Cubism and classicism is discussed by tracing the history of these art forms with reference to the theories of Ruskin, Laforgue, and Fiedler.

381. ISARLOV, GEORGES. "Georges Braque." *Orbes* 3(Spring 1932):71-97.

Includes a list of Braque's works, 1906-29; exhibitions, 1906-26; collections including works by Braque; and a brief bibliography.
a. Reprint: Paris: José Corti, 1932. 31 p.

382. JOUFFROY, ALAIN. "Musée Georges Braque, Dieppe." *XX^e siècle* 40(June 1973):183; *Connoisseur* 184(Dec. 1973):286; *L'Œil* 234-5(Jan.-Feb. 1975):53.

383. KAHNWEILER, DANIEL-HENRY. "Braque au Salon d'Automne." *Beaux-arts* (8 Sept. 1933).

384. KALLAÏ, ERNÖ. "Georges Braque." *Magyar Müvészet* (Budapest) 14(10 Oct. 1938):289-301.

385. LANGSNER, JOHANNES. "Braque at Pasadena." *Art News* 59(Summer 1960):56.

386. LARRIEUX, J.-M. "Braque: le tableau devient sa raison d'être!" *Arts* 71(9 July 1982):12-3, 22. 4 illus.

On the occasion of the centenary celebration of Braque's birth, Laprieux offers a critical evaluation of the artist's work and its relationship to that of contemporaries such as Cézanne and Picasso. He describes the circumstances behind the painting of individual works, evaluates the broad themes, methods and aims of Cubism and

shows how it diverges from previous movements such as Impressionism. He discusses Braque's use of the collage technique, quoting from critics, poets, and the artist himself.

387. LAUDE, JEAN. "Picasso et Braque, la transformaton des signes" in *Le Cubisme Travaux IV* (Saint-Etienne: Université de Saint-Etienne, 1971).

388. LEYMARIE, JEAN. "Georges Braque, l'oiseau et son nid." *Quadrum* (Brussels) 5(1958):72-3.

Occasioned by Braque's fourteen paintings on display at the exhibition *50 ans d'art moderne*, Brussels, Palais des Beaux-arts (17 April-21 July 1958).

389. LHOTE, ANDRE. "Sur une exposition Braque." *La Nouvelle revue française* 6:69(1 June 1919):153-7.

Occasioned by the Braque exhibition at Galerie Léonce Rosenberg, Paris (March 1919). Reprinted in *La Peinture, le cœur et l'esprit* (Paris: Denoël et Steele, 1933):25-9.

390. LHOTE, ANDRE. "Le Symbolisme plastique de Georges Braque." *La Nouvelle revue française* 48(May 1937):795-7.

Article occasioned by an exhibition at Galerie Paul Rosenberg, Paris (3-30 April 1937). Reprinted in the author's *Peinture d'abord* (Paris: Denoël, 1942):159-60 and his *Ecrits sur la peinture* (Paris: Editions Lumière, 1946):272-6.

391. LITTLE, ROGER. "Saint-John Perse et les arts visuels." *Revue d'histoire littéraire de la France* 86:2(1986):220-34.

392. MAX, KARL. "Georges Braque." *Le Télégramme* (Toulouse) (11 Jan. 1909).

393. MCGARRY, S. H. "Georges Braque: The Late Paintings 1940-1963." *Southwest Art* 13:3(Aug. 1983):99-102. 4 illus.

On the occasion of the travelling exhibition of the same name, which began at the Phillips Collection, Washington, D.C. (9 Oct.-12 Dec. 1982), McGarry surveys Braque's career, focusing on the great influence which Cézanne had on Braque and the way in which Braque extended the vocabulary of 20th century art from the confines of his studio. She describes the cooperation between Braque and Picasso on analytic and synthetic Cubism and concludes with a discussion of the later period covered by the exhibition.

394. MCMULLEN, R. "'Something More Difficult than Painting': The Work of Georges Braque." *Réalités* 281(April 1974):24-33. 7 illus.

Examines the subject matter of Braque's paintings to show how his true interest lay in the questioning of reality and the function of painting. Braque was interested in Fauvism, but was untempermentally suited to Expressionism. Two great influences on his development were Cézanne's work and his relationship with Picasso, lasting from 1908 to 1914, during which time there was a continual exchange of ideas and

theories between the two artists. McMullen then examines in detail the effect on Braque of Cubism and his invention of *"papier collé,"* and concludes with a suggestion that Braque reached a point of nihilism from which there was no departure.
See also *Connaissance des arts* 261(Nov. 1973).

395. MILHAUD, DANIEL. "Matisse, Picasso et Braque, 1918-1926: y a-t-il un retour à l'ordre?" in *Le Retour à l'ordre dans les arts plastiques et l'architecture 1919-1925* (Paris: Spadem, 1976), pp. 95-142.

Discussion and detailed iconographical and philosophical analysis of the work of Matisse, Picasso, and Braque, vis-à-vis their position in the "retour à l'ordre" in which Milhaud describes the economic and psychological effects of the First World War on the French art scene and notes the attempts by such authors as Albert Gleizes and André Lhote to classify the achievements of Cubism. Milhaud assesses the influence of contemporary literature "nihilistic" art movements and Marxism on the three artists in question who, because they manifested a specificity, found themselves in a restricted position during the 1920s. He concludes that the ideology of the "return to order" made "sacred monsters" of these men whom the history of art should attempt to disarm.

396. MOE, H. "Georges Braque." *Kunsten Idag* (Oslo) 1(1964).

397. MORICE, CHARLES. "Georges Braque." *Mercure de France* (Jan. and April 1909).

398. OLIVIER, G. "G. Braque: la conquête de la méthode, 2." *Arts* 69(11 June 1982):12-3. 2 illus.

Examines of the technique of Georges Braque. Paintings of the town of L'Estaque show Braque's methodical approach to problem solving. After returning to Paris, Braque went back to the same motifs, showing how important his researches into two-dimensionality were at that time. His efforts at synthesis and homogenization of the surface culminated in the *La Roche-Guyon Bridge* (1909), based on advances in concentration made by Cézanne. He was concerned with the difficulty of paintings the area between objects, which he felt defined their relationship. Picasso's *Les Demoiselles d'Avignon* was a great influence on Braque's methods, eventually resulting in *The Great Nude*, drawn from three points of view. There was a striking similarity between the concerns of Braque's and Picasso's pictures when in 1908 Braque returned to L'Estaque and Picasso left for the village of Rue des Bois, mainly due to their discussions on Cézanne's recommendations on light, spheres, and pyramids.

399. PAULHAN, JEAN. "Braque, ou le sens du caché." *Cahiers d'art* 15-19(1940-44):87-114.

Includes thirty-one reproductions of Braque's works, 1940-44.

400. PEARSON, R. M. "Braque and Abstract Painting." *Art Digest* 23(15 May 1949):23 and (June 1949):4.

401. PERL, JED. "Late Lyrics: Braque." *Art in America* 71:2(Feb. 1983):78-86. 8 illus.

With reference to the exhibition *Georges Braque: The Late Paintings 1940-1963* organized by the Phillips Collection, Washington, D.C. (9 Oct.-12 Dec. 1982), Perl surveys this period of Braque's artistic life, concluding that it is through an "Expressionism of color relations that Braque conveys his final, intense feelings about the world around him," and describing the paintings of his last decade as "an avowal of the painter's craft, beyond all artifice, in its most elemental form."

402. PERRONE, JEFF. "Genius . . . Gender . . . " *Arts Magazine* 55:4(Dec. 1980):120-2.

Analyzes Picasso's attitude toward women. Perrone refers to a lecture by Leo Steinberg comparing Braque and Picasso and concluding that the genius of Picasso's work is self-evident while Braque's work is merely "decorative." This "decorative" tendency of art he relates to the feminine gender.

403. PLEYNET, MARCELIN. "Georges Braque et les écrans truqués" [Georges Braque and Faked Screens]. *Art press international* 8(Dec. 1973-Jan. 1974):6-9. 11 illus.

Study of Braque and Cubism, in which Pleynet analyzes methods of representation from Cézanne to Cubism. Braque's work from 1905 made use of what the author calls "a formal fixation with the Cézanne syndrome." But from 1906, the painter was indebted to the Fauves for the variations he introduced with relation to Cézanne's "distributive structure." In 1911, a period began during which Braque and Picasso established the most advanced phase of Analytical Cubism, often referred to as "hermetic." The stylistic differences that finally separated Picasso and Braque developed after a collaboration involving much reciprocal influence. Pleynet argues that the methods of the two artists are marked by the same determination, more "passionate" in Picasso's case, more "laborious" in that of Braque.

404. PODESTA, ATTILIO. "Braque." *Emporium* 108:643-4(July-Aug. 1948):41-4.

Article occasioned by an exhibition at the 1948 Biennale, Venice.

405. ["Reproductions de l'œuvre de Braque"]. *Cahiers d'art* 22(1947):9-36.

406. STEMP, ROBIN. "The Vase and the Void: Space, Shape and Composition in Braque's Still Lifes." *The Artist* 106:2(Feb. 1991):25-7. 4 illus., 3 col.

Discusses the still lifes of Georges Braque, focusing on his mastery of the use of space. He notes the artist's preoccupation with music and art and goes on to outlines his background and artistic development. Several of Braque's Cubist paintings are examined and his relationship with Picasso is considered. In conclusion, Stemp briefly comments on the "dignity and tranquility of Braque's work."

407. TERIADE, EMMANUEL. "L'Epanouissement de l'œuvre de Braque." *Cahiers d'art* 3:10(1928):409-17. 12 illus.

408. TINTEROW, GARY. "Paris, Beaubourg—Braque Centenary Exhibition." *Burlington Magazine* 124:955(Oct. 1982):651-2.

Article occasioned by the exhibition *Georges Braque, les papiers collés* at the Centre Georges Pompidou, Paris (June-Jan. 1982-83).

409. TORRES-GARCÍA, JOAQUIN. "Georges Braque" in *Universalismo constructivo* (Buenos Aires: Editorial Poseidon, 1944), pp. 510-2.

410. UHDE, WILHELM. "Liste complète des prix atteints aux ventes Uhde." *L'Esprit nouveau* 2(1921):1563.

Lists seventeen works by Braque. The sale took place at Hôtel Drouot, Paris, on May 30, 1921.

411. VALLIER, DORA. "Braque dans sa force." *La Nouvelle revue française* 253(1974):75-80.

412. VAUXCELLES, LOUIS. "Georges Braque." *Gil Blas* (10 March 1908); (14 Nov. 1908); (25 March 1909).

413. VAUXCELLES, LOUIS. "Georges Braque." *Le Télégramme* (5 Jan. 1909).

414. VERDET, ANDRE. "Le Sentiment du sacré dans l'œuvre de Braque." *XX^e siècle* 24:20(Dec. 1962):17-23.

415. WOODRUFF, H. A. "Georges Braque, Master of the Still Life." *School Arts* 56(April 1957):39.

416. ZAHAR, MARCEL. "Orientation de Georges Braque" in *Panorama des arts* (Paris: Aimery Somogy, 1948), pp. 148-9.

Article occasioned by an exhibition at Galerie Maeght, Paris (June-July 1948).

417. ZERVOS, CHRISTIAN. "Observations sur les peintures récentes de Braque." *Cahiers d'art* 5:1(1930):5-10. 8 illus.

418. ZERVOS, CHRISTIAN. "Le Classicisme de Braque." *Cahiers d'art* 6:1(1931):35-40. 6 illus.

419. ZERVOS, CHRISTIAN. "Braque et la Grèce primitive." *Cahiers d'art* 15:1-2(1940):3-13. 22 illus.

420. ZERVOS, CHRISTIAN. "Œuvres de Braque." *Cahiers d'art* 21:22(1947).

421. ZERVOS, CHRISTIAN. "Georges Braque." *Cahiers d'art* 24:25(1950).

III. Individual Paintings

Books

422. BRAQUE, GEORGES. *Georges Braque: Stilleben mit Violine und Krug.* Einführung von Hans Platte. Stuttgart: Reclam, 1963. 32 p., illus., 16 pl. Volume in "Werkmonographien zur bildenden Kunst" series.

423. VENTURI, LIONELLO. *Painting and Painters.* New York: Scribner's, 1945.

Includes an analysis of Braque's *Platter of Fruit* (1925).

Articles

424. "Accession to the Art Institute of Chicago." *Apollo* 93(Jan. 1971):66.

Highlights Braque's *Port in Normandy*.

425. AMBLER, JAQUELIN. "The Gallic Traditionalism: *The Blue Mandolin* of Braque." *The City Art Museum Bulletin, St. Louis* 20:1-2(April 1945):1-4.

Analyzes *The Blue Mandolin* acquired by the St. Louis City Art Museum. Also mentioned in *Pictures on Exhibit* 6(Feb. 1945):39 and *Art Digest* 19(15 Jan. 1945):8.

426. "Analytical Braque, Still Life, Presented to Honolulu." *Art Digest* 15(Sept. 1941):6.

427. ARNAUDET, D. "Braque: modernité et tradition." *Vie des arts* (Canada)27:109(Dec. 1982-Feb. 1983):38-40. 3 illus.

Argues that, in addition to some strokes of genius, Braque's painting also displays some regrettable lapses towards academicism, resulting from his conscience as an artisan. Therein resides the ambiguity of his output. Braque inherited from Cézanne the possibility of applying to painting the economy and precision traditional in the craftsman's milieu from which Braque came. *The Musician* is discussed as a major work because it sums up the modernist trajectory of Braque's work, offering a tactile surface, perfect integration of color and opening towards abstraction, but also bringing about his return to tradition, by posing questions to which he cannot reply without denying his background.

428. ASTIER, COLETTE. "L'Ordre des oiseaux de Braque et les oiseaux de Saint-John Perse: Une vision pour deux langages." in *Actes du Congrès de la Société Française de littérature générale et comparative* (Aix-en-Provence, 24-26 Sept. 1986), pp. 35-48. Aix-en-Provence: Université de Provence, 1988. 636 p.

429. BARSKY, VIVIANNE. "Soberly Celebrating Life: A 'Cabinet Picture' by Braque." *Israel Museum Journal* 6(Spring 1987):97-9. 1 illus.

Presents Braque's 1924 painting, *Bottle, Glass and Fruit*, recently acquired by the Israel Museum, Jerusalem, setting it in the context of his other work.

430. BLIGNE, YVES. "Saint-John Perse et les oiseaux." *Peinture* 536(1 Jan. 1977):6-7. 2 illus.

Review of an exhibition of paintings of birds by Braque and others, shown at the Musée Jacquemart-André, Paris (Jan. 1977). Bligne comments on the fascination of birds through the ages, and explains the friendship between Braque and the poet Saint-John Perse, based on their common love of birds.

431. "*Blue Mandolin* Purchased by the City Art Museum of St. Louis." *Pictures* 6(Feb. 1945):25,39.

432. BRAQUE, GEORGES. "*Aegle.*" *Art in America* 75(May 1987):4.

433. BOUISSET, MAÏTEN. "Acquis en 1908: des cubistes dans la lumière du nord." *Beaux-arts magazine* 91(June 1991):76-83. 12 illus., 11 col.

Explores the history of the collection started by Roger Dutilleul and bequeathed by his nephew Jean Masurel to the Musée d'Art moderne du Nord in Villeneuve d'Asq near Lille. In 1908 Dutilleul bought Braque's *Maisons et arbres*, the work which marks the official entry of Cubism into art history, from Daniel-Henry Kahnweiler, who championed such artists as Picasso, Gris, and Léger. Until the First World War, Dutilleul regularly bought works by Braque and Picasso. He and his nephew also collected works by Fernand Léger, by whom the museum now has fifteen paintings. There is also an outstanding set of works by Miró, Klee, Kandinsky, Utrillo, and Modigliani.

434. BRAQUE, GEORGES. "*L'Arlequin.*" *L'Œil* 410(Sept. 1989): inside cover.

435. BRAQUE, GEORGES. "*Atelier IX.*" *Connaissance des arts* 394(Dec. 1984):59.

436. BRAQUE, GEORGES. "*Le Billard.*" *Apollo* 121(April 1985):274.

437. BRAQUE, GEORGES. "*Boats on the Beach, L'Estaque.*" *American Artist* 55(March 1991):10.

438. BRAQUE, GEORGES. "*Bouteille de marc.*" *Connaissance des arts* 479(Jan. 1992):121.

439. BRAQUE, GEORGES. "*Casas en el Estaque.*" *Goyá* 180(May-June 1984):330.

440. BRAQUE, GEORGES. "*The Checkerboard.*" *Art in America* 73(May 1985):39.

441. BRAQUE, GEORGES. "*Le Chevalet.*" *L'Œil* 414-5(Jan.-Feb. 1990):41.

442. BRAQUE, GEORGES. "*Compotier, bouteille et verre.*" *Domus* 656(Dec. 1984):78.

443. BRAQUE, GEORGES. "*Femme au torse nu.*" *Domus* 656(Dec. 1984):78.

444. BRAQUE, GEORGES. *"Femme lisant."* Art News 85(Nov. 1986):23; *Art & Artists* 243(Dec. 1986): back cover *Connaissance des arts* 417(Nov. 1986):116; 422(April 1987):96; 428(Oct. 1987):22.

445. BRAQUE, GEORGES. *"Guitare (le petit éclaireur)."* L'Œil 429(April 1991):53.

446. BRAQUE, GEORGES. *"Instrument de musique et journal."* Apollo 121(April 1985):272.

447. BRAQUE, GEORGES. *"Job."* Bulletin of the Los Angeles County Museum of Art 28(1984):44.

448. BRAQUE, GEORGES. *"Naturaleza muetta: Gillette."* Goyá 221(March-April 1991):300.

449. BRAQUE, GEORGES. *"Nature morte à la guitare."* Connaissance des arts 433(March 1988):29.

450. BRAQUE, GEORGES. *"Nature morte aux cerises."* Connaissance des arts 465(Nov. 1990):179.

451. BRAQUE, GEORGES. *"Nature morte au verre et au journal."* L'Œil 396-7(July-Aug. 1988):29.

452. BRAQUE, GEORGES. *"Nature morte aux pêches."* Yale University Art Gallery Bulletin 39(Fall 1984):31; *Gazette des Beaux-arts* 465(Nov. 1990):179.

453. BRAQUE, GEORGES. *"Nature morte II: cubiste."* Gazette des Beaux-arts ser. 6, 105(March 1985): supp. 44.

454. BRAQUE, GEORGES. *"Nature morte."* Antiques 140(Nov. 1991):691.

455. BRAQUE, GEORGES. *"Nu."* Du 6(1984):75.

456. BRAQUE, GEORGES. *"L'Oiseau blanc."* Ceramic Review 135(May-June 1992):24.

457. BRAQUE, GEORGES. *"L'Olivier."* Du 11(1987):89.

458. BRAQUE, GEORGES. *"Paysage à L'Estaque."* Connaissance des arts 446(April 1989):31.

459. BRAQUE, GEORGES. *"Le Piège de Méduse."* Architectural Digest 49(July 1992):158.

460. BRAQUE, GEORGES. *"Le Quotidien du midi."* Connaissance des arts 436(June 1988):52.

461. BRAQUE, GEORGES. *"The Round Table."* Apollo 124(Aug. 1986):81.

462. BRAQUE, GEORGES. *"The Shower."* *Studio International* 199(June 1986):27.

463. BRAQUE, GEORGES. *"Still Life, Sorgues."* *Art International* 8(Autumn 1989):6.

464. BRAQUE, GEORGES. *"Still Life with Jug, Pomegranate and Pears."* *Apollo* 126(Nov. 1987):47.

465. BRAQUE, GEORGES. *"Still Life with Violin."* *Art International* 27(April-June 1984):62; *Apollo* 124(Nov. 1986):427.

466. BRAQUE, GEORGES. *"Stilleben mit Harfe und Violine."* *Du* 3(1986):21.

467. BRAQUE, GEORGES. *"La Table de toilette."* *Gazette des Beaux-arts* ser. 6, 105(March 1985): supp. 13.

468. BRAQUE, GEORGES. "[untitled: *Two Birds*]." *L'Œil* 360-1(July-Aug. 1985):63.

469. BRAQUE, GEORGES. *"Vase, Palette, and Mandolin."* *Arts Magazine* 59(April 1985):90.

470. BRAQUE, GEORGES. *"Le Violin."* *Art News* 88(March 1989):145.

471. BRAQUE, GEORGES. "[untitled: *Wine Bottle Label*]." *Connaissance des arts* 398(April 1985):74.

472. BRAQUE, GEORGES. *"Woman with a Mandolin."* *Art & Antiques* (Oct. 1988):85.

473. "Braque Joins Americans in Norton Gallery Accessions." *Art News* 46(April 1947):39.

Highlights Braque's *Mantel*, recently acquired by the Norton Gallery.

474. "Braque Painting: Kimbell Art Museum." *Museum News* 68(May-June 1989):21.

Discusses the acquisition by the Kimbell Art Museum (Fort Worth, Texas) of Braque's *Girl with a Cross*.

475. "Braque Still Life." *Chicago Art Institute Quarterly* 53-4(Feb. 1960):12-3.

476. "Braque's *Mantel* Joins Americans in Norton Gallery Accessions." *Art News* 46(April 1947):39.

477. BUCHNER, JOACHIM. "Hannover Kunstmuseum mit Sammlung Sprengel; Erweiterung einer Sammlung" [Hanover Kunstmuseum mit Sammlung Sprengel; Expanison of a Collection]. *Weltkunst* 51:8(15 April 1981):1154-6. 7 illus.

Discusses three recent acquisitons by the Kunstmuseum, Hanover: a 1914 Braque collage, a 1920 Klyun painting, and a Lipchitz stone relief dating from 1918. Braque's collage, *Pipe, verre, et journal* fulfilled the museum's desire to acquire a central Cubist work. The strength of Lipchitz's *Still Life* relief lies in its strict formal composition, and the interplay between forceful diagonals and curving planes. Klyun's *Composition* corresponds exactly with the tenets of his Constructivism: the interplay of color with planes, light and form.

478. CHASTEL, ANDRE. "New Life at the Louvre; Braque's Ceiling Decorations." *Art News* 52(June 1953):22, 72.

479. CLARK, E. "Milestones in Modern Art: *Woman with a Mandolin.*" *Studio* 154(Nov. 1957):130-1+.

480. "Cleveland: adieu Braque." *L'Œil* 244(Nov. 1975):64.

481. CLOONAN, WILLIAM. "Braque's *Le Portugais* and a Portuguese Nun" *The French Review: Journal of the American Association of Teachers of French* 63:4(March 1990):607-16.

482. COWART, JACK. "*Still Life with Glass* by Braque." *Saint Louis Art Museum Bulletin* 12:2(March-April 1976):24-5. 1 illus.

The St. Louis Art Museum's recently acquired *Still Life with Glass* (1931) by Braque is an intimate work, yet it has a visually strong composition in tense opposition to its sensitive intellectual restraint. It appears that Braque set himself several artistic challenges to be resolved. The result is a haunting composure and a curious sense of contrast between the mass of the objects and the openness of the background.

483. "Le Décor central du plafond de la salle Henri II au Louvre." *France illustration* 402(Sept. 1953):60-1.

484. DESCARGUES, PIERRE. "Georges Braque en un tableau." *Plaisir de France* (Nov. 1973):37-41.

485. DORIVAL, BERNARD. "Un an d'activité au Musée d'Art moderne—I, les dons." *Bulletin des Musées de France* (Aug.-Sept. 1948):172-80.

Discusses Braque's *Les Poissons noirs*, pp. 178-9.

486. "Forthcoming Sales." *Burlington Magazine* 103(Oct. 1961):441.

Discusses Braque's *La Lampe sur la table*.

487. FOYE, EDWARD. "Braque's (Real) Art in the *Still Life with Violin and Pitcher.*" *Artforum* 16:2 (Oct. 1977):56-8. 1 col. illus.

Analyzes the *Still Life with Violin and Pitcher* of 1909-10, owned by the Kunstmuseum, Basel, and places it in the context of Cubism. The object has been broken down and rebuilt in a way that amounts to a declaration of the artist's right

to reconstruct reality. The *trompe l'œil* nail and shadow in this painting is evidence of the complex transaction between art and nature in Cubism—the dialectic between the concrete and the abstract is basic to the style. For all its allegiance to the objective world, the originating impulse in Cubist art is deeply subjective and parallels can be drawn here with the works of James Joyce and Virginia Woolf, the philosophy of Hüsserl, and the music of Stravinsky.

488. FREE, R. "European Acquisitions: 1972-83." *Art and Australia* 22:1(Spring 1984):63-7. 4 illus.

Surveys the European works of art acquired by the Art Gallery of New South Wales, Sydney, between 1972 and 1983, including Braque's *Houses and Trees* (1909).

489. "Georges Braque, nature morte." *Cahiers d'art* 4(May 1929):161.

490. GROSS, LORI. "*Guitar and Bottle of Marc on a Table.*" *Bulletin of the Cleveland Museum of Art* 64:4(April 1977):141-6. 6 illus.

Describes this 1930 painting in oil and sand by Braque, owned by the Cleveland Museum of Art.

491. "*La Guitare bleue.*" *Oberlin College Bulletin* 5(Dec. 1948):44-5.

492. HENNING, EDWARD B. "Pablo Picasso; bouteille, verre, et fourchette." *Cleveland Museum of Art Bulletin* 59(Sept. 1972):195-203.

493. HENNING, EDWARD B., et al. "Two Major Paintings by Georges Braque." *Cleveland Museum of Art Bulletin* 64:4(April 1977):137-51. 18 illus.

During the 1920s and early 1930s, Georges Braque painted a series of still lifes, reaching an aesthetic summit in a group of canvases done between 1928 and 1932. Among these is *The Crystal Vase* (1929) and *Guitar and Bottle of Marc on a Table* (1930), both now in the Cleveland Museum's collection. Braque's life is traced to indicate the influence of his friendship with Picasso before the First World War, and the benefits of the patronage of Paul Rosenberg, who became his dealer in 1924. The two paintings discussed here represent an importance change in his Cubist still lifes, in which he returned to a "Cézannesque synthesis of suggested deep space and surface composition." Following Henning's discussion are two essays: "*Guitar and Bottle of Marc on a Table*" by Lori Gross, and "*The Crystal Vase*" by Peter Moskowitz. These analyze the relevant works in detail.

494. KEEN, G. "Times-Sotheby Index: Twentieth-Century Paintings." *Connoisseur* 171(May 1969):26.

Mentions Braque's *L'Homme à la guitare*.

495. KERSTING-BLEYL, HANNELORE. "Realitätsprobleme der Kubistischen Malerei" [Problems of Reality in Cubist Paints]. *Städel-Jahrbuch* 8(1981):313-23. 6 illus.

Discusses the different levels of reality in Georges Braque's *Woman Playing a Guitar*, 1913 (Musée National d'Art moderne, Paris) and *Violin and Jug*, 1910 (Kunstmuseum, Basel). Compares them with Michael Harnett's *Faithful Colt*, 1890 (Wadsworth Atheneum, Hartford) and with Richard La Barre Goodwin's *Cabin Door Still Life*, about 1886 (National Collection of Fine Arts, Smithsonian Institution, Washington, D.C.). Focuses on Cornelia Norbertus Gysbrecht's *Vanitas* (Museum of Fine Arts, Boston) and *Vanitas*, 1668 (Statens Museum for Kunst, Copenhagen).

496. LARSON, PHILIP. "Five Cubist Prints." *Print Collector's Newsletter* 7:4(Sept.-Oct. 1976):106-8.

Discusses Braque's *Bass*, among four other Cubist prints in Minneapolis' Walker Art Center's permanent collection. *Bass* was one of several still-life prints made by Braque during his most active period as an etcher.

497. LAWLESS, CATHERINE. "Informations: l'atelier double de Braque." *Cahiers du Musée National d'Art moderne* 10(1982):329-34. 10 illus.

Brief examination of Braque's studios and his series, *Ateliers* (1949-56), focusing on *Atelier VII*, reworked as *Atelier IX* (Centre Georges Pompidou, Paris).

498. LEYHAUSEN, KARL. "Zu einem Stilleben von Georges Braque." *Kunstblatt* 14(1930):102-3.

Analyzes Braque's *Still Life* (1927).

499. LLOYD, CHRISTOPHER H. "Reflections on La Roche-Guyon and the Impressionists." *Gazette des Beaux-arts* ser. 6, 127:1392 (Jan. 1985):37-44. 14 illus. French summary.

Discusses La Roche-Guyon, a village on the Seine halfway between Paris and Rouen, featured extensively in French painting of the second half of the 19th century. Examines Pissarro's works done there and compares them with works by Cézanne. Also discusses Braque's treatement of the site (*La Roche-Guyon, The Castle*, 1909, Moderna Museet, Stockholm). Affinities between Cézanne's Impressionism and Braque's nascent Cubist style are noted.

500. MARREY, BERNARD. "Un grand projet inachevé: la Faculté des sciences de Paris." *Revue de l'art* (1975):100-6. 14 illus. Summary in English.

Discusses Edouard Alberts's original plans, the paintings and decorations by Braque, Vasarely, and other artists, and alterations to the project, 1964-75.

501. MARTIN, ALVIN RANDOLPH III. "The Moment of Change: A Braque Landscape in the Minneapolis Institute of Arts." *Minneapolis Institute of Arts Bulletin* 65(1981-82):82-93. 8 illus., 1 col.

Considers that the Braque landscape *Viaduct at L'Estaque*, painted in October, 1907 and now in the holdings of the Minneapolis Institute of Arts, represents a link between Braque's understanding of the structural implications of Cézanne's work and

his development of the formal vocabulary of early Cubism. After discussing Braque's Fauvist style and his later Cézannism in *House on the Hill, La Ciolat*, Martin assesses the influence on Braque of the 1907 Cézanne retrospective in Paris, and proposes a chronology for Braque's paintings after the retrospective (including analyzes of *Viaduct at L'Estaque, View of L'Estaque, and Terrace of the Hôtel Mistral*). Other aspects of his life and work in the 1907-08 period discussed are his meeting with and response to Picasso, his still lifes, the evolution of his works, and the exhibition at the Salon des Indépendents (1908). Apollinaire's comments on Braque's work are also cited.

502. "Masters in the Art News." *Art News* 65(Oct. 1966):27; 66(Sept. 1967):21.

Highlights Braque's *La Monacre* and *Bouteille de rhum*.

503. MILGATE, R. "Georges Braque: *Paysage de la Roche-Guyon.*" *Art and Australia* 18:2(Summer 1981):150-1. 1 illus.

Brief appreciation of the 1909 oil-on-canvas painting *Paysage de la Roche-Guyon* by Georges Braque. A tender balance is discerned in this painting in the use of colors and tone, in the composition, in the contrasts of form and light, and of light and dark, and in the use of heavy and thin color. This delicate balance also informs the tree that is the subject of the painting.

504. MOSKOWITZ, PETA. *"The Crystal Vase."* *Bulletin of the Cleveland Museum of Art* 64:4(April 1977):147-51. 5 illus.

Painted by Braque 1929 and commissioned by his dealer Paul Rosenberg, *The Crystal Vase* was one of four compositions translated into marble mosaic panels for Rosenberg's dining-room in Paris. The painting is now in the Museum of Art, Cleveland.

505. "Notable Works of Art Now on the Market." *Burlington Magazine* 101(June 1959):4.

Mentions Braque's *Still Life* (1952).

506. "Notable Works of Art Now on the Market." *Burlington Magazine* 105(Dec. 1963):2.

Mentions Braque's *Nature morte-verre et journaux*.

507. "Notable Works of Art Now on the Market." *Burlington Magazine* 110(June 1968):12.

Mentions Braque's *Bouteille de rhum*.

508. RICH, D. C. "Five Contemporary French Paintings." *Chicago Art Institute Bulletin* 24(Jan. 1930):2.

Discusses a still life by Braque.

509. ROSENTHAL, GERTRUDE. "The Art of Georges Braque." *Baltimore Museum of Art News* 11(April 1948):1-4.

Includes an analysis of Braque's *Le Journal*.

510. SCHMIDT, GEORG. "Georges Braque: *Nature morte au guéridon*, 1918." *Museumjournal* 1:9-10(July 1956):157-60.

511. SEUPHOR, MICHEL [pseud. F. L. BERCKELAUERS]. "Contrast and Varieties; Ceiling by Braque at the Louvre." *Art Digest* 27(June 1953):9.

512. STEFANI, ALESSANDRO DE. "Matisse e il cubismo: per una nuova datazione del *Grand nu* di Braque" [Matisse and Cubism: Towards New Dating of Braque's *Large Nude*]. *Paragone* 39:457(March 1988:35-61. 15 illus.

Argues that the traditional dating of Braque's painting, *Grand Nu* to early Dec. 1907 is wrongly based on the dogma of Picasso's influence on Braque and the start of Cubism in general. Referring to Picasso's painting *Les Demoiselles d'Avignon*, the representation in paintings and sculpture at the time of the reclining nude, the interconnections between various artists bringing about the birth of Cubism from 1906-08, and in particular to the artistic work of Matisse and also his writings on the art world, Stefani suggests a date for Braque's painting late in 1908.

513. "*Still Life with Fish* Purchased by Toledo Museum of Art." *Art News* 49(Dec. 1950):28-9.

514. "*Still Life with Glass*." *Saint Louis Art Museum Bulletin* 12:2(1977).

515. "Twentieth Century European Paintings and Sculpture Recently Acquired by Museums." *Burlington Magazine* 126(Feb. 1984):1.

Mentions Braque's *Viaduct at l'Estaque*.

516. WAGNER, ANNI, et al. "Das Cleveland Museum of Art." *Kunst und das Schöne Heim* 95:8(Aug. 1983):531-8, 579. 8 illus. Summary in English.

Description of the holdings of the Cleveland Museum of Art, which has a collection of over 45,000 works from various cultural fields, including western and oriental art from all periods. Some of the recent acquisitons of the museum are described in detail, including Turner's *Burning of the Houses of Parliament*, Cézanne's *The Pigeon Tower at Bellevue*, Braque's *Still Life with Guitar and Bottle on a Table*, and Picasso's *La Vie*.

517. WAGNER, ANNI. "Museo de Arte Contemporaneo in Caracas." *Kunst* 7-8(July-Aug. 1986):550-7. 7 col. illus. In German.

Survey of the collection housed by the Museo de Arte Contemporáneo in Caracas, briefly discussing Picasso's *Portrait of Dora Maar* (1941), Matisse's *Odalisque in Red* (1925), and Braque's *Palette and Flowers* (1954), which are owned by the Museum, and summarizing the careers of the respective artists. She moves on to consider the Museum's Latin American collection, focusing on the careers of

Marisol Escobar (b. 1930) and Carlos Cruz-Diez (b. 1923) which exemplify the interest of South American artists in European developments. She praises the wider facilities provided by the Museum.

518. WINSPUR, STEVEN. "Saint-John Perse's Oiseaux: The Poem, the Painting and Beyond." *L'Esprit créateur* 22:4(Winter 1982):47-55.

519. "Y aura-t-il une affaire Braque? le plafond du Louvre." *France illustration* 404(Nov. 1953):103-4.

520. "*Yellow Cloth* Awarded First Prize at the 1937 Annual Carnegie Institute Exhibition in Pittsburgh, Pennsylvania." *Life* (1936-37):273.

521. "*The Yellow Cloth* Glitters." *Art Digest* 14(1 Dec. 1939):5.

Note indicating prizes won by the painting and selling price to current owner.

IV. Drawings

Books

522. GIEURE, MAURICE. *Georges Braque: dessins*. Paris: Editions des Deux Mondes, 1955. 15 p., 80 pl. Volume in "Dessins des grands peintres" series.

523. PONGE, FRANCIS. *Braque: dessins*. Paris: Braun, 1950. 11 p., 16 pl., some col.

Articles

524. BRAQUE, GEORGES. "Seven Drawings by Braque." *Drawing and Design* 4(April 1928):91-6, 100.

525. "Georges Braque et la peinture française. Les Dessins de Georges Braque." *Cahiers d'art* 2:1(1927):5-16, 34; 4-5(1927):141-5.

526. GROHMANN, WILL, ANTOINE TUDAL, and REBECCA WEST. "Carnets intimes de Georges Braque." *Verve* 8:31-2(1955). Reprinted in *The Intimate Sketchbooks of Georges Braque* (1955).

527. LE BUHAN, D. "Braque, textes illustrés—*Cahiers*: un homme sans idées." *Opus international* 47(Nov. 1973):20-4. 6 illus.

Braque's work raises the basic problem of easel painting, that of the relationship of the concept with plastic reality. Le Buhan considers his work and what it represents in terms of the man and his ideas. He describes the life of the artist and traces the development of his work. He then analyzes Braque's *Cahiers* with respect to the relationship between the maxims and the drawings. These writings are presented as the result of mediations on material things. In the author's view, Braque revealed in his work "the inexhaustible multiplicity of reality as it appeared to him in the course of his interior time."

528. SHATTUCK, ROGER W. "Art and Ideas: Captions or Illustrations? An Artist's Handbook." *Salmagundi* 81(Winter 1989):5-28.

529. TERIADE, EMMANUEL. "Les Dessins de Georges Braque." *Cahiers d'art* 2:4-5(1927):141-5. 4 illus.

V. Graphic Works and Prints

Books

530. BRAQUE, GEORGES. *G. Braque: das graphische Gesamtwerk, 1907-1955.* Bremen: M. Herz, 1955. 16 p., illus., some col.

531. BUCHHEIM, LOTHAR GÜNTHER. *Georges Braque: das graphische Werk.* Herausgeber von Lothar Günther Buchheim. Feldfing, Germany: Buchheim-Militon, 1950, 16 p., illus.

Reproduces prints by Braque from 1912-50, including the *Théogonie* suite for Vollard (1932).
a. Another ed.: 1952.

532. HOFMANN, WERNER. *Georges Braque: das graphische Werk.* Einleitung Werner Hoffman. Stuttgart: Hatje, 1961. 86 p., illus., some col.

a. U.S. ed.: *Georges Braque: His Graphic Work.* New York: Abrams, 1961. 86 p., illus., some col.
b. French ed.: *L'Œuvre graphique de Georges Braque.* Lausanne: La Guilde du Livre et Clairefontaine, 1962.
c. English ed.: London: Thames & Hudson, 1962. 86 p., illus., pl.

533. SEUPHOR, MICHEL (pseud. for F. L. Berckelauers). *L'Œuvre graphique de Braque.* Catalogue réalisé par Michel Seuphor. Paris: Berggruen, 1953.

Catalogue prepared to accompany an exhibition at the Musée des Beaux-arts, Liège (14 Nov.-6 Dec. 1953).

Articles

534. ASPEL, PAULENE. "Les Esthétiques jumelles de Rene Char et de Georges Braque: '*La Bibliothèque est en feu*' ou '*L'Atelier du poète*'." *Sud* (1984):253-73.

535. BLIN, GEORGES. "Braque et Char—mutualité de l'entente." *Parler* (Spring-Summer 1976):57-61.

536. "Braque—A Master's Art 'livres'." *Scrapbook of Art & Artists of Chicago* (1956):90.

537. "Braque Lithograph: *Still Life with Apple*." *Art News* 46(Oct. 1947):10.

538. CABANNE, PIERRE. "Mourlot." *Connaissance des arts* 278(April 1975):62-7. 13 illus., 4 col.

Account of the Parisian printers, Mourlot frères, used by Braque, Matisse, Picasso, and others.

539. CHAPON, FRANCIS and E. SCHULUMBERGER (Interviewer). "Le Livre illustré français au 20ᵉ siècle." *Connaissance des arts* 341(July 1980):71-80. 15 illus.

In this interview, Chapon, librarian of the Bibliothèque littéraire Jacques Doucet, discusses aspects of the development of the illustrated book in France over the period 1870-1970, with reference to the annotated illustrations of books illustrated by Braque, Picasso, Redon, Sonia Delaunay, Miro, Matisse, Masson, André Derain, Bonnard, Toulouse-Lautrec, Manet, Giacometti, and others.

540. "*Le Char*, Color Lithograph." *Buffalo Gallery of Art Notes* 19(Jan. 1955):74.

541. CHARBONNIER, GEORGES. "Contremots." *Derrière le miroir* 115(1959):18.

Illustrated with lithographs by Braque.

542. CHASTEL, ANDRE. "L'Art graphique de Georges Braque." *Médecine de France* 146(1963):17-32.

543. CRANSTON, MECHTHILD. "Char and Braque: le soleil des eaux: The Theater of Water and Sun." *Romance Quarterly* 30:2(1983):123-31.

544. DANIELE, S. "Georges Braque and Market Trends." *Print Collector* 1(March-April 1973):44-59. 16 illus.

Examination of the fluctuating value of the work of Georges Braque in European galleries and auction rooms. Thirteen etchings and lithographs are examined in terms of gallery price fluctuation between the years 1960 and 1970. These prices are then compared with those fetched at auction sales of another group of Braque lithographs. Despite the fluctuations of the auction sales, the gallery prices remained surprisingly high, and would seem to suggest that the market is controlled not merely by the laws of supply and demand but also by those wishing to make a handsome profit.

545. GARVEY, ELEANOR W. "Cubist and Fauve Illustrated Books." *Gazette des Beaux-arts* 63(1964):37-50.

546. GASSER, M. "Exhibition Posters by Famous Painters." With German and French texts. *Graphis* 16(March 1960):108-19.

547. GASSER, M. "Georges Braque, Three New Examples of Book Art." German and French texts. *Graphis* 18(Sept. 1962):490-9[+].

548. HAAS, I. "Braque: Print-Maker." *Art News* 47(Feb. 1949):8[+].

549. HAAS, I. "Braque Drypoints Discovered." *Art News* 49(Nov. 1950):54.

550. "Helmuts with Weather Vanes: Illustrations for Hesiod." *Time* 65(17 Jan. 1955):60.

551. HINES, T. J. "L'Ouvrage de tous les temps admiré: *Lettera amorosa,* René Char and Georges Braque." *Bulletin du bibliophile* 1(1973):40-57. 4 illus. In English, summary in French.

A desire to produce a synthesis of art forms is common to many 20th century art movements, and this is a study of an example of collaboration between two artists, both masters of their craft: the *Lettera amorosa* poems by René Char and lithographs by Georges Braque, published in 1963. *Lettera amorosa* is neither an "art book" nor "a poem" but is seen as "the work" (*l'ouvrage*), almost a third art form where poetry and painting fuse. Hines attempts to provide a basis for criticism of this new category, one which normally falls outside the scope of any one specialist critic.

552. KORNFELD, EBERHARD W. "Meister der Grafik des 19. und 20. Jahrhunderts" [Masters of the print in the 19th and 20th Centuries]. *Du* 36:420(Feb. 1976):26-51. 21 illus.

Illustrated and chronological summary of twenty-one print artists, from Goyá to Lissitzky. The masters chosen include Daumier, Toulouse-Lautrec, Munch, Picasso, Braque, Klee, and Kandinsky. Kornfeld supplies short accounts of each artist, concentrating on his activity in the graphic arts. Appended are lists of books and catalogues of the artists' graphic works, and descriptions, with some technical details, of the works illustrated here.

553. LEVEQUE, JEAN-JACQUES. "Pierre-André Benoit en odeur de sainteté." *Les Nouvelles littéraires* (7 Sept. 1978).

Benoit published many of Braque's illustrated books.

554. LIEBERMAN, WILLIAMS. "Braque as Printmaker." *Arts Digest* 29(15 Nov. 1955):13-4.

555. LIMBOUR, GEORGES. "La Théogonie d'Hésiode et de Georges Braque." *Derrière le miroir* 71-2(Oct.-Nov. 1954):1-22.

556. MCEWEN, JOHN. "The Complete Artist." *Studio International* 187:966(May 1974):214+.

Discusses Emmanuel Tériade's inspirational work as an editor of the periodicals *Minotaure* and *Verve*. His editing gave rise to Braque's *Carnets intimes* and Matisse's *Jazz* series.

557. MELOT, MICHEL. "Cubists and Etchings." *Apollo* 96(Aug. 1972):138+.

558. NOGACKI, EDMOND. "Peinture et poésie chez René Char" in *Des mots et des couleurs: études sur le rapport de la littérature et de la peinture (19ème et 20ème siècles)* (Lille: Publications de l'Université de Lille, 1979), pp. 165-71.

Studies the affinities of René Char's poetics, the painters he associated with, and his graphic works. Char's thematic and aesthetic progression led him first to the "illuminations" of Braque, Giacometti, Miró, Picasso, Vieira de Silva, and many other well-known contemporary painters and then to his own graphic equivalents for poetic fragments in his œuvre. Proposes a classing of the illuminations by aesthetic affinities and a study of the unpublished, unexhibited pictorial works of René Char.

559. "Recent Acquisitions." *St. Louis Museum of Art Bulletin* 1(Jan. 1966):4.

Mentions Braque's etching *Fox*.

560. RIBEMONT-DESSAIGNES, GEORGES. "Georges Braque illustrateur." *L'Œil* 47(Nov. 1958).

561. RUTTEN, PIERRE VAN. "Peinture et poésie ou le pouvoir de l'art dans Oiseaux." *Revue des lettres modernes* (1989) in *Saint-John Perse et les arts*. Textes réunis par Daniel Racine (Paris: Lettres Modernes/Minard, 1989), pp. 141-6.

In *L'Ordre des Oiseaux*, published in 1962 and illustrated by twelve lithographs by Braque, Saint-John Perse explains the process of knowing and the finality of art as a universal language of the absolute.

562. SELZ, JEAN. "L'Oiseau et la grève." *Lettres nouvelles* (July 1959).

563. SHARP, E. "Some Notable Additions to the Print Collection." *Detroit Institute of Art Bulletin* 51:2-3(1972):81-9. 10 illus.

Mentions Braque's etching *Fox*, part of a collection of School of Paris prints presented to the Detroit Institute (p. 85).

564. SIGNOVERT, JEAN. "Gravure et émulation." *Nouvelles de l'estampe* 8(Aug.-Sept. 1964).

565. SOLIER, RENE DE. "L'Œuvre gravée de Braque." *Cahiers de la Pléiade* 12(1951).

566. SOLIER, RENE DE. "L'Oiseau de Braque." *Cahiers d'art* 31-2(1956-7):235-45. 15 illus.

567. SOOS, EMESE. "Images d'oiseaux chez Braque et Perse." *Revue lettres modernes* (1989) in *Saint-John Perse et les arts*. Textes réunis par Daniel Racine (Paris: Lettres Modernes/Minard, 1989), pp. 77-85.

Concerns Braque and Perse's collaboration on *L'Ordre des oiseaux* (1962)—twelve lithographs by Braque accompanying Perse's poem. The place of bird imagery in the works of the two men is also discussed.

568. STAHLY, F. "G. Braque: Illustrations for the Tibetan Songs of Milarepa; with German and French Texts." *Graphis* 6:29(1950):80-2+.

569. STEIN, DONNA M. "Cubism in Prints." *Print Review* 18(1983):37-53. 16 illus.

Contends that the print was a significant part of the Cubists' artistic output, the linear nature of the traditional etching and the austerity of black and white images appealing to Braque, Picasso, and Gleizes, among others. While many high-quality prints of the Cubists are not known, Stein shows that the print was used to generate new ideas and provides a useful history of the movement.

570. STEIN, DONNA M. "Stampe cubiste rare" [Rare Cubist Prints]. *Print Collector (Il Conoscitore di stampe)* 60(1983):2-15. 12 illus. In Italian and English.

Examines graphic techniques and styles of such artists as Picasso, Braque, and Archipenko.

571. TERENZIO, STEPHANIE. "Braque's *Job*: The Imprint of Cubism." *Bulletin of the William Benton Museum of Art, University of Connecticut* 11(1983):16-27. 5 illus.

Study of Braque's drypoint etching of 1911, in the William Benton Museum, University of Connecticut, Storrs.

572. VALLIER, DORA. "A propos de la thégonie de Braque." *Nouvelles de l'estampe* 66(Nov.-Dec. 1982):24-6. 2 illus.

Account of the Vollard suite for Hesiod's *Theogony*, 1932-36, as distinct from the volume published in 1954 by Aimé Maeght.

573. VOLBOUDT, PIERRE. "La Liberté des mers de Pierre Reverdy. Résurrection de l'oiseau de Frank Elgar et Georges Braque." *Derrière le miroir* 117(1959):5-8, 12-3.

574. WALLEN, B. "The Habbing Zigzagging Lines Arcs Spirals of Cubist Prints." *Art News* 81:4(April 1982):88-91. 7 illus.

Prints were instrumental in the formation of Cubism's mature style and Picasso's influential *Saint Matorel* etchings unleashed the graphic potentials of Cubism, translating the new vision of the movement into printmaking media. Wallen discusses the creation of a new graphic syntax by Picasso and Braque and describes the work of the two best-known Cubist printmakers after them, Jacques Villon and Louis Marcoussis. The Cubists radically expanded definitions of book illustration for the 20th century, using such methods as process (photomechanical) techniques or pochoir, for many the preferred means of reproducing multi-colored synthetic compositions in the original watercolor or gouache pigments. It is concluded that prints helped Cubism to become an international phenomenon, while the diverse directions taken by Cubist printmakers underscore the liberating effect of the movement on the graphic arts.

VI. Illustrated Books and Portfolios

575. REVERDY, PIERRE. *Les Ardoises du toit*. Paris: Impr. Paul Birault, 1918.

576. *Nord-sud* 13(1918). Journal published by Pierre Reverdy. Includes two original wood engravings by Braque and several proofs.

577. SATIE, ERIK ALFRED LESLIE. *Le Piège de Méduse; comédie lyrique en un acte de M. Erik Satie, avec musique de danse du même monsieur*. Ornée de gravures sur bois, par M. Georges Braque. Paris: Galerie Simon [D.-H. Kahnweiler], 1921. 32 p., 11 col. illus. 112 copies. Lyrical comedy by Satie with three color wood engravings by Braque.

578. BRAQUE, GEORGES, et al. *Les Facheux*. Paris: Editions des Quatre Chemins, 1924. 2 vol. in 1 portfolio, illus., some col.

579. *Programme de Soirée de Paris organisée sous la direction de M. le comte Etienne de Beaumont au théâtre de La Cigale, du 17 mai au 30 juin 1924*.

580. EINSTEIN, CARL. *Georges Braque*. Illustré de Georges Braque. Paris: Editions des Chroniques du Jour, 1934. 140 p., 103 illus., 1 col. 50 copies. Volume in "XXᵉ siècle" series.

First monograph devoted to Braque. Includes two original aquatints and one color plate by Braque.
a. Excerpt: *Beaux-arts* 73:19(6 July 1934):1,5.
b. U.S. ed.: *Georges Braque*. Trans. by M. E. Zipruth. New York: E. Weyhe, 1934. 140 p., illus., 89 pl., some col.

581. PAULHAN, JEAN. *Braque, le patron*. Geneva, Paris: Fernand Mourlot; editions de Trois Collines, 1945. 78 p., illus., 57 pl. 225 copies. Text first published in *Poésie* 43:13(March-April 1943):2-15. Volume in "Collection les grands peintres par leurs amis" series.

Includes two color lithographs by Braque (cover and frontispiece) and "Réflexions par Georges Braque."
a. Other eds.: Paris, Geneva: Editions des Trois Collines, 1946 (with three additonal chapters); Geneva: Gérard Cramer & François Lachenal, 1947 (90 copies, 2 original lithographs); Paris: Gallimard, 1952.
b. English extract: *Horizon* 11:65(May 1945):329-39.
c. Danish extract: *Open oog* (Amsterdam) 1(Sept. 1946):15-6.

582. TUDAL, ANTOINE. *Soupente*. Préface de Pierre Reverdy. Avec une lithographie en huit couleurs de Georges Braque pour la couverture. Paris: Robert J. Godet, 1945. 38 p., illus. 125 copies. Includes one color lithograph (cover) by Braque.

583. KOBER, JACQUES. *Le Vent des épines*. Illustré par *Bonnard, Braque* [et] *Matisse*. Paris: Pierre à feu. Maeght éditeur, 1947. 22 p., illus., 1 pl.

584. *Hérclite d'Ephèse*. Traduction nouvelle et intégrale avec introduction et notes par Yves Battisini. Avant-propos de René Char. Paris: Aux Editions "Cahiers d'Art," 1948. 104 p., illus. 1000 copies.

Includes one aquatint by Braque (frontispiece).

585. ARTAUD, ANTONIN. *Poésie de mots inconnus*. Paris: Le Degré 41 [Iliazd], 1949. 29 p.

Includes one lithograph on black by Braque on p. 7.

586. CHAR, RENE. *Le Soleil des eaux: spectacle pour une toile des pêcheurs*. Illustré par Georges Braque avec quatre eaux-fortes dont une en couleurs pour le frontispiece. Paris: H. Matarasso, 1949. 147 p., 4 illus., 1 col. 200 copies.

Includes four aquatints (one color as frontispiece) by Braque.

587. REVERDY, PIERRE. *Une aventure méthodique*. Avec une lithographie en trois couleurs en frontispiece et vingt-six lithographies en noir dans le texte. Paris: Fernand Mourlot; Maeght, 199. 114 p., illus. 250 copies.

Illustrated by Braque: one three-color lithograph (frontispiece), twenty-six black-and-white lithographs, twelve color compositions after paintings by Braque.

588. MILARASPA. *Milarepa, magicien-poète-ermite-tibétain, XI^e siècle*. Traduction de Jacques Bacot. Avec cinq eaux-fortes et dix lettrines de Georges Braque. Paris: Maeght éditeur, 1950. 44 p., 5 pl.

Includes five aquatints and ten decorated initials (*lettrines*) by Braque.

589. PONGE, FRANCIS. *Cinq sapates*. Eaux-fortes de Georges Braque. Paris: Georges Braque, 1950. 50 p., illus. 100 copies.

Includes five black-and-white aquatints by Braque.

590. CHAR, RENE. *La Bibliothèque est en feu*. Orné d'une gravure originale de Georges Braque. Paris: Louis Broder, 1950. 21 p., col. illus. Volume in "Ecrits et gravures" series.

591. BENOIT, PIERRE-ANDRE. *Impuissant à t'aimer*. Alès: P. A. Benoit, 1953.

592. REVERDY, PIERRE. *Cercle doré*. Paris: Mourlot, 1953. 2 p., illus. 12 copies.

Includes a lithograph by Braque as title-page.

593. BENOIT, PIERRE-ANDRE. *Salut à René Char*. Alès: P. A. Benoit, 1955. 20 p., illus.

Illustrated by one print on celluloid heightened with China ink by Braque.

594. HESIOD. *La Théogonie*. Eaux-fortes de Georges Braque, vingt eaux-fortes, dont seize dans le texte correspondant aux suites Vollard, tirées sans remarques, une en frontispiece, gravée en 1932 et complétée en 1953 ainsi qu'une pour la couverture, une tête de chapitre et un cul-de-lampe, spécialement réalisés pour cette édition.

595. PAULHAN, JEAN. *Les Paroles transparentes*. Lithographies originales de Georges Braque. Paris: Les Bibliophiles de l'Union Française, 1955. 91 p., illus.

Includes four color lithographs and twelve decorated motif monochromes (one cover) by Braque.

596. TZARA, TRISTAN. *La Bonne heure*. Avec une aquatinte en couleurs de Georges Braque en frontispiece. Paris: Raymond Jacquet, 1955. 16 p., illus.

Color aquatint as frontispiece by Braque.

597. CHAR, RENE. *La Bibliothèque est en feu*. Orné d'une gravure originale de Georges Braque. Paris: Louis Broder, 1956. 52 p., illus., 500 copies.

Includes one color aquatint (frontispiece) by Braque.

598. CHAR, RENE. *Jeanne qu'on brula verte*. Alès: Pierre-André Benoit, 1956. 14 p., 1 illus.

599. ELUARD, PAUL. *Un poème dans chaque livre*. Douze poèmes choisis et autographiés par l'auteur, orné de seize gravures et lithographies de divers artistes. Paris: Louis Broder, 1956. 148 p., illus. 500 copies.

Illustrated with one color aquatint on two pages by Braque.

600. BENOIT, PIERRE-ANDRE. *Né le* . . . [à René Char pour ses cinquante ans]. Alès: P.-A. Benoit, 1957. 24 p., illus.

Includes one frontispiece aquatint by Braque.

601. SATIE, ERIK ALFRED LESLIE. *Léger comme un œuf*. Texte par Erik Satie. Eau-forte originale par Georges Braque. Paris: Louis Broder, 1957. 30 p., 1 pl. 500 copies. Volume in "Miroir du poète" series.

One color aquatint (frontispiece) by Braque.

602. BOISSONNAS, EDITH. *Passionné*. Avec une lithographie de Georges Braques en frontispiece. Alès: Pierre-André Benoit, 1958. 16 p., col. pl.

Color a lithograph (frontispiece) by Braque.

603. BRAQUE, GEORGES. *XX [20] pensées de Georges Braque*. Choisis par P.-A. Benoit dans le *Cahier de Georges Braque* avec une lithographie en couleurs sur double page. Alès: P.-A. Benoit, 1958. 24 p., illus.

Includes one color lithograph on two pages by Braque.

604. CHAR, RENE. *Cinq poèmes en hommage à Georges Braque*. Avec une lithographie de Georges Braque en couverture. Geneva: Edwin Engleberts, 1958. 52 p., illus. 106 copies.

Includes one double-page color lithograph (cover) by Braque.

605. ELGAR, FRANK. *La Résurrection de l'oiseau*. Avec quatre lithographies de Georges Braque, dont une pour la couverture, une en frontispiece et deux dans le texte, ainsi que trois motifs décoratifs dans le texte. Paris: Maeght, 1958. 40 p., illus. 225 copies.

Illustrated by Braque with four lithographs—three color (one cover and one as frontispiece) and three monochrome motif decorations.

606. SAINT-POL, ROUX. *Aôut. Braque*. Avec cinq aquatints et différentes suites avec des variantes. Paris: Louis Broder, 1958. 56 p., 5 pl. 40 copies. Volume in "Ecrits et gravures" series.

Includes four aquatints by Braque (one in two colors as frontispiece; one in blue).

607. TUDAL, ANTOINE and ROGER VIELLARD. *Georges Braque, grands livres illustrés*. Poème de Antoine Tudal, texte de Roger Vieillard. Paris: Adrien Maeght, 1958. 32 p., illus.

Cover color lithograph by Braque. Catalogue of the exposition *Livres illustrés par Braque* at the Adrien Maeght Gallery in Paris.

608. BENOIT, PIERRE-ANDRE. *Braque et le divin manifeste*. Alès: P.-A. Benoit, 1959.

609. BENOIT, PIERRE-ANDRE. *Dans vos jardins*. Alès: P.-A. Benoit, 1959. 24 p., illus.

Includes one paste-board engraving by Braque.

610. BENOIT, PIERRE-ANDRE. *Mon tableau*. Alès: P.-A. Benoit, 1959.

611. VERDET, ANDRE. *Georges Braque le solitaire*. Avec une lithographie en couleurs de Georges Braque. Paris: XXe siècle; Hazan, 1959. 60 p., illus. 900 copies.

Includes one color engraving by Braque.

612. BENOIT, PIERRE-ANDRE. *Invisible visible*. Avec une gravure sur carton de Georges Braque pour la couverture.

613. PINDAR. *Le Ruisseau de blé*. Poème de Pindare, traduit par Jean Beaufret; avec des textes de René Char, P.-A. Benoit, Dominique Fourcade et une gravure sur carton de Georges Braque. Alès: P. A. Benoit, 1960. 24 p., illus.

Illustrated by one paste-board engraving by Braque.

614. REVERDY, PIERRE. *La Liberté des mers*. Avec sept lithographies en couleurs de Georges Braque, dont une pour la couverture et soixante décors en noir et en couleurs dans le texte. Paris: Maeght, 1959. 170 p., illus. 250 copies.

Illustrated by Braque with seven color lithographs and sixty decorative monochrome lithographs.

615. RIBEMONT-DESSAIGNES, GEORGES. *La Nuit la faim*. Avec deux lithographies en couleurs de Braque, dont une en frontispiece. Paris: Adrien Maeght, 1960. 34 p., illus. 163 copies.

Includes two color engravings by Braque.

616. SATIE, ERIK ALFRED LESLIE. *Oui*. Lettres adressées à Pierre de Massot. Alès: Pierre-André Benoit, 1960. 12 p., illus.

617. SUZUKI, DAISETZ TEITARO and E. HERRIGEL (translators). *Le Tir à l'arc*. Mis en lumière par Georges Braque. Textes choisis de D. T. Suzuki et E. Herrigel, extraits de *Le Zen dans l'art chevaleresque du tir à l'arc*, 1955, et quelques aphorismes et pensées de Georges Braque extraits de ses *Cahiers 1917-1952*, avec une eau-forte pour la couverture, deux gravures sur bois et huit lithographies en couleurs. Paris: Louis Broder, 1960. 62 p., illus. 165 copies.

618. ZERVOS, CHRISTIAN. *Georges Braque—nouvelles sculptures et plaques gravées*. Présentées par Christian Zervos. Tirage de tête avec une eau-forte en couleurs de Georges Braque. Paris: Editions Albert Morancé, 1960. 16 p., 32 pl. 50 copies.

Includes one color aquatint by Braque.

619. JOUHANDEAU, MARCEL. *Descente aux enfers*. Avec quatre lithographies en couleurs de Georges Braque. Paris: Nouveau Cercle Parisien du Livre, 1961. 98 p., illus. 170 copies. Includes four color lithographs by Braque.

620. BENOIT, PIERRE-ANDRE. *Les Livres de Braque réalisés par PAB*. Avec une gravure sur carton de Georges Braque. Alès: P.-A. Benoit, 1961. 12 p. 45 copies.

Includes an engraving on paste board by Braque.
a. Supplement: 4 p., (Catalogue), 1964.

621. ILIAZD. *Sentence sans paroles*. Paris: Le Degré 41, 1961. 23 p., illus. In French and Russian.

Cover aquatint ("Pour Hiazd") by Braque. Includes an engraving by Alberto Giacometti.

622. APOLLINAIRE, GUILLAUME. *Si je mourais là-bas*. Bois original de Georges Braque. Paris: Louis Broder, 1962. 78 p., illus., some col.

Includes a woodcut by Braque and eighteen color wood engravings.

623. BENOIT, PIERRE-ANDRE. *Mariette dans l'atelier, ou la meilleure part.*
Alès: P.-A. Benoit, 1962.

Includes one color lithograph (frontispiece) by Braque.

624. CHAR, RENE. *Nous ne jalousons pas les dieux.* Placard illustré d'une gravure
sur carton de Georges Braque tirée en bleu. Alès: P.-A. Benoit, 1962. 1 p., illus.
73 copies.

Includes one paste-board engraving by Braque.

625. PAULHAN, JEAN. *Paroles peintes.* Textes de quatorze auteurs, illustré par
quatorze artistes, avec une eau-forte de Georges Braque. Paris: O. Lazar-Vernet,
1962. 130 p., illus.

Includes one aquatint by Braque.

626. PERSE, SAINT-JEAN. *L'Ordre des oiseaux.* Paris: Au Vent d'Arles, 1962.
54 p., illus., 130 copies. Includes twelve color aquatints by Braque.

a. Bilingual U.S. ed: *Birds*; with reproductions of four original color etchings by
Georges Braque. Trans. by Robert Fitzgerald. New York: Bollingen Foundation;
dist. by Pantheon, 1966. 71 p., 4 col. pl.

627. REVERDY, PIERRE. *A René Char.* Alès: P.-A. Benoit, 1962.

628. BRAQUE, GEORGES. *Six pensées.* Avec une gravure sur carton de Georges
Braque. Alès: P.-A. Benoit, 1963. 16 p., illus. 43 copies.

Includes one paste-board engraving by Braque.

629. CHAR, RENE. *Lettera amorosa.* Avec vingt-neuf lithographies en couleurs
dont deux culs-de-lampes et une lithographie en noir pour la couverture des suites.
Geneva: Edwin Engelberts, 1963. 64 p., col. illus. 200 copies.

Review: T. Hines, *Bulletin du bibliophile* 1(1973):40-57.

630. *Georges Braque, René Char: manuscrits, livres, documents, estampes: édition
illustrée de 'Lettera amorosa'.* Avant-propos de Georges Blin. Paris: Bibliothèque
littéraire Jacques Doucet, 1963. 56 p., illus.

631. PONGE, FRANCIS and FERNAND MOURLOT. *Braque lithographe.* Préface
de Francis Ponge. Notices et catalogue établis par Fernand Mourlot. Avec cinq
lithographies dont deux hors-texte, une pour la couverture, une pour le frontispièce
et une pour la page de titre. Monte Carlo, Paris: André Sauret, 1963. 184 p., illus.
125 copies.

632. VALLIER, DORA. *Georges Braque—dix œuvres.* Précédé de: *Braque, la
peinture et nous.* Propos de l'artiste recueillis par Dora Vallier. Avec une

lithographie en couleurs, hors-textes. Basel: Les Editions Phoebus, 1963. 16 p., 10 pl. 600 copies (French ed.); 200 copies (English ed.).

Includes one color lithograph by Braque.

633. BENOIT, PIERRE-ANDRE. *Bibliographie des œuvres de René Char.* Avec une gravure sur carton de Georges Braque. Ribault-les-Tavernes: Le Demi-Jour, 1964. 104 p., illus. 50 copies.

Includes one paste-board engraving by Braque, among works by other artists.

634. BENOIT, PIERRE-ANDRE. *Les Petites heures de Thouzon.* Avec une eau-forte en noir de Georges Braque. Alès: P.-A. Benoit, 1964. 24 p., illus. 75 copies.

Includes one aquatint by Braque.

635. BRAQUE, GEORGES. *Hommage à Georges Braque.* Textes de Pierre-André Benoit, et al. Paris: Maeght, 1964. 83 p., illus., col. pl.

636. BRAQUE, GEORGES and JACQUES PREVERT. *Varengeville.* Paris: Maeght éditeur, 1968. 17 p., illus., 17 col. pl.

Portfolio of views of Varengeville-sur-mer, France.

637. CHAR, RENE. *L'Effroi, la joie.* Saint-Paul: Au Vent d'Arles, 1969. 19 p., illus.

638. *San Lazzaro et ses amis: hommage au fondateur de la revue XX^e siècle.* Textes de Pierre Volboudt . . . [et al.] et de Gualtieri di San Lazzaro; lithographies originales de Max Bill, Alexander Calder, Marc Chagall, Max Ernst, Hans Hartung, Joan Miró, Henry Moore, Graham Sutherland et Zao Wou-Ki; lithographies en second tirage de Braque, Fontana, Magnelli, Magritte, Picasso et Poliakoff. Paris: XX^e siècle, 1975. 145 p., col. illus., 15 pl.

VII. *Papiers découpés* (Cutouts)

Book

639. MONOD-FONTAINE, ISABELLE and E. A. CARMEAU. *Braque: The Papiers Collés.* With contributions by T. Clark et al. Washington D.C.: National Gallery of Art, 1982. 189 p., illus., some col.

Articles

640. DAIX, PIERRE. "Des bouleversements chronologiques dans la révolutions des *papiers collés* (1912-1914)." *Gazette des Beaux-arts* ser. 6, 82(Oct. 1973):219.

641. DAIX, PIERRE and J. ROSSELET. "Pablo Picasso: la révolution des *papiers collés.*" *L'Œil* 284(March 1979):52-7. 6 illus.

Occasioned by the forthcoming publication of the authors' catalogue raisonné of Picasso's Cubist œuvre, this article presents a synopsis of their statements and findings on Picasso's "pasted papers" of the 1912-13 period. Picasso's technique in the execution of these collaged works, their revelation of the many optical possibilities offered by collage, and the correlations between Picasso's explorations and those of Braque are mentioned.

642. ELGAR, FRANK. "Une conquête du cubisme: le *papier collé*. Derniers collages de Braque." *XX^e siècle* 6(1956).

643. GREENBERG, CLEMENT. "The Pasted-Paper Revolution." *Art News* 57:5(Sept. 1958):46-9, 60-1.

644. SCHNEIDER, PIERRE. "Collages by Braque." *Art News* 62(Oct. 1963):17.

645. HENNING, EDWARD B. "Georges Braque, *Le Violoncelle*." *Cleveland Museum of Art Bulletin* 56(Feb. 1969):55-60.

646. HENNING, EDWARD B. "Major *papier-collé* (*Le Violoncelle*) Acquired by Cleveland Museum of Art." *Burlington Magazine* 112(May 1970):338.

647. TZARA, TRISTAN. "Le *Papier collé*." *Cahiers d'art* 2(1931): 5 illus.

648. "Georges Braque. Plâtre coloré. L'Epanouissement de l'œuvre de Georges Braque." *Cahiers d'art* 3:1(1928):5-11; 7(1928):284; 10(1928):409-17.

VIII. Sculpture

Books

649. FUMET, STANISLAS. *Sculptures de Braque*. Préface de Stanislas Fumet. Paris: Jacques Damase, 1951. 14 p., illus., 35 pl., portfolio.

a. Another ed.: Paris: Editions Albert Morancé. 12 p., 35 pl.

650. ZERVOS, CHRISTIAN. *Georges Braque: nouvelles sculptures et plaques gravées*. Présentées par Christian Zervos. Paris: Albert Morancé, 1960. 15 p., 32 pl., 8 col.

a. German ed.: *Georges Braque: neue skulpturen und gravierte platten*. Düsseldorf; Lausanne: A. G. de May, 1960. 15 p., 32 pl., 8 col.

Articles

651. DORIVAL, BERNARD. "Musée d'Art moderne—sculptures de peintres." *Bulletin des musées de France* (Dec. 1949):263-71.

652. GRAND, P. M. "Céramiques de peintres." *Art et décoration* 30(1952):4-7.

653. HÜNEKE, ANNE. "Plastiken von malern" [The Sculptures of Painters]. *Bildende Kunst* 6(1979):289-94. 12 illus.

Points out that many important developments in modern sculpture came about due to the efforts of artists who were known primarily for their work as painters. In this connection Hüneke looks at sculptures by Daumier, Degas, Renoir, Gauguin, Matisse, Picasso, Braque, Boccioni, Derain, Ernst, Modigliani, Schmidt-Rottluff, Nolde, Schwitters, and Shlemmer. She concludes with a closer look at the work of two German "realist" painter-sculptors: Käthe Kollwitz and Otto Pankol.

654. JOUFFROY, ALAIN. "Ceramics and Small Sculpture by Painters." With German and French texts. *Graphis* 13(May 1957:236-9)+.

IX. Jewelry

Books

655. CRAVEN, JOHN. *Les Bijoux de Braque*. Paris: Publications Filmées d'Art et d'Histoire, 1969. 44 p., 8 pl., 36 col. slides. Text in French, English, German, and Spanish.

656. LANLLIER, JAN and MARIE-ANNE PINI. *Five Centuries of Jewelry 16th to 20th Century*. London: Alpine Fine Arts Collection, 1983. 327 p., 299 illus., 59 col.

Presents a survey of jewelry from the 16th to the 20th century. The authors describe the jewelers' raw materials in terms of their structure, production, sources and uses. Jewelry from the Renaissance, the Classical period, and the 19th and 20th centuries is described. A selection of jewelry designed by Braque, Dalí, Herbert Jochems, and Charles de Temple among others is included.

657. LOWENFELD, HEGIER DE. *Bijoux de Braque*. Paris: Imprimerie Transatlantique, 1965. 12 p., illus., some col.

Articles

658. ERNOULD-GANDOUET, MARIELLE. "La Bague, bijou symbolique et objet d'art." *Jardin des arts* 182(Jan. 1970):40-50.

659. MOUTARD-ULDRY, R. "Un atelier d'émailleurs à l'abbaye Saint-Martin de Ligugé: émaux exécutés d'après les peintres de Braque et d'autres artistes." *Art et décoration* 22(1951):14-5.

X. Theatre Designs

Articles

660. ANTHELME, GILLE. "Un aspect décisif des ballets Diaghilev: Léonide Massine." *Variétés* 4(15 Aug. 1928):184-96.

661. COGNIAT, RAYMOND. "La Décoration théâtrale: Braque et les Ballets russes." *L'Amour de l'art* 12(May 1931):206-8.

Discusses designs for *Les Fâcheux, Zéphyr et Flore,* and *Salade.*

662. "Georges Braque, décors et costumes." *Le Bulletin de la vie artistique* 5(1 March 1924):116-7.

663. L., A. "Décor théâtral." *Beaux-arts* 17(15 Oct. 1924).

664. STEWART, IAN. "Diaghilev's Magic Lantern: The Work of Some Designers for the *Ballets Russes.*" *Country Life* 151:3901 (16 March 1972):626-7. 6 illus.

The most flamboyant revelation of what artists could do in the theater was provided by Serge Diaghilev's *Ballets Russes* when they burst upon Paris in 1909. Here a synthesis of music, dance and decorative design was fully realized. The revolution in décor consisted principally in the abandonment of realistic perspective in favor of simplified, brilliantly colored, animated picture. Léon Bakst was the most successful and versatile designer in an exotic vein but the First World War cut Diaghilev off from Russia and impelled him into a search for new artists in Europe: Picasso, Derain, Matisse, Braque, Ernst, Miró, and Rouault all worked for him in this second decade.

665. VOSTER, HANS. "Llegan los pintores, arriba el telón!" [The Painters are Here, Bring Down the Curtain!] *Correo del arte* 45(April 1987):18. 3 illus.

On the occasion of the exhibition *20th Century Painters in the Theatre,* held in Frankfurt-am-Main (1987), Voster describes the revolution in the scenic arts that took place in the early years of the 20th century. He notes the work in Berlin of Max Reinhardt who commissioned set designs from Edvard Munch and Lovis Corinth; of August Macke in Dusseldorf and of Koloman Moser in Vienna; of Picasso, Braque and Gris for Serge Diaghilev's Ballets Russes; and of El Lissitzky and Malevich in Moscow.

666. WOODCOCK, SARAH. "An Introduction to the Costume Tradition." *Apollo* 125:302(April 1987):265-70. 10 illus.

Discusses the costume collection at the Theatre Museum, London, with preliminary discussions of the importance of costume collections in general. Woodcock comments on the predominance of dance costumes in the collection; the items from the Diaghilev Ballet; the use of artists as costume designers, considering the designs of Picasso, Braque, Larinov, Norman Wilkinson, Christian Dior, Wilhelm, and Philip Prowse.

XI. Special Issues of Journals Devoted to Georges Braque

667. *Les Soirées de Paris* (Paris) 23(15 April 1914).

a. Reprint: Geneva: Slatkine Reprints, 1971.

668. *Sélection* (Antwerp) 3:4(1914).

669. *Bulletin de l'Effort Moderne* (Paris) 3(March 1924).

670. *Cahiers d'Art* (Paris) 8:1-2(1933). 84 p., 172 illus. Issued on the occasion of the exhibition at the Kunsthalle, Basel (9 April-14 May 1933). Texts by Christian Zervos, "Georges Braque"; Guillaume Apollinaire, "Les Peintres cubistes," Figuière, 1913, p. 40; "Georges Braque," *La Revue Indépendante* (August 1911): pp. 167+; "Georges Braque," *Le Mercure de France* (16 January 1909; André Salmon "Georges Braque"; Roger Bissière "Georges Braque," *L'Effort moderne*; Léonce Rosenberg, 1920; Blaise Cendrars, "Georges Braque"; Ardenzo Soffici, "Georges Braque, *La Voce* (Florence), (24 August 1911); André Lhote, Georges Braque," *Nouvelle Revue Française* (1 June 1919); Jean Cassou, "Georges Braque"; Carl Einstein, "Braque der Dichter".

671. *Derrière le miroir* (Paris) 4(June 1947). Text by René Char. "*La Main de l'ouvrier*" by Jacques Kober.

672. *Derrière le miroir* (Paris) 25-6(Jan.-Feb. 1950). "Sous la verrière" by René Char; text by Henri Maldiney.

673. *Derrière le miroir* (Paris) 48-9(June-July 1952). "Gris, brun, noir" by Alberto Giacometti; "Ainsi de Braque" by Jean Grenier.

674. *Mizue* (Tokyo) (Oct. 1952). Texts by Francis Ponge and A. Imaizumi.

675. *Le Point* (Souillac) 46(Oct. 1953). "Georges Braque peintre contemplatif" by Stanislas Fumet; "Georges Braque à Varengeville" and "Le Plafond de Georges Braque" by Georges Limbour; "A propos d'une nature morte" by Georges Ribemont-Dessaignes.

676. *Derrière le miroir* (Paris) 71-2(Dec. 1954-Jan. 1955). "La Théogonie d'Hésiode et de Georges Braque" by Georges Limbour.

677. *Verve* (Paris) 8:31-2(1955). "Carnets intimes de Georges Braque" by Will Grohmann (pp.3-14); "L'Oreille dans la serrure" by Antoine Tudal (pp.17-8); "Les Carnets intimes de Georges Braque" by Rebecca West. Issue devoted to Braque's drawings.

678. *Derrière le miroir* (Paris) 85-6(April-May 1956). "Le Nuage en échec" by Jacques Dupin; "L'Atelier parisien de Georges Braque."

679. *Preuves* 65(July 1956).

680. *Derrière le miroir* (Paris) 115(1959). "Contremots" by Georges Charbonnier (pp. 3-18).

681. *Art international* (Zurich) 6(Nov. 1962).

682. *Derrière le miroir* (Paris) 135-6(Dec. 1962-Jan.1963). "Battements" by Stanislas Fumet (pp. 1-9); extracts from: "La Liberté des mers" by Pierre Reverdy (pp. 11-9); "Le Mur et la mer" by François Chapon (pp. 20-6).

683. *Derrière le miroir* (Paris) 138(May 1963). *Georges Braque, papiers collés 1912-1914.* "Ne nous évadons pas, ma peinture" by Stanislas Fumet (pp. 1-15).

684. "Témoignages." *Arts*(4 Sept. 1963).

Special edition on Braque with texts by Borsi, P. Cabanne, Carzou, M. Chagall, Ciry, S. Delaunay, A. Dunoyer de Segonzac, J. Lurçat, A. Maeght, A. Magnelli, Verdet, Waroquier, and O. Zadkine.

685. *Mizue* (Tokyo) 38(Dec. 1963).

686. *Derrière le miroir* (Paris) 144-6(March-May 1964). *Hommage à Georges Braque.* "Pierre levée" by Saint-John Perse (p. 5); "Avec Braque peut-être, on s'était dit..." by René Char (p. 6); "31 août 1963" by Alberto Giacometti (p. 8); "Feuillet votif" by Francis Ponge (pp.10-1); "Lettre à René Char" by Martin Heidegger (pp.14-5); "Peindre en Dieu" by Jean Paulhan (pp. 16-9); "Braque, tu m'as dit un jour...," lithographed text by Pablo Picasso (pp. 17-8); "De vive joie" by Jacques Prévert (p. 22); "L'Oiseau bleu...," lithographed text by Joan Miró (p. 23); "Adieu à Georges Braque" by Daniel-Henry Kahnweiler (p. 24); "Du travail de la nature aux chefs-d'oeuvre d'un tel artiste" by Jean Cassou (pp. 26-7); "Ni le soleil ni l'éclat de la lune..." by Marc Chagall (pp.28-9); "A la place des fleurs..." by Gaëtan Picon (pp. 30-2); "Braque" by Douglas Cooper (p. 38); "Le Thème de l'oiseau" by Georges Salles (p. 40); "Braque inventeur" by Christian Zervos (pp. 41-4); gouache with caption by Roger Bissière (p. 45); "L'Oeil de Braque" by Stanislas Fumet (pp.46-7); "Dernière visite à Braque" by Jean Grenier (p. 50); "Le Prophète, le mage, le saint" by Marcel Jouhandeau (p. 51); "A Georges Braque" by Georges Ribemont-Dessaignes (p. 52); "Braque ou l'échange" by André Chastel (pp. 54-5); "La Trace" by Antoine Tudal (pp. 58-60); "L'Espace et son parcours" by Jean Leymarie (pp. 62-3); "Ce qui prime dans l'art de Braque" by Frank Elgar (p. 66); "Tous les jours" by Claude Laurens (p. 67); "Aux clartés d'un adieu" by André Verdet (p. 68); "Où s'arrête la mer..." by P.-A. Benoit (p. 70); "L'Accomplissement" by Jacques Dupin (p. 71); Indian ink sketch dedicated to Braque by Eduardo Chillida (pp. 72-3); "Pierre Reverdy et Georges Braque. Le 10 février 1950" (pp. 74-6). With original lithographs by Pablo Picasso, Joan Miró, Pierre Tal-Coat, Raoul Ubac, Pierre Pallut and photographs by Man Ray, Jules Brassaï, Routhier, and Mariette Lachaud.

687. "Georges Braque." *XXe siècle* 26(1965).

XII. Audiovisual Materials

688. *Georges Braque*, 1950. 16 (35) mm film, sound, black and white, 24 min., directed by André Bureau. Production: C.A.P.A.C. and Claudon Films. Distribution: Films du temps and B.F.I. Texts: Stanislas Fumet; with the voice of Hurd Hatfield and commentary spoken by Jean Desailly. Music: Jean-Sébastien Bach. Version: French.

689. *Painter and Printmaker*, 1950. 16 mm film, sound, color, 22 min., directed by Stanislas Fumet. Production: Stanislas Fumet. Distribution: The Museum of Modern Art, New York. Texts: Hurd Hatfield. Version: English.

690. *Peintres et artistes de Montmartre*, 1950. 35 mm film, sound, black and white, 23 min., directed by Jean-Claude Bernard. Production and distribution: Films Jean-Claude Bernard. Works by Utrillo, Braque, Gen Paul, Léger, Frochot, D'Espardès, Creixhams, and Collamarini. Version: French.

691. *Georges Braque*, 1954. 16 mm film, sound, black and white, 17 min., directed, produced and distributed by Films Images. Version: French.

692. *Statues d'épouvante*, 1956. 35 mm film, sound, black and white, 23 min., directed by Robert Hessens. Production: Films Jacqueline Jacoupy. Distribution: Films Jacqueline Jacoupy and C.N.D.P. Images: Ghislain Cloquet and Sacha Vierny. Texts: Dhomme; with the voice of Michel Bouquet. Music: Pierre Barbaud. Works by Picasso, Braque, Léger. Version: French.

693. *Braque*, 1961. In the series: "En français dans le texte," distributed on 22 June 1961. 16 mm film, sound, black and white, directed by Jean Jouhannot. Production: O.R.T.F. Distribution: I.N.A. Works by Braque, Chagall, Léger, and Picasso. Version: French.

694. *Hommage à Georges Braque*, 1964. Ceremony for Braque. 16 mm film, sound, black and white, 27 min., directed by Maurice Beuchey. Production: O.R.T.F. Distribution: I.N.A. Version: French.

695. *Paris à l'heure de New York: exposition Braque*, 1964. 16 mm film, sound, black and white, 15 min., directed by Jacques Sallebert and distributed on 16 June 1964. Production: O.R.T.F. Distribution: I.N.A. Version: French.

696. *Braque et Jean-Sébastien Bach*, 1965. In the series: "Musique pour les yeux," distributed on 16 June 1965. 16 mm film, sound, black and white, 18 min. 20 sec., directed by Roger Kahane. Production: O.R.T.F. Distribution: I.N.A. Music: Jean-Sébastien Bach. Version: French.

697. *Braque à l'Orangerie*, 1972-1973. In the series: "Des yeux pour voir," distributed 2 January 1973. 16 mm film, sound, color, 55 min., directed by Adam Saulnier and Pierre Desfons. Author: Pierre Desfons. Production: O.R.T.F. Distribution: I.N.A. Version: French.

698. *Braque*, 1973. In the series: "Du côté de chez les Maeght," distributed on 12 June 1973. 16 mm film, sound, color, directed by Jean-Michel Meurice. Production: O.R.T.F. and Fondation Maeght. Delegated producer: Eliane Victor. Distribution: I.N.A. Version: French.

699. *Chagall, Braque, Reverdy*, 1973. In the series: "Du côté de chez les Maeght," distributed on 12 June 1973. 16 mm film, sound, color, 26 min. 7 sec., directed by Jean-Michel Meurice. Production: O.R.T.F. and Fondation Maeght. Delegated producer: Eliane Victor. Distribution: I.N.A. and Fondation Maeght. Version: French.

700. *Braque au Louvre*, 1973. In the series: "Forum des arts," distributed on 9 September 1973. 16 mm film, sound, color, directed by Martin Sarraut. Production: T.F.1. Delegated producer: Alain Parinaud. Distribution: I.N.A. Version: French.

701. *Rétrospective Braque à l'Orangerie*, 1973. 16 mm film, sound, black and white, 2 min. 16 sec. Production: Ministère des Affaires Etrangères, Magazine France-Panorama. Distribution: Médiathèque Centrale. Version: French.

702. *Georges Braque ou le temps différent*, 1974-1975. 16 (35) mm film, sound, color, 80 min., directed by Frédéric Rossif. Production and distribution: Télé Hachette. Scenario and texts: Jean Lescure; with the voices of Suzanne Flon and Pierre Vaneck. Music: B. Vangelis Papathanassiou. With the participation of Claude Laurens, Jean Leymarie, Mariette Lachaud, and Louis Turin. Version: French.

703. *La Peinture cubiste*, 1981. Programme "Regards entendus." 16 mm film, sound, color, 50 min., directed by Thierry Kuntzel and Philippe Grandrieux. Production: T.F.1. Distribution: T.F.1. and I.N.A. Text: Jean Paulhan, *La Peinture cubiste*. After works by Picasso, Braque, Gris. Version: French.

704. *Georges Braque*, 1982. 16 mm film, sound, color, 52 min., directed by Jean-Paul Roux. Responsible for cohesion of the program: Jean-Michel Meurice. Production: A2. distribution: I.N.A. Version: French.

705. *Balthus ou Braque*, 1984. Programme "Désirs des arts" no. 2, distributed on 8 January 1984. Video, sound, color, 27 min. 50 sec., directed by Philippe Collin, Pierre-André Boutang, Roger Ikhlef and Simon Freige. Author: Pierre Daix. Production: A2. Distribution: A2, I.N.A. with the participation of Jean Masurel. Version: French.

706. *Braque: les ateliers*, 1984. 16 mm film, sound, color, 52 min., directed by Jean-Paul Roux, distributed on 29 April 1984. Production: A2. Distribution: A2, I.N.A. Texts: Georges Braque and Francis Ponge; with the voices of Henri Serre and Jean-Marie Fertey. With the participation of Francis Ponge, Jean Leymarie and Nadine Lehni. Works by the artist: collages from 1912. Version: French.

707. *New Ways of Seeing: Picasso, Braque and the Cubist Revolution*. Video, Sound, color, 58 min., directed by Andrew S. Clayman, produced by Burton S. Minkoff, written by Pepe Karmel, distributed by Home Vision and Facets Multimedia, 1989.

Discusses the free-form collaboration in Cubism between Braque and Picasso between 1907 and 1914. Presents an overview of the two artists' formal and creative innovations; the influence of dealers, critics, lovers, and current events; and above all, their own intimate yet competitive friendship. Offers a behind-the-scenes look at the organization of the 1989 exhibition *Picasso and Braque: Pioneering Cubism* at The Museum of Modern Art in New York City and shows 150 of the over 300 pieces from fourteen countries that appear in the exhibition. Includes commentary by Williams Rubin, director emeritus of the department of painting and sculpture at the museum, and observations of painter Elizabeth Murray, artist David

Hockney, and architect Frank Gehry on the pervasive effect Cubism has had on art and architecture throughout the twentieth century.

708. *Derrière le miroir* (Paris) 166(June 1967). *G. Braque, derniers messages.* "Braque dans son atelier" by Jean Grenier (pp. 1-19). Photographs by Mariette Lachaud.

Influence and Mentions

I. Influence on Other Artists .93
 Books .93
 Articles .97
II. Mentions of Georges Braque .101
 Books .101
 Articles .124

I. Influence on Other Artists

Books

709. ABADIE, DANIEL. *Bissière.* Neuchâtel: Ides et Calendes, 1986. 198 p., 213 illus., 110 col.

Published on the occasion of the centenary of the birth of Roger Bissière and of the retrospective exhibition of his paintings at the Musée de la Ville de Paris, this monograph on the artist presents a selection of his work and gives an account of his career and art. Particular emphasis is put on the last twenty years of Bissière's life when he emerged as a major figure of the French avant-garde. His early career is discussed with particular reference to his friendship with Braque and to the influence of the Cubists on him.

710. BOZO, DOMINIQUE. *Henri Laurens: le cubisme—constructions et papiers collés, 1915-1919.* Exhibition: Paris, Musée National d'Art moderne (18 Dec. 1985-16 Feb. 1986). Introduction de Dominique Bozo. 135 p., 117 illus., 56 col.

Catalogue to an exhibition of sculptures, terracotta reliefs and collages (Paris, Musée National d'Art moderne, Salle d'Art graphique, 18 Dec. 1985-16 Feb. 1986) by Henri Laurens (1885-1954) produced during the most intense period of his involvement with Cubism. The painted wooden assemblages are founded on motifs common to the paintings of Picasso and Braque, while the reliefs and collages also bear a close relationship to Braque's work. It includes an essay by Isabelle Monod-Fontaine, first published in the catalogue to a 1985 retrospective of Laurens's work at the Kunstmuseum, Bern.

711. BROWN, ROBERT K. and SUSAN REINHOLD. *The Poster Art of A. M. Cassandre*. Edited by Adolphe Edouard Mouron. New York: Dutton, 1979. 89 p., illus., some col.

First monograph on the commercial and graphic artist since 1948. Takes the position that Cassandre was more influenced by the Parisian avant-garde in painting from the years 1908-30 (i.e., Picasso, Braque, Léger, Gerald Murphy, and Le Corbusier) than by the commercial art of the period.

712. CALABRESE, OMAR. *Silvio Pasotti: dalle alle piramidi* [Silvio Pasotti: From the Alps to the Pyramids]. Milan: Electa, 1987. 70 p., 54 illus., 38 col. In Italian and French.

Presents a selection of paintings by Pasotti set against the backdrop of the Alps and of the Pyramids. A short introductory text analyses the significance of travel as a theme and as a symbol, and the travel concept in the portrayal of human figures. Calabrese also notes that the paintings draw on the work of such artists as Braque, Severini and Picasso, while bearing the imprint of contemporaneity.

713. CHABERT, PHILIPPE. *Kolle*. Exhibition: Cologne, Art Cologne (10-16 Nov. 1988). Also shown Dusseldorf, Galerie Vömel (18 Nov.-31 Dec. 1988). Katalog von Philippe Chabert. Dusseldorf: Galerie Vömel, 1988. 60 p., 28 illus., 26 col.

Catalogue to an exhibition of paintings by Helmut Kolle (1899-1931). In his introduction to his work, Chabert describes Kolle's impressions of Paris in the 1920s compared with his native Berlin, and notes the influence on his work of Braque, Picasso and Rousseau; he assesses Kolle's contribution to the strength of cultural relations between France and Germany in the early 20th century.

714. FAVELA, RAMÓN. *Diego Rivera: The Cubist Years*. Exhibition: Phoenix, Phoenix Art Museum, 10 March-29 April 1984. Also shown New York, IBM Gallery of Science and Art (13 June-8 Aug. 1984); San Francisco, Museum of Modern Art (27 Sept.-11 Nov. 1984); Mexico City, Museo de Arte Moderno (6 Dec. 1984-11 Feb. 1985). Guest curator: Ramón Favela. Organized by James K. Ballinger. 176 p., illus., some col. 77 works shown

Presented seventy-seven paintings, watercolors, and drawings depicting landscapes, still lifes, portraits, and figure compositions, 1913-18. Detailed study of Rivera's sojourn in Europe, 1911-21, identifying the various pre-Cubist, Cubist, and other influences on his development. Discusses Angel Zárraga's role in awakening Rivera's interest in Cubism. Gauges the influence on Rivera's art of El Greco, Mondrian, and Cézanne, in addition to examining his relationships with Picasso, Braque, and Gris. Investigates the conditions leading to Rivera's eventual break with the Cubists in 1918.
Reviews: H. Herra, *Connoisseur* 214:865(March 1984):27; G. Levin, *Arts Magazine* 59:2(Oct. 1984):122-5; C. French, *Artweek* 15:35(20 Oct. 1984):1.

715. FANDSEN, JAN WÜRTZ. *Richard Mortensen: ungdomsårene 1930-1940; mellem surrealisme og abstraktion* [Richard Mortensen: The Early Years 1930-1940; Between Surrealism and Abstraction]. Copenhagen: Statens Museum for Kunst; Department of Prints & Drawings, 1984. 352 p., 336 illus., 15 col. In Danish.

Focuses on the ten formative years of the artist, who was of great importance to the genesis of Danish abstract art in the 1930s. Analyzes Mortensen's theoretical basis in Kandinsky and Malevich and his formal and iconographic sources and influences—including Picasso and Braque of the 1920s, the surrealistic trends of Ernst, Arp, et al, the poetry of Paul Eluard, Stravinsky's music, the philosophy of Henri Bergson, the ideas of Freud, Zen-Buddhism, etc. As a documentation of the rise of Danish abstract art, the book also explores to what extent and in what form French abstraction and Surrealism influenced Danish artists in the 1930s.

716. GENER, CHARLOTTE. *Marie Laurencin*. London: Academy Editions, 1977. 95 p., 110 illus., some col.

Heavily illustrated biographical essay with a brief bibliography and a comprehensive list of books illustrated by the artist. Marie Laurencin is shown in the context of her period as a friend of Apollinaire, Picasso, Braque and others, and as an influential decorative artist whose œuvre included stage design, illustration, wallpaper design and posters. The works illustrated come from all stages of her career which lasted from 1905-53.

717. GREEN, CHRISTOPHER. *Léger and the Avant-Garde*. New Haven, London: Yale University Press, 1976. 350 p., 222 illus, some col.

Detailed examination of Léger's painting from 1909 to 1927 which focuses on how his response to the technology and urbanism of the early 20th century reflected contemporary architectural, musical, literary and philosophical currents. The Parisian avant-garde is examined with reference to such figures as Apollinaire, Cendrars, Bergson, Le Corbusier, René Clair, Cocteau, Picasso, Gris and Braque, and the development of Léger's art is traced from a Cubism employed to depict the speed and power of city life towards a more idealistic classicism expressing an ordered sense of modern life.

718. KNIGHT, VIVIEN, et al. *Patrick Heron*. Texts by Vivien Knight, James Faure Walker, and Alan Gouk. 56 p., 64 illus., 29 col.

Catalogue to an exhibition of paintings by Heron (b. 1920) (London, Barbican Art Gallery, 11 July-1 Sept. 1985) with three essays. Knight traces the various shifts in Heron's attitude toward abstraction and color as revealed by his statements over the course of his career. Walker analyses Heron's paintings and writings from the 1970s, a period during which he intensely applied his theories of paint and color. Gouk discusses the vibrant chromatic harmonies and increasingly less restrained composition in Heron's recent painting, emphasizing the links between the artist and Matisse and Braque evident in his treatment of light.

719. LYNCH, JAMES B., JR. *Rufino Tamayo: Fifty Years of his Painting*. Exhibition catalogue, Washington, D.C., Phillips Collection (7 Oct.-16 Nov. 1978); San Antonio, Marion Kroogler McNay Art Institute (6 Jan.-17 Feb. 1979). Sponsored by the National Endowment for the Arts and the National Endowment for the Humanities, Washington D.C. 89 p., 59 illus., some col.

Acknowledges Tamayo's strong debt to European artists such as Picasso, Braque, and Klee.

720. MADSEN, AXEL. *Sonia Delaunay: Artist of the Lost Generation*. New York: McGraw-Hill, 1989. 357 p., 24 illus.

Biography of Sonia Delaunay (1885-1979), born Sarah Stein in Czarist Russia, who fled to Paris at the age of twenty and became part of the French cultural scene. Her circle of friends included Picasso, Braque, Matisse, Chagall, Arp, and Diaghilev. While married to her first husband she met and began an affair with Robert Delaunay, and married him after becoming pregnant with his child. Madsen shows how, as Robert Delaunay's fame and success as an artist declined over the years that followed, Sonia's grew even greater. He discusses her important role in the development of abstract painting and her impact in the fields of textiles, fashion, furnishings and graphic design, emphasizing the visual exuberance of her work.

721. ROBBINS, DANIEL. *The Formative and Maturity of Albert Gleizes: A Biographical and Critical Study, 1881 through 1920.* Ph.D. diss., New York University, 1975. 416 p.

Albert Gleizes was the most vocal of those artists identified as the "right bank" or minor Cubists, and examination of his development reveals differences between Cubism as developed by Picasso and Braque and the concerns of Metzinger, Léger, Le Fauconnier, Delaunay, Villon, and Gleizes. Robbins begins with an outline of Gleizes's life, discussing his education, family, and entry into the artistic world, with particular reference to his participation in the establishment of the "Abbaye de Créteil." His stylistic development is examined from late Impressionism to Cubism, charting the coalescence of the artists of Passy and outlining the circumstances and ideas that brought this group together in 1911-12. A chapter is devoted to the iconography of the minor Cubists and how these concerns led them to pursue similar themes which evolved into Abstract Art. The last section illustrates how the Second World War destroyed the Cubist avant-garde and, in the case of Gleizes, retarded the continuity of development. Various exponents of different forms of avant-garde art, including Duchamp, Picabia and the Dada movement are discussed in relationship to Gleizes and Gleizes's theoretical position is analyzed in detail.

722. SARKIS, ROBERT. *William Ivey: Three Decades of Painting*. Exhibition: Seattle, Henry Art Gallery (15 Nov. 1989-7 Jan. 1990). Sponsored by Henry Gallery Association and University of Washington and the College of Arts and Sciences. Seattle: Henry Art Gallery, University of Wisconsin, 1989. 60 p., 78 illus., 77 col.

Catalogue to an exhibition of paintings by William Ivey (b. 1919) spanning the years 1959 to 1989, with an essay by Sarkis, who has followed Ivey's work since the 1960s, in which he identifies the key to the content of Ivey's paintings as the visual dialogue. He discusses Ivey's style which is characterized by an expressive approach and an interpretation of the visual world in terms of abstract and abstracted forms, a search for a combination of lyricism and a special kind of strength, and the paring down of each painting to its essentials. Finally he discusses influences on Ivey's art: Edouard Manet, Georges Braque, Kurt Schwitters, Arshile Gorky and, most importantly, Pierre Bonnard, and to a certain extent Henri Matisse, and concludes by briefly outlining his artistic achievements.

723. SUPKA, MAGDOLNA B. *Kohán György (1910-1966): Emlékkiállítása* [György Kohán (1910-1966):Retrospective]. Exhibition: Budapest, Magyar nemzeti Galéria

(Dec. 1976-Jan. 1977). 54 p., 32 illus. Summaries in French, English, German, and Russian.

Catalogue to an exhibition of Kohán's paintings, with an essay describing his debt to ancient (Egyptian and Assyrian) and Renaissance art, and in particular the influence on his style of Cézanne and Braque among the Cubists. However, Supka feels that he soon developed a style unique to himself, deeply rooted in his own peasant Hungarian origins, and that his spacious monumental style is characteristically Hungarian.

724. WERNER, ALFRED. *Raoul Dufy.* New York: Harry N. Abrams, 1985. 168 p., 121 illus. Volume in "The Library of Great Painters."

Includes discussion of Dufy's period of Fauvism when he profited from his association with Braque and Matisse.

725. WERNER, KLAUS. *Henri Rousseau.* Berlin: Herschelverlag Kunst und Gesellschaft, 1987. 72 p., 75 illus., 19 col. Volume in "Welt der Kunst" series.

Study of the life and work of Henri Rousseau with commentaries on twenty-eight of his paintings, describing their history and provenance and identifying the influence of other artists, including van Gogh, Picasso, Georges Braque, and Giorgio de Chirico.

Articles

726. AGAR, EUNICE. "Jeffrey Carr." *American Artist* 52:547(Feb. 1988):36-9, 97-9. 5 illus., 4 col.

Account of the painter Jeffrey Carr, who creates still lifes with multiple layers of meaning, sometimes including figures or historical references. Agar sees the richness of his imagery as enhanced by his ability to combine strong value contrasts with vibrant color. Drawing is equally important to him. He explained to the author the appeal of still life painting and described some of the painters whose work has influenced him, including Braque and Matisse.

727. ANFAM, DAVID. "Arshile Gorky: Tradition and Identity." *Antique Collector* 61:2(Feb. 1990):26-33. 8 illus., 5 col.

Profile of Armenian artist Arshile Gorky, who in 1920 emigrated to the United States. Anfam states that the subsequent identity crisis resulted in Gorky's resolve to become an artist. His early work created in the 1920s and 1930s is characterized by its reliance upon the style of others, namely Post-Impressionist artists like Cézanne, Cubists like Braque, and other leading European avant-garde artists. Anfam charts his artistic development, focusing on his breakthrough in the early 1940s brought about mainly by his encounter with nature during a stay with a friend in Virginia. In his subsequent paintings memories, realistic details, and emblems from the unconscious are translated into an abstract language. Anfam concludes by considering the possibilities of Gorky as a colorist and a draughtsman, and the works created shortly before his tragic death in 1948. They already contain the tragic, expressionistic force and anticipate Abstract Expressionist gesturalism.

728. BELOUBEK-HAMMER, ANITA. "'Ich strebe nach der Reife der Formen': zum Schaffen des französischen Bildhauers Henri Laurens (1885-1954)" ['I Strive for Maturity of Form': The Work of the French Sculptor Henri Laurens (1885-1954)]. *Bildende Kunst* 37:7(1989):22-4. 6 illus., 3 col.

Traces the career of French sculptor Henri Laurens, who belonged to the Cubist school. His works were often still lifes incorporating color and collage. Laurens believed that a sculpture should have its own inherent light reflected by natural light and shadows. From 1911 he was associated with Picasso and Braque among others, which led to the evolution of his Cubist sculptures, but from the 1920s onwards his work became more realistic.

729. BODDINGTON, J. "Paul Strand 1890-1976: Milestone in Photography." *Art Bulletin of Victoria* (Australia) 18(1977):33-9. 4 illus.

Strand's interest in photography began when he was taken as a schoolboy to an exhibition at Alfred Stieglitz's "291" gallery in New York. He occasionally showed his work to Stieglitz, Clarence White, and Gertrude Käsebier, all members of the Photo-Secession, but he later recalled that they were of little assistance in his development. His imagination was fired by the Cubist theories of Braque, Matisse, and Picasso and he began to experiment with abstraction and reduced form.

730. BONET, J. M. "Campano." *Art Press International* 56(Feb. 1982):21. 1 illus. In French.

Campano has looked outside Spain for his inspiration, to the American action painters and Motherwell in particular, and more recently to France. There his models have been literary—Rimbaud, for example, was the starting point for his series of *Voyelles* (Vowels) shown in 1980—as well as painters: Poussin, Corot, Delacroix, Cézanne, and Braque. Bonet insists however that Campano has already got sufficient strength not to succumb to mere imitation, but to appreciate his own position as the continuer of a tradition.

731. CHALUMEAU, JEAN-LUC. "Hélène Mugot: la peinture qui nous regarde." *Opus international* 83(Winter 1982):26-7. 2 illus.

Claims that Hélène Mugot's *Black Chambers* extend the traditional theme of the door as an opening into the unknown, as explored by Aragon, Matisse, and Rauschenberg. She paints, burns, and repaints surfaces to reveal the harmony, which Braque discovered, between the artist and external objects.

732. GAUTHIER, P. "Ulisse Melegari's Paintings or the 'Good Experience' of a Tradition." *Cimaise* 27:149(Nov.-Dec. 1980):51-62. 12 illus. In English and French.

Account of the life and work of this Italian-born artist, who was a pupil and friend of Braque and Morandi, and who has made his home in France for the last twenty years. His favorite subjects are still lifes, often with people and vistas of the white walls and sea of the Mediterranean, painted in flat areas of color that border on abstraction. A critique of his work and its eclectic sources is provided.

733. HIRSH, SHARON LATCHAW. "Carlo Carrà's *The Swimmers*." *Arts Magazine* 53:5(Jan. 1979):122-9. 18 illus.

Carlo Carrà's *The Swimmers* (Museum of Art, Carnegie Institute, Pittsburgh) is considered one of his earliest Futurist canvases, signed 1910 and included in the first European show of Futurism in Paris," March, 1912. Mentions the Cubist influence on Carrà, including paintings he viewed by Braque and Picasso in 1911.

734. KOCH, MICHAEL. "Gefrorene Wirklichkei" [Frozen Reality]. *Weltkunst* 61:9(1 May 1991):1309-11. 6 illus., 3 col.

Examines the influence of Alexander Kanoldt's still-life work on the Neue Sachlichkeit of the 1920s. Koch traces the artist's influences from the early French Post-Impressionists and early cubist works of Picasso and Braque to his frenetic activity in the immediate post-War years. His subsequent turning from expressionism and abstract styles, a tendency which Kanoldt led, brought together abstract qualities with realism in a way that made him a paradigm for the post-Expressionist Neue Sachlichkeit movement. It is concluded that Kanoldt's painting was thus instrumental in forging a new direction in German painting.

735. LAND, JOHN R. "The Sources of Max Weber's Cubism." *Art Journal* 35:3(Spring 1976):231-6. 7 illus.

Deals with Max Weber's Paris years (1906-08) and his knowledge of modernism there, particularly his interest in Paul Cézanne and his studies with Henri Matisse. Weber returned to New York before acquiring a knowledge of Cubism. He painted the first Cubist paintings to be made in America in 1910, probably under the influence of photographs of works by Pablo Picasso and Georges Braque reproduced in an article in the May, 1910 issued of *Architectural Record*, "The Wild Men of Paris," by Gelett Burgess. Discusses Weber's art theory, 1909-11, and analyzes key works.

736. MARINI, MARINO, et al. "Incontro con Marino Marini" [A Meeting with Marino Marini, 3]. *Critica d'arte* 50:7(Oct.-Dec. 1985):57-69. 17 illus.

Final part of a 1971 conversation between Marini, Carlo R. Ragghianti, Piero Bargellini, and Giovanni Carandante. The discussion covers Marini's period in Paris, his contact there with Gonzales and his series of abstract drawings, the influence on his work of Braque, Marini's reaction to the Second World War, the tension introduced into his work by contact with New York, the cultural differences between Europe and the U.S., and the importance of a sense of form and space to architecture.

737. ORSI, DONATELLA. "Perché Segal ha ucciso i suoi manichini" [Why Segal has Killed his Manikins]. *Arte* 20:208(June 1990):64-7. 5 col. illus.

Introduction to the work of American sculptor George Segal, which is best known for its inclusion of human figures in the shape of manikins. Segal's recent work has shown a change in direction with the recreation of the still lifes of Picasso, Braque, and Morandi. He attributes this new orientation to a "rethinking of Cubism and a reading of James Joyce."

738. PETROVÁ, EVA. "Ke vztahu: Filla—Picasso-Braque" [On the Relationship: Filla-Picasso-Braque]. *Umění* (Czechoslovakia)36:3(1988):205-18. 10 illus. English summary.

Discusses Filla's place in the development of Cubism in the years leading up to the First World War. Combinations of impulses from Cézanne (whose phase of Cubism Filla did not follow), Daumier and El Greco, with whose work he became familiar on repeated visits to Paris, resulted in the 1910 painting *The Good Samaritan*. In the next phase of his work he became involved with the problems resolved by Picasso's Cubism; the Dutch still lifes he saw in the Netherlands gave him a better understanding of the still lifes of the analytical period of Picasso and Braque. Petrová concludes that Filla was nearest to Braque in style and was gradually coming closer to Picasso, but he followed a distinctly individual path.

739. POIRIER, PATRICK, JEAN CLARBOUST, and M. FEITO. "Trois artistes d'aujourd'hui devant Braque." *Galerie—Jardin des arts* 131(Nov. 1973)):28-30. 6 illus.

In this discussion held in the offices of *Galerie-Jardin des arts*, three young artists, Patrick Poirier, Jean Clarboust, and M. Feito talked about what Braque's work meant to them and what relevance, if any, it had to their own researches. Poirier felt he had no connections with Braque at all, Clarboust found mythical themes in Braque's work that interested him, though he felt that these themes were subordinate in importance to the painted objects themselves. Feito saw himself as being part of a line of development that included Braque himself.

740. QUAYTMAN, H. "Arshile Gorky's Early Paintings." *Arts Magazine* 50:7(March 1976):104-5. 2 illus.

No other American painter of the 1940s and 1950s so evidently wedded past art and original statement. Quaytman details, however, crucial differences in spirit, philosophy, and goals between Gorky and his first three mentors—Cézanne, Braque, and Picasso. Unlike Cézanne he had no passion for volume, only issues of local shape and general organization; he could not approximate Braque's translucent scumbles even with Braque's comb; and unlike Picasso he was not reluctant to leave subject matter for pure plastic invention. By 1932, he was near to a new "imagery full of the most liquid, lateral fluidity." Quaytman also outlines Gorky's portraits and concludes that "he was unique in his 'autre-didacticism' and supremely unrepentant."

741. TARBELL, ROBERTA K. "Hugo Robus' Pictorial Works." *Arts Magazine* 54:7(March 1980):136-40. 23 illus.

Though principally known as a sculptor, Robus produced about twenty-five canvases between 1912 and 1920. This article concentrates on the influences and events that led to these works and discusses the history of drawing in the artist's œuvre. After studying at the National Academy of Design, Robus traveled to Europe in 1912 where the exposure to artists involved with Synchromism and Futurism were of paramount importance in his development. On returning to the U.S. in 1914, he moved to New York City and continued to experiment with various styles. Influenced by the Cubism of Picasso and Braque and by the Precisionists, Robus's academic illusionism gave way

to ambiguity and contradiction, but he was never able to crystallize a vision of painting for himself and after 1920 turned to sculpture.

742. TSCHECHNE, MARTIN. "Über Posen zum scharfen Profil" [On Posing for a Sharp Profile]. *ART: das Kunstmagazin* 2(Feb. 1989):56-67. 11 illus., 10 col.

The painter Markus Oehlen (b. 1956) grew into a cynic in changing poses, whose pictures mingle stylistic quotations from Cubism, Pop Art, Moore, Picasso, Arp, and Braque. Tschechne describes Oehlen's early years in Düsseldorf, his close relationship with his artist brother Albert, and his reactions to the art movements of the 1970s, besides his collaboration with Werner Büttner and Martin Kippenberger to form the "Hetzler-Boys" group in 1981. Oehlen also outlines his method of using the language of painting to discuss painting itself.

II. Mentions of Georges Braque

Books

743. ADEMA, PIERRE MARCEL. *Apollinaire*. Trans. by Denise Folliot. New York: Grove Press, 1955.

744. ANGIOLINI, GERARD. *Estampes*. Introduction de Robert Rey. Paris: Image littéraire; New York: R. Finelli-Feugère, 1950. 8 p., 36 pl., some col.

745. APOLLINAIRE, GUILLAUME. *Chroniques d'art moderne (1902-1918)*. L.-C. Breunig, ed. Paris: Gallimard, 1960.

a. U.S. ed.: *Apollinaire on Art, Essay and Reviews (1902-1918)*. Trans. by Susan Suleiman. New York: Viking Press, 1972.

746. APOLLINAIRE, GUILLAUME. *Apollinaire zur Kunst: Texte und Kritiken 1905-1918* [Apollinaire on Art: Texts and Critical Essays 1905-1918]. Edited by Hajo Düchting. Cologne: DuMont, 19189. 37 p., 75 illus., 8 col.

Compilation of texts and essays on art, artists, art movements and exhibitions by Guillaume Apollinaire (1880-1913) spanning the years 1905 to 1918. Apollinaire, whose poetry and prose writings brought about a revolution in the 20th century, was until the beginning of the First World War a key figure of the French intellectual and artistic avant-garde, defending and pioneering the modernist revolution taking place in Paris with the help of his numerous publications. The book is organized into twelve chapters in chronological order covering art related subjects and artists such as Picasso, Matisse, Braque, Cézanne, Gauguin, Manet, Futurism, Cubism, the different salons, and Archipenko. In the introductory essay the author traces Apollinaire's life and analyzes the key influences on his artistic development. A selection of poems relating to painters and painting is appended.

747. APOLLONIO, UMBRO. *Fauves and Cubists*. New York: Crown Publishers, 1959. 93 p., illus., some col.

748. ARGAN, GIULIO CARLO. *L'Arte moderna, 1770-1970.* Florence: Sansoni, 1970. 774 p., illus., pl., some col.

749. ARGAN, GIULIO CARLO. *Da Hogarth a Picasso: l'arte moderna in Europa* [From Hogarth to Picasso: Modern Art in Europe]. Presentzione di Giulio Carlo Argan; introduzione di Bruno Contardi. Milan: Feltrinelli, 1983. 604 p., illus., 32 pl.

Collection of forty essays on modern art and theory, including remarks on Braque.

750. ARNASON, H. *Geschichte der Modernen Kunst. Malerei—Skulptur—Architektur.* Bremen, 1970.

751. ASSOULINE, PIERRE. *L'Homme de l'art: D.-H. Kahnweiler (1884-1979).* Paris: Balland, 1988. 540 p., 31 illus., pl.

Biography of Daniel-Henry Kahnweiler, known as one of the greatest art dealers of his time and renowned in particular for his patronage of the Cubists. Assouline traces his early life in Germany, his early encounters with the arts, his training as a banker, and his move to Paris in 1907. He describes how he became known as an ardent supporter of Cubism, and discusses his long association with Vlaminck, Derain, Picasso, Braque, Gris, Léger, Masson and Klee, among other artists.

752. AURIC, GEORGES. *Quand j'étais là.* Paris: B. Grasset, 1979. 222 p.

753. BANN, S. *Stephen Edlich: The Carving Approach—A Continuation.* Exhibition: London, Marlborough Fine Art (24 Jan.-1 March 1980). 40 p., 45 illus. 24 paintings and collages.

Discusses Edlich's work in terms of its inheritance and modification of Cubism, arguing as he does so against the concept of linear development in modern Western art that is often taken for granted. He states that Edlich's work of the last two years represents a counterpoint between order and free association similar to that manifested by Braque and Motherwell, and concludes that he is one of the few contemporary American painters who is continuing the "classical" lines of the work of Cézanne and the Cubists. A list of collections of his work is appended.

754. BARTHEL, GUSTAV. *Französische Maler illustrierten Bücher.* Stuttgart, 1965. 126 p., illus.

755. BASLER, ADOLPHE and CHARLES KUNSTLER. *The Modernists from Matisse to de Segonzac.* Translated from the French. New York: W. Farquehar Payson, 1931. 78 p., illus., pl.

Mentions Braque on pp. 44-5.

756. BENSUSAN-BUTT, JOHN. *On Naturalness in Art: A Lecture Based on the Sayings of Painters and Others, with a Postscript on Aesthetics and Index of Sources.* Colchester, England: The Author, 1981. 63 p., 2 illus.

Comprises the text of a lecture delivered to students of art history at Essex University (March, 1978) and a postscript on aesthetics. The lecture presents the sayings of artists from the 11th century Chinese Su Shih to Picasso, on the topics of conviction in painting and the nature of beauty. Among artists quoted are John Nash, Brancusi, Braque, Poussin, Blake, Cézanne, Constable, Pissarro, Corot, and Picasso, and an index of sources for the artists' statements is provided. A postscript, entitled "A Plea for the Re-study of Aesthetics," argues the case for the visual arts to react against the often destructive forces for modern technology and "reclaim their proper role in life."

757. BERGER, JOHN. *The Moment of Cubism and Other Essays.* London: Weiderfeld and Nicholson, 1969. 139 p., 16 pl.

758. BRASSAÏ, JULES. *Les Artistes de ma vie.* Paris: Denoël, 1982. 223 p., illus.

Brassaï's photographs of artists (as well as their works, studios, and homes), 1930s-1950s, accompanied by his impressions of them and their art. Includes Brassai's portraits of Bonnard, Braque, Dalí, Despiau, Dufy, Giacometti, Kokoschka, Laurens, Le Corbusier, Léger, Lipchitz, Maillol, Matisse, Miró, Picasso, Hans Reichel, Germaine Richier, Rouault, and Jacques Villon.
a. U.S. ed.: *The Artists of my Life.* Trans. by Richard Miller. New York: Viking Press, 1982. 135 illus.
b. English ed.: London: Thames and Hudson, 1982.
Reviews: M. Vaizey, *Art Book Review* 1:4(1982):50; C. Bedient, *Art in America* 71:5(May 1983):17, 19, 21; A. Berman, *Art News* 82:6(Summer 1983):28.

759. BRETON, ANDRE. *Le Surréalisme et la peinture.* Paris: Gallimard, 1920. 72 p., illus., 77 pl.

Includes mentions of and reproductions of Braque's works, pp. 33-6.
a. Other eds.: New York: Bretano's, 1945, 203 p., illus.; 1965, 427 p., illus.; 1979.
b. German ed.: *Der Surrealismus und die Malerei.* Trans. by Manon Maren-Grisebach. Berlin: Propyläen, 1967. 427 p., illus.
c. U.S. ed.: *Surrealism and Painting.* Trans. by Simon Watson Taylor. New York: Harper & Row, 1972. 415 p., illus.
d. English ed.: *Surrealism and Painting.* London: Macdonald and Co., 1972. 416 p., illus.

760. BRETTELL, RICHARD R. *An Impressionist Legacy: The Collection of Sara Lee Corporation.* Introduction by David Finn. New York: Abbeville; dist. in the U.K. and Europe by Pandemic, London, 1986. 127 p., 80 col. illus.

Catalogue raisonné of the collection of paintings and sculpture on permanent display at the Chicago headquarters of the Sara Lee Corporation, which were acquired from the personal collection of the company's founder, Nathan Cummings. They are principally French—works by Camille Pissarro, Berthe Morisot, Henri Matisse, Roger de la Fresnaye, Gauguin, Bonnard, Léger, Toulouse-Lautrec, Eugène Boudin, Renoir, Degas, Braque, Rouault, Dufy, Jean Metzinger, Maillol, Vuillard, and Vlaminck, among others.

761. BRION-GUERRY, LILIANE. *L'Année 1913: les formes esthétiques de l'œuvre d'art à la veille de la première guerre mondiale.* Paris: Klincksieck, 1971. 2 vols., 129 p., illus. Volume in "Collection d'esthétique" series.

Volume I contains information on Braque.

762. BULLIET, CLARENCE JOSEPH. *The Significant Moderns and Their Pictures.* New York: Covici, Friede, 1936. 199 p., 274 pl.

Pages 88-91 discuss Braque, including statements by the artist.

763. BURGER, FRITZ. *Cézanne und Hodler: Einführung in die Probleme der Malerei der Gegenwart.* Munich: Delphin Verlag, 1919. 2 vols., illus.

Braque is mentioned in I:122 and II:136, including a brief analysis of *Lady with a Mandolin.*

764. CABANNE, PIERRE. *L'Épopée du cubisme.* Paris: La Table Ronde, 1963. 431 p., illus., pl.

765. CAROLI, FLAVIO. *Primitivismo e cubismo.* Contributi di Paolo Grossi. Milan: Fratelli Fabbri, 1977. 127 p., illus. Volume in "L'Arte nella società" series.

766. CASSOU, JEAN, BERNARD DORIVAL, and GENEVIEVE HOMOLLE. *Musée National d'Art moderne—catalogue-guide.* Paris: Editions des Musées Nationaux, 1954. 256 p., illus., 24 pl.

767. CASSOU, JEAN. *Panorama des arts plastiques contemporains.* Paris: Gallimard, 1960. 796 p., 117 illus. Volume in "Le Point du jour" series.

768. CASSOU, JEAN, EMILE LANGUI, and NIKOLAUS PEVSNER. *Les Sources du XX^e siècle.* Paris, Brussels: Editions des Deux Mondes, 1961. 363 p., illus., some col. Volume in "Collection 'Conseil de l'Europe'" series.

769. CHENEY, SHELDON. *Expressionism in Art.* New York: Tudor Publishing Company; Liveright Publishing Corporation, 1934. 415 p., 205 illus.

Includes notes on Braque.
a. Other eds.: 1939, 1948, 1958, 1962.

770. COGNIAT, RAYMOND. *Décors de théâtre.* Edité sous la direction de M. G. di San Lazzaro. Paris: Les Chroniques du Jour, 1930. 37 p., illus., 12 pl., some col.

771. COGNIAT, RAYMOND. *Les Décorateurs de théâtre; cinquante ans de spectacles en France.* Paris: Librairie Théâtrale, 1955. 222 p., pl.

772. COLLES, BAXTER. *Modern Illustrated Books: The Selma Erving Collection.* Introduction by Ruth Mortimer. Edited by John Lancaster. Northampton, MA: Smith College Museum of Art, 1977. 64 p., 60 illus.

The 20th century saw the revival of a number of earlier techniques of book illustration, including wood-engravings, lithography and copperplate engraving. Ambroise Vollard's *Parallèlement* (1900), poems by Verlaine illustrated with lithographs by Pierre Bonnard, was the first true *livre d'artiste* and signalled a revolution in the quality and imagination of book illustration. The Selma Erving collection, consisting of 110 books and four portfolios of prints related to books, is presented in the following order in the catalogue: *Livres d'artiste*; books containing original prints; portfolios containing prints related to specific books; books illustrated with reproductions; and reference books. Artists include Pierre Bonnard, Georges Braque, Chagall, Raoul Dufy, Aristide Maillol, Marquet, Matisse, Picasso, Redon, Rouault, Dunoyer de Segonzac, and Jacques Villon.

773. COLLINS, JUDITH, et al. *Techniques of Modern Masters*. London: Macdonald, 1983. 192 p., 309 illus.

Survey of the techniques of painting developed during the 20th century, divided into four chronological sections, each with an introduction covering general trends: 1900-20, 1921-40, 1941-60, and 1961 onwards. The sections consist of detailed analyses of one painting by each of the following artists: Cézanne, Derain, Rousseau, Braque, Picasso, Kandinsky, Severini, Duchamp, Miró, Mondrian, Wadsworth, Bonnard, Klee, Ernst, Dalí, Bacon, Dubuffet, Pollock, Matisse, Giacometti, Johns, Blake, Louis, Rauschenberg, Warhol, Stella, Lichtenstein, Hockney, LeWitt, and Freud. Technological innovations in materials as well as stylistic developments are identified, so that they can be related to artistic practice. A glossary of terms is appended.

774. COLOMBIER, PIERRE DU and ROLAND MANUEL. *Les Arts: peinture, sculpture, gravure, architecture, cinéma, photographie, musique et danse*. Paris: Denoël et Steele, 1933. 360 p., illus., 35 pl. Volume in "Tableau du XXe siècle" series.

Scattered references to Braque on pp. 23, 62, 74, 79, 80, 94, 110.

775. COOPER, DOUGLAS. *The Cubist Epoch* [exh. cat., Los Angeles County Museum of Art and the Metropolitan Museum of Art, 1970]. New York and London: Phaidon, 1970. 320 p., illus.

a. Spanish ed.: *La Epoca Cubist*. Trans. by Aurelio Martinez Benito. Madrid: Alianza Editorial, 1984. 354 p., illus.

776. COQUIOT, GUSTAVE. *Cubistes, futuristes et passéistes*. Paris: Librairie Ollendorf, 1914. 277 p., illus.

Mentions Braque on pp. 7-8.
a. New ed.: 1923. 277 p., pl.

777. COURTHION, PIERRE. *Panorama de la peinture française contemporaine*. Paris: S. Kra, 1927. 192 p., 2 pl. Volume in "Les Documentaires" series.

Braque is discussed on pp. 113-6.

778. CRESPELLE, JEAN-PAUL. *Les Fauves*. Neuchâtel: Ides et Calendes, 1962. 365 p., illus., some col.

779. *Le Cubisme; colloque d'histoire de l'art contemporain*. Saint-Etienne: Université de Saint-Etienne, 1973. Volume in "Centre interdisciplinaire d'études et de recherche sur l'expression contemporaine, 'travaux'" series.

Volume of texts presented at the First Conference of the History of Contemporary Art, held at the Museum of Art and Industry, Saint-Etienne, Nov. 19-21, 1971. The twelve essays are: "Fauvism, the Source of Cubism" by M. Giry; "Contacts Between Braque and Picasso and the Beginnings of Cubism" by R. Jullian; "Cubism and Cubisms" by A. Dubois; "Cubism and Problems of Colour" by M. Hoog; "Space and Cubism (architectural problems)" by G. Dargent; "Transformation of Signs" by J. Laude; "The Letter in Cubist Painting" by F. Will-Levaillant; "Robert Delaunay and Cubism" by B. Dorival; "Mondrian and Cubism" by M. Le Bot; "Cubist Sculpture" by D. Milhau; "Henri Laurens" by M. Menier; and "Cubism and the Russian Avant-Garde" by J.-P. Bouillon.

780. DAIX, PIERRE. *Journal du Cubisme*. Geneva: A. Skira, 1982.

Discusses the sources of Cubism; the partnership of Braque and Picasso; influence of Cubism on Matisse, Mondrian, Gris, the Futurists, and others; Cubist sculpture; Cubism ouside France; the Cubist heritage.
a. U.S. ed.: *Cubists and Cubism*. Trans. by R. F. M. Dexter. Geneva: Skira; New York: Rizzoli, 1982. 170 p., 265 illus., 90 col.

781. DAUCHER, HANS. *Wege des Zeichnens: Band 3-Figur* [Ways of Drawing: Volume 3-Figure]. Ravensburg: Otto Maier, 1985. 128 p., 107 illus.

Introduction to methods and techniques of drawing the human figure, with particular regard to proportion and positions. Daucher traces the history of figurative drawing from the 17th century, indicating the variety of different styles that can be employed and illustrating his comments with reference to works by such artists as Klee, Picasso, Braque, De Kooning, and Dubuffet.

782. DESCARGUES, PIERRE. *Le Cubisme*. Paris: Aimery Somogy, 1956. 64 p., 24 illus. Volume in "Tendances de la peinture moderne" series.

783. DIEHL, GASTON. *Les Fauves: œuvres de Braque, Derain, Dufy, Friesz, Marquet, Matisse, van Dongen, Vlaminck*. Introduction de Gaston Diehl. Paris: Les Editions de Chêne, 1943. 6 p., 12 col. pl.

a. Another ed.: 1948. 5 p., 16 col. pl.

784. DIEHL, GASTON. *Les Fauves*. Paris: Nouvelles Editions Françaises, 1971. 190 p., illus., some col.

785. DORIVAL, BERNARD. *Les Etapes de la peinture française contemporaine*. Paris: Gallimard, 1944.

Volume II: *Le Fauvisme et le cubisme, 1905-1911*.

786. DORIVAL, BERNARD. *Les Peintres célèbres*. Geneva, Paris: L. Mazenod, 1948. 423 p., illus., some col. Volume in "La Galerie des hommes célèbres" series.

787. DORIVAL, BERNARD. *Les Peintres du XXe siècle*. Paris: P. Tisné, 1957. 2 vols. Volume in "Pictura" series.

788. DORIVAL, BERNARD. *L'Ecole de Paris au Musée National d'Art moderne*. Paris: Editions Aimery Somogy, 1961. 324 p., illus., col. pl. Volume in "Trésor des grands musées" series.

789. DUVAL, JEAN-LUC. Geneva: Skira, 1985.

Traces the development of oil painting in the west over five centuries, from Jan van Eyck in the 15th century. Artists discussed in the later chapters include Manet, Monet, Renoir, Gauguin, van Gogh, Cézanne, Nicolas de Staël, Matisse, Alberto Giacometti, Picasso, Braque, Masson, Picabia, Pollock, Miró, and Rothko. Technical notes on how oil paints are made are appended.
a. English ed.: *Oil Painting: From van Eyck to Rothko*. London: Weidenfeld & Nicolson, 1985. 126 p., 102 illus., 86 col.

790. EARP, THOMAS WADE. *The Modern Movement in Painting*. Edited by C.G. Home. London, New York: The Studio, 1935. 48 p., 16 col. pl.

Mentions Braque on p. 33.

791. EDDY, ARTHUR JEROME. *Cubist and Post-Impressionism*. Chicago: A. C. McClurg, 1914. 245 p., 46 illus., 23 col. pl.

a. Other eds.: 1919, 1973.

792. EINSTEIN, CARL. *Die Kunst des 20. Jahrhunderts*. Berlin: Imp. Propyläen-verlag, 1926 576 p., 43 pl. some col.

Discusses Braque on pp. 88-91, 26-317.
a. Other eds.: 1928, 1931.

793. ESCHOLIER, RAYMOND. *La Peinture française XXe siècle*. Paris: H. Floury, 1937. 152 p., illus., col. pl.

Mentions Braque on pp. 86-8.

794. FELS, FLORENT. *Propos d'artistes*. Paris: La Renaissance du Livre, 1925. 215 p., illus., 32 pl.

795. FLANNER, JANET. *Men and Monuments*. New introduction by Rosamond Bernier. New York: Da Capo Press, 1990. 297 p., illus., 4 pl.

796. FOSCA, FRANÇOIS (pseud.). *Bilan du cubisme*. Paris: La Bibliothèque des arts, 1956. 179 p., illus. Volume in "Souvenirs et documents" series.

797. FRANCASTEL, PIERRE. *Peinture et société.* Paris, Lyon: Audin, 1951. 298 p., illus., pl.

798. FRASNAY, DANIEL. *Peintres et sculpteurs; leur monde.* Texte et photographes de Daniel Frasnay. Préface de René Huyghe. Paris: Draeger, 1969. 371 p., illus., some col.

Braque discussed on pp. 21-31.

799. FROST, ROSAMUND. *Contemporary Art; The March of Art from Cézanne Until Now.* New York: Crown Publishers, 1942. 240 p., pl., some col.

Includes notes on Braque.

800. FRY, EDWARD F. *Cubism.* Translations from French and German by Jonathan Griffin. London: Thames and Hudson, 1966. 200 p., illus., pl., some col.

a. U.S. eds.: New York: McGraw-Hill, 1966; New York: Oxford University Press, 1978. 200 p., illus., 42 pl.
b. German ed.: *Der Kubismus.* Trans. by Irmtraud Schaarschmidt-Richter. Cologne: DuMont Schauberg, 1966. 214 p.

801. GABO, NAUM. *Of Divers Arts.* Washington, D.C.: National Gallery of Art; New York: Pantheon Books, 1959. 205 p., illus., some col. Volume in "Bollingen Series."

a. Another ed.: 1962.

802. GALLATIN, ALBERT EUGENE. *Museum of Living Art, A. E. Gallatin Collection, New York University.* Includes critical notes by Georges L. K. Morris. Introduction by Jean Hélion. The collection is now in the Philadelphia Museum of Art. New York: New York University, 1940. 72 p., illus., pl.

Works by Braque are described on pp. 12, 22-3.

803. GAMWELL, LYNN. *Cubist Criticism: 1907-1925.* Ph.D. diss., University of California, Los Angeles, 1977. 315 p.; Ann Arbor, MI: UMI Research Press, 1980. 244 p., illus. Volume in "Studies in Fine Arts Criticism" series.

Argues that the main view of Cubism that runs throughout the early literature is that Cubism is a conceptualized depiction. The conceptualized view was formulated before World War I by Jean Metzinger, Roger Allard and Maurice Raynal, and after the War, Raynal, together with Daniel-Henry Kahnweiler and Juan Gris, crystallized this view, thus becoming the three major early spokesmen for Cubism. Also examines non-objective outgrowths of Cubism as advocated by Guillaume Apollinaire who realized, however, that the heart of Cubism in Picasso and Braque remained a conventionalized depiction. After the War, the first non-objective views of the entire movement, including the founders, appeared with critics such as Amédée Ozenfant and Pierre Jeanneret. Other critical themes which emerge in the early literature are the development of the distinction between analytic and synthetic Cubism, the establishment

of chronological divisions, and changing attitudes towards multiple viewpoints, science, and collage.

804. GATEAU, JEAN-CHARLES. *Paul Eluard et la peinture surréaliste (1910-1939)*. Geneva: Droz, 1982, 394 p., 86 illus., 1 col. Volume in "Histoire des idées et critique littéraire" series.

Studies in historical context the relationship of Paul Eluard to the Surrealist painters: Analyzes the often hermetic poems and texts that Eluard devoted to Arp, Picabia, Chirico, Ernst, Picasso, Braque, Masson, Miró, Klee, Tanguy, Dalí, Matisse, Magritte, Man Ray, Delvaux, Penrose, Jennings, Fini, V. Hugo, and D. Maar, as well as the relationship of the text and the image in collaborative collections. In its two-fold goal, historical and biographical on the one hand, exegetic and aesthetic on the other, this study sheds new light on the Surrealist movement, on thirty years of literary and artistic life in Paris and on the intersemiotics of literature and painting.

805. GEE, MALCOLM. *Dealers, Critics, and Collectors of Modern Painting: Aspects of the Parisian Art Market 1910-1930*. Ph.D. thesis, History of Art, University of London, 1977; New York: Garland Publishing Co., 1981. 2 vols, 566 p.

Analysis of the "support-system" for modern painting. Chapters on salons, the Hôtel Drouot, dealers, the press, and collectors, followed by a chronological survey of modern art on the market, in four selections: the avant-garde 1910-25 and 1925-30, l'Ecole de Paris, and l'Ecole Française 1918-30. Sections are on D.-H. Kahnweiler, P. Guillaume, Bernheim-Jeune, W. Uhde, A. Breton, M. Duchamp, A. Ozenfant, P. Eluard, G. Aubry, L. Zborowski and A. Basler; L. Vauxcelles, A. Salmon, W. George, M. Raynal, A. Lefèvre, D. Tzanck, P. Poiret, and J. Doucet. A second volume contains appendices including an annotated catalogue of modern paintings sold at auction 1918-30; an analysis of buyers at auction; a detailed study of the Uhde and Kahnweiler auctions 1921-23; and a list of modern art exhibitions in Paris 1910-30. The principal artists considered are Braque, Chagall, de Chirico, Derain, Dufy, Ernst, de la Fresnaye, Gris, Kisling, Laurencin, Léger, Matisse, Metzinger, Modigliani, Picasso, Rivera, Segnozac, Severini, Soutine, and Utrillo.

806. GERA, GYÖRGY. *A Kubizmus: Vàlogatàs a mozgalom dokumentumaiból*. Budapest: Gondolat, 1975. 253 p.

807. GILOT, FRANÇOISE. *Le Regard et le masque*. Paris: Calmann-Levy. 1975.

Semi-autobiographical account of the author's life, experiences and acquaintances at the height of the modern movement in painting in France. Published as a companion volume to her *Life With Picasso* (New York: McGraw-Hill, 1964). Gilot comments on Picasso, Braque, Miró, Gris, and Duchamp as well as on the work of lesser artists she knew. She describes her own development as a painter, and parallels this with an examination of the way artists through the centuries see and interpret through paint various objects, particularly the harlequin, the card game, the chess game, and the cage.
a. U.S. ed.: *Interface: The Painter and the Mask*. Trans. by F. Gilot. Fresno: Press at California State University, 1983. 196 p., 24 illus.

808. GIRY, MARCEL. *Le Fauvisme; ses origines, son évolution*. Préface de René Jullian. Neuchâtel: Ides et Calendes; Paris: La Bibliothèque des Arts, 1981. 271 p., 130 illus., 72 col.

On Fauve painting, 1905-07, and the precursors of the movement. Artists discussed include Matisse, Marquet, Derain, Vlaminck, van Dongen, Dufy, Friesz, and Braque.
a. U.S. ed.: *Fauvism: Origins and Development*. New York: Alpine Fine Art Collections, 1982.
b. German ed.: *Der Fauvismus: Ursprünge und Engwicklung*. Würzburg: Popp, 1982.
Review: R. Schiebler, *Weltkunst* 53:1(Jan. 1983):46-7.

809. GLEIZES, ALBERT and JEAN METZINGER. *Du cubisme*. Paris: Figuière et Cie., 1912. 44 p., 26 pl. Volume in "Tous les arts" series.

810. GLEIZES, ALBERT. *Kubismus*. Munich: A. Langen, 1928. 101 p., 4 illus. Volume in "Bauhausbücher" series.

a. Facsimile ed.: Mainz: Florian Kupferberg, 1980.
b. Hungarian ed.: *A Kubizmus*. Trans. by Hegyi Lórándírta. Hungary: Corvina Kiadó, 1984. 111 p.

811. GOLDAINE, LOUIS, PIERRE ASTIER, and PIERRE RESTANY. *Ces peintres vous parlent*. Paris: Les Editions du Temps, 1964. 200 p. Volume in "L'Œil du temps" series.

Braque is mentioned on pp. 18-21.

812. GOLDING, JOHN. *Cubism: A History and an Analysis, 1907-1914*. London: Faber & Faber, 1959. 207 p., pl., some col.

Surveys the role and position of Cubism during the cited period. Golding traces the history of Cubism, relating it to earlier art movements and considering the influence of non-Cubist artists. He provides an appraisal of the work of Picasso, Braque, and Gris and their development towards the adoption of a Cubist style, and discusses the influence of Cubism in France, focusing on the work of artists such as Fernand Léger and Robert Delaunay.
a. U.S. ed.: New York: George Wittenborn, 1959. 207 p., illus., some col.
b. Revised U.S. eds.: Boston: Boston Book and Art Shop, 1968; Cambridge: Harvard University Press, 1988. 237 p., illus., 108 pl.
c. French ed.: Paris: Julliard; Livre de Poche, 1968.
d. 3rd revised ed.: London: Faber & Faber, 1988. 348 p., 160 illus.

813. GOLDWATER, ROBERT JOHN. *Primitivism in Modern Painting*. New York, London: Harper, 1938. 210 p., pl.

814. GÓMEZ DE LA SERNA, RÁMON. *Ismos. El vetrato de la cubierta*. Madrid: Biblioteca nueva, 1931. 398 p. 6 illus.

a. Other eds.: 1943, 1947, 1968, 1975.

815. GORDON, JAN. *Modern French Painters*. London: J. Lane; New York: Dodd, Mead, 1923. 88 p., illus., pl.

Includes notes on Braque and one illustration, pp. 143-4.
a. Other eds.: 1926, 1929, 1936, 1970.

816. GRAY, CHRISTOPHER. *Cubist Aesthetic Theories*. Baltimore: Johns Hopkins Press, 1953. 190 p., illus., 5 pl.

817. GREEN, CHRISTOPHER. *Cubism and its Enemies: Modern Movements and Reaction in French Art, 1916-1928*. New Haven, CT and London: Yale University Press, 1987. 325 p., illus., some col.

818. GRENIER, JEAN. *L'Esprit de la peinture contemporaine, suivi études sur Braque, Chagall, Lhôte*. Paris, Lausanne: Editions Vineta, 1951. 93 p.

819. GUGGENHEIM, MARGUERITE. *Art of This Century: Objects, Drawings, Photographs, Paintings, Sculpture, Collages, 1910 to 1940*. Edited by Peggy Guggenheim. New York: Art of This Century, 1942. 156 p., illus.

Includes one work by Braque and a translation of a statement by the artist (see pp. 62-4).

820. GUINEY, MORTIMER. *Cubisme et littérature*. Geneva: Georg, 1972. 191 p.

821. HABASQUE, GUY. *Le Cubisme; étude biographique et critique*. Geneva: Skira, 1959. Volume in "Le Goût de notre temps" series.

822. HAFTMANN, WERNER. *Malerei im 20. Jahrhundert*. Munich: Prestel-Verlag, 1954-55. 2 vols., illus., pl.

a. English ed.: *Painting in the Twentieth Century*. London: Lund Humphries, 1968. 2 vols.

823. HALPERN, DANIEL, ed. *Writers on Artists*. San Francisco: North Point Press, 1988. 378 p., 36 illus.

Collection of essays by forty writers on artists from the 15th century until the 20th century. Includes writings on Braque and Matisse.

824. HAMILTON, GEORGE HEARD. *Painting and Sculpture in Europe 1880-1940*. London: Penguin Books, 1967. 443 p., 193 pl.

a. U.S. ed.: Baltimore: Penguin Books, 1967.

825. HEVESY, IVAN. *A Futurismus, Expresszioniszmus és Kubismus művészete*. Gyoma: Kner Izidor Könyvnyomtató Kiadása, 1922. 115 p., illus.

Pages 40-3, 54-5, 103 deal with Braque.

826. HIGGINS, IAN. *Francis Ponge*. London: Athlone Press; dist. in the U.S.A. by Humanities Press, 1979. 145 p.

Includes an important aspect of Ponge's work, his art criticism, in particular texts on Braque.

827. HILDEBRANDT, HANS. *Die Kunst des 19. und 20. Jahrhunderts*. Wildpark-Potsdam: Akademische Verlagsgesellschaft Athenaion, 1924. 458 p., illus., 23 pl., some col.

Braque is discussed on pages 385-95, 407-24.

828. HOBBES, ROBERT CARLETON. *Milton Avery*. Introduction by Hilton Kramer. New York: Hudson Hills Press; dist. in the U.S. by Rizzoli, 1989. 263 p., 150 illus., 125 col.

Discusses the life and work of Milton Avery, a friend an colleague of the Abstract Expressionists who nevertheless maintained his commitment to representation. His paintings depicted family and friends, intimate settings, and landscapes encountered on holidays reflect the concerns he shared with the French modernists including Dufy, Matisse, Braque and Picasso—saturated color, pictorial logic and the retention of the two-dimensional character of the canvas. Hobbes shows how Avery adapted these concerns to create a distinctly American brand of modernism.

829. *Hommage à Yvonne Zervos*. Paris: Editions des Cahiers d'Art, 1970. 34 pl., illus.

830. HUYGHE, RENE. *Histoire de l'art contemporain: la peinture*. Paris: Alcan, 1935. 536 p., illus.

Article on Braque printed from *L'Amour de l'art* 14(Nov. 1933):209-40.

831. HUYGHE, RENE and GERMAIN BAZIN. *Les Contemporains*. Paris: P. Tisné, 1939. 91 p., 160 pl. Volume in "Bibliothèque Française des arts" series.

Information on Braque begins on p. 34.
a. Another ed.: 1949. 160 p., 164 pl.
b. U.S. ed.: *French Painting; The Contemporaries*. New York: French and European Publications, 1939.

832. HUYGHE, RENE and JEAN RUDEL. Avec la collaboration de Thérèse Burollet, et al. *L'Art et le monde moderne*. vol. 2, *De 1920 à nos jours*. Paris: Librairie Larousse, 1970. 2 vols., illus., some col.

833. ILÍÁZD. *Prigovor Bezmolvnyí i Ilíázd*. Paris: Sorok Pervyí gradus, 1961. 27 p., 1 pl.

834. JANNEAU, GUILLAUME. *L'Art cubiste; théories et réalisations, étude critique*. Paris: Charles Moreau, Editions d'Art, 1929. 111p., 48 pl., some col.

835. JANNEAU, GUILLAUME and MARCEL-ANDRE STALTER. *L'Art moderne.* Paris: Presses Universitaires de France, 1970. 186 p., pl., some col. Volume in "Histoire générale des arts; les neuf muses" series.

836. JARDOT, MAURICE and MARTIN KURT. *Les Maîtres de la peinture française contemporaine.* Baden-Baden: Waldemar Klein, 1949. 102 p., illus., some col.

837. JEDLICKA, GOTTHARD. *Begegnungen Künstlernovellen.* Basel: B. Schwabe, 1933. 249 p.

Discusses Braque on pp. 127-52.

838. JOHNSON, ROBERT STANLEY. *Cubism & la section d'or: Reflections on the Development of the Cubist Epoch, 1907-1922.* Chicago: Klees/Gustorf Publishers, 1991. 160 p., illus., some col.

839. KAHNWEILER, DANIEL-HENRY. *Der Weg zum Kubismus.* Munich: Delphin Verlag, 1920. 55 p., illus., 36 pl.

Pages 15-47 deal with Braque.
a. U.S. ed.: *The Rise of Cubism.* Trans. by Henry Aronson. New York: Wittenborn, Schultz, 1949. 35 p., illus.
b. French ed.: *Les Années héroiques du cubisme.* Paris: Braun, 1950. 63 p., illus.

840. KAHNWEILER, DANIEL-HENRY. *Juan Gris: sa vie, son œuvre, ses écrits.* Paris: Gallimard, 1946. 344 p., illus.

a. U.S. ed.: *Juan Gris: His Life, His Work, His Writings.* Trans. by Douglas Cooper. New York: Curt Valentin Gallery, 1947. 177 p., illus., pl.

841. KAHNWEILER, DANIEL-HENRY and FRANCIS CREMIEUX (Interviewer). *Mes galeries et mes peintres; entretiens avec Francis Crémieux.* Préface d'André Fermigier. Paris: Gallimard, 1961. 223 pl.

a. 2nd ed.: Paris: Gallimard, 1982. 217 p.
b. U.S. ed.: *My Galleries and Painters.* Trans. by Helen Weaver. New York: Viking Press, 1971. 160 p., illus.

842. KAHNWEILER, DANIEL-HENRY. *Confessions esthétiques.* Paris: Gallimard, 1963. 244 p. Volume in "Les Essais" series.

843. KAMON, YASUO. *Masterworks: Paintings from the Bridgestone Museum of Art.* Tokyo: Bridgestone Museum of Art, 1990. 102 p., illus.

844. KELDER, DIANE. *The Great Book of Post-Impressionism.* New York: Abbeville Press, 1986. 383 p., 413 illus., 236 col.

Mentions Matisse, Derain, Dufy and Vlaminck in reference to Fauvism and Picasso, Braque, Léger, and Gris in reference to Cubism.

845. KELDER, DIANE. *Masters of the Modern Tradition*. New York: LeFrak Organization, 1988. 94 p., 55 illus., 49 col.

Selection of paintings from the collection of Samuel J. and Ethel LeFrak which consists of works by the Impressionists, Post-Impressionists and later painters. The collection includes works by Braque, Dufy, Matisse, Rouault, van Dongen, and Vlaminck, among other artists.

846. KRAMER, VINCĚNC. *Kubismus*. Brně: Nákladem Morav.-Slezské Revue, 1921. 87 p., illus., 24 pl.

847. LANGUI, EMILE. *50 ans d'art moderne*. Cologne: DuMont Schauberg, 1960.

848. LAUDE, JEAN. *La Peinture française (1905-1914) et l'art nègre; contributions à l'étude des sources du fauvisme et du cubisme*. Paris: Klincksieck, 1968. 2 vols., pl. Volume in "Collection d'esthétique" series.

849. LEMAITRE, GEORGES EDOUARD. *From Cubism to Surrealism in French Literature*. London: H. Milford, Oxford University Press; Cambridge, MA: Harvard University Press, 1941. 247 p., pl.

a. Other eds.: 1947, 1967, 1978.

850. LEVINE, EDWARD M. *Visual Ambiguity in Cubist Painting and its Relationship to Contemporary American Painting*. Ph.D. diss., New York University, 1975. 304 p., illus.

Examines the formal devices used by selected Cubist painters in order to determine the extent of the relationship between the experience of visual ambiguity in the work of these artists. The artists concerned are Picasso, Braque, Gris, and Léger. Analysis demonstrates that visual ambiguity is fostered through the use of aesthetic devices that produce conflicting visual cues. To create this ambiguity the artists referred to employed such techniques as conflicting use of line, color, and light, changing scales, multiple perspectives, metamorphosis of form and juxtaposition of diverse levels of illusion and representation. The devices can be categorized under the following headings: deliberate oscillation of appearances; studied multiplicity of readings; and conscious compounding of identities. Each is analyzed for its content and another category is deduced, interaction between the abstract and figurative. In the second part of the study, the author investigates the critical writings and selected paintings of de Kooning, Jasper Johns, and Frank Stella and, by using the criteria developed in the first part, determines that visual ambiguity plays an important role in the aesthetic experience of their works. It is concluded that all the painters studied consciously used such aesthetic devices and that their use was a means for them to suggest the complexity of their visual experience.

851. LEYMARIE, JEAN. *Le Fauvisme*. Geneva: Skira, 1959.

852. LEYMARIE, JEAN aned MICHELE RICHET. *Legs Marguerite Savary au Musée National d'Art moderne*. Paris: Editions des Musées Nationaux, 1970.

853. LHOTE, ANDRE. *La Peinture, le coeur et l'esprit*. Paris: Denoël et Steele, 1933. 234 p., 6 pl.

Reprints reviews of Braque exhibitions on pp. 25-9, 165-70.

854. LHOTE, ANDRE. *Peinture d'abord, essais*. Paris: Denoël, 1942. 178 p.

Reprints an essay (pp. 159-60) by Lhote, "Le Symbolisme plastique de Georges Braque," first published in *La Nouvelle revue française* 48(May 1937):795-7. See also pp. 157-8 for more information on Braque ("A propos de Georges Braque").

855. LHOTE, ANDRE. *Ecrits sur la peinture*. Paris: Aux Editions Lumière, 1946. 329 p., illus. Volume in "Collection Témoignages" series.

See pp. 272-81 for information on Braque, including an article written in 1937.

856. LIBERMAN, ALEXANDER. *The Artist in his Studio*. London: Thames and Hudson, 1988. 292 p., 216 illus., 161 col.

From his visits to thirty-three artists in their studios, Liberman has compiled a collection of reflections on the artists, art, and the act of creation in words and photographs. Braque, Chagall, Dali, Kandinsky, Matisse, Picasso, and Renoir are among the artists featured.

857. LOEB, PIERRE. *Voyages à travers la peinture*. Paris: Bordas, 1946. 144 p., 48 pl.

858. MALEVICH, KASIMIR. *The Non-Objective World*. Chicago: Paul Theobalc & Co., 1959. 102 p.

859. MARCHIORI, GIUSEPPE. *Scultura francese moderna*. Milani Silvana, 1963.

a. French ed.: *Sculpture moderne en France*. Trans. by David Roseet. Paris, Lausanne: La Bibliothèque des Arts, 1963.

860. MATHEY, FRANÇOIS. *Il Cubismo. La Ricerca della struttura delle cose*. Milan: Fratelli Fabbri, 1975.

861. MCQUILLAN, MELISSA ANN. *Painters and the Ballet, 1917-1926: An Aspect of the Relationship Between Art and Theatre*. Ph.D. diss., New York University, 1979. 3 vols., 808 p., illus.

Studies the commissions for décor and costume design given between 1917 and 1926 by three theatrical enterprises, the Ballets Russes, Ballets Suédois and the Soirées de Paris, to painters who had been active in the pre-War Parisian avant-garde. Investigates the broad art historical questions of the episode in relation to early 20th century art, and focuses on detailed reconstruction of twenty-six works by thirteen artists: Balla, Depero, Picasso, Robert Delaunay, Sonia Delaunay-Terk, Derain, Matisse, Léger, Gris, Braque, Picabia, Miró and Ernst. It is proposed that, rather than being an aberration or an interruption of more serious pursuits, the collaboration

between these painters and the three companies occupied a central position in the artistic concerns of the period.

862. MELLOW, JAMES R. *Charmed Circle: Gertrude Stein & Company.* New York: Praeger, 1974. 528 p.

863. Miller Company, Meridan, Connecticut. *Painting Toward Architecture.* Text by Henry-Russell Hitchcock; foreword by Alfred H. Barr, Jr. New York: Duell, Sloan and Pearce, 1948. 118 p., illus., some col.

Pages 60-1 include a brief text accompanying a color reproduction of *Black Rose*, stressing architectural implications of Braque's style.

864. MOURLOT, FERNAND. *Art in Posters; The Complete Original Posters of Braque, Chagall, Dufy, Léger, Matisse, Miró, Picasso.* Monte Carlo: A. Sauret; New York: G. Braziller, 1959. 247 p., 102 pl., some col.

865. MOURLOT, FERNAND. *Souvenirs et portraits d'artistes.* Paris, Amiel, New York: Editions Mazo, 1972.

866. MOUSSEIGNE, ALAIN. *Musée de l'Annonciade, Saint-Tropez.* Saint-Tropez: Le Musée, 1977.

Catalogue of the Museum's holdings.

867. MULLER, JOSEPH-EMILE. *Le Fauvisme.* Paris: Hazan, 1956. 95 p., col. illus. Volume in "Bibliothèque Aldine des arts" series.

Discusses Braque on pp. 49-52.

868. NASH, JOHN MALCOLM. *Cubism, Futurism and Constructivism.* London: Thames and Hudson, 1974. 64 p., 64 pl., some col. Volume in "A Dolphin Art Book" series.

869. NEAR, PINKNEY L. *French Paintings in the Collection of Mr. and Mrs. Paul Mellon in the Virginia Museum of Fine Arts.* Introduction by John Rewald. Richmond, VA: Virginia Museum of Fine Arts; dist. by the University of Washington Press, Seattle and London, 1985. 145 p., 69 col. illus.

Catalogue to the paintings by 19th and 20th century French artists collected by Paul and Rachel Mellon, now in the collection of the Virginia Museum of Fine Arts, Richmond, Virginia. It includes works by Braque and Matisse, among other artists.

870. OPPLER, ELLEN CHARLOTTE. *Fauvism Reexamined.* Ph.D. thesis, Columbia University, 1969; New York, London: Garland Publishers, 1976. 413 pp., illus., 23 pl.

871. OZENFANT, AMEDEE and CHARLES-ETIENNE JEANNERET. *La Peinture moderne.* Paris: G. Crès, 1925. 172 p., illus., 33 pl., some col. Volume in "L'Esprit nouveau" series.

872. OZENFANT, AMEDEE. *Art. I. Bilan des arts modernes en France*; Paris: J. Budry, 1928. 216 p., illus., pl.

Braque is mentioned on pp. 70, 73, 75, 111-2.
a. Another ed.: 1929.
b. German ed.: *Leben und Gestaltung*. Trans. by Gertrud Grohmann. *I. Bilanz des 20. Jahrhunderts*. Potsdam: Müller I. Kiepenheuer, 1931. 316 p., illus.

873. PÁSSUTH, KRISZTINA. *Le Corbusier, Maillol, Braque*. Budapest: Képzómusvészeti Alap Kiadóvállalata, 1970. 31 p.

874. PAULHAN, JEAN. *Peindre en Dieu*. Paris: Nouvelle Revue Française, 1963.

875. PAULHAN, JEAN. *La Peinture cubiste*. Paris: Denoël-Gonthier, 1970. 188 p., pl. some col.

876. PAYRÓ, JULIO E. *Pintura moderna, 1800-1940*. Buenos Aires: Editorial Poseidōn, 1942. 238 p., illus. Volume in "Colleción Todo para todos" series.

a. Another ed.: 1944.

877. PENROSE, ROLAND. *Scrap Book 1900-1981*. London: Thames and Hudson, 1981. 299 p., 748 illus., some col.

In this book Penrose, a Surrealist painter and the major protagonist of Surrealism in England since the 1920s, recalls encounters with and anecdotes about 20th century artists. The founder and director of the Institute of Contemporary Art in London for more than twenty years, he was a close friend of Picasso, Braque, Breton, Ernst, Man Ray, Henry Moore, Calder, Miró and Francis Bacon, among others. The photographs are from his own collection.

878. PERL, JED. *Paris Without End: On French Art Since World War I*. San Francisco: North Point Press, 1988. 194 p., 50 illus., pl.

Series of ten interlinked essays in which Perl explores the developments and major personalities of French art since the First World War, focusing on Matisse, Derain, Dufy, Léger, Picasso, Braque, Giacometti, Hélion, and Balthus. In the final essay he compares and contrasts Paris and New York as the cultural capitals, respectively, of the early and late 20th century.
Review: D. Todd, *Journal of Aesthetics and Art Criticism* 47:4(Fall 1989):394-5.

879. PERLMAN, BERNARD B. *Walt Kuhn 1877-1949*. Exhibition: New York, Midtown Galleries (11 Nov.-30 Dec. 1989). Foreword by John W. Payson. 56 p., 51 illus., 30 col.

Catalogue to an exhibition of watercolor paintings, portraits, landscapes and gouaches by Walt Kuhn, one of the organizers of the Armory Show of 1913. Kuhn, best known for his circus figures, started out as a cartoonist and illustrator, executed several paintings in the Impressionist style and eventually founded the Association of American Painters and Sculptors, the organization behind the 1913 Armory Show. Van Gogh's paintings, which he saw for the first time on his trip to Europe in 1912, had a lasting

influence on his work. His greatest influence, however, was Cézanne, which is obvious in all of his mature paintings. In 1917, he founded the Penguin Club for New York artists and organized exhibitions of contemporary art at its headquarters which included, among others, works of Picasso, Braque, and Max Weber.

880. PIERRE, J. *Le Cubisme.* Lausanne, 1966.

881. PUY, MICHEL. *L'Effort des peintres modernes.* Paris: Albert Messein, 1933. 158 p. Volume in "La Phalange" series.

882. RAUCH, NICHOLAS. *Les Peintres et le livre; constituant un essai de bibliographie des livres illustrés de gravures originales par les peintures et les sculpteurs de 1867-1957; Catalogue de la librairie Nicholas Rauch.* Geneva, 1957.

Pages 114-22 concern Braques' *livres d'artistes.*

883. RAYNAL, MAURICE. *Anthologie de la peinture en France de 1906 à nos jours.* Paris: Montaigne, 1927. 320 p., illus.

Discusses Braque on pp. 85-92.
a. U.S. eds.: *Modern French Painters.* Trans. by Ralph Roeder. New York: Brentano's, 1928. 275 p., pl.; New York: Arno Press, 1969. See pp. 50-5 for information on Braque.

884. RAYNAL, MAURICE. *Peintres du XXᵉ siècle.* Geneva: Albert Skira, 1947. 38 p., illus., 53 pl., some col. Volume in "Trésors de la peinture française" series.

885. RAYNAL, MAURICE. *Peinture moderne.* Geneva; Skira, 1953. Volume in "Peinture, couleur, histoire" series.

886. READ, HERBERT EDWARD. *Art Now; An Introduction to the Theory of Modern Painting and Sculpture.* London: Faber and Faber, 1933. 144 p., 128 pl.

887. READ, HERBERT EDWARD. *Histoire de la peinture moderne.* Paris: Aiméry Somogy, 1960.

888. RICHARDSON, JOHN. *Deutsche Bearbeitung von G. W. Lorenz.* Milan, Würzburg, Vienna, 1960.

889. ROGER-MARX, CLAUDE. *Dufy, Pferderennen.* 52 p., illus.

890. ROSENBLUM, ROBERT. *Cubism and Twentieth Century Art.* New York: Harry N. Abrams, 1960. 328 p., col. illus., pl.

a. Other eds.: 1966, 1976, 1982.
b. German ed.: *Der Kubismus und die Kunst des 20. Jahrhunderts.* Stüttgart: G. Hatje, 1960. 332 p., col. illus., pl.

891. ROSKILL, MARK WENTWORTH. *The Interpretation of Cubism.* Philadelphia: Art Alliance Press; London; Toronto: Associated University Presses, 1985. 344 p., 40 illus.

This study of Cubism examines its discrepancies, the artists' views of what they were engaged in and contemporary theorizing. The first part of the book surveys the art and the theory of Cubism from an historical perspective (1909-25), concentrating on the work of Picasso, Braque, and Gris as it developed in its own terms and the body of theoretical writings that sough to justify and explain it. The second part deals with the problems of applying four traditional art historical methods to Cubism: the consideration of style based upon internal periodization; the exploration of supposed parallels in the other arts, especially literature; the iconographic or iconological approach; and the application of principles derived from visual psychology. In the third part of the book, two philosophical problems relevant to the larger arguments are examined; the various ways in which "the artists's intentions" affects the critical description of developments and the drawing of inferences; and the recognition and identification of objects in a painting. In an afterword Roskill suggests that traditional art history cannot be applied successfully to Cubism.
Reviews: P. Daix, *Burlington Magazine* 127:993(Dec. 1985):909-10; B. Kennedy, *British Journal of Aesthetics* 26:3(Summer 1986):295-7.

892. RUBIN, WILLIAM STANLEY, et al. *Cézanne: The Late Works*. Essays by Theodore Reff and others. New York: Museum of Modern Art; Boston: dist. by New York Graphic Society, 1977. 416 p., 427 illus., 50 col. pl.

a. English ed.: London: Thames and Hudson, 1978.

893. RUTTER, FRANK VANE PHIPSON. *Evolution in Modern Art: A Study of Modern Painting, 1870-1925*. London: G. G. Harrap & Co., 1926. 166 p., 35 pl.

Discusses Braque on pp. 80, 93-6.
a. Another ed.: 1932. 159 p., pl.
b. U.S. ed.: New York: Lincoln Macveagh, The Dial Press, 1927. 166 p., illus., 34 pl.

894. RYNDEL, NILS. *Franskt maleri i Göteborgs Konstmuseum.* Göteberg: Konstmuseum, Rundqvasts, 1961. 79 p., illus., some col.

895. SALMON, ANDRE. *La Jeune peinture française.* Paris: A. Messein, 1912. 124 p. Volume in "Société des trente" series.

896. SALMON, ANDRE. *L'Art vivant.* Avec douze phototypies. Paris: G. Crès, 1920. 302 p., illus. Volume in "Artistes d'hier et d'aujourd'hui" series.

897. SALMON, ANDRE. *Twenty-Five Years of Abstract Painting: Souvenirs.* 1932.

898. SARANE, ALEXANDRIAN. *Panorama du cubisme.* Paris: Filipacchi, 1976. 67 p., illus., some col. Volume in "Collection Les Yeux fertiles" series.

899. SCHNUNCK, VOLKER. *Das provozierte Sehen: Ironie und Reflexion im Kubismus von Picasso, Braque, und Juan Gris (1907-1914).* Ph.D. diss., Universität Zürich, 1984; Zurich: ADAG Administration & Druck, 1984. 167 p., 8 illus.

Argues that previous research on Cubism has been too narrowly oriented towards problems of space and form. Considers Cubism as a "laboratory" of the avant-garde,

in which for the first time the symbolic meaning of the art work resides in the contradiction between illusion and abstraction, image and language, signifier and signified. The multilayered, fragmented structure of Cubist paintings in the years 1910-14 reveals previously unrecognized forms of verbal-visual irony and persiflage. Transmitted by Dada and Surrealist artists, this approach is still evident in contemporary avant-garde art.

900. SCHULZ, GISELA, ed. *Malerbücher und Verwandtes* [Artists' Books and Related Material]. Hamburg: Museum für Kunst und Gewerbe, 1987. 126 p., 94 illus., 7 col.

This book marks the retirement of Gisela Schulz after fifty years' service as librarian of the Hamburg Museum für Kunst und Gewerbe, where she had a special interest in books illustrated by artists, eighty of which are represented here. They include works illustrated by Braque, Picasso, Chagall, Kokoschka and David Hockney, presented with details of the editions. A list of further titles in the Museum's collection and a bibliography are appended.

901. SCHWARTZ, PAUL WALDO. *The Cubists*. London: Thames and Hudson, 1971. 216 p., 152 illus., some col. Volume in "The World of Art Library, Modern Movements" series.

Includes extensive references to Braque.

902. SCOTT, DAVID. *The Modern Art Collection: Trinity College, Dublin*. Dublin: Trinity College Press, 1989. 101 p., 34 illus., 34 col.

The modern art collection of Trinity College, Dublin has been formed since the 1960s by a succession of student committees who visited galleries, staged exhibitions and appealed to the College, the Arts Council and other organizations for grants. Scott describes the collection, which comprises paintings, drawings, prints and sculptures, mentioning outstanding works by international artists including Lichtenstein, Braque, Karel Appel, David Hockney and Larry Rivers, as well as representative pieces by leading contemporary Irish artists, among them Michael Farrell, Louis Le Brocquy, and Anne Madden.

903. SERULLAZ, MAURICE. *Le Cubisme*. Paris: Presses Universitaires de France, 1963. 126 p. Volume in "Que sais-je?" series.

904. SEUPHOR, MICHEL (pseud. for F. L. Berckelauers). *L'Art abstrait: ses origines, ses premiers maîtres*. Paris: Maeght, 1950. 322 p., illus., 10 pl., some col.

905. SEUPHOR, MICHEL (pseud. for F. L. Berckelauers). *La Peinture abstraite: sa genèse, son expansion*. Paris: Flammarion, 1962. 327 p., illus., some col.

906. SHATTUCK, ROGER. *The Banquet Years: The Arts in France, 1885-1918: Alfred Jarry, Henri Rousseau, Erik Satie, Guillaume Apollinaire*. London: Faber & Faber, 1959. 306 p., illus.

907. SILVER, KENNETH ERIC. *Esprit de corps: The Great War and French Art 1914-1925*. Ph.D. diss., Yale University, 1981. 526 p., 314 illus.

Study of the changes in the art of the Parisian avant-garde during the war and reconstruction. The following issues are considered: the separation of the French from foreigners during the war, the distinction between combatant and civilian, the campaign against Cubism and other avant-garde movements, the theory of the infiltration of French culture by Germany, the French image of themselves as a decadent culture. The artists discussed are Braque, Delaunay, Gris, La Fresnaye, Le Corbusier, Léger, Matisse, Ozenfant, Picasso, and Severini. Wartime magazines *L'Elan* and *Le Mot* are examined in detail.

908. SIMA, MICHEL. *21 visages d'artistes*. Paris: F. Nathan, 1959. 157 p., illus., 16 col. pl.

909. SKIRA, ALBERT, ed. *Anthologie du livre illustré par les peintres et sculpteurs de l'école de Paris*. Reproductions de Beaudin, Bonnard, Braque . . . Geneva: Skira, 1946. 222 p., illus., pl.

Braque is mentioned on p. 12.

910. SKIRA, PIERRE. *La Nature morte*. Geneva: Albert Skira, 1989. 183 p., 150 col. illus.

Retraces the wide variety of subjects and expressions of the theme of still life from Ancient Egyptian frescoes through Roman mosaics and frescoes, Dutch banquets, kitchen scenes, music lessons, vanity paintings depicting the power of death, to more modern examples such as Cézanne's pears or van Gogh's irises. Picasso, Braque, Bonnard, and Matisse all continued the tradition at times, as have contemporary artists such as de Staël, Morandi and Marsans, their subjects including jugs, bottles, and books.

911. SOWERS, ROBERT. *The Language of Stained Glass*. Forest Grove, OR: Timber Press, 1980. 206 p., 134 illus.

Reappraisal of the medium of stained glass divided into sections for a discussion of the nature and use of light, and for a consideration of the "claims of the medium" (in terms of the "texture of light," the "fabric" of the window, and the awareness of luminosity as opposed to the search for pictorial illusion). In the third section of the book, the place of stained glass within the contemporary world is examined while Sowers concludes that the most successful modern stained-glass artists are rediscovering the aesthetic principles of the art of eight centuries. Modern stained-glass artists whose work is discussed and illustrated in the book include Marc Chagall, Georg Meistermann, Helmut Lander, Georges Braque, Ludwig Schaffrath, and Robert Sowers.

912. STRACHAN, WALTER JOHN. *The Artist and the Book in France; The 20th Century Livre d'artiste*. Peter Owen, ed. New York: G. Wittenborn, 1969. 368 p., 181 illus., 8 col. pl.

913. SWEENEY, JAMES JOHNSON. *Plastic Redirections in 20th Century Painting; The Meaning of Unintelligibility in Modern Art*. Chicago: University of Chicago Press, 1934. 103 p., illus. Volume in "Studies of Meaning in Art" series.

a. Another ed.: New York: Arno Press, 1972. 103 p., illus.

914. TASSI, ROBERTO. *Fauvismo, Expressionismo, Realismo Sociale.* Milan: Fratelli Fabbri, 1966. 1 vol., illus. Volume in "I Maestri del colore" series.

915. TURR, KARINA. *Zur Antikenrezeption in der französischen Skuptur des 19. und frühen 20. Jahrhunderts* [On the Reception of the Antique in French Sculpture in the 19th Century and Early 20th Century]. Berlin: Mann, 1979. 256 p., 155 illus.

Sculptors discussed include Braque, among others.

916. *Twentieth-Century Modern Masters.* William S. Lieberman, ed. Foreword by Philippe de Montebello and Sabine Rewald. New York: Metropolitan Museum of Art, 1989. 355 p., 281 illus., 95 col.

This book accompanies an exhibition of the Jacques and Natasha Gelman Collection, shown in public for the first time at the Metropolitan Museum of Art, New York (12 Dec. 1989-1 April 1990). The collection comprises eighty-one masterpieces, mainly of the art of the School of Paris, by artists including Bonnard, Braque, Dali, Dubuffet, Matisse, Miró, and Picasso. The entries examine each work individually and in its broader cultural context. Also included are essays on art currents such as Fauvism, Cubism, and Surrealism, and appreciations of the artists considered to be among the main proponents of these major developments in the history of 20th century art. An illustrated checklist and an index are appended.

917. VALLERY, JEAN. *Guillaume Apollinaire.* Paris: Bibliothèque Nationale, 1969.

918. VALLIER, DORA. *Histoire de la peinture, 1870-1940.* Brussels: La Connaissance, 1963. 291 p., illus., pl., some col. Volume in "Témoins et témoignages" series.

919. VALLIER, DORA. *La Peinture 1870-1940, les mouvements d'avant-garde.* Cologne: Verlag DuMont Schauberg, 1963.

920. VALLIER, DORA. *L'Intérieur de l'art: entretiens avec Braque, Léger, Villon, Miró, Brancusi (1954-1960).* Paris: Editions du Seuil, 1982. 152 p., 4 illus. Volume in "Pierres vives" series.

Series of interviews with Braque, Léger, Villon, Miró, and Brancusi, previously published separately in the journal *Cahiers d'art* from 1954 to 1960. In her introduction, Vallier sets the scene for each conversation and explains how the series grew from a homage to Braque alone to include further discussion of aspects of Cubism with Léger and Villon—"Picasso, le grand absent" having evaded her approaches. The conversation with Miró takes the discussion beyond Cubism into Surrealism, and her recollected meeting with Brancusi provides a most rare insight into his studio and life-style in general.

921. VENTURI, LIONELLO. *Pittura contemporanea.* Milan: U. Hoepli, 1948.

a. French ed.: *La Peinture contemporaine.* Milan: U. Hoepli, 1948. 74 p., 239 p.

922. VILDRAC, CHARLES. *Musée de l'Annonciade, Saint-Tropez; catalogue.* Saint-Tropez: Le Musée, 1955. 15 p., illus.

923. WARNOD, ANDRE. *Ceux de la butte.* Paris: René Julliard, 1947. 290 p., illus. Volume in "La Petite histoire des grands artistes" series.

Brief personal reminiscence about Braque on pp. 148-9.

924. WARNOD, JEANINE. *Le Bateau-Lavoir, 1892-1914.* Paris: Connaissance, 1975. 163 p., illus., pl., some col. Volume in "Témoins et témoignages: histoire" series.

Describes the little-known Bohemian life of those who lived in an old wooden Parisian building consisting entirely of artists' studios and known as the Bateau-Lavoir. The social life there and the struggle for existence are described with reference to such artists as Picasso, van Dongen, Braque, Derain, Vlaminck, Gris, Max Jacob, and others.

925. WECHSLER, HERMAN JOEL. *La Gravure art majeur, des maîtres inconnus à Picasso: guide pratique de l'amateur d'estampes.* Paris: Edition Cercle d'Art, 1969. 244 p., illus.

926. WEILL, BERTHE. *Pan! dans l'œil, ou trente ans dans les coulisses de la peinture contemporaine (1900-1930).* Avec une préface de Paul Reboux; orné des aquarelles et dessins de Raoul Dufy, Pasch et Picasso. Paris: Librarie Lipschutz, 1933. 325 p., illus., 4 pl., some col.

927. WESCHER, HERTA. *Die Collage; Geschicte eines Künstlerischen Ausdrucksmittels.* Cologne: Dumont Schauberg, 1968. 416 p., illus., pl., some col.

928. WESTHEIM, PAUL, ed. *Künstlerbekenntnisse.* Berlin: Im Propyläen Verlag, 1923. 356 p., illus., 32 pl.

Braque discussed on pp. 148-50.
a. Another ed.: 1925.

929. WESTHOLM, ALFRED and NILS RYNDEL. *The Gothenburg Art Gallery. 103 Paintings.* Stockholm: Albert Bonniers Förlag, 1952. 227 p., illus., some col.

930. WHITFIELD, SARAH. *Fauvism.* London: Thames and Hudson, 1988. 216 p., 171 illus., 24 col. Volume in "World of Art" series.

Examines the art of the group of painters led by Henri Matisse known as the Fauves. Whitfield discusses the artists (including Albert Marquet, Henri Manguin, Charles Camoin, André Derain, Maurice Vlaminck, Raoul Dufy, Othon Friesz, and Georges Braque), their work, their influences and the response to their style of painting which involved the use of strong colors and bold brush strokes.
a. Another ed.: 1991.

931. WHEELER, MONROE, ed. *Modern Painters and Sculptors as Illustrators.* New York: Museum of Modern Art, 1936. 115 p., pl. 2,500 copies.

932. WILENSKI, REGINALD HOWARD. *Modern French Painters*. 424 pp., 96 pl. New York: Reynal & Hitchcock, 1940.

a. Other eds.: 1949, 1954, 1960, 1963.
b. English eds.: London: Faber & Faber, 1944; 1947; 1954; 1963.

933. WOLFRAM, EDDIE. *History of Collage: An Anthology of Collage, Assemblage and Event Structures*. London: Studio Vista, 1975. 192 p., 135 illus., some col.

Although a highly developed collage technique existed in 10th century Japan, its reemergence as a legitimate form of artistic expression only came about during the first years of this century under the influence of Cubism and its originators, Braque and Picasso. The development of collage is traced in Western culture through Futurism, Suprematism, Dada, Surrealism and the work of the modern masters of the idiom—Rauschenberg and Warhol. The significance of collage in the development of 20th century art is assessed, and its contribution to such diverse fields as theater design, political propaganda, bookbinding and advertising is evaluated.

934. ZERVOS, CHRISTIAN. *Histoire de l'art contemporain*. Préface par Henri Laugier. Paris: Editionis Cahiers d'art, 1938. 447 p., illus., pl.

Includes information on Braque and thirty-eight illustrations (see pp. 127, 138, 223-34, 273-86).

Articles

935. ALLENDY, R. "Neue Gedanken in Universitäts Kreisen" in *Europa Almanach* (Potsdam: G. Kiepenhner, 1925).

936. ALVARD, JULIEN. "L'Espace cubiste." *Art d'aujour'hui* 3-4(May-June 1953).

937. AMPATZĒ-KŌDŌNA, RANIA. "To Provlēma tēs Kallit-Khnikēs Keramikēs stē Sygkhronē Ellada" [The Problem with Fine Art Ceramics in Comtemporary Greece]. *Zygos* (Greece) 54(July-Aug. 1982):62-7. 6 illus., 4 col.

Describes the problems of trying to establish a trend towards fine art ceramics in a country as full of tradition as Greece. Pointing out the use of clay by Picasso and Braque, Ampatzē-Kōdōna discusses ways of surmounting these problems and escaping from the classification of ceramics as decorative. Her own ceramic sculptures are illustrated.

938. APOLLINAIRE, GUILLAUME. "Du sujet dans la peinture moderne." *Les Soirées de Paris* 1(1912):1-4.

939. APOLLINAIRE, GUILLAUME. "Guillaume Apollinaire: notes critiques (choix)." *Cahiers du Musée National d'Art moderne* 6(1981):75-125. 143 illus.

Publishes selected critical notes by Apollinaire on Picasso, Braque, Metzinger, Gleizes, Laurencin, Gris, Léger, Picabia, Duchamp, Duchamp-Villon, Villon, Archipenko, Fresnaye, Le Fauconnier, and Delaunay. Compiled and edited by Miriam de Dreuzy, Jean Lacambre, and Annick Lionel-Marie.

940. ARLAND, MARCEL. *Chronique de la peinture moderne*. Paris: Corréa, 1949.

Discusses Braque on pp. 183-91.

941. "L'Art d'aujourd'hui." *Cahiers d'art* 10:1-4(1935):20-7, 29-30.

942. "Artist and the Book." *Studio* 162(Sept. 1961):119.

943. AUGUST, MARILYN. "The House of Maeght." *Art News* 85:6(Summer 1986):93-7. 7 illus., 2 col.

Describes the life and career of Adrien Maeght, the son of Aimé and Marguerite Maeght who put together a collection of 20th century masterpieces which is now housed in Saint-Paul-de-Vence, France as part of the Maeght Foundation. The artists who passed through the Maeght household during Adrien's childhood are named, including Bonnard, Braque, and Matisse. Later Adrien broke with his father and started his own gallery and printing shop. He now has control over the family collection, but the relationship between the gallery artists and the owner has changed.

944. AURIC, GEORGES. "Les Concerts—soirées de Paris." *Les Nouvelles littéraires* 84(24 May 1924):7.

945. BARKER, MICHAEL. "Stained Glass in France in the 1950s." *Journal of the Decorative Arts Society 1850 to the Present* 15(1991):5-13. 16 illus.

Surveys the production and use of stained glass as an art form in France in the 1950s. The art form was popular in France both before and during this decade. The best examples of the 1950s cited by Barker include Le Corbusier's Nôtre-Dame-de-Haut at Ronchamp, near Belfort, of 1954; Maurice Novarina's church of the Sacré-Cœur of 1950, also near Belfort, with glass by Fernand Léger; Matisse's work for the Chapel of the Rosary at Vence, near Nice; another combined work of Novarina and Léger, the church of Nôtre-Dame-de-Toute-Grace of 1950 at Plateau d'Assy; and numerous works by Marc Chagall, Jean Cocteau, Georges Braque, and August Perret.

946. BARTSCH, INGO. "Stilleben und Avangarde" [Still Life and Avant-Garde] in *Stilleben in Europa*, ed. by Uta Bernsmeier, et al. (Münster: Westfälisches Landesmuseum für Kunst und Kulturgeschichte, 1980), pp. 511-38. 21 illus.

Examines the possibilities and limits of still life, considering in particular the influence of Chardin and his attempts to overcome these limitations, the aesthetic appeal of still life in the works of Manet and Courbet, the "art for art's sake" work of Matisse with its emphasis on color and shape, and the individuality shown in the compositions of Gauguin, Cézanne, and van Gogh at the turn of the century. In addition, Bartsch discusses ideas on still life and the aesthetic representation of objects in the early 20th century and assesses the still life paintings of Pablo Picasso, Georges Braque, Giorgio Morandi, and Roy Lichtenstein.

947. BATTISTINI, YVES. "Parménide et l'absolu" *Cahiers d'art* (1947).

948. BAUER, HELMUT. "Forum für moderne Kunst" [A Forum for Modern Art]. *Weltkunst* 60:2(15 Jan. 1990):132-3. 2 illus.

Heidenheim in Germany has been a settlement for centuries and has rich collections of Roman antiquities as well as other cultural and historical objects; the latest addition was opened on 26 April 1989. The Kunstmuseum Heidenheim, Galerie der Stadt is a municipal fine arts collection which will concentrate on 20th century art. A core collection will be posters by and about Pablo Picasso, assembled by Christoph Czwiklitzer. There will also be numerous posters by the wood engraver Hap Grieshaber and representative poster art by such artists as Braque, Chagall, Cocteau, and Klee. There are ambitious plans for future extensions to the collection, with unknown and little known artists being sought as well as the already famous.

949. BEAUMONT, MARY ROSE. "A Morality Tale for Object Modernist: The Fine Art of Selling Work and Keeping Faith." *Artissues* (U.K.) 1(Summer 1990):8-9. 3 illus.

Citing Salvador Dalí's life as indicative of the destructive power of greed, the author discusses the relationship between artist and dealer and the pressure on artists to stick to a formula for financial security, unless they have enlightened private collectors as patrons. Beaumont contrasts the work of Picasso, Braque, and Matisse collected by Gertrude and Leo Stein with the formulaic work of Utrillo, for whom sales were vital. The temptation to vulgarize art in order to become sought after or well paid is considered, but the author suggests means of overcoming the problem, concluding with the example of Francis Bacon, who succeeded as a loner.

950. BERGER, R. "Le Cubisme." *XXe siècle* 24(June 1962):3-8.

951. "Berichte der Staatlichen kunstsammlungen, neuerwerbungen: Bayerische staatsgemäldesammlungen." *Müncher Jahrbuch der Bildenden Kunst.* ser. 3, 19(1968):248.

952. BERTHOLLE, J. and ALFRED MANESSIER. "Témoignages." *L'Art sacré* (Sept.-Oct. 1963).

953. BILLOT, MARLE-FRANÇOIS. "Le Père Couturier et l'art sacré" in *Paris-Paris: créations en France 1937-1957.* Compiled by A. Lionel-Marie, M.-C. Llopès, M. Thomas (Paris: Centre Georges Pompidou, 1981), pp. 196-205. 23 illus.

Discusses the injection of new life into the increasingly decadent art of church decoration and architecture during the two decades immediately following the Second World War. The commissioning of new and vigorous murals, stained-glass windows, sculpture and entire church buildings by such artists as Matisse, Léger, Braque, Picasso, and Le Corbusier is described and demonstrated to have been largely the result of one man's efforts, the priest/artist Pierre Couturier.

954. BISSIERE, ROGER and JEAN CAIN. "Témoignages." *Les Lettres françaises* (5 Sept. 1963).

955. BOE, ALF. "Paris-Kronikk 1956." *Kunst Kultur* (1957).

956. BROOS, KEES. "Het beeld van de taal" [The Picture of Language]. *Openbaar Kunstbezit* 23:5(Oct. 1979):149-59. 15 illus., 6 col. In Dutch.

Demonstrates that texts, words, and typefaces were used in 20th century art as independent formal elements, to underscore the flatness of the painting or to indicate the different relations between words, art and reality. The examples include paintings by Mondrian, Malevich, Braque, Magritte, Klee and Dubuffet, and works by Dine, Kosuth, and Weiner.

957. BRUNO, R. "Arnoldo Cantù, 1912-1914: Part 2." *Critica d'arte* 43:157-9(1978):7-21.

Chronicle of Cantù's critical writings of these two years, especially in relation to the Impressionists, Picasso and Braque and the other Cubists, and the Italian Futurists. His position is compared to that of Soffici. Also discussed are his reactions to the two Secessionist exhibitions in Rome in 1913 and 1914, and in particular his analysis of Matisse's art.

958. BUCHHEIM, LOTHAR GÜNTHER "Im Atelier am Parc Montsouris." *Die Kunst* (1962).

959. BUFFET-PICABIA, G. "Matières plastiques." *XX^e siècle* 2(1938).

960. CABUTTI, LUCIO. "Sulle orme del cavaliere azzurro" [In the Footsteps of the Blue Rider]. *Arte* 17:173(April 1987):68-73, 127. 12 col. illus.

Describes some of the works in the Staatsgalerie, Stüttgart. As well as works by members of the Blaue Reiter group (Franz Marc and Kandinsky), there are examples of work by members of Die Brücke (Erich Heckel, Ernst Ludwig Kirchner, Karl Schmidt-Rottluff, Emil Nolde, and Otto Müller), and by Cubist artists (Picasso, Braque, Gris, and Léger). Cabutti describes the general principles of the collections and the sources of the modern collection, and concludes with a survey of some other 20th century works, including Schlemmer and de Chirico.

961. CABY, ROBERT. "Musique française—1928." *Montparnasse* 52(July-Aug. 1928).

962. CACHONS, JACQUES DE. "La Peinture d'après-demain?" *Je sais tout* (15 April 1912):349-56.

963. CAMPAGNE, JEAN-MARC. "Cent chefs-d'œuvre de l'art français" in *Les Débats de ce temps* (Paris; 1957).

964. CAREY, FRANCIS. "From Picasso to Lichtenstein." *Studio* 188(Dec. 1974):8.

965. CASSOU, JEAN. "Dessins des peintres et sculpteurs de l'Ecole de Paris." *Art et style* 48(1958).

966. CEMBALEST, ROBIN. "Jacques and Marta Hachuel: Good Vibrations." *Art News* 90:2(Feb. 1991):81-3. 5 col. illus.

Jacques Hachuel is an investment banker in Madrid who began collecting art seriously in the 1960s. In general, only art of the present century attracts him and his wife—artists such as Bacon, Braque, Chagall, Miró, Mondrian, Klee, and Giacometti.

While he owns works by several young Spaniards, he believes that Spain does not generate much contemporary art of a level for him to collect. Cembalest states that he has a cordial relationship with the government regarding his collection—he lends works on a rotation basis to Spanish museums and he does not have to pay customs on the works he buys outside the country. His works travel because he does not believe it right that a person should reserve such things just for himself.

967. CHARENSOL, GEORGES. "La Quinzaine artistique—copies et décors." *L'Art vivant* (1 March 1930):216-8.

968. CHAVENON, ROLAND. "Cubisme et néo-cubisme." *Le Crapouillot* (16 Oct. 1920).

969. CINOTTI, MIA. "Fernand Léger, il primitivo dei tempi moderni" [Fernand Léger, the Primitive of Modern Times]. *Arte* 19:202(Dec. 1989):72-9. 8 illus., 7 col.

Summarized account of the life and work of Fernand Léger on the occasion of the opening of a large exhibition of his work at the Palazzo Reale, Milan (9 Nov. 1989-18 Feb. 1990). His involvement in Cubism, the subsequent highly individual orientation of his work—distinguishing it clearly from that of Braque and Picasso—with his "mechanistic" paintings, are described. The importance of his meeting with Le Corbusier and of his entry into film and theater work, and his late production, encompassing religious art, ceramics and mosaics, are referred to.

970. COLLAER, PAUL. "Musique nouvelle." *Sélection* 5(15 Dec. 1920).

971. COLLET, HENRI. "Erik Satie: L'Esprit nouveau." 2(1920):145-48.

972. COLLINS, AMY FINE. "Sequined Simulacra." *Art in America* 76:7(July 1988):51-3. 4 col. illus.

The 1988 Spring and Summer collections from fashion designers Bill Blass and Yves Saint Laurent quote in their fabric designs the paintings of van Gogh, Matisse, and Braque. The prices of these costumes reflect the market prices of the paintings they quote. Collins examines the phenomenon, analyzing the reasons for this symbiosis of fashion and art and the exorbitant cost of such an outfit.

973. CONOVER, CARL. "Woman with a Book after Braque." *Boundary* 2:26(Winter-Spring 1989):174.

Poem inspired by Braque's painting of the same title.

974. COSTA, VANINA. "L'Œuvre ultime." *Beaux-arts magazine* 70(July-Aug. 1989):74-9. 5 col. illus.

With reference to the exhibition *De Cézanne à Dubuffet, œuvres ultimes* at the Fondation Maeght, Saint-Paul-de-Vence, France (4 July-4 Oct. 1989), Costa discusses the vitality of the late works of such artists as Picasso, Braque, Dubuffet, Klee, Gauguin, and Kandinsky. Some of the major works on show are illustrated and annotated.

975. COURTHION, PIERRE. "Les Grandes étapes de l'art contemporain, 1907-1917." *XX^e siècle* 28(May 1966):79[+].

976. CRANSHAW, ROGER. "Cubism 1910-12: The Limits of Discourse." *Art History* 8:4(Dec. 1985):467-83.

Aims to demonstrate that it is inappropriate to apply normal art history criteria to a consideration of the work of Picasso and Braque in the years 1910-12. Cranshaw identifies the programmatic intent of the two artists, noting that normally art historians agree that Cubism was not the result of a programmatic approach. He explains their programmatic intent, as inferred from their writings, as a denial of personal identity in their work, a denial of the object or a unity of the object and an attempt to step out of art tradition and create something entirely new. He then confronts the selectivity of their refusal to signify and the failure of art historians to recognize their aims. Finally, he recognizes the contradictions of his position in trying to assign programmatic intention and an art historical position to two artists who had rejected them.

977. CREVEL, RENE. "Les Soirées de Paris." *Les Nouvelles littéraires* 82(10 Mayy 1924):7.

978. DALEVEZE, JACQUES. "La Bande à Picasso au Bateau-Lavoir." *L'Œil* 244(Nov. 1975):72-3. 5 illus.

Article following a recent book by Jeanine Warnod *Le Bateau-Lavoir, 1892-1914*, which describes the little known Bohemian life of those who lived in an old wooden Parisian building consisting entirely of artists' studios and known as the Bateau-Lavoir. The social life there and the struggle for existence is described with reference to such artists as Picasso, van Dongen, Braque, Derain, Vlaminck, Gris, Max Jacob, and others.

979. DEGAND, LEON. "A propos des 'ateliers'." *Art d'aujourd'hui* 7-8(1950).

980. DEGAND, LEON. "La Peinture cubiste." *Art d'aujourd'hui* 4(May-June 1953).

981. DORIVAL, BERNARD. "Le Cubisme au Musée d'Art moderne." *Bulletin des Musées de France* 4(June 1946):14-9.

982. DORIVAL, BERNARD. "Musée d'Art moderne, I-Nabis et cubistes." *Bulletin des Musées de France* 5(May-June 1947).

983. DORIVAL, BERNARD. [Untitled]. *La Revue des arts* 4(1953).

984. DORIVAL, BERNARD. "Musée National d'Art moderne: nouveaux enrichissements." *La Revue des arts* 11(March-April 1957).

985. DORIVAL, BERNARD. "Le Musée National d'Art moderne." *Kunsten Idag* 3(1961).

986. DORIVAL, BERNARD. "La Donation André Lefèvre au Musée National d'Art moderne." *Revue du Louvre et des musées de France* 14:1(1964):23-44.

Braque's works are discussed on pp. 38-40.

987. DORIVAL, BERNARD. "La Préemption de l'Etat, à la 2ᵉ vente Lefèvre." *La Revue du Louvre et des musées de France* 16:2(1966):111-20.

Braque's works are discussed on pp. 111-5.

988. DORIVAL, BERNARD. "Musée National d'Art moderne: le legs Gourgaud." *Revue du Louvre et des musées de France* 17:2(1967):93-101.

Braque's works are discussed on pp. 96-7.

989. DORIVAL, BERNARD. "Le Cubisme, la peinture et la gravure" in *Encyclopédie de la Pléiade, Histoire de l'art*, vol. 4, *Du réalisme à nos jours*. (Paris: Gallimard, 1969).

990. DORR, G. H. III. "Putnam Dana McMillan Collection." *Minneapolis Institution of Art Bulletin* 50(Dec. 1961):60-1.

991. DU COLOMBIER, PIERRE. "Critique de l'exposition: le noir est une couleur." *Fantasia* (26 Dec. 1946).

a. Reprint: *Derrière le miroir* (Feb.-March 1947).

992. DUFOUR, P. "Actualité du cubisme." *Critique* (Aug.-Sept. 1969).

993. DUFOUR, P. "La Mort de l'image dans la peinture." *Critique* 291-2(Aug.-Sept. 1971).

994. DUNOYER DE SEGONZAC, ANDRE and LOUIS SÜE. "Musée de l'Annonciade, Saint-Tropez." *Art et Style* 53(1959).

995. DUPIN, JACQUES. "Le Nuage en échec." *Derrière le miroir* 85-6(April-May 1956):1-8.

996. DUTHUIT, GEORGES. "Le Fauvisme." *Cahiers d'art* 4:5(1929):177-92; 4:6(1929):258-68; 4:10(1929):429-35; 5(1930):129-34; 6:2(1931):78-82.

997. DUTHUIT, GEORGES. "Union et distance." *Cahiers d'art* 1-4(1939):57-64.

998. EINSTEIN, CARL. "Notes sur le cubisme." *Documents* 1:3(1929).

999. EISENDRATH, W. N., JR. "Painting and Sculpture of the School of Paris in the Collection of Mr. & Mrs. Joseph Pulitzer, Jr. of St. Louis." *Connoisseur* 151(Sept. 1962):30.

1000. EISENDRATH, W. N., JR. "Paintings and Sculpture in the Collection of Mrs. Mark C. Steinberg." *Connoisseur* 154(Dec. 1963):268.

1001. ELLIOT, J. H. "Three Young Artists." *Los Angeles Museum of Art Quarterly* 13:2-3(1957):7-10.

1002. ENCKELL, RABBE. "Konstproblem" [Art Problem]. *Paletten* (Sweden) 1(1990):19-21. 3 illus.

First published in 1947, this article was a response to the great exhibition of Impressionist painting in Paris that year, discussing the relationship between the external reality of objects and the Impressionist vision of them, together with the consequences for subsequent schools of painting, such as Expressionism and Surrealism. Picasso, Braque, and Léger are described as significant figures in the transition from Impressionism, in which color and form, appearance and reality are one, to a style of painting based on the tension between the decorative element and the reality behind it.

1003. "Enquête." *Cahiers d'art* 14:1-4(1939):65-6.

1004. FABIANI, ENZO. "Cominicia dal monte Sainte-Victoire l'epopea di Paul Cézanne" [Paul Cézanne's Epic Starts from Mount Sainte-Victoire]. *Art* 19:199(Sept. 1989):70-7. 7 illus.

Descriptive and anecdotal account of facets of Cézanne's life is given as an introduction to the conception and execution of his masterpiece *Mont Sainte-Victoire*, begun in 1904 and completed in 1906. Drawing extensively on Emile Bernard's reminiscences and comments, Fabiani describes the composition of this work and its seminal influence on the work of such artists as Braque, Léger, Jacques Villon, and Picasso.

1005. FRY, EDWARD F. "Cubism, 1907-1908: An Early Eyewitness Account." *Art Bulletin* 48:1(March 1966):70-3.

1006. FRY, ROGER. "La Peinture moderne en France." *L'Amour de l'art* 5(May 1924):141-56.

1007. FUMET, STANISLAS. "Ne nous évadons pas, ma peinture." *Derrière le miroir* (1963).

1008. GACHONS, JACQUES DES. "La Peinture d'après-demain." *Je sais tout* (15 April 1912).

1009. GERSON, MARK. "Ida Kar, Photographer." *British Journal of Photography* 136(16 Nov. 1989):8-9.

1010. GIACOMETTI, ALBERTO. "Gris, brun, noir . . ." *Derrière le miroir* 48-9(1964).

1011. GOTTLIEB, AURELIE. "Repräsentative ausländische Künstler." *Deutsche Kunst und Dekoration* 64(April 1929):3-5. 3 illus.

1012. GOUK, I. ALAN. "Patrick Heron." *Artscribe* 34(March 1982):40-54. 27 illus.

Examines Patrick Heron's work as a painter and an art critic, describing him as one of "four major critics in England this century." Gouk studies Heron's critical response to the American Abstract Expressionists of the 1950s, his admiration for the Parisian post-War artists, and his essay on Georges Braque. There is a detailed description of

Heron's artistic technique and the major influences in his work—Hans Hofmann, Georges Braque, de Staël, and Mark Rothko.

1013. GUERGUEN, PIERRE. "En marge de la Théogonie." *Cahiers d'art* 7:8-10(1932):390-2.

1014. HENDERSON, LINDA DALRYMPLE. "X-Rays and the Quest for Invisible Reality in the Art of Kupka, Duchamp, and the Cubists." *Art Journal* 47:44(Winter 1988):323-40. 22 illus.

Discusses the impact of the scientific discovery of x-rays on early modernist art, specifically Cubism. While the connections between Cubism and modern physics remain speculative, the impact of x-rays is historically demonstrable. Supporting popular, occult and artistic speculation about a fourth dimension, x-rays suggested to modern artists the relativity of perception and the existence of a hidden realm. The paintings of Kupka and Duchamp reflect their interest in chronophotography and show the direct visual influence of x-ray images. The works of Picasso, Braque, and the Puteaux Cubists more indirectly capture the type of hidden reality suggested by the rays.

1015. HENNING, EDWARD B. "Pablo Picasso: *Fan, Salt Box, and Melon.*" *Cleveland Museum of Art Bulletin* 56(Oct. 1969):276[+].

1016. HENNING, EDWARD B. "Picasso: *Harlequin with Violin* (si tu veux)." *Cleveland Museum of Art Bulletin* 63(Jan. 1976):2-11.

1017. HENNING, EDWARD B. "The Cubist Collection at the Cleveland Museum of Art." *Apollo* 105(Jan. 1977):53-6. 8 illus.

Since 1966 the Cleveland Museum has acquired prime examples from every stage of Cubism's development: five major works by Picasso and Braque, a sculpture by Lipchitz, a Cubist related work by Braque and three prints by Picasso and Braque. In addition, Cubist influenced work has been acquired. Cubist work had not previously been obtained because the late 19th and 20th century collections had been largely assembled with the help of Leonard Hanna, whose interest did not extend beyond Post-Impressionism. The Fauves and Surrealists are still unrepresented at Cleveland but the outlook for them seems bright.

1018. HENNING, EDWARD B. "Two New Cubist Paintings by Juan Gris and Pablo Picasso." *Cleveland Museum of Art Bulletin* 68(Feb. 1981):38-50.

1019. "Henri Rousseau and Modernism" in *Henri Rousseau* (Paris: Grand Palais, 1984), pp. 35-89. 104 illus.

Considers Rousseau in the context of his contemporaries, comparing him with Gauguin and Seurat. The authors find his paintings very different in feeling from the former's though having much in common with his manner, and noting a similar candor in the process of painting of both Rousseau and Seurat. They consider Rousseau in relation to the Post-Impressionists and Fauvists, stating that he used the styles of both schools, and describe the influence of Rousseau on Picasso from 1908, comparing it with that of Cézanne. In their opinion, it was through Picasso that Rousseau's influence

penetrated to later artists such as Derain, Dufy, Diego Rivera, and Weber; for Braque and Léger, however, the influence of Rousseau was direct.

1020. HOBHOUSE, JANET. "The Fauve Years: A Case of Derailments." *Art News* 75:6(Summer 1976):47-50. 7 illus.

1021. HOCHFIELD, SYLVIA. "The Rubin Years." *Art News* 89:ppt. 2(Feb. 1990):130-3. 4 illus., 2 col.

Reviews William Rubin's time as Director of New York's Museum of Modern Art, during which he orchestrated many landmark exhibitions, referring to the Museum's *Picasso Retrospective* (1980) and *Picasso and Braque: Pioneering Cubism* (1989).

1022. HODIN, J. P. "Quand les artistes parlent du sacré." *XX^e siècle* 26(Dec. 1964):24.

1023. HOEREE, ARTHUR. "Chronique musicale." *Beaux-arts* 14(15 July 1924):220-1.

1024. HOOG, MICHEL. "*Les Demoiselles d'Avignon* et la peinture à Paris en 1907-1908." *Gazette des Beaux-arts* ser. 6., 82(Oct. 1973):212.

1025. HOPPE-SAILER, RICHARD. "Ding und Form: Thesen zur Neubestimmung einer radikalen Malerei" [Object and Form: Theses for a New Understanding of a Radical Painting]. *Kunstforum International* 88(March-April 1987):134-41. 6 col. illus.

Seeks to dispense with rigid lines of artistic development and to open perspectives on current radical art by setting it in the context of 20th century modernism. Hoppe-Sailer considers works by Mondrian, Picasso, Braque, Kandinsky and Klee, and takes Marcel Duchamp's *Door, 11 rue Larry* of 1927—a single door with two openings in walls at right angles to each other—as a metaphor for the intermeshing of object and form, concept and realization, and the "balance, tension and risk" of current radical art.

1026. HUBER, C. "Die Begegnung von Architektur und freiere Kunst in der neuen Hochschule St. Gallen für Wirschafts- und Sozialwissenschaften." With English and French summaries. *Quadrum* 19(1965):136-7.

1027. HUGGLER, M. "Die Sammlung Hermann und Margrit Rupf." *Du* (March 1956).

1028. HUMBERT, AGNES. "Les Fauves et le Fauvisme." *Jardin des arts* 12(Oct. 1955).

1029. HUYGHE, RENE. "Histoire de l'art contemporain: la peinture." *L'Amour de l'art* 14(Nov. 1933):209-40.

a. Reprint: Paris: Alcan, 1935.

1030. "Ici et ailleurs—prospectus de la quinzaine." *Le Bulletin de la vie artistique* 24(15 Dec. 1924).

1031. JUDKINS, WINTHROP. "Toward a Reinterpretation of Cubism." *Art Bulletin* 30:4(Dec. 1948):270-8.

1032. KAHN, WOLF. "Hofmann's Mixed Messages (A Former Student Remembers the Artist's Famous Teaching Method)." *Art in America* 78(Nov. 1990):188-91[+].

1033. KOWZAN, TADEUSZ. "Spójność Czasu i Przestrzeni w Nowych Formach Muzycznych i Plastycznych" [The Interdependence of Time and Space in New Musical and Plastic Forms]. *Rocznik Historii Sztuki* 10(1974):56-71. 7 illus. Summary in French.

Enlarged version of an essay published in French in *Diogène* 73(Jan.-March 1971) which discusses in part Braque's Cubist vision.

1034. LA FURETIERE. "La Curiosité." *L'Amour de l'art* (June 1921).

1035. LANGNER, JOHANNES. "Figur und Saiteninstrument bei Picasso: Ein Bildthema im Kubismus" [The Figure and Stringed Instrument in Picasso's Work: A Pictorial Motif in Cubism]. *Pantheon* 40:2(April-June 1982):93-113. 31 illus. Summary in English and French.

Examines the origin and development of the pictorial motif of the figure and stringed instrument in Pablo Picasso's œuvre from 1909-20. Argues that the origins of this motif can be traced back to Camille Corot's works and examines the significance of this theme for Picasso: he particularly favors the traditional erotic interpretation of the stringed instrument as a metaphor for the female body. Picasso's untiring inventive treatment of this motif inspired not only Georges Braque but also many avant-garde artists like Jacques Lipchitz, Marc Chagall, Man Ray, and Balthus.

1036. LAUDE, JEAN. "Retour et/ou rappel à l'ordre?" in *Le Retour à l'ordre dans les arts plastiques et l'architecture, 1919-1925. Travaux VII.* (Saint-Etienne: Université de Saint-Etienne, 1975).

1037. LEBENSZTEJN, JEAN-CLAUDE. "SOL(I)" [and] "SOL II" in *Scolies* 1(Paris: PUF, 1971):95-119 and *Scolies* 2(Paris: PUF, 1972):89-111.

1038. LEYMARIE, JEAN. "Il Fauvismo: la piena maturità." *L'Arte moderna* 3:26-7(1967).

1039. LLOYD, CHRISTOPHER H. "Reflections on La Roche-Guyon and the Impressionists." *Gazette des Beaux-arts* ser. 6, 105(Jun. 1985):37-44.

1040. MAKOVISKI, SERGEI. "Khudozhestvinnye itogi." *Apollo* 10(1910):24-34.

Russian text that discusses French and Russian painting of the early 20th century, including Braque and Matisse.

1041. MARCUS, SUSAN. "The Typographic Element in Cubism, 1911-1915: Its Formal and Semantic Implications." *Art International* 17(May 1973):24-7[+].

1042. MASARYKOVÁ, ANNA. "III. výtvarných umělců" [The Third Exhibition of the 'Group of Avant-Garde Artists' in the Communal House, Prague, May-June 1913]. *Umĕni* 30:4(1982):379-81. 1 illus. In Czech.

Appreciation of the historical importance of the exhibition of Czech and foreign artists (Picasso, Braque, Derain) as well as of popular art; analyzes the poster designed by Josef Kysela and the theoretical positions of the participants revealed in the introduction to the catalogue by the painter Vincenc Benĕs.

1043. MATHEY, FRANÇOIS. "Le Laboratoire cubiste." *L'Arte moderna* 4:30(1968).

1044. MCCLAIN, JEORALDEAN. "Time in the Visual Arts: Lessing and Modern Criticism." *Journal of Aesthetics and Art Criticism* 44(Fall 1985):41-58.

1045. METZINGER, JEAN. "Note sur la peinture." *Pan* (Oct.-Nov. 1910):649-52.

1046. MITCHELL, T. "Bergson, Le Bon, and Hermetic Cubism." *Journal of Aesthetics and Art Criticism* 36:2(Winter 1977):175-83.

Links Henri Bergson's ideas with certain Cubist works incorporating aspects of the subject glimpsed over a period of time. The scientific writings of Gustav Le Bon relate, and were seen at the time to relate, to Bergson's philosophy. Le Bon's work was also available to a large public and anticipates, to a striking degree, modern physics, especially in its view of energy and matter as interchangeable. For Le Bon, only energy was fundamental, matter being "a temporary stabilization in the constant flux of energy." Mitchell draws an analogy between this view of reality and two paintings by Picasso and Braque, as representative of "hermetic cubism," in which the "effect is simply that of a momentary consolidation within the pervasive atmospheric medium."

1047. "Modern Art and Modern Taste: The Albert D. Lasker Collection." *Art News Annual* 27(1958):38+.

1048. MYERS, B. "Cubism, the Search for Form and Space." *American Artist* 16(Jan. 1952):40-3+.

1049. "National Gallery of Art, Washington, D.C.: Chester Dale Bequest." *Burlington Magazine* 107(July 1965):397.

1050. NAUMANN, FRANCIS M. and MARIUS DE ZAYAS. "How, When and Why Modern Art Came to New York." *Arts Magazine* 54:8(April 1980):96-126. 129 illus.

With the help of his better-known friend and associate Alfred Stieglitz, the Mexican author, caricaturist and gallery owner Marius de Zayas was instrumental in the presentation, promotion and acceptance of modern art in New York during the second decade of this century. This account, composed by de Zayas sometime in the late 1940s, makes extensive use of the many newspaper reviews which accompanied or followed exhibitions held at either his gallery or "291." Of special note are his discussions of Matisse, Braque, Derain, and Maurice de Vlaminck, among many other artists and modern art movements. The article is accompanied by an introduction,

conclusion and notes by Francis Naumann, with an appendix by Eva Epp Raun listing the exhibitions held at the Modern and de Zayas galleries.

1051. OZENFANT, AMEDEE and CHARLES-ETIENNE JEANNERET. "Nature et création." *L'Esprit nouveau* 19(1923).

1052. PAULHAN, JEAN. "Le Patron des cubistes." *Nouveau femina* (Feb. 1956).

1053. PEILLEX, GUY. "Quelques chefs-d'œuvre des collections suisses." *Werk* 51(Sept. 1964):346.

1054. PERATE, ANDRE. "Salons de 1907." *Gazette des beaux-arts* 38(1 May 1907).

Exhibition review which mentions Braque in context of the Fauves.

1055. PERET, BENJAMIN. "Handle with Care" [inspired by a painting by Braque] in Samuel M. Kootz, *Women* (New York: S. M. Kootz Editions, 1948), pp. 9-11.

1056. PERRUCHOT, HENRI. "Les Origines de l'abstraction." *Jardin des arts* 90(May 1962).

1057. PICARD, D. "Cubiquer en noir et blanc." *Connaissance des arts* 397(March 1985):72-7. 8 illus.

Reassesses the character of the Cubist's research and experimentation, on the occasion of an exhibition of Cubism at the Galerie Berggruen, Paris (1985). The individual interpretations of the Cubist ethic, as expressed in the art and writings of Picasso, Braque, Jacques Villon, Gleizes, Metzinger and Marcel Duchamp, and the role of Kahnweiler and Apollinaire are briefly discussed.

1058. PONCE DE LEON, AROLINA. "El objeto: antes, durante, y lo demás" [The Object: Before, During, and so forth]. *Art en Colombia* (Colombia) 35(Dec. 1987):75-9, 131-2. 7 illus. Summary in English.

Traces the use of the object in 20th century art, as an example of the variety of interpretations of artistic identity pursued by the avant-garde. The author describes the Cubist's use of objects: distortions of perspective, interplay of two-and three-dimensional space, and the collages of Picasso and Braque; Marcel Duchamp's ready-mades, in which the context of the object contributes to the definition of its identity; "*objets trouvés*"; and new possibilities in art after the Second World War, with particular reference to Joseph Beuys, whose sculptures and performances are discussed in detail.

1059. PONTIGGIA, ELENA. "Il primo rapporto sul Cubismo; lettera di Severini a Boccioni" [The First Report on Cubism: Severini's Letter to Boccioni]. *Critica d'arte* 52:12 (Jan.-March 1987):62-70. 5 illus., 4 col.

Introduces and publishes Severini's letter of 1910 from Paris to Boccioni, now in the Boccioni Archive in Padua, Italy. Pontiggia notes that the letter constitutes the first information that the Futurist received of the avant-garde. Severini's criticism of Cubism, his discernment of a distinction between Picasso and Braque and the Cubists,

and Boccioni's use of the letter in his own writings of 1911-12 are discussed. In the letter Severini distinguishes three groups among the avant-garde (Cubists, Picassians, and Independents), calls Cubism "heroic but infantile," comments caustically on Braque and criticizes both the Picassians (for their restricted use of color, choice of humble subjects, and their ideas on the representation of objects) and the Cubists (dismissed as backward-looking), though he has praise for Picasso's and Braque's "truly new and formidable boldness."

1060. PORTER, ALLAN. "Die Einsicht kam von Bild zu Bild" [The Vision Which Spread From Photograph to Pictures]. *Du* 4(April 1989):26-9. 5 illus.

Study of the first attempts by photographers in the late 19th century, such as Eadweard Muybridge and Etienne Jules Marey, to convey the impression of movement in their pictures of objects in motion. Porter states that these experiments greatly influenced Picasso, Braque, Marcel Duchamp, and the Italian Futurist painters, thus contributing to the development of modernism in art.

1061. RAYNAL, MAURICE. "L'Actualité de Corot et Delacroix." *L'Intransigeant* (23 June 1930).

1062. RESTANY, PIERRE. "Les Biennales contre l'Ecole de Paris." *La Galerie des arts* 18(July-Sept. 1964):12-21.

1063. REWALD, JOHN. "Modern Fakes of Modern Pictures." *Art News* 52(March 1953):16.

1064. RIBEMONT-DESSAIGNES, GEORGES. "L'Abstraction c'est de la peinture mondaine." *Arts* (Dec. 1953).

1065. ROBINSON, KEITH. "Still Life to Stilled Lives." *Creative Camera* 3(1987):12.

The conventional view of the still life, suggests Robinson, has been more concerned with the description of objects than with any intrinsic meaning. The genre of still life is offered as the testing ground for innovation in art techniques, from the trompe l'œil of Chardin to the modernist compositional experiments of Cézanne, Braque, and Picasso. Robinson suggests that the effects of light upon the traditional objects of the still life, the rendering of reflection and transparency, are analogous to the photographic process itself. While the medium's properties may convey a certain interest in themselves, he sees contemporary photographers' use of still life as part of a quest for meaning beyond formal content.

1066. ROCHE, HENRI-PIERRE. "Souvenirs du collectionneur Henri-Pierre Roché." *L'Œil* 51(March 1959).

1067. ROSENBERG, C. "Cubist Object Treatment: A Perceptual Analysis." *Artforum* 9(April 1971):30-6.

1068. ROSENBERG, LEONCE. "Parlons peinture." *L'Esprit nouveau* 5(1920):578-84.

1069. ROSENBERG, LEONCE and TERIADE EMMANUEL. "Nos enquêtes: entretien avec M. Léonce Rosenberg." *Feuilles volantes* 6(1927):1-3.

1070. ROSENBERG, LEONCE. "Les Lettres de Léonce Rosenberg à Roger Dutilleul." Edited by Francis Berthier. *Archives de l'art français* 26(1984):271-6.

Presents a selection of letters written by the art dealer Léonce Rosenberg (1877-1947) to Roger Dutilleul (1874-1957), one of the most important collectors of modern paintings of the period and the first person to collect Cubist works. Berthier describes Rosenberg as a dealer who supported paintings for its artistic qualities, paying scant regard to commercial aspects and prevailing tastes. He represented Georges Braque, Pablo Picasso, Fernand Léger, Jean Metzinger, Juan Gris, and Jacques Lipchitz, among others. The letters are concerned less with pure business matters than with questions of philosophy and art theory, and convey Rosenberg's conviction that, despite the doubts of the public and of the establishment, avant-garde would be of lasting importance.

1071. ROSENBERG, PAUL. "French Artists and the War." *Art in Australia* 4:4(Dec. 1941-Feb. 1942):19-29.

Braque is mentioned on p. 26.

1072. ROTZLER, WILLY. "Apollinaire und seine Freunde" [Apollinaire and His Friends] *Du* 3(March 1982):26-67. 42 illus.

In the artistic milieu of early 20th century Paris, Guillaume Apollinaire was a key advocate of the new. Rotzler comments on his unhappy love life and traces his career as writer and journalist, concentrating on his contacts with artists: the Fauves, Picasso, who during these years inaugurated Cubism, Braque, Robert and Sonia Delaunay, and the Futurists. The relationship between his poetry and developments in art is noted. His literary and critical activity continued unchecked through war service till his death in 1918.

1073. ROTZLER, WILLY. "Das lebendige Museum: zur Geschichte der Sammlung" [The Living Musem: On the History of the Collection]. *Du*(1986):18-53. 36 illus., 17 col.

Comments on the opening of a new building for the collection of 20th century art of the Kunstsammlung Nordrhein-Westfalen in Düsseldorf in March, 1986. Rotzler discusses the origins of this collection in the acquisition by the regional government of eighty-eight works by Paul Klee in 1960, and asserts that the collection has since become one of the finest of its kind in existence. He emphasizes the vital role played by the museum's director, Werner Schmalenbach, in establishing the collection and mentions some of its outstanding works, including paintings by Picasso, Braque, Kandinsky, Juan Gris, Robert Delaunay, Marc Chagall, Max Ernst, Fernand Léger, Miró, Magritte, Dalí, and Mondrian.

1074. RUBIN, WILLIAM STANLEY. "Cézannism and the Beginning of Cubism" in *Cézanne, The Late Works*, (New York: The Museum of Modern Art, 1977).

1075. RUSSOLI, FRANCO. "L'Arte Europea tra il 1930 e il 1945: problemi, richerche, proposte." *L'Arte moderna* 12:100(1967).

1076. SAIDENBERG, NINA. "Juan Gris le cubiste." *Galerie-Jardin des arts* 135(March 1974):10-3. 7 illus.

On the occasion of the first retrospective devoted to the work of Juan Gris, at l'Orangerie, Paris, Saidenberg re-examines the artist's importance in the history of Cubism. She gives an outline of his career from his early life in Madrid and Barcelona, showing how his meeting with Picasso in Paris in 1906 established him in that city. His early career was as a cartoonist for such journals as *Charivari* and *Cri de Paris*, while at the same time he painted in secret. In 1911, for the first time, his studio was opened to the public and a new and important Cubist painter was revealed. Gris's connections with Picasso, Braque, Kahnweiler, Gertrude Stein, and Matisse are outlined and his subsequent career traced, with the statement that if Picasso played the role of enlightener, Gris was the explorer of the as yet new fields of Cubism.

1077. SALLES, GEORGES. "Histoire d'un plafond." *Preuves* (June 1963).

1078. SALMON, ANDRE. *L'Art vivant* (1920).

1079. SALMON, ANDRE. "Les Fauves et le fauvisme." *L'Art vivant* 57(1 May 1927):321-2.

1080. SAURE, WOLFGANG. "Das Musée d'Art moderne in Troyes." *Kunst* 4(April 1986):267-74. 8 col. illus.

Discusses the holdings of the Musée d'Art moderne, Troyes, which houses the collection of Pierre Lévy, and important private collector whose holdings of modern art are rendered all the more interesting by his refusal blindly to follow tastes dictated by intellectuals. The museum thus possesses works by significant artists who have almost been forgotten, including Charles Despiau, Marcel Gimond, and Joseph Csaky. The strength of the collection is its holdings of works by Derain and Braque.

1081. SAURE, WOLFGANG. "Berlin-Paris." *Kunst* 4(April 1987):314-8. 5 col. illus. In German.

Discusses the influence of French literature, fashion, painting and lifestyle on the culture and society of Berlin since the 17th century. Saure describes Berlin as the catalyst and crystallization point between East and West and notes the part played by Berlin in promoting the Parisian avant-garde, Fauves and Cubists. He comments on the influence of Robert Delaunay, Cézanne, Picasso, and Georges Braque on the Berlin art scene of the early 20th century.

1082. SHATTUCK, ROGER W. "Art and Ideas: Captions or Illustrations? An Artists's Handbook." *Salmagundi* 81(Winter 1989):5-28.

1083. SIMPSON, I. "Modern Art." *Artist* 95:1(Jan. 1980):28-31. 8 illus.

In this introduction to modern art Simpson takes as his starting point the Impressionist movement, which illustrates, he claims, the artist's alienation from society, his

rejection of traditional modes of representation, and the way in which artists have turned to looking to themselves for motivation. He develops further the theme of artists concentrating on one aspect of art and exploring its limitations, tracing a concern for the structure of a painting from Cézanne through Braque and Picasso to Mondrian, and a concern with the handling of paint from Titian through van Gogh and Munch to Rothko and Pollock.

1084. "Soirée de Paris." *Le Bulletin de la vie artistique* 24(15 Dec. 1924).

1085. STEINBERG, LEO. "Resisting Cézanne: Picasso's *Three Women*." *Art in America* 66:6(Nov.-Dec. 1978):114-33.

1086. SUMNER, MAUD. "Recollections of Paris." *Apollo* 102:164(Oct. 1975):286-93. 16 illus.

Maud Sumner's account of her life and work in Paris from her entry into the Ateliers de l'art sacré in 1926. Sumner writes of her contact with Maurice Denis, Georges Desvallières, Maria Blanchard, Braque, Léger, Villon, and Lacasse.

1087. SUTTON, DENYS. "The World of Sachaverell Sitwell, 7: 'Tonight the Ballet'." *Apollo* 112:224(Oct. 1980):238-47. 25 illus.

1088. TERIADE, EMMANUEL. "Documentaire sur la jeune peinture, II: L'Avènement classique du cubisme." *Cahiers d'art* 10(1929):447-53. 7 illus.

1089. TERIADE, EMMANUEL. "Devoirs d'écoliers ou inquiétudes de maîtres." *L'Intransigeant* (4 Feb. 1930).

1090. TERRASSE, ANTOINE. "La Règle est l'émotion." *La Nouvelle revue française* 253(Jan. 1974):68-71.

1091. THORSTENSON, INGER JOHANNE. "André Lhote og den første Kubismen" *Konsthistorisk Tidskrift* 53:3(1984):125-32. 5 illus. In Danish; English summary.

Examines Lhote's Cubist paintings of 1910-20, arguing that these works were the product of Lhote's own theory of Cubism, which differed internationally from the Cubist theory of Picasso and Braque.

1092. VAN RUTTEN, PIERRE. "Peinture et poésie, ou le pouvoir de l'art dans oiseaux." *La Revue des lettres modernes: histoire des idées et des littératures* 925-31(1989):141-6.

1093. VLAMINCK, MAURICE DE. "Fauves et cubistes." *L'Art vivant* (1 Jan. 1929):1-2.

1094. W., H. "Les Collages cubistes." *Art d'aujourd'hui* 5(March-April 1954):4-7.

1095. WALLE, ODILE VAN DE and HENRI DESCHAMPS. "L'Artistan des artistes. Entretien avec Henri Deschamps chromistes chez Mourlot." *Le Point* (17 July 1978).

1096. WEISBERG, GABRIEL P. "Paris Cafés: Their Role in the Birth of Modern Art." *Arts Magazine* 60:5(Jan. 1986):90-1. 2 illus.

Reviews the exhibition *Paris Cafés: Their Role in the Birth of Modern Art* at Wildenstein's, New York (13 Nov.-20 Dec. 1985), which proposed that the Paris café was the center for the avant-garde where many new ideas were proposed and exchanged. Among the artists whose work was included in the exhibition were Degas, Félix Vallotton, and Braque. Although sometimes pedestrian in manner, Weisberg concludes that the exhibition developed a rich theme and showed that much more could be learned about how all aspects of artistic creativity were intertwined, not just the avant-garde.

1097. WEN, GEORGE. "Hélèna Bokanowski: Parquet and Pop." *Art News* 88:7(Sept. 1989):97-8, 100. 5 illus., 4 col.

Profile of wealthy Parisian collector Hélène Bokanowski, looking at the way her eclectic collection fits into the décor of her house. Wen notes that Bokanowski's home is full of juxtapositions that seem to defy "good taste." Artists and designers mentioned include Roy Lichtenstein, Charles Rennie Mackintosh, Gustav Klimt, and Braque. She inherited the backbone of her collection from her uncle, gold industrialist Alphonse Kahn, whom she describes as one of the most perceptive collectors of the early 20th century.

1098. "What's Modern to Whom? Samples of Letters from Readers." *Art News* 48(March 1949):11.

1099. WILL-LEVAILLANT, FRANÇOISE. "La Lettre dans la peinture cubiste" in *Le Cubisme*, Travaux IV (Saint-Etienne: Université de Saint-Etienne, 1973).

1100. ZERVOS, CHRISTIAN. "Les Dernières œuvres de Picasso." *Cahiers d'art* 4:6(1929).

1101. ZOLLINGER, HEINRICH. "Farben—gesehen, erkannt und erlebt" [Colors—Seen, Recognized and Perceived] in *Von Farbe und Farben: Albert Knoepfli zum 70. Geburtstag.* pp. 9-12. 3 illus.

After discussion of the dichotomy between Newton's and Goethe's color theories, shows that Newton was correct concerning light stimuli in the cone cells of the retina, but that Hering's opponent color scheme which is consistent with Goethe's theory is substantiated by electropotential measurements in consequent nerve cells of the eye and in the brain. The linguistic evolution of basic color terms as found by Berlin and Kay (1969) and correlated with the neurophysiology of color vision by Zollinger (1976, 1979) is compared to the history of painting (Cubism, Suprematism) in statements of Malevich, Braque, Picasso, and others.

Exhibitions

I. Individual Exhibitions . 143
II. Group Exhibitions . 162

I. Individual Exhibitions

1908, 9-28 November	Paris, Galerie Kahnweiler. *Exposition Georges Braque*. Catalogue texte de Guillaume Apollinaire. 27 paintings. First private exhibition. Reviews: L. Vauxcelles, *Gil Blas* (14 Nov. 1908); *Télégramme* (Toulouse) (5 Jan. 1909); *Mercure de France* (16 Jan. 1909). Braque's first one-artist exhibition. Included paintings rejected at the 1908 Salon d'Automne (Paris, Grand Palais).
1914, Spring	Dresden, Galerie Emile Richter. *Georges Braque*. Also shown Berlin, Galerie Feldmann. 38 works.
1919, 5-31 March	Paris, Galerie de l'Effort moderne (Léonce Rosenberg). *Georges Braque*. Reviews: R. Bissière, *Opinion* (29 March and 26 April 1919); A. Lhote, *Nouvelle revue française* 6:69(1 June 1919):153-7 (reprinted in *La Peinture, le cœur et l'esprit*. Paris: Denoël et Steele, 1933, pp. 25-9).
1921, 30 May	Paris, Hôtel Drouot. *Catalogue des tableaux, aquarelles, dessins par Georges Braque* [et al.] *composant la collection Uhde*. 15 p., illus. 17 works. A list of Braque's works with prices fetched appeared in *L'Esprit nouveau* 2(1921):1563.
1922, 1 November-20 December	Paris, Grand Palais, *Salon d'Automne* (Salle d'honneur) 18 works. Honor room devoted to Braque. Works exhibited included his *Canephorae*. Reviews: P. Husson, *Montparnasse* 17(1 Nov. 1922):2; A. Salmon,

La Revue de France (Dec. 1922):618; P. Fiérens, *Sélection* 9-10(15 Dec. 1922):279-83.

1924, 2-21 May	Paris, Galerie Paul Rosenberg. *Georges Braque.* 16 works. Review: P. Crevel, *Les Nouvelles littéraires* 82(10 May 1924):7.
1925, March	Berlin, Galerie Flechtheim. *Georges Braque.*
1925, December	Paris, Galerie Vavin-Raspail. *Georges Braque.*
1926, 8-27 March	Paris, Galerie Paul Rosenberg. *Exposition d'œuvres de Georges Braque.* Frontispiece of the catalogue illustrated with Braque's first lithograph. 62 works. Reviews: H. Hertz, *L'Amour de l'art* 7(April 1926):135-40; G. Charensol, *L'Art vivant* 32(15 April 1926):316-8.
1930, May	Paris, Galerie Paul Rosenberg. *Georges Braque.* Review: P. Fierens, *Art News* 28(17 May 1930):26.
1933, 9 April-14 May	Basel, Kunsthalle. *Georges Braque.* Préface de Carl Einstein. 23 p., 163 illus. 183 works. Reviews: *Werk* 20:5(Sept. 1933):30; *Cahiers d'art* 8:1-2(1933):1-84 Includes texts by Christian Zervos, Guillaume Apollinaire, André Salmon, Roger Bissière, Blaise Cendrars, André Lhote, Ardenzo Soffici, Jean Cassou, André Breton, H. S. Ede, and Carl Einstein.
1934, July	London, Alex Reid & Lefevre Galleries. *Paintings by Georges Braque.* 10 p., illus. 41 works. Reviews: *Cahiers d'art* 9:5-8(1934):205; *Apollo* 20:116(Aug. 1934):1004.
1934, 26 November-15 December	New York, Valentine Gallery. *Exhibition of Recent Paintings by Georges Braque.* 2 p. 16 works. Review: *Art News* 33(8 Dec. 1934):6.
1936, 8-31 January	Paris, Galerie Paul Rosenberg. *Œuvres récentes de Georges Braque.* 8 p., illus. 20 works. Review: *L'Amour de l'art* 17:4(April 1936):151-2.
1936, July	London, Alex Reid & Lefevre Galleries. *Thirty-six Paintings by Georges Braque.*
1936, 28 September-11 November	London, Tate Gallery. *An Exhibition of Paintings G. Braque.* Arranged by the Arts Council of Great Britain; in association with the Edinburgh Festival Society. 51 p., 24 pl.

1936, November–December	Brussels, Palais des Beaux-arts. *Georges Braque.* Préface de Georges Aragon. 16 p., illus. 81 works. Review: *L'Amour de l'art* 18(Feb. 1937):64.
1937, 3-30 April	Paris, Galerie Paul Rosenberg. *Exposition d'œuvres récentes de Georges Braque.* 5 p. 18 works. Reviews: A. Lhote, *Nouvelle revue française* 48(May 1937):795-7; *Cahiers d'art* 12:1-3(1937):96-100.
1938, 4-21 February	Paris, Galerie Pierre. *Georges Braque; Paysages de l'époque fauve (1906).* Review: J. Bonjean, *Les Beaux-arts* 75:268(18 Feb. 1938):4.
1938, July	London, Rosenberg & Helft, Ltd. *Recent Works of Braque.* 3 p. 22 works.
1938, 14-29 October	New York, Buchholz Gallery. *Some Selected Paintings by G. Braque.* 3 p., illus. 16 works. Review: *Art News* 37(22 Oct. 1938):14.
1938, 16 November–10 December	Paris, Galerie Paul Rosenberg. *Exposition Braque.* 3 p. 22 works. Reviews: *Renaissance* 21(Jan. 1939):44; M. Zahar, *London Studio* 17:117(Feb. 1939):82-3.
1939, 4-29 April	Paris, Galerie Paul Rosenberg. *Exposition Braque (œuvres récentes).* 3 p., illus. 27 works. Reviews: G. Bazin, *Prométhée* 20(June 1939):179-81; *Emporium* 90(July 1939):40; *Studio* 118(July 1939):35.
1939, 6 June-8 July	London, Rosenberg & Helft, Ltd. *Georges Braque: Recent Works* 3 p., illus. 24 works. Review: *Studio* 117(Feb. 1939):82-3.
1939-40, 7 November-3 March	Chicago, Arts Club of Chicago. *Georges Braque Retrospective Exhibition.* Also shown Washington, D. C., Phillips Collection (6 Dec. 1939-6 Jan. 1940) and San Francisco, Museum of Art (6 Feb.-3 March 1940). Preface by James Johnson Sweeney; biographical note by Henri McBride. Facsimile of Braque's letter to Mrs. Goodspeed. 8 p., 5 illus. 68 works (Chicago); 55 works (Washington D. C.); 67 works (San Francisco). Reviews: *Art Digest* 14(1 Dec. 1939):5; A. Frankfurter, *Art News* 38(6 Jan. 1940):10.
1941, 13 January–8 February	New York, Valentine Gallery. *An Exhibition of Paintings by Georges Braque.* 2 p., 27 works. Review: *Art News* 39(25 Jan. 1941):15.

1942, 7-25 April	New York, Paul Rosenberg & Co. *An Exhibition of Paintings by Braque.* 3 p. 13 works. Reviews: *Art Digest* 16(15 April 1942):10; *Art News* 41(1 May 1942):33.
1942, 22 November-27 December	Baltimore, Baltimore Museum of Art. *Georges Braque.* 1 p. 16 works.
1943, 21 May-19 June	Paris, Galerie de France. *Douze peintures de Georges Braque (1908-1910).* 12 paintings.
1945, 20 October-12 November	Amsterdam, Stedelijk Museum. *Georges Braque.* 6 p., illus. 26 works. Review: W. Münsterberger, *Phoebus* 1:1(1946):40.
1945, 24 November-13 December	Brussels, Palais des Beaux-arts. *Georges Braque.* 7 p. 27 works.
1946, 29 April-18 May	New York, Paul Rosenberg & Co. *Paintings by Braque.* 3 p. 1 works. Reviews: *Art Digest* 20(1 May 1946):12; *Pictures on Exhibit* 8(May 1946):58; *Art News* 45(June 1946):52.
1947, 30 May-30 June	Paris, Galerie Maeght. *Georges Braque.* Catalogue published in *Derrière le miroir* 4(1947). Textes de René Char, Georges Braque, Jacques Kober. 8 p. Special issue. 58 works. Char's texte reprinted in *Cahiers d'art* 22(1947):334. Reviews: S. Fumet, *Studio* 133(May 1947):152; M. Zahar, *Panorama des arts* (1947):148-9; C. Zervos, *Cahiers d'art* 22(1947):320; R. Cognia, *Arts Magazine* 118(6 June 1947):1; G. Veronesi, *Emporium* 106:635-6(Nov.-Dec.1947):121-3.
1947, November	New York, Seligmann-Helft Gallery. *Georges Braque.* Review: *Art News* 46(Nov. 1947):58.
1948, 5-24 January	New York, Paul Rosenberg & Co. *Paintings by Braque.* 3 p. 15 works. Reviews: *Pictures on Exhibit* 10(Jan. 1948):18, 20, 32; *Art News* 46(Jan. 1948):40; *Art Digest* 22(15 Jan. 1948):11.
1948, 29 May-30 September	Venice, *XXIV Biennale Internazionale d'Arte.* *Salle Braque.* Venice: Serenissima, 1948. Note by Raymond Cogniat. 20 works, 2 in the Peggy Guggenheim Collection. Room devoted to Braque. Awarded the Grand Prix for painting. Braque's works discussed on pp. 266-8, 339. Review: A. Podestà, *Emporium* 108:613-4(July-Aug. 1948):41-4.
1948	Chaux de Fonds. *Braque.*

1948, September	Geneva, Musée d'Athénee. *Georges Braque.*
1948, October	Freiburg-im-Breisgau, Paulussaal. *Georges Braque; Gemälde, Graphik, Plastik.* Introduction by Elfried Schulze. 24 p., illus.
1948, October	Basel, Galerie d'Art moderne. *Exposition Georges Braque.*
1949, January	Paris, Galerie Maeght. *Georges Braque.* Catalogue published in *Derrière le miroir* 25-6 (1949). Textes de René Char et Henri de Maldiney.
1949, 25 January-12 June	Cleveland, Cleveland Museum of Art. *Georges Braque.* Also shown New York, Museum of Modern Art (29 March-12 June). Catalogue by Henry Radford Hope. Texts by Jean Cassou (trans. by Monroe Wheeler) and William S. Lieberman. 16 p., illus. Pages 11-28 cover Braque's early career and Fauve period. Reviews: L. Burchfield, *Cleveland Museum of Art Bulletin* 36(Jan. 1949):16; A. Frankfurter, *Art news* 47(Feb. 1949):1, 24-35+; *Art Digest* 23(15 April 1949):17; C. Greenberg, *Partisan Review* 16(April 1949):528-31; *Pictures on Exhibit* 11(April 1949):16, 47.
1949	Stockholm, Galerie Blanche. *Braque.*
1949	New York, Paul Rosenberg & Co. *Georges Braque.* Reviews: *Pictures on Exhibit* 12(Nov. 1949):24; *Art Digest* 24(1 Nov. 1949):9; *Art News* 48(Nov. 1949):51.
1949	Copenhagen, Association pour l'art français. *Braque.*
1949	Stuttgart, *Georges Braque: Gemalde, Graphik, Plastik.* Avec la cooperation du gouvernement militaire de Bâle.
1950, January-February	Paris, Galerie Maeght. *Peintures de Braque.* Préface de René Char. Paintings, prints, and illustrated books by Braque. Reviews: *Werk* 37(April 1950):44; *Art News* 49(May 1950):53; *Emporium* 112(July 1950):42; *Cahiers d'art* 25:2(1950):388-91.
1950, September	Stockholm, Galerie Samlaren. *Braque.*
1950	Feldfing. *Georges Braque: das graphische Werk.* Katalog von Lotha Günther Buchheim. 16 p., illus.
1952, June-July	Paris, Galerie Maeght. *Peintures de Georges Braque.* Catalogue published in *Derrière le miroir* 48-9(1952). Textes d'Alberto Giacometti et Jean Grenier; lithographies en couleurs de Braque. Reviews: *Time*

60(14 July 1952):70; *Apollo* 56(Aug. 1952):34; *Studio* 144(Oct. 1952):121-3.

1952, September-
October

Tokyo, National Museum. *Exposition des œuvres de Georges Braque à Tokio.* Exposition organisée pour le Musée National de Tokio et le journal Yomiuri par un comité d'organisation composé de A. Maeght [et. al]. 32 p., illus., 33 pl., some col.

1952, 6-25 October

New York, Paul Rosenberg & Co. *Braque, 1924-1952.* Reviews: *Art Digest* 27(1 Oct. 1952):16; *Pictures on Exhibit* 15(Oct. 1952):14, 24; *Art News* 51(Oct. 1952):44.

1953, 24 April-
19 July

Bern, Kunsthalle. *Georges Braque.* Also shown Zurich, Kunsthaus (7 June-19 July). Preface by Arnold Rüdlinger. 16 p., illus., 32 pl. (Zurich ed.: 20 p., 32 pl.). Reviews: *Werk* 40(June 1953):88; *Emporium* 118(July 1953):36-45; *La Biennale di Venezia* 15(Aug. 1953):32; *Werk* 40(Aug. 1953):121-2.

1953, 14 November-
6 December

Liège, Musée des Beaux-arts, A.P.I.A.W. Exposition organisée par l'A.P.I.A.W. *L'Œuvre graphique de Braque.* Catalogue et texte de Michel Seuphor. 100 works. Nearly all of Braque's graphic works were represented.

1953, November-
December

Paris, Berggruen & Cie. *Braque, graveur.* Catalogue par Michel Seuphor (pseud. F. L. Berckelauers). 244 p., 19 pl., some col. 40 prints.

1954, 20 March-
19 April

Basel, Kunsthalle. *Georges Braque, œuvres graphiques.* Préface, extraits du *Cahier* de Braque. 8 p., illus., 8 pl. 84 works, 75 prints, 4 illustrated books, 5 posters. Reviews: *Emporium* 119(May 1954):223-5; *Werk* 41(May 1954):88.

1954, 14 May-3 July

London, Institute of Contemporary Arts Gallery. *Braque; Paintings and Drawings from Collections in England with Lithographs.*

1955, January-July

Cologne. *Georges Braque, das graphische Gesamtwerk 1907-1955.* Also shown Düsseldorf, Krefeld, and Berlin. Preface by Paul Wember. 59 prints, 10 illustrated books.

1955, 3 October-
29 November

New York, Paul Rosenberg & Co. *Paintings by Braque.* Reviews: *Arts Magazine* 30(Oct. 1955):48[+]; *Art News* 54(Nov. 1955):49.

1956, April-May

Paris, Galerie Maeght. *Œuvres récentes de Georges Braque*. Catalogue published in *Derrière le miroir* 85-6(1956). Texte de J. Dupin. Review: *Studio* 152(Sept. 1956):89-90.

1956

New York, Knoedler Galleries. *Braque Bronzes*. Reviews: *Art News* 55(May 1956):236-9[+]; *Pictures on Exhibit* 19(May 1956):16.

1956, 18 August-
11 November

Edinburgh, Royal Scottish Academy. *An Exhibition of Paintings, Georges Braque*. Sponsored by the Edinburgh Festival Society and arranged by the Arts Council of Great Britain in association with the Royal Scottish Academy. International Festival, 1956. Including the essay "The Evolution of a Vision." Also shown London, Tate Gallery (28 Sept.-11 Nov.). Catalogue by Douglas Cooper. 51 p., 87 illus., 12 pl. Reviews: J. Richardson, *Studio* 152(Sept. 1956):82-7; *Illustrated London News* 229(1 Sept. 1956):345; R. Alley, *Burlington Magazine* 98(Nov. 1956):417; D. Lewis, *Aujourd'hui* 2:11(Jan. 1956):42; P. Heron, *Arts Magazine* 31(Feb. 1957):34-8; *Architectural Review* 121(Feb. 1957):128-9.

1956, December

Rotterdam, Boymans-van Beuningen Museum. *Sculptures et gravures de Braque*. Preface by E. W. [J.-C. Ebbinge Wubben]. Organized by l'Association française d'action artistique. 44 p., illus. Sculptures, 66 lithographs, 13 illustrated books.

1956-57, December-
January

Cincinnati, The Contemporary Arts Center. *The Sculpture of Georges Braque*. Preface by Jean Leymarie. 12 p., illus.

1958, 15 June-
19 October

Venice, *XXIX^e Biennale Internazionale d'Arte. Salles Braque*. Rooms XLI and XLII were devoted to Braque's works. Review: J. Leymarie, *Quadrum* 5(1958):72-3.

1958, 13 September-
19 October

Geneva, Musée d'Art et d'histoire. *L'Œuvre graphique complète de Georges Braque*.

1958

Geneva, Galerie Nicolas Rauch. *L'Œuvre graphique originale de Braque; livres illustrés de Braque*. Poèmes de René Char. Catalogue raisonné établi par Edwin Engelberts. Review: *Werk* 45(Nov. 1958):222.

1958, October

Paris, Galerie Adrien Maeght. *G. Braque: Grands livres illustrés*. Poèmes d'Antoine Tudal; texte de Roger Vieillard.

1958-59, November-early January	Rome, Palazzo Barberini. *Ente premi Roma, Mostra antológica di Georges Braque.* Catalogue by R. Pallucchini. Braque was awarded the Feltrinelli Prize by the Academy of the Arts. Review: J. Lucas, *Arts Magazine* 33(Feb. 1959):18-9.
1959, 19 June	Paris, Galerie Maeght. *Georges Braque.* Catalogue published in *Derrière le miroir* 115(1959). Reviews: *Kunstwerk* 13(Aug. 1959):69; *Studio* 158(Nov. 1959):124.
1959	Boston, Museum of Fine Arts. *Paintings from the Stedelijk Museum, Amsterdam.* Also shown Milwaukee and Columbus.
1960, 5 April-6 May	Geneva, Galerie Gérald Cramer. *Le Tir à l'arc, mis en lumière par Georges Braque.* Texte de Jean Paulhan. 52 p., 5 pl.
1960, 9 April-29 May	Basel, Kunsthalle. *Georges Braque.* Textes d'Arnold Rüdlinger, Pierre Volboudt, Carl Einstein. 60 p., illus. Reviews: *Kunstwerk* 13(March 1960):15-6; S. Frigerio, *L'Art aujourd'hui* 5(June 1960):58-9; *Werk* 47(June 1960):113-4.
1960, 20 April-5 June	Pasadena, Pasadena Art Museum. *Georges Braque.* Introduction by Thomas W. Leavitt; Catalogue by Robert M. Ellis. 28 p., illus.
1960, 24 June-16 October	Paris, Bibliothèque nationale. *Georges Braque, œuvres graphiques.* Préface de Julien Cain, textes de Jean Valléry-Radot et Jean Adhémar. 46 p., 30 illus 128 works. Reviews: K. Morand, *Burlington Magazine* 102(Aug. 1960):378; P. Schneider, *Art News* 59(Oct. 1960):48; A. Michelson, *Arts Magazine* 35(Nov. 1960):21.
1961, November-December	Paris, Galerie Mollien, Musée du Louvre. *L'Atelier de Braque.* Préface de Jean Cassou. Catalogue rédigé par Gabrielle Vienne. Review: E. Roditi, *Arts Magazine* 36(March 1962):28.
1962, 21 June-26 July	Paris, Galerie Adrien Maeght. *Georges Braque, dessins.*
1962-63, 22 September-20 January	Cincinnati, Contemporary Arts Center. *Braque: An Exhibition to Honor the Artist on the Occasion of his Eightieth Anniversary.* Also shown Chicago, Arts Club (6 Nov.-6 Dec.); Minneapolis, Walker Art Gallery (20 Dec.-20 Jan. 1962). Introduction by Allen T. Schoener.

32 p., illus. Review: F. Schulze, *Art News* 61(Dec 1962):24.

1962-63,
17 December-
17 January

Paris, Bibliothèque nationale. *L'Ordre des oiseaux. Saint-Jean Perse—Georges Braque.*

1962-63, December-
January

Paris, Galerie Maeght. *La Liberté des mers. Pierre Reverdy—Georges Braque.* Textes de Stanislas Fumet, Pierre Reverdy, François Chapon. Catalogue published in *Derrière le miroir* 135-6(1962). 28 p., illus., some col.

1963, 22 March-Fall

Paris, Musée des Arts décoratifs. *Bijoux de Braque.* Also shown Zurich, Gimpel-Hanover Galerie (June-July); New York, Wally F. Galleries. Catalogue by Jeanine Fricker. 111 p., col. illus. Reviews: T. Del Denzio, *Apollo* 77(May 1963):420-1; R. Goodden, *Design* 176(Aug. 1963):58-9; L. Moholy, *Burlington Magazine* 105(Sept. 1963):419; *Werk* 50(Aug. 1963):180; F. Mathey, *Quadrum* 14(1963):94.

1963, 13-31 May

Paris, Bibliothèque littéraire Jacques Doucet. *Georges Braque—René Char. Manuscrits, livres, documents, estampes. Edition illustrée de Lettera Amorosa.* Avant-propos de Georges Blin. Catalogue par François Chapon.

1963, May

Paris, Galerie Maeght. *Georges Braque, papiers collés 1912-1914.* Catalogue published in *Derrière le miroir* 138(1963). Texte de Stanislas Fumet. Review: G. di San Lazzaro, *XX^e siècle* 25(Dec. 1963):12.

1963, 18 October-
15 December

Munich, Haus der Kunst. *Georges Braque.* Katalog Redaktion: Douglas Cooper. 84 p., 165 illus., 7 col. pl. 107 works. Reviews: K. Champa, *Art International* 7:9(5 Dec. 1963):42-3; L. Moholy, *Burlington Magazine* 105(Dec. 1963):580-1.

1963, November-
December

Stuttgart, Galerie Valentien. *Georges Braque: Ausstellung. 80 Blatt Originalgraphik und 10 illuustrierte Bücher.* 12 p., illus.

1964, 1 February-

Menton, Palais de la Méditerranée. *V^e Biennale [de la peinture de France].* Exposition internationale dédiée en hommage posthume à Georges Braque.

1964, 7 April-2 May

New York, Saidenberg Gallery. *Georges Braque, 1882-1963: An American Tribute.* Edited by John Richardson. New York: Public Education Association, 1964. 108 p., 89 pl. Included exhibitions at various

New York galleries, including Saidenberg Gallery, *Fauvism and Cubism*; Perls Galleries, *The Twenties*; *Paul Rosenberg & Co.*; *The Thirties*; M. Knoedler & Co., *The Late Years, 1940-1963, and the Sculpture.* Reviews: J. Richardson, *Art News* 63(April 1964):29-31+; S. Tillim, *Arts Magazine* 38(Sept. 1964):60.

1964, 14 June-
2 August

Lubeck, Gebrüder Schmidt. *Georges Braque; Bewegung, Ruhe und Reife; das graphische Werk.* 62 p., illus.

1964, 18 June-18 July

Geneva, Galerie Gérard Cramer. *Guillaume Apollinaire, 'Si je mourais là-bas': poèmes ornés de bois gravés originaux de Georges Braque.* Préface de Jacques Guignard. Paris: L. Border, 1964. 12 p., illus.

1964, 26 July-
31 August

Honfleur, Salle des expositions du Grenier à sel. *Hommage à Georges Braque.* Préface d'André Richard.

1964-65,
14 November-
7 February

Oslo, Kunsterns Hus. *Georges Braque, Malerier, Grafik, Skulptur.* Also shown Bergen, Kunstforening (15 Jan.-7 Feb. 1965). Preface by Jean Cassou, texts by Frederick Matheson and Bjarne Johannessen. 62 p.

1965, 13 February-
21 March

The Hague, Gementemuseum. *Sieraden van Georges Braque.* Compiled by Heger de Löwenfeld. 10 p., illus.

1965, 26 May-
30 September

Paris, Musée du Louvre, Salle Etrusque. *Présentation de la donation Braque.* Organisée par la Réunion des Musées Nationaux de France. Préface de Jean Cassou, Catalogue par Jean Leymarie. 40 p., 23 illus., 4 col. Review: G. Schurr, *Connoisseur* 159(Aug. 1965):258.

1965

New York, Wally F. Galleries. *Braque Jewelry.* Reviews: *Art News* 64(Oct. 1965):8; T. Gentille, *Craft Horizons* 25(Nov. 1965):43; *Arts Magazine* 40(Dec. 1965):59.

1965

Dallas, Neiman-Marcus. *Jewels of Braque.* 4 p., col. illus.

1965

Mainz, Bildende Kunst. *Georges Braque. Festrade zu seinem Gedächtnis gehalten in Mainz.*

1967, 15 April-
31 May

Le Havre, Nouveau Musée du Havre. *Georges Braque: peintures, sculptures, céramique, tapisserie, œuvres graphiques.* Préface de Patrice Hugues. 28 p., 13 illus., 2 col. 100 prints.

1967, June	Paris, Galerie Maeght. *Georges Braque: derniers messages*. Introduction de Jean Grenier. Catalogue published in *Derrière le miroir* 166(1967). 34 p., 24 illus., 6 col.
1968, 5 April-4 May	Paris, Galerie Stadler. *Cinquante bijoux de Georges Braque*.
1968, July-September	Basel, Galerie Beyeler. *Georges Braque*. Textes de Georges Braque et Dora Vallier. 84 p., illus., col. pl.
1969, January-February	Nice, Galerie des Ponchettes. *Bijoux de Braque*. Catalogue par Henri-Michel Heger de Löwenfeld.
1971, 15 July-31 August	Munich, Galerie Stangl. *Georges Braque. Katalog der sculptures, précieuses et bijoux Braque*. Ausgeführt durch Heger de Löwenfeld. 21 p., illus.
1971, 7 November-4 December	Bonn, Rheinisches Landesmuseum. *Georges Braque; das lithographische Werk*. Katalog der Ausstellung aufgestellt von Hermann Wünsche; mit einem Brief von Edwin Engelherts als Vorwort. 155 p., 136 col. pl. 158 works.
1971	Milan, Galleria d'Arte Cavour. *Georges Braque*. Catalogo delle sculture preziose e dei gioielli, realizzati da Heger De Löwenfeld. Esposizione delle repliche. 102 p., 37 illus., 36 col.
1972, 22 March-16 July	Wolfenbüttel, Herzog-August-Bibliothek. *Georges Braque*. 4 p., illus.
1972, 7 October-3 December	Chicago, Art Institute of Chicago. *Braque: The Great Years*. Text by Douglas Cooper. Catalogue edited by Donald H. Karshan. 116 p., 106 illus., 16 col. This exhibition consisted of the major and monumental works of the late period of Braque. Douglas Cooper re-examines a series of Braque's works saying that we can now forget about the schools and theories of the early part of the 20th century, forget misguided critical opinion and rediscover the truth about Braque as revealed by his works and utterances, rare and sibylline as the latter are. Cooper traces an historical line from Braque's formative years 1905-17, through the period of self-reorientation 1917-18, the Guéridons of 1918-19, the Mantelpieces and Kanepholi of 1920-27, more Guéridons 1922-30, the '30s, the war years—from the Kitchen Tables to the Billiard Tables 1940-49, to the Studios of 1949-56, and other late works. a. English ed.: London: Weidenfeld, 1973.

Reviews: *Chicago Art Institute Calendar* 66(May-Aug. 1972):7; *Burlington Magazine* 114(Nov. 1972):803; M. Young, *Apollo* 97(Jan. 1973):101-3.

1972 Stuttgart, Galerie Valentien. *Bijoux de Braque: Goldschmuck nach Entwürfen von Georges Braque.*

1972 London, Lumley Cazelet Gallery. *Georges Braque.* Reviews: P. Gilmour, *Arts Review* 24:22(4 Nov. 1972):685; *Burlington Magazine* 114(Dec. 1979):884.

1973, 4 February-October Dieppe, Château-musée de Dieppe. *Georges Braque, œuvres graphiques (donation Laurens I).* Préface de Pierre Bazin. 45 p., illus. 50 works. Review: A. Jouffroy, *XX^e siècle* 35:40(June 1973):183.

1973, 12 July-31 August Mont-de-Marsan, Musée de Mont-de-Marsan. *Georges Braque.*

1973-74, 16 October-14 January Paris, Orangerie des Tuileries. *Georges Braque.* Texte de Jean Leymarie. Catalogue rédigé par Michèle Richet et Nadine Pouillon. Paris: Editions des Musées Nationaux, 1973. 185 p., 152 illus., 16 col. 140 works shown. Jean Leymarie contributes an introduction to this exhibition catalogue in which he briefly outlines the artist's life and gives a short description of the development of the painter's style, with reference to various paintings in the exhibition. Leymarie notes Braque's association with Picasso, the effect of the First World War on his work and his period of decorative luxuriance in the 1930s. There is also an analysis of each painting in the exhibition, noting historical, bibliographical and exhibition information. Reviews: M. Richet and N. Pouillon, *La Revue du Louvre et des musées de France* (1973):319-22; P. Descarges, *L'Œil* 219(Oct. 1973):32-41; *Connaissance des arts* 260(Oct. 1973):151; J. Chabanon, *Peintre* 473(15 Nov. 1973):6-7; J.-J. Lévêque, *Galerie-Jardin des arts* 130(Oct. 1973):48-9, 52-4; L. Cabatti, *Bolafiarte* 33:4(Oct. 1973):72-5; P. Davay, *Clés pour les arts* 38(Dec. 1973):19-21; *Art International* 17(Dec. 1973):52; *Art News* 72(Dec. 1973):83; E. Hoffman, *Burlington Magazine* 116:850(Jan. 1974):63-4; *Gazette des Beaux-arts* ser. 6, 83(Jan. 1974):15-6; J. Dauriac, *Pantheon* 32:1(Jan. 1974):94-5; *Connoisseur* 185(Jan. 1974):83; P. Daix, *Gazette des Beaux-arts* ser. 6, 83(Feb. 1974):261-2; J. Gállego, *Goyá* 120(1974):371.

1974-75, 15 November-20 January Rome, Accademia di Francia, Villa Medici. *Braque.* In collaboration with l'Association française d'action artistique. Text by Jean Leymarie. 180 p., 96 illus., 13

col. In Italian. 78 works shown. Forty-three paintings, mainly from public and private collections in Paris, nineteen drawings, and fourteen sculptures, mainly from the collection of Mr. and Mrs. Claude Laurens, Paris, who are the beneficiaries of the Braque estate. Most of the drawings and gouaches had never been exhibited before. Full catalogue entries are included. Each work is illustrated and many of the sculptures are accompanied by sketches from the Laurens collection. Review: A. Henze, *Kunstwerk* 28(March 1975):47.

1974	Germany, Kunstvereins für die Rheinlande und Westfalen. *Georges Braque: Buchgraphik.* Mit Unterstüzung des Kulturministeriums Nordrhein-Westfalen. Katalog von Melita Dederichs. 79 p., illus.
1974	Dieppe, Château-musée de Dieppe. *Braque donation Laurens II.* 50 prints.
1975	Barcelona, Sala Gaspar. *Georges Braque (1882-1963): 19 pinturas de 1919-1962.* Review: *Goyá* 125(March 1975):312.
1975	Tokyo, Shinchosa. *Braque.* Text by Magochi Kushida.
1978, 26 April-28 May	Montrouge, Centre Culturel et artistique. *XXIIIᵉ Salon de Montrouge: Art contemporain et Georges Braque.* 69 p., illus.
1978, May-June	Chicago, Art Institute of Chicago. *Georges Braque.* Thirteen paintings were displayed to represent the various periods or the styles of the artist's work. Four are owned by the Art Institute, Chicago: *Still Life* (1919), *Harbor in Normandy* (1909), *Fruits and Guitar* (1938), and *Wheatfield* (1951-52). On loan were nine additional paintings, eight from the Leigh B. Block collection. Review: A. Speyer, *Bulletin of the Art Institute of Chicago* 77:3(May-June 1978):6.
1978, September-November	Madrid, Fundación Juan March. *Georges Braque: Oleos, gouaches, relieves, dibujos y grabados.*
1978-79, Fall-3 March	London, Arts Council of Great Britain. *The Graphic Work of Georges Braque.* Also shown London, French Institute (2-30 Nov. 1978); Aberdeen, Art Gallery and Museum (16 Dec.-21 Jan. 1979); Stalybridge, Astley Cheetham Public Library and Art Gallery (6 Feb.-3 March 1979). Introduction by Tim Hilton. 8 p., 11 illus., 1 col. 71 works shown. Brings together all early works and a full selection of later graphics, 1908-62. Catalogue focuses on the influence of Cézanne and

Picasso, outlining the development of Cubism and the role of graphic art within Braque's œuvre. Braque's etchings and lithographs date mainly from two periods, before and after the 1920s and 1930s. This exhibition brings together all the early prints and a wide selection of the later prints, with an introduction tracing the Impressionist, Fauvist and Cubist strains in Braque's work, and analyzing the influence of Cézanne and Picasso on his prints. Hilton compares Braque's etching technique to his use of paint and considers the contribution of the prints to his total œuvre. The list of exhibits provides details of title, date, materials, measurements and edition. Reviews: F. Watson, *Arts Review* 30:22(10 Nov. 1978):611; B. Reynolds, *Arts Review* 31:8(27 April 1979):215.

1978-79, 7 October-21 January

Marcq-en-Barcoeul, Fondation Anne et Albert Prouvost à Septentrion. *Georges Braque*. Préface de Jacques Lassaigne; texte de Martine Mathias. 30 p., illus. Review: *L'Œil* 281(Dec. 1978):89.

1979, January

Saint-Paul-de-Vence, Fondation Maeght. *Gravures de Braque*. Préface de Jean-Louis Prat. 70 works.

1979, September-November

Madrid, Fundación Juan March. *Georges Braque: oleos, gouaches, relieves, dibujos y grabados* [Georges Braque: Oils, Gouaches, Reliefs, Drawings and Graphics]. Textos, Jean Paulhan, et al. Traducción, Martan Sanchez. 65 p., 54 illus., 24 col. 69 prints. Review: *Goyá* 154(Jan.-Feb. 1980):236-7.

1980, 5 July-30 September

Saint-Paul-de-Vence, Fondation Maeght. *Georges Braque*. Exhibition réalisée par Jean-Louis Prat. 12 p., 127 illus., 53 col. Texts include an introduction by Jean-Louis Prat (pp. 7-10); "Bref condensé de notre dette à jamais et reconnaissance à Braque particulièrement en cet été 80" by Francis Ponge (pp. 13-20); "Un espace devenu tactil" by Claude Esteban (pp. 31-47); "L'Apparence" by Nicolas Calas (pp. 54-70). Reviews: *L'Œil* 300-1(July-Aug. 1980):71; M. Böhan, *Kunstwerk* 33:6(1980):55.

1981-82, 22 November-31 January

Stuttgart, Staatsgalerie Stuttgart. *Georges Braque: Ausstellung zum 100. Geburtstag: Zeichnungen, Collagen, Druckgraphik, illustrierte Bücher*. Katalogbearbeitung, Magdalen M. Moeller. Ausstellung, Magdalena M. Moeller und Gunther Thiem. 42 p., illus., some col. Review: G. Presler, *Weltkunst* 51:24(15 Dec. 1981):3814-5.

1981

Münster, Hachmeister & Schnake Galerie. *Georges Braque aus dem graphischen Œuvre von 1911-1963.* Mit einem Vorwort von H. A. Hachmeister. 82 p., illus., some col.

1982, May-June

Argenteuil, Galerie du Centre culturel, municipalité d'Argenteuil. *Georges Braque: eaux-fortes, lithographies.* Textes par Francis Ponge, Elizabeth Caillet, Antoine Tudal. 43 p., illus., some col.

1982, 14 May-
28 November

Bordeaux, Galerie des Beaux-Arts. *Georges Braque en Europe: centenaire de la naissance de Georges Braque (1882-1963).* Also shown Strasbourg, Musée d'Art moderne (11 Sept.-28 Nov. 1982). Préface de Jean Leymarie; avant-propos par Gilberte Martin-Mery, Jean Favière. 304 p., 159 illus., 18 col.
Introduction by Jean Leymarie followed by the catalogue, comprising the following sections: paintings, beginnings (1900-07); Cubism (1908-19, 1920-39, 1940-63); sculpture; plaster and ceramics; and tapestries. Includes full catalogue entries with illustrations. In the introduction Leymarie traces Braque's early life and considers in detail the different stages of his artistic development. Most of the works completed by Braque in his youth have been destroyed, but they consisted of landscapes influenced by Cézanne and still lifes. Between 1909 and 1928 Braque abandoned landscapes and concentrated on figure painting and still life. The author also examines the association between Braque and Picasso in the period 1909-18, before their paths divided. In 1923 Braque returned to Normandy and between 1933 and 1938 worked on a succession of still lifes placed on tablecloths on varying colors. During the German Occupation of France in the Second World War he painted interiors which revealed that his feelings at this time fluctuated between hope and anguish. After France was liberated in 1944 he returned to Normandy to complete his work *Le Salon* and between 1949 and 1956 he completed his visionary *Ateliers* sequence. The catalogue is divided into sections for Braque's early paintings 1900-07, Cubism 1908-19, The softening 1920-39, the final blooming 1940-63, sculptures, ceramics, and tapestries. Also included are a facsimile reprint of Guillaume Apollinaire's introduction to the catalogue of the exhibition *Georges Braque* at the Galerie Kahnweiler, Paris (Nov. 1908) and a list of Braque's exhibitions. Reviews: R. Micha, *Art International* 25:7-8(Sept.-Oct. 1982):8-17; J.-P. Dauriac, *Pantheon* 40:3(July-Sept. 1982):251-2; M. Brunner, *Kunstchronik* 35:12(Dec. 1982):464-9; H. Ellweger, *Kunstwerk* 36:1(Feb. 1983):32-3.

1982, 16 June-17 July
Paris, Galerie Louise Leiris. *Braque et la mythologie*. Paris: La Galerie; dist. Librairie des Quatre Chemins, Editart, 1982. 85 p., illus., some col.

1982, 17 June-
27 September
Paris, Musée National d'Art moderne. Centre Georges Pompidou. *Œuvres de Georges Braque (1882-1963); Collections du Musée National d'Art moderne.* Catalogue établi par Nadine Pouillon avec le concours de Isabelle Monod-Fontaine. 224 p., 312 illus., 39 col. Reviews: *Goyá* 167-8(March-June 1982):330; F. Dunlop, *Arts Review* 34:15(16 July 1982):383.

1982-83, 17 June-
16 January
Paris, Musée National d'Art moderne, Centre Georges Pompidou. *Georges Braque, les papiers collés.* Also shown Washington, D.C., National Gallery (31 Oct.-6 Jan. 1983). Catalogue par Isabelle Monod-Fontaine. Trans. by Annie Perez and Anny Amerni. 224 p., 175 illus., 9 col. Texts include "Braque et le papier collé" by Douglas Cooper (pp. 7-11); "Braque et Picasso au temps des papiers collés" by Pierre Daix (pp. 12-25); "Braque, le cubisme et la tradition française" by Edward F. Fry (pp. 26-36); "Braque, la lenteur de la peinture" by Isabelle Monod-Fontaine (pp. 37-42); "Georges Braque et les origines du langage du cubisme synthétique" by Alvin Martin (pp. 43-56); and "Braque, le collage et le cubisme tardif," by E. A. Carmean Jr. (pp. 57-63).
a. U.S. ed.: *Braque, the papiers collés*. Washington, D.C.: National Gallery of Art, 1982. 179 p., illus., some col. Reviews: M. Bompart, *Zygos* 54(July-Aug. 1982):6-10; G. Tinterow, *Burlington Magazine* 124:955(Oct. 1982):651-2; *Gazette des Beaux-arts* ser. 6, 100(Oct. 1982):27.

1982, 4 October-
10 November
Geneva, Galerie Patrick Cramer. *Georges Braque: 30 livres illustrés.* 63 p., illus.

1982-83, 9 October-
14 September
Washington, D.C., Phillips Collection. *Georges Braque: The Late Paintings (1940-1963).* Also shown San Francisco, Fine Arts Museums of San Francisco, California Palace of the Legion of Honor (1 Jan.-15 March 1983); Minneapolis, Walker Art Center (14 April-14 June 1983); Houston, Museum of Fine Arts (7 July-14 September 1983). Introduction by Robert C. Cafritz; "Georges Braque: The Late Paintings (1940-1963)," by Herschel B. Chipp; text by Laughlin Phillips. 112 p., 68 illus., 50 col., 13 photos. 50 works shown. Catalogue to an exhibition of the oil paintings Braque produced in the last twenty-three years before his death. In his introduction, Cafritz discusses the expressive power of the late paintings in the context of Braque's

entire œuvre. Chipp's essay provides a detailed analysis of the exhibited paintings in thematic groupings for still lifes, billiard tables, birds, studios, landscapes and seascapes. He concludes that the *Billiard Tables* and *Studios* series represent the fulfillment of Braque's obsession with the formal potentialities of Cubism, while the clarity and classic restraint of Cubism also dominates the other works. This centenary exhibition was the first in the U.S. to attempt a survey of Braque's œuvre from the final phase of his career. Assembled form European and American collections, the fifty oils in the exhibition displayed the full range of Braque's late, lyrical expression, in monumental still lifes, figures and landscapes. Reviews: *Art Journal* 43:19(Spring 1983):83-6; R. Cafritz, *Connoisseur* 212:849(Nov. 1982):140-4; *Apollo* 116(Dec. 1982):424; R. Rubenfeld, *New Art Examiner* 10:3(Dec. 1982):6; J. Perl, *Art in America* 71:2(Feb. 1983):78-86; W. Agee, *New Criterion* 1:6(Feb. 1983):5106; K. Moss, *Artweek* 14:8(26 Feb. 1983):1,16; A. Martin, *Art Journal* 43:19(Spring 1983):83-6; S. McGarry, *Southwest Art* 13:3(Aug. 1983):99-102; L. Fleming, *Art News* 82:4(April 1983):117-8.

1983, November-December	Stüttgart, Galerie Valentien. *Georges Braque: Ausstellung*. 80 prints, 10 illustrated books.
1983	Bari, Castello Svevo. *Georges Braque: Opere 1900-1963*. Edited by Carmine Benincasa. Venice: Marsilio Editori. 96 p., 61 illus., 46 col., 12 photos.
1984, 9 May-16 June	Milan, Galleria dell'incisione. *Georges Braque: opera grafica*. 6 p., illus., 17 pl., some col.
1984	Tokyo, Misukoshi, Nihon-bashi. *Toute l'œuvre gravée de Georges Braque*. Organized and published by Yomiuri Shimbun and Japanese Association of Art Museums. 176 p., 229 illus., 114 col. In French and Japanese.
1985, 3 April-4 May	London, Waddington Galleries. *Georges Braque: Engravings and Lithographs, 1911-1963*.
1985	Paris, Galerie Adrien Maeght. *Georges Braque: sculptures*. Texte de Dora Vallier. 46 p., illus., some col. Reviews: *Connaissance des arts* 401-2(July-Aug. 1985):90; *L'Œil* 360-1(July-Aug. 1985):97.
1985, 23 November-1987	Warminster, Warminster Art Centre. *Georges Braque: Illustrations to Poems by Guillaume Apollinaire*. Text by Helen Luckett. Organized by the Arts Council of

Great Britain. 6 p. (1 folded sheet), 7 illus. Exhibition guide to the illustrations by Braque for his own selection of poems by Apollinaire, *If I Should Die Out There*, with a description of the relationship between the two men and the circumstances of the commission, completed when Braque was in his late seventies. Extracts from Braque's notebooks and translations of two poems by Apollinaire are included. The exhibition toured to nine further venues in England in 1986 and was due to continue into 1987.

1986, March Biot, Musée National Fernand Léger. *Bonjour, Georges Braque!* Préface de Georges Bauquier. 85 p., illus.

1986, Summer Barcelona, Fundación para el Apoyo de la Cultura. *Georges Braque, 1882-1963*. Texts include: "Picasso i Braque, una trobada a Barcelona" by Gilberte Martin-Méry and Maria Teresa Ocana (pp. 13-5); "La 'Cordada de muntanya' Braque/Picasso" by Pierre Daix (pp. 17-25); "La Guitarra adormida" by Isabelle Monod-Fontaine (pp. 27-37); "Braque. La Recerca d'una nova bellesa" by Maria Teresa Ocana (pp. 39-53).

1987 Vienna, Kulturhaus der Stadt Graz. *Georges Braque, das druckgraphische Werk*. Introduction by Gustav Peichl. Texts by Otto Breicha, Sigrun Loos, Margret Sterneck. 157 p., illus.

1988, 4 March-
15 May Munich, Kunsthalle der Hypo-Kulturstiftung. *Georges Braque*. Herausgegeben von Jean Leymarie; mit Beiträgen von Jean Leymarie, Magdalena M. Moeller und Carla Schulz-Hoffmann. Munich: Prestel, 1988. 278 p., illus. Review: R. Müller-Mehlis, *Kunst* 4(April 1988):267-8.

1988, 10 June-
11 September New York, Solomon R. Guggenheim Musem. *Georges Braque*. Catalogue by Jean Leymarie, with contributions by Jean Leymarie, Magdalena M. Moeller, Carla Schulz-Hoffmann. Munich: Prestel-Verlag; New York: Te Neues Pub. Co., 1988. 280 p., 159 illus., 120 col. Retrospective exhibition of paintings, drawings and sculptures by Braque (1882-1963), with a detailed chronicle of his life and work by the author. Following an early stereometric phase inspired by Cézanne, Braque began to investigate form and its pictorial energy. This marked the beginning of his association with Picasso and their joint exploration of Cubism. Explaining how their paths separated during the First World War, Leymarie charts Braque's subsequent experiments with color, his return to landscape, his decorative still lifes of the 1930s, and his experiments with sculpture during the

Second World War. He concludes with an assessment of Braque's sequence of *Studio* paintings (1949-56), "the last and supreme phase of his journey." There are two other essays. Carla Schulz-Hoffmann focuses on Braque's investigation of Cubism in an attempt to rediscover its "significant value." Noting the problems they shared and influence they exerted on one another, she nevertheless identifies and explores the fundamental differences between Braque and Picasso. Magdalena M. Moeller discusses Braque's post-Cubist work after 1917, looking at how his works after this date diverged from strict Cubism in his explorations of volume, color and space. A list of his major solo and group exhibitions is appended.
Reviews: B. Schwabsky, *Arts Magazine* 63:1(Sept. 1988):93; R. Cafritz, *Burlington Magazine* 130:1026(Sept. 1988):717-9; L. Malen, *Art News* 87(Oct. 1988):175; K. Wilkin, *New Criterion* 7(Oct. 1988):52-8; L. Kachur, *Art International* 5(Winter 1988):106-7.

1988, 14 July-Winter

Shinjuku, Japan, Isetan Museum of Art. *Georges Braque*. Also shown Fukuoka, Fukuoka Art Museum (Summer 1988); Shizuoka, Shizuoka Prefectural Museum of Art (Fall 1988); and Yokohama, Sogo Museum of Art (Winter 1988). Catalogue by Gabriel P. Weisberg. Tokyo: Art Life, 1988. 160 p. 219 illus., 78 col. In Japanese and English. Catalogue to an exhibition of paintings, watercolors, drawings, prints, sculpture, and ceramics by Braque dating from 1902-62. The essay notes that as early as 1905 Braque had abandoned traditional ways of seeing and painting, and by 1909 his work reflected the period of analytical Cubism. By 1918 he had entered into the period of late synthetic Cubism and in the late 1920s he returned to painterly concerns within a decorative format. During the 1930s his position in the art world strengthened and a renewed period of activity returned in the later 1940s when he further developed one of his continuing interests: the subject of the artistic studio. His late canvases diverge in several directions but throughout his career he turned to objects close at hand for his subjects, and his late work reveals a creator motivated by the highest ideals of simplification.

1989

Geneva, Galerie du Théâtre. *Les Bijoux de Braque*. Review: *L'Œil* 406(May 1989):76.

1989

Madrid, Real Academia de Bellas Artes de San Fernando. *Georges Braque: estampes y ediciones de*

arte. Realización, Escuela-Taller 'Arte Grafico.' 113 p., illus.

1989

Tarascon, Château de Tarascon. *Braque: œuvre gravé*. Also shown Zaragoza, Museo Pablo Gargallo. Paris: A. Maeght, 1989. 160 p., illus.

1990

Bristol, City Museum and Art Gallery. *Georges Braque: Still-Lifes and Interiors*. Review: *Apollo* 132(Nov. 1990):354-5.

1990, 7 September-
9 December

Liverpool, Walker Art Gallery. *Braque: Still Lifes and Interiors*. A South Bank Centre Touring Exhibition. Also shown Bristol, City Museum and Art Gallery (27 Oct.-9 Dec. 1990). Text by John Golding and Sophie Bowness. 72 p., 47 illus., 31 col. Catalogue to an exhibition focusing on Braque's still lifes and atelier interiors, with thirty-two paintings from between 1908 and 1958 and four etchings. Braque's life and career is set out in detail in the essay by Golding who devised and selected the exhibition. He follows the progression of Cubist inventions and explores the theme of space in Braque's compositions, unraveling their iconographic riddles. The other essay by Bowness concentrates on Braque's interest in music and the musical objects in his compositions. The analogy between Cubist still life and chamber music is suggested. Reviews: M. Lothian, *Arts Review* 42(5 Oct. 1990):537; A. Parigoris, *Apollo* 132(Nov. 1990):354-5; D. Cottingham, *Burlington Magazine* 132(Nov. 1990):805-6.

1992

Martigny, Fondation Pierre Gianadda. *Georges Braque*. Reviews: *L'Œil* 443(July-Aug. 1992)):86; 444(Sept. 1992):80-3; L.-A. Prat, *Connaissance des arts* 485-6(July-Aug. 1992):48-53; S. Whyte, *Arts Review* 44(Oct. 1992):486-7; S. Bowness, *Burlington Magazine* 134(Oct. 1992):681-3.

II. Group Exhibitions

1906, 20 March-
30 April

Paris, Grand Palais, Cours la Reine. *Salon des Artistes Indépendants*. 7 paintings (which he later destroyed). Reviews: R. Chavance, *L'Autorité* (21 March 1906).

1906, 26 May-
30 June

Le Havre, Hôtel de Ville. *Cercle de l'Art moderne*.

1907, 20 March-
30 April

Paris, Grand Palais, Cours la Reine. *Salon des Artistes Indépendants*. 6 landscapes from L'Estaque, all sold, 5 to the German art critic Wilhelm Uhde.

1907, June	Le Havre, Hôtel de Ville. *Cercle de l'Art moderne.* Catalogue texte par Ferdinand Fleuret. 2 paintings.
1907, 1-22 October	Paris, Grand Palais. *Salon d'Automne.* 1 painting, later withdrawn by Braque. Review: G. Apollinaire, *Je dis tout* (19 Oct. 1907). Reprinted in *Apollinaire in Art* (1972):18-36.
1908, 20 March-2 May	Paris, Grand Palais, Cours la Reine. *Salon des Artistes Indépendants.* 5 paintings. Review: G. Apollinaire, *La Revue des lettres et des arts* (May 1908). Reprinted in *Apollinaire on Art* (1972):41-6.
1908, 18 April-24 May	Moscow, Salon de la Toison d'Or. 5 paintings.
1908, June	Le Havre, Hôtel de Ville. *Cercle de l'Art moderne.* Catalogue texte de Guillaume Apollinaire. 2 paintings. Apollinaire's essay, translated "The Three Plastic Virtues," is reprinted in *Apollinaire on Art* (1972):47-59.
1908, 3-20 July	Paris, Galerie E. Druet. 27 paintings.
1908-09, 21 December-15 January	Paris, Galerie Notre-Dame-des-Champs. 6 paintings. Reviews: K. Max, *Le Télégramme* (Toulouse) (Dec. 1908); C. Morice, *Mercure de France* (16 Dec. 1908):736-7.
1909, 22 January-28 February	Paris, Galerie Berthe Weill.
1909, 24 January-28 February	Moscow, Salon de la Toison d'Or.
1909	Paris, Grand Palais, Cours la Reine. *Salon des Artistes Indépendants.* 2 works.
1910, 1-15 September	Munich, Thannhauser Gallery.
1911, May	Berlin, 22 Berliner Sezession.
1911	Amsterdam, Stedelijk Museum. *Moderne Kunst Kunstkring.*
1912, 25 May-30 September	Cologne, Städische Ausstellungshalle am Aachenertor. *Internationale Kunstausstellung des Sonderbundes.*
1912, 5 October-12 December	London, Grafton Gallery. *Second Post-Impressionism Exhibition.*
1912, October	Amsterdam, *Modern Kunstkring.*

1913, 17 February- 15 March	New York, Association of American Painters and Sculptors, 69th Regiment Armory. *International Exhibition of Modern Art*. (Armory Show). Also shown Chicago and Boston. 3 works. First U.S. showing.
1913, 3 March- 6 April	Moscow. *Bubnovyi valet* (Jack of Diamonds).
1913, May-June	Prague, Communal House. *III. výstava Skupiny výtvarných umělců*. [Third Exhibition of the 'Group of Avant-Garde Artists' in the Communal House]. Included paintings of Czech and foreign artists (Braque, Picasso, and Derain, among others).
1914, 1 November- 20 December	Paris, Grand Palais. *Société du Salon d'Automne*.
1914-15, 9 December- 11 January	New York, Little Galleries of the Photo-Secession (291). *Drawings and Paintings by Picasso and Braque*.
1920	Paris, Grand Palais, Cours la Reine. *Salon des Artistes Indépendants*. 4 works.
1920	Paris, Grand Palais. *Salon d'Automne*. 3 works. Review: F. Fels, *Action* (5 Oct. 1920):61-5.
1921, 13-14 June	Paris, Hôtel Drouot. *Galerie Kahnweiler Collection*. 22 paintings. First (of four) sales of the Daniel-Henry Kahnweiler collection, during which Braque and dealer Léonce Rosenberg argued and came to blows. Altogether, 183 works by Braque were sold in the four sales (1921-23). Prices fetched for the first sale were published in *L'Esprit nouveau* 2(1921):1565-6. Review: G. Mounereau, *Echo de Paris*. (1921).
1921, 17-18 November	Paris, Hôtel Drouot. *Galerie Kahnweiler collection*. 38 paintings. Second of four Kahnweiler collection sales. Braque's works fetched low prices (see *L'Esprit nouveau* 2(1921):1825-9). Review: *Comoedia* (18 Nov. 1921).
1921	Paris, Galerie de l'Effort moderne. Review: W. George, *L'Esprit nouveau* 9(1921):1023-8.
1922, 4 July	Paris, Hôtel Drouot. *Galerie Kahnweiler collection*. 18 works. Third Kahnweiler collection sale.
1923, 7 May	Paris, Hôtel Drouot. *Galerie Kahnweiler collection*. 85 works.

1924, May-June	Paris, Théâtre des Champs-Elysées. *Ballets russes de Sergei de Diaghilev: grande saison d'art de la VIIIe Olympiade.* 40 p., illus., 6 pl.
1924, Summer-20 December	Paris, Galerie Paul Rosenberg. *Quelques peintres du XXe siècle.* Review: H. Martinie, *Der Cicerone* 16(Aug. 1924):751-6.
1924	Chicago, Arts Club of Chicago. *Braque and Laurencin.* Review: *Chicago Art Institute Newsletter* (1924):10.
1925	Mexico City, Instituto Nacional de Bellas Artes, Museo Nacional de Arte Moderno.
1926-27, 19 November-9 January	Brooklyn, Brooklyn Museum. *An International Exhibition of Modern Art.* Assembled by the Société anonyme.
1927, 15-30 April	Paris, Galerie Bing. *Les Fauves, 1904 à 1908.* Catalogue avec préface par Waldemar George. Review: *Drawing and Design* 2(June 1927):180-1.
1927	Hamburg, Kunstverein. *Europäische Kunst der Gegenwart.* Review: *Feuilles volantes* 6(1927):6-7.
1927	Washington, D.C., Phillips Memorial Gallery. *Leaders of French Art Today: Exhibition of Characteristic Works by Matisse, Picasso, Braque, Segonzac, Bonnard, Vuillard, Derain, André Maillol.* 16 p., 9 illus.
1927, 1-29 November	Washington, D.C., Phillips Memorial Gallery. *Intimate Decorations; Chiefly Paintings of Still Life in New Manners by Matisse, Braque, Hartley, Man Ray, Kuhn, O'Keeffe, Knaths and Others.* Text by Duncan Phillips. 5 p., 1 illus.
1929, May	Paris, Galerie Paul Rosenberg. *Georges Braque.*
1929, October	New York, Reinhardt Galleries. Opening exhibition. Review: *Art News* 28(19 Oct. 1929):4.
1930, February	Paris, Galerie Cardo. *Exposition de copies.*
1930, February	Paris, Galerie de France. *Exposition de maquettes de théâtre.* Organisée par Raymond Cogniat et *Les Chroniques du jour.*
1930, 21 September-mid-October	Berlin, Galerie Alfred Flechtheim. *Matisse, Braque, Picasso: 60 Werke aus deutschem Besitz.* 24 p., illus. 24 works. Braque's works discussed on pp. 10-4. Review: *Apollo* 12(Nov. 1930):372-3.

1930	New York, Paul Rosenberg Gallery. Review: L. Goodrich, *Art News* 17(Nov. 1930):117-9.
1930	New York, Reinhardt Galleries. Review: L. Goodrich, *Arts Magazine* 17(Nov. 1930):117-9.
1931, February	New York, Museum of French Art. *Picasso, Braque, Léger: Loan Exhibition.* Foreword by Maud Dale. 4 p. 5 works. Reviews: R. Flint, *Art News* 29(21 Feb. 1931):3-4; C. Burrows, *Apollo* 13(April 1931):238.
1931	Prague. *Exposition d'art français contemporain.*
1933	Paris, Salon d'Automne. Review: D. H. Kahnweiler, *Beaux-arts* (8 Sept. 1933):2.
1934, 13-31 March	New York, Durand-Ruel Galleries. *Braque, Matisse, Picasso.* 13 works. Review: L. Eglington, *Art News* 32:24(17 March 1934):3-5.
1934	Paris, *Exposition des Archives internationales de la danse.*
1935, March-April	Paris, *Beaux arts* and *Gazette des Beaux Arts.* *Les Etapes de l'art contemporain: V les créateurs du cubisme.* Préface de Maurice Raynal; texte de Raymond Cogniat. 33 p., illus. 25 works.
1935	Paris, Hôtel Drouot. *Collection Jacques Zoubaloff, tableaux modernes.* 16 works. Pages 5, 7, 23-4 describe paintings by Braque.
1936, 2 March-19 April	New York, Museum of Modern Art. *Cubism and Abstract Art.* Edited by Alfred H. Barr, Jr. 9 works. Braque's works are discussed beginning on p. 205.
1936, 5-31 October	London, Rosenberg & Helft, Ltd. *Exhibition of Masterpieces by Braque, Matisse, Picasso.* 11 p., illus. 14 works. Review: *Apollo* 24:143(Nov. 1936):301.
1936,	New York, Bignou Gallery. *Modern French Tapestries by Braque, Raoul Dufy, Léger, Lurcat, Henri Matisse, Picasso, Rouault: From the Collection of Madame Paul Cuttoli.* Foreword by Edouard Herriot. 20 p., illus.
1937, 6-30 January	Paris, Galerie Paul Rosenberg. *Braque, Picasso, Matisse.*
1937, June-October	Paris, Musée du Petit Palais. *Les Maîtres de l'art indépendant 1895-1937.* Catalogue avec textes de Raymond Escholier et Albert Sarraut. Paris: Arts et

Métiers Graphiques, 1937. 120 pp., illus. 29 works
(pp. 96-7). Review: 1. Vauxcelles, *Beaux-arts* 235(2
June 1937):2; M. Florisoone, *Beaux-arts* 237(2 July
1937):8.

1937, 14 October- 5 December	Pittsburgh, Carnegie Museum of Art. *The 1937 International Exhibition of Paintings.* Awarded first prize for *The Yellow Tablecloth* (1935).
1938,	Oslo, Kunstnernes Hus. *Utställning i de nordiska huvudstäderna, anordnad av Walther Halvorsen, av arbeten av Matisse, Picasso, Braque och Laurens.* Also shown Stockholm, Liljevalchs Konsthall; Copenhagen; Götenberg. Förord av Leo Swane om Matisse. Photograph by Roger-André. 32 p., illus. 39 works by Braque (p. 26). Review: W. Haalvorsen, *Cahiers d'art* 12:6-7(1937):18-21 (includes a catalogue excerpt translated into French).
1939, 25 February- 10 April	Amsterdam, Stedelijk Museum. *Parijsche Schilders.*
1939, 6 May-4 June	Bern, Kunsthalle. *Picasso, Braque, Gris, Léger, Borès, Beaudin, Vinés.*
1939	Paris, Galerie Charpentier. Review: G. M. Lo Duca, *Emporium* 90(July 1939):40.
1941, 6 January- 4 March	Richmond, Virginia Museum of Fine Arts. *Collection of Walter P. Chrysler, Jr.*. Also shown Philadelphia, Philadelphia Museum of Art. Catalogue by Henry McBride. 154 p., illus. 15 paintings (pp. 24-33).
1941, 20 October- 22 November	New York, Marie Harriman Gallery. *Les Fauves.* Preface by R. Lebel. 6 p. Reviews: *Art Digest* 16(1 Nov. 1941):9; *Art News* 40(1 Nov. 1941):32.
1942, 12 June-11 July	Paris, Galerie de France. *Les Fauves; peintures de 1903 à 1908.*
1943, 6 April-1 May	New York, Paul Rosenberg & Co. *Braque and Picasso.* 3 p. 6 works. Review: *Art Digest* 17(15 April 1943):14.
1943, 25 September- 31 October	Paris, Palais des Beaux-arts de la Ville de Paris. *Salon d'Automne* (Salle d'honneur). 26 paintings, 9 sculptures.
1943, 16 November- 4 December	New York, Buchholz Gallery. *Early Work by Contemporary Artists.*

1944, 6 October- 5 November	Paris, Grand Palais. *Salon d'Automne*. 2 works.
1944, 6 November- 2 December	New York, Paul Rosenberg & Co. *Exhibition of Paintings: Braque, Matisse, Picasso*. 3 p. 4 works.
1945, 25 May- 30 June	Paris, Galerie de France. *Le Cubisme, 1911-1918*. Introduction de Bernard Dorival; texte sur *La Guitare*. (1913) de Braque par André Lhote. 59 p., illus. 9 works (p. 31).
1945, June- 9 November	Philadelphia, Philadelphia Museum of Fine Art. *Picasso, Braque, and Léger*. 9 works. Review: *Art Digest* 19(June 1945):24.
1945, 28 September- 29 October	Paris, Palais des Beaux-arts de la Ville de Paris. *Salon d'Automne*.
1945-46 October- October	Limoges, Musée des Beaux-arts. *Peintures du Musée d'art moderne*. Also shown Saint-Etienne (Dec. 1945-Jan. 1946); Perpignan (Feb. 1946); Toulouse (March-April 1946); Bordeaux (May-June 1946); Amiens (July-Aug. 1946); Lille (Sept.-Oct. 1946).
1946, 29 January-	Paris, Galerie Maeght. *Sur 4 murs*.
1946, April-May	London, Tate Gallery. *Braque-Rouault: Exhibition of Paintings*. Introduction by Germain Bazin. 11 p. 28 works. Reviews: *Art News* 42(June 1946):43; H. Fell, *Connoisseur* 117(June 1946):123-4; C. Gordon, *Studio* 132(July 1946):21.
1946, 28 June- 30 September	Chicago, Art Institute of Chicago. *Braque and Picasso*. 5 works.
1946, 21 September- 20 October	Zurich, Kunsthaus. *Georges Braque, Wassily Kandinsky, Pablo Picasso*. 22 p. 26 works. Reviews: C. Giedion-Welcker, *Werk* 33(Nov. 1946):143; M. Bill, *Arts Magazine* 100(3 Jan. 1946):8. Braque's works are discussed on pp. 3-5.
1946, 18 November- 28 December	Paris, Musée d'Art moderne. *Exposition internationale d'art moderne—peinture, art graphique et décoratif, architecture*. Organisée par la Commission préparatoire de l'ONU.
1946-47, 6 December- 11 January	Paris, Galerie Maeght. *Le Noir est une couleur*. Reviews: P. Du Colombier, *Fantasia* (26 Dec. 1946), *Derrière le miroir* (Feb.-March 1947); J. Guichard, *Temps présent* (13 Dec. 1946); M. F. *Le Courrier de*

l'étudiant (8 Jan. 1947); J. Kober, *Derrière le miroir* (Feb.-March 1947).

1946-47	Rotterdam, Boymans-van Beuningen Museum. *Moderne Buitenlandse Kunst uit Nederlands bezit.*
1947, 14 January-15 February	Paris, Galerie de France. *Influence de Cézanne, 1908-1911.*
1947, 19-24 April	Paris. *Union nationale des intellectuels.*
1947, 27 June-30 September	Avignon, Palais des Papes. *Exposition de peintures et sculptures contemporaines.* 92 pp., illus. 13 works. Braque's works listed on p. 10. Stylistic comments on pp. 35-6 and a reprint of a statement by Braque on the back cover.
1947, 20 October-23 November	Freiburg-im-Brisgau, Friedrichsbau. *Die Meister französischer Malerei der Gegenwart.*
1947-48	Eindhoven, Stedelijk van Abbe-museum. *Moderne Meesters.*
1948, 26 February-29 April	Basel, Kunsthalle. *Juan Gris, Georges Braque, Pablo Picasso.* Also shown Berne, Kunsthalle (2-29 April). 37 works. Pages 9-10 discuss and list Braque's works. Review: *Werk* 35:4(April 1948):37.
1948, June-July	Paris, Galerie Maeght. *Braque, les œuvres graphiques.* Also shown Venice, Galleria d'Arte del Cavallino (July).
1948, 20 August-mid-September	Zurich, Kunsthaus. *Exposition Braque, Picasso, Gris.* 25 works.
1948, 21 September-5 December	New York, Museum of Modern Art. *Collage.*
1948	New York, Buchholz Gallery. *Sculpture: Arp, Braque* [et al.] 12 p., illus.
1949	Zurich, Kunsthaus. *Gustav Gamper . . . Augusto Giacometti . . . Aus schweizerischen Privat-sammlungen: Braque, Gris, Picasso.* 23 p. 25 works (p. 12).
1949	New York, Hugo Gallery. Review: *Art News* 48(May 1949):46.
1949, 20 October-18 December	Chicago, Art Institute of Chicago. *Twentieth Century Art from the Louis and Walter Arensberg Collection.*

1949	New York, Hugo Gallery. Review: *Art News* 48(Nov. 1949):52.
1950, 29 April-29 May	Bern, Kunsthalle. *Les Fauves: Braque, Derain, Dufy, Friesz, Manguin . . . und die Zeitgenossen, Amiet, Giacometti, Jawlensky, Kandinsky.* Foreword and essay by Arnold Rüdlinger. 26 p., 14 pl. 11 works. Review: G. Veronesi, *Emporium* 112(Aug. 1950):50-60.
1950, 8 June-15 October	Venice, XXV Biennale. *Internaztionale d'Art: Mostra dei Fauves.* Salle V, *Quattro maestri del Cubismo.* 6 works. Reviews: M. Georges-Michel, *Biennale di Venezia* 2(1950):9-10; G. Veronesi, *Emporium* 112(1950):51-60.
1950, September	Copenhagen, Charlottenborg. *Levende Farver. Foreningen Fransk Kunst.*
1950, 13 November-23 December	New York, Signey Janis Gallery. *Les Fauves.* Catalogue, 8 p. Reviews: *Art Digest* 25(1 Dec. 1950):15; *Art News* 49(Dec. 1950):46.
1950-51, 29 November-21 January	Paris, Musée Nationale d'Art moderne. *Art sacré, œuvres françaises des XIX^e et XX^e siècles.*
1950	Paris, Galerie Charpentier. *Autour de 1900.*
1950	Verviers, *Sous les signes d'Apollinaire.* Also shown Ghent and Brussels.
1951, 13 April-5 May	Paris, Galerie de France. *Emaux de Ligugé.*
1951, 25 May-20 July	Paris, Galerie Max Kaganovitch. *Œuvres choisies du XX^e siècle.*
1951, June-September	Paris, Musée National d'Art moderne. *Le Fauvisme.* Catalogue avec préface par Jean Cassou. 43 p., illus. Review: *Emporium* 114(July 1951):25-8.
1951, 24 September-13 October	New York, Curt Valentin Gallery. *Lehmbruck and His Contemporaries.*
1951	Helsinki, Galerie Artek.
1951	London, The Royal Academy of Arts. *L'Ecole de Paris, 1900-1950.*
1952, March-April	Paris, Musée des arts décoratifs. *Cinquante ans de peinture française dans les collections particulières—de Cézanne à Matisse.*

1952, 18 April- 14 July	Amsterdam, Stedelijk Museum. *100 chefs-dœuvre du Musée National d'Art moderne de Paris*. Also shown Brussels, Palais des Beaux-arts (31 May-14 July).
1952, May-17 August	Paris, Musée National d'Art moderne. *L'Œuvre du XXᵉ siècle*. Also shown London, Tate Gallery (15 July-17 Aug.)
1953, 30 January- 9 April	Paris, Musée National d'Art moderne. *Le Cubisme, 1907-1914*.
1953	New York, Theodore Schempp & Co. Galleries. Reviews: *Art Digest* 27(15 Feb. 1953):15; *Art News* 52(March 1953):35; *Arts & Architecture* 70(April 1953):8-9.
1953-54, 1 August- 30 November	Annecy. *De Bonnard à Picasso*. Also shown Mâcon (5 Sept.-5 Oct.); Valence (11 Oct.-11 Nov.); Marseille (15 Nov.-15 Dec.); Cannes (20 Dec.-31 Jan. 1954); Nîmes (6-25 Feb.); Seés (7-27 March); Montauban (31 March-28 April); Limoges (30 April-30 May); Orléans (2-25 June); Bourges (27 June-19 July); Blois (20 Juily-15 Aug.); Boulogne (22 Aug-20 Sept.); Rabat (4-13 Nov.); Casablanca (21-30 Nov. 1954).
1953	New York, Curt Valentin Gallery. *Sculpture and Sculptors Drawings*.
1953	Paris, Galerie Charpentier. *100 tableaux d'art religieux*.
1953	Sao Paulo, Museu de Arte Moderna. *IIᵉ Biennale*. Special Cubism room.
1954	Paris, Galerie Chalette. *Lithographes et gravures*. Reviews: *Art News* 52(March 1954):40; *Art Digest* 28(15 March 1954):22.
1954, 18 June- 31 August	Ostende. *Dix dances actuelles de l'art français*.
1954, 10 July- 20 September	Rotterdam, Boymans-van Beuningen Museum. *Vier Eeuwen Stilleven in Frankrijk*.
1954-55, December- January	Paris, Galerie Maeght. *Livres d'artistes*. Catalogue published in *Derrière le miroir* 71-2(1954). Texte de Georges Limbour. Included aquatints and drawings from *La Théogonie d'Hésiode et de Georges Braque* (1955). Review: *Graphis* 10:56(1954):16-21.
1954	Paris Galerie Charpentier. *Plaisirs de la campagne*.

1954	Rio de Janeiro, Museu de Arte Moderna. *Exposicão do Cubismo.*
1954	Stockholm, Liljevalchs Konsthall. *Från Cézanne till Picasso.*
1955, 14 May-12 June	Anvers, Musée royal des Beaux-arts. *Kunst van Heden—L'Art contemporain.* Exposition jubilaire.
1955, 6 June-6 July	Vienna, Oesterreichisches Museum für Angewandte Kunst. *Europaische Kunst—Gestern und Heute.*
1955	Cassel, Museum Fridericianum. *Documenta.*
1955	Eindhoven, Stedelijk van Abbe Museum. *Franse religieuze.*
1956, 15-22 April	Amiens, Musée de Picardie. *Permanence de l'art.* Exposition organisée par la Jeunesse et les sports.
1956-57, May-15 January	Valenciennes. *50 Chefs-d'œuvre du Musée National d'art moderne, Paris.* Also shown Dijon (2 July-25 Aug.); Besançon (Sept.-Oct.); Strasbourg (10 Oct.-25 Nov.); Reims (1 Dec. 1956-15 Jan. 1957).
1956, 17 June-30 July	Recklinghausen, Kunsthalle. *Beginn und Reife.* 10 Ruhr-Festspiele.
1956, 27 July-9 September	London, Tate Gallery. *Autour du cubisme.* An exhibition of paintings lent by the Musée d'Art moderne, Paris.
1956, 19 August-2 October	Berlin, Akademie der Künste. *120 Meisterwerke des Musée d'Art moderne Paris.*
1956, 20 October-25 November	Frankfurt-am-Main, Städelsches Kunstinstitut. *Ausgewählte Werke aus dem Musée d'Art moderne Paris.*
1956-57, 15 December-13 January	Luxembourg, Musée de l'Etat. *Maîtres de la peinture moderne.* Peintures et gravures du Musée national d'art moderne de Paris.
1957, 9 March-4 April	Cardiff, National Museum of Wales. *Pictures from the Musée National d'art, Paris.*
1957, 13 April-18 May	London, R. B. A. Galleries. *An Exhibition of Paintings from the Musée d'Art moderne, Paris.* Sponsored by the Arts Council of Great Britain.
1957, 23 May-24 November	Tokyo, Metropolitan Art Gallery. *The Fourth International Art Exhibition of Japan.* Also shown

Osaka, Sogo Gallery (28 June-10 July; Ubé, Watanabe Memorial Hall (17 July-7 Aug.); Fukuoka, Iwataya Gallery (12-25 Aug.); Saseho, Public Hall Gallery (5-15 Sept.); Kumamoto, Tsuruya Gallery (20 Sept.-4 Oct.); Hiroshima, Fukuya Gallery (8-20 Oct.); Takamatsu, Modern Art Museum (25 Oct.-7 Nov.); Nagoya, Oriental Nakamura (13-24 Nov. 1947). Sponsored by The Mainchi Newspapers, Tokyo.

1957, 16 July- 1 September	Salisbury, South Rodesia. The Rhodes National Gallery. *Souvenir-Catalogue of the Opening Exhibition: Rembrandt to Picasso.*
1957, 18 July- 15 September	Tours, Musée des Beaux-arts. *50 œuvres d'artistes du XX^e siècle.*
1957-58, 2 October- 15 April	Boston, The Institute of Contemporary Art. *Paintings from the Musée National d'Art moderne, Paris.* Also shown Columbus, Columbus Gallery of Fine Arts (1 Dec. 1957-1 Jan. 1958); Pittsburgh, Carnegie Institute (15 Jan.-15 Feb. 1958); Minneapolis, Walker Art Center (1 March-15 April 1958).
1957	Paris, Galerie Charpentier. *100 chefs-d'œuvre de l'art français, 1750-1950.* Review: J.-M. Campagne, *Les Débats de ce temps* (Paris; 1957).
1958, January-March	Belgrade. *Savremeno Francusko Slikarstvo* [Contemporary French Art]. Also shown Zagreb.
1958	New York, Museum of Modern Art. *Exhibition of Prints by Braque, Miró and Morandi.* Reviews: *Art News* 56(Feb. 1958):10; *Arts Magazine* 32(March 1958):57; *Burlington Magazine* 100(March 1958):105.
1958, 17 April- 21 July	Brussels, Palais des Beaux-arts. *50 ans d'art moderne.* Exposition universelle et internationale. 14 works. Review: J. Leymarie, *Quadrum* 5(1958):72-3.
1958	New York, Paul Rosenberg & Co. Review: *Arts Magazine* 32(May 1958):52.
1958	Amsterdam, Stedelijk Museum. *Die Renaissance der XX eeuw.*
1958	Paris, Galerie Knoedler. *Les Soirées de Paris.*
1959, 30 April- 31 May	Varsovie, Musée National. *Peinture française de Gauguin à nos jours.*

1959	New York, F. A. R. Gallery. *Graphics.* Reviews: *Art News* 58(May 1959):16⁺; *Arts Magazine* 33(June 1959):55.
1959, June-August	Basel, Galerie Beyeler. *Les Fauves.* Catalogue, 29 p., col. pl. Text in German and French, introduction in English. Review: *Werk* 4(Oct. 1959):supp. 221.
1959	Paris, Petit Palais. *De Géricault à Matisse, chefs-d'œuvre français des collections suisses.*
1959, 5 July-15 November	Berlin, National Galerie der Ehemnals Staatlichen Museen, Orangerie des Schloss Charlottenburg. *Triumph der Farbe: die Europäischen Fauves.* 1 vol., col. illus. Reviews: *Werk* 46(Sept. 1959):supp. 192-3; *Kunstwerk* 13(Oct. 1959):38,41.
1959, November	Paris, Galerie Louise Leiris. *50 ans d'édition de D.-H. Kahnweiler.* Introduction et catalogue rédigés par Jean Hugues.
1960, 23 July-18 September	Nice, Palais de la Méditerranée. *Peintres à Nice et sur la Côte d'Azur, 1860-1960.*
1960-61, 4 November-23 January	Paris, Musée National d'Art moderne. *Les Sources du XXᵉ siècle—Les Arts en Europe de 1884 à 1914.*
1961, May-July	Boston, Museum of Fine Arts. *The Artist and the Book, 1860-1960, in Western Europe and the United States.* Introduction by Philip Hofer.
1961-62, 2 October-13 April	New York, Museum of Modern Art. *The Art of Assemblage.* Also shown Dallas, Dallas Museum of Contemporary Arts (9 Jan.-11 Feb. 1962); San Francisco, San Francisco Museum of Art (5 March-13 April 1962). Catalogue with text by William S. Seitz.
1961, December	Rome, Galerie de l'Obelisco. *Inaugurano la stanza delle sculture della galleria de l'Obelisco.*
1961	Moscow, Cultural Pavillon. *Exposition d'art français.*
1961	Recklinghausen, Kunsthalle. *Polarité. Le Côté apollinien et le côté dionysiaque dans les beaux-arts.* Also shown Amsterdam, Stedelijk van Abbe Museum.
1961	Turin. *Da Boldini a Pollock, Mostra del Moda Stile Costume.*

1961 — Wolfsburg. *Französische Malerei von Delacroix bis Picasso.*

1961-62, 3 November- 15 March — Tokyo, National Museum of Fine Arts. *Exposition d'art français 1840-1940.* Also shown Kyoto, City Museum (25 Jan.-15 March 1962).

1962 — New York, Paul Rosenberg Gallery. Reviews: *Art News* 61(March 1962):16; S. Tillim, *Arts Magazine* 36(April 1962):53.

1962, 23 March- 6 May — Hamburg, Museum für Kunst und Gewerbe. *Georges Braque, Marc Chagall, Joan Miró: Tapisserien, Keramik, Plastik, Wanddekorationen, Illustrationen, Dekorative Graphik, Plakate: Ausstellung.*

1962, May-July — Basel, Galerie Beyeler. *Le Cubisme: Braque, Gris, Léger, Picasso.*

1962, March-May — Paris, Galerie Charpentier. *Les Fauves.* Préface de Raymond Nacenta. 80 p., illus., 60 pl. Reviews: A. Brookner, *Burlington Magazine* 104(May 1962):221; H. Lessore, *Apollo* 76(May 1962):223-5[+]; P. Schneider, *Art News* 61(May 1962):44[+].

1962, 7 June- 7 October — Venice, *31ᵉ Biennale.* Section *Les Grands prix de la Biennale de Venise, 1948-1960.*

1962, 12 September- 9 December — Cologne, Wallraf-Richartz Museum. *Europäische Kunst 1912.*

1962 — Zurich, Kunsthaus. Review: E. Hüttinger, *Werk* 49(Sept. 1962):330.

1962-63, 3 October- 6 January — New York, Solomon R. Guggenheim Museum. *Modern Sculpture from the Joseph H. Hirshhorn Collection.*

1963 — Utica. Review: S. Sachs, *Art News* 61(Feb. 1903):27.

1963, 16 March- 28 April — Basel, Kunstmuseum. *Die Schenkungen Raoul La Roche.*

1963, June-August — New York, Solomon R. Guggenheim. *Cézanne and Structure in Modern Painting.*

1963, 1 September- 1 November — Paris, Bibliothèque nationale. *Cinq siècles de cartes à jouer en France.*

1963-64, 1 October- 9 April — Bombay. *Exhibition of Tapestries and Contemporary French Decorative Art.* Also shown New Delhi, Lalit Kala Akademi; Calcutta; Madras; Hyderabad.

1963	Rotterdam, Boymans-van Beuningen Museum. *Paysage français*.
1964, 10 July-4 October	Ghent, Stadsbestuur, Museum voor Schone Kunsten. *Figuratie-Defiguratie—De menselijke figuur sedert Picasso*.
1964	Lausanne, Inyedjian. *Huit tapisseries.* Included tapestries by Braque, Beaudin, Estève, and Picque.
1965, 3 April-4 May	Lille, Palais des Beaux-arts. *Apollinaire et le cubisme*.
1965, 3 June-December	Rio de Janeiro, Museu de Arte moderna. *Pintura francesa contemporanea.* Also shown Buenos-Aires, Museo (9 Aug.-20 Sept.); Montevideo, Museo Nacional de Bellas Artes (Oct.-Nov.); Santiago, Chile, Museo (Dec. 1965).
1965, 12 June-25 July	Recklinghausen, Städtische Kunsthalle. *Signale: Manifeste-Proteste im 20. Jahrhundert*.
1965, 21 October-8 December	Houston, Museum of Fine Arts. *The Heroic Years: Paris 1908-1914*.
1965-66	New York, Museum of Modern Art. *The School of Paris: Paintings from the Florene May Schoenborn and Samuel A. Marx Collection.* Traveling exhibition. Introduction by James T. Soby, with notes by L. R. Lippard. 56 p., 44 illus. Text analyzes the characteristics of the School of Paris with annotations for each entry. Particularly well-represented artists are Matisse, Picasso, Braque, and Rouault. Information on the collectors is also given. a. 2nd ed.: 1978.
1966, 15 January-10 July	Paris, Musée National d'Art moderne. *Le Fauvisme français et les débuts de l'expressionisme allemand.* Also shown Munich, Haus des Kunst (26 March-15 May).
1966, 19 March-26 May	Saint-Paul-de-Vence, Fondation Maeght.
1966, 15 April-1 July	Montréal, Musée d'Art contemporain. *Peinture française.* Also shown Québec, Musée des Beaux-arts (15 May-1 July).
1966, 25 May-10 July	Hamburg, Kunstverein. *Matisse und seine Freunde—Les Fauves.* Catalogue with introduction by Hans Platte. 105 p., 82 illus., 24 pl. Review: S. Whitfield, *Burlington Magazine* 108(Aug. 1966):439.

1966, 4-19 June	Thonon, Maison de la culture. *10 chefs-d'œuvre du Musée National d'Art moderne.*
1966, 8 June-31 July	Recklinghausen, Städtische Kunsthalle. *Variationen.*
1966, 9-11 June	Bern, Kornfeld und Klipstein. *Moderne Kunst.*
1966, 16 June-30 August	Paris, Galeries nationales du Grand Palais. *Exposition d'art nègre.*
1966	St. Gallen, Hochschule. Review: R. Hanhart, *Werk* 53(Oct. 1966):410-1.
1966-67, 21 November-12 February	Luxembourg, Musée d'Histoire et d'art. *24 peintres français.* Also shown Copenhagen, Kunstforeningen (14 Jan.-12 Feb. 1967) under title *24 Franske Malere 1946-1966.*
1967, March-June	Dallas. *The Art of the French Book, 1900-1965.* Also shown New Haven, CT, Yale University.
1967, April	Geneva, Galerie Krugier. *Jean Paulhan et ses environs.*
1967, 28 April-27 October	Montréal, Galerie Nationale du Canada. *Terre des hommes—Exposition internationale des Beaux-arts.*
1967, 3 May-30 June	Paris, Galerie Jean-Claude Bellier. *Autour du cubisme.*
1967	New York, Metropolitan Museum of Art. *Summer Loan Exhibition.* Review: C. Virch, *Metropolitan Museum of Art Bulletin* 26:1(Summer 1967):31.
1967-68	Darmstadt, Darmstadt Hessisches Landesmuseum. *Jewelry by Contemporary Painters and Sculptors.* Also shown, New York, Museum of Modern Art; Amsterdam, Boymans van Veuningen Museum.
1967	Paris, Musée National d'Art moderne. *Paris-Prague, 1906-1930. Les Braque et Picasso de Prague et leurs contemporains et cheques.*
1967	Saint-Paul-de-Vence, Fondation Maeght. *Dix ans d'art vivant.*
1968, February-April	New York, Solomon R. Guggenheim Museum. *Neo-Impressionism.*
1968, 6 March-12 April	Brussels, Palais des Beaux-arts. *40 ans d'art vivant—hommage à Robert Giron.*

1968, 13 March- 1972	Houston, University of St. Thomas. *Look Back: An Exhibition of Cubist Paintings and Sculptures from the Menil Family Collection.* Also shown at eight other North American museums.
1968, 8 May- 15 September	Strasbourg, Ancienne Douane. *L'Art en Europe autour de 1918.*
1968, 8 June- 18 August	Zurich, Kunstgewerbemuseum. *Collagen.*
1968-69, November- January	London, Institute of Contemporary Art. *Guillaume Apollinaire, 1880-1918: A Celebration 1968.* Also shown Liverpool, Walker Art Gallery (Dec. 1968); Bristol, City Art Gallery (Jan. 1969).
1968	Paris, Orangerie des Tuileries. *Chefs-d'œuvre des collections suisses de Manet à Picasso.*
1968	Tokyo, Grand magasins Takashimaya. *Chefs-d'œuvre d'art moderne de France.* Salle I: Œuvres conservées au Musée National d'Art moderne, Paris.
1968-69	Washington, D.C., National Gallery of Art. *Painting in France, 1900-1967.* Also shown New York, Metropolitan Museum of Art; Boston, Museum of Fine Arts; Chicago, Art Institute; San Francisco, M. H. de Young Memorial Museum.
1969, February	Cairo, Hotel Sémiramis. *La Peinture française du XXᵉ siècle.* Œuvres du Musée National d'Art moderne, Paris. Also shown Teheran, Museum of Teheran (April); Athens, Hilton Hotel; Istanbul, Museum of Painting and Sculpture; Ankara, New Exposition Gallery.
1969, 22 March- 4 May	Humlebaek, Louisiana Museum. *Georges Braque-Henri Laurens.*
1969, 26 May- 1 September	New York, Museum of Modern Art. *Twentieth-Century Art from the Nelson Aldrich Rockefeller Collection.*
1969, 30 May- 30 September	Bordeaux, Musée des Beaux-arts. *L'Art et la musique.*
1969, 30 August- 30 November	London, Burlington House, The Royal Academy of Arts. *French Painting Since 1900.*
1969, September	Paris, Fête de l'humanité. *Aperçu sur les origines de la sculpture contemporaine.*

1969-70, 9 December- 25 January	New York, New York Cultural Center. *A Selection of Drawings, Pastels and Watercolors from the Collection of Mr. and Mrs. Lester Francis Avnet.*
1969	Aix-en-Provence, Pavillon Vendôme. *Paysage du Midi, de Cézanne à Derain.*
1969	Berne, Kunstmuseum. *Hermann und Margrit Rupf-Stiftung.*
1969-70, December- April	Montréal, Musée des Beaux-arts. *Portraits et figures de France.* Also shown Québec, Musée des Beaux-arts (March-April 1970).
1969	Stuttgart, Galerie Valentien. *Braque, Chagall, Picasso: Graphik.*
1970	Rouen, Musée des Beaux-arts. *Collection du Menil: œuvres cubistes.* Also shown at four other French museums.
1970, Summer-Fall	Saint-Paul-de-Vence, Fondation Maeght. *A la rencontre de Pierre Reverdy.* Also shown Paris, Musée National d'Art moderne.
1970, 23 October- November	Paris, Fondation Le Corbusier. *Hommage à Raoul La Roche.*
1970	Paris, Galerie Maeght. Review: J. Applegate, *Art International* 14(Nov. 1970):83.
1970	Prague, Nār Galerie. *Henri Laurens. Sochy a Kresby. Georges Braque, Pablo Picasso. Grafika.* Text by P. Emmeram Ritter and Claude Laurens. 64 p., 28 illus.
1970-71, 15 December-8 June	Los Angeles, Los Angeles County Museum of Art. *The Cubist Epoch.* Also shown New York, Metropolitan Museum of Art (9 April-8 June). Catalogue with text by Douglas Cooper. Reviews: M. Young, *Apollo* 93(Jan. 1971):18-27; R. Krauss, *Artforum* 9(Feb. 1971):33; H. Kramer, *Art in America* 59(March 1971):52.
1970	Paris, Musée National d'Art moderne. *Legs Marguerite Savary au Musée National d'Art moderne.*
1971, 15 January- 21 March	New York, New York Cultural Center. *Laurens et Braque—Les Donations Laurens et Braque à l'état français.* Organized in association with Fairleigh-Dickinson University, Madison. Catalogue par Donald Karshan. 64 p., 50 illus. Reviews: C. Ratcliff, *Art*

	International 15(March 1971):47; *Arts Magazine* 45:5(March 1971):51; 45:8(Summer 1971):58.
1971, March-April	Montpellier, Musée Fabre. *Les Livres réalisés par P.A. Benoit, 1942-1971.*
1971, 17 April-31 May	Amsterdam, Stedelijk Museum. *Kubisme, Tekeningen en prenten vit het Kupferstichkabinett, Basel.*
1971	New York, Perls Gallery. Review: M. Hancock, *Arts Magazine* 45(Summer 1971):58.
1971, Summer-Fall	Saint-Paul-de-Vence, Fondation Maeght. *Exposition René Char.* Also shown Paris, Musée National d'Art moderne.
1972	Geneva, Galerie Engelberts. Review: *Art International* 16(April 1972):64.
1972	Paris, Musée Bourdelle. *Centaures, chevaux, cavaliers.*
1973, 4 May-10 November	Bordeaux, Galerie des Beaux-arts. *Les Cubistes.* Also shown Paris, Musée d'Art moderne de la Ville de Paris (26 Sept.-10 Nov.); Rome, Museum de Arte Moderna. Catalogue avec textes de Jean Cassou, Jacques Lassaigne, Gilberte Martin-Méry. Exhibition catalogue includes an interview of Braque by Jacques Lassaigne, reprinted in *XXᵉ siècle* 35:41(1973):3-9.
1973-74, October	Belgrade, Museum of Modern Art. *De Bonnard à Soulages.* Also shown Skopie, Museum of Modern Art (18 Nov.-12 Dec.); Sarajevo, Ljubljana, Zagreb.
1973-74, 3 November-April	Sacramento, E. B. Crocker Art Gallery. *19th and 20th Century Prints and Drawings from the Baltimore Museum of Art.* Also shown Honolulu, Academy of Arts (18 Jan.-17 Feb. 1974); Chapel Hill, University of North Carolina, William Hayes Ackland Memorial Art Center (April 1974). Catalogue by Victor I. Carlson and Roger D. Clisby. 24 p., 16 illus. 70 works shown. Included prints by Braque, among other 19th and 20th century artists.
1973	Geneva, Musée d'Art et d'histoire. *Art du XXᵉ siècle.*
1973	Paris, Galerie Berggruen. *Œuvres cubistes: Braque, Gris, Léger, Picasso.*
1974, 1 February-15 April	Paris, Galeries Nationales du Grand Palais. *Jean Paulhan à travers ses peintres.*

1974, 17 May-14 July	Recklinghausen, Städtische Kunsthalle. *Was war—was ist—25 Jahre Ausstellungen der Ruhrfestspiele.*
1974, September-December	Tokyo, Magasins Mitsukoshi. *Paris, sa vie, son histoire.*
1974-75, 15 November-2 March	Vienna, Graphische Sammlung Albertina. *Gedächtnisausstellung Otto Benesch; Erwerbung und Bestimmung grosser Meisterwerke für die Albertina* [Otto Benesch Memorial Exhibition; Acquisitions and Bequests of Great Masterpieces for the Albertina]. Essay by Walter Koschatzky. 70 p., 35 illus. 194 works shown. Included prints by Braque and Rouault, among many other artists represented.
1974-75, 22 November-20 January	Paris, Musée National d'Art moderne *Dessins du Musée National d'Art moderne, Paris.*
1974-75, 20 December-31 January	Teheran, Centre international des expositions. *Braque, Kandinsky, Chagall, Léger, Picasso, Miró, Giacometti, Calder, Bazaine, Tal Coat, Steinberg, Ubac, Chillida, Tapiès, Bram Van Velde, Rebeyrolle, Riopelle, Pol Bury, Geer Van Velde, Adami, Fiedler, Le Yaouanc, Garache, Monory.* Patronnée par la Fondation Maeght.
1974	Houston, Museum of Fine Arts, Jesse H. Jones Gallery. *The Collection of John A. and Audrey Jones Beck; Impressionist and Post-Impressionist Paintings.* Catalogue by Thomas P. Lee. 101 p., illus., 47 col. Catalogue issued on the occasion of the first public exhibition of the Beck Collection, put on indefinite loan at the Houston Museum. Among the 47 works catalogued are paintings by van Gogh, Matisse, Seurat, Degas, Toulouse-Lautrec, Braque, Cassatt, and Derain.
1974	La Courneuve, Fête de l'humanité. *Aux sources de la peinture moderne—L'Impressionnisme.*
1975, 31 January-16 March	Ixelles, Museum van Elsene. *La Fondation Marguerite et Aimé Maeght.*
1975, 5 March-13 April	Hartford, CT, Wadsworth Atheneum. *Selections from the Joseph L. Shulman Collection.* Texts by James Elliott, Joseph L. Shulman, Mark Rosentha. 47 p., 22 illus., 3 col. 50 works shown. Works by early 20th century European artists including Matisse, Braque, Dufy, and Rouault, among others.

1975, 14 March-
11 May

Moscow, Pushkin Institute and Museum. *Cinquantenaire des relations diplomatiques franco-soviétiques.*

1975, 11 April-
11 May

Toronto, Art Gallery of Ontario. *The Fauves.* Catalogue by R. J. Wattenmaker. 45 p., 29 illus. In the catalogue essay, an account of the Fauves' reception at the Paris Salon d'Automne of 1905 is followed by a discussion of Fauvism's basic constituent pictorial features and the traditional sources upon which the Fauve painters drew. The interrelationships and influences within the group of Matisse, André Derain, Maurice de Vlaminck, Albert Marquet, and Henri Manguin, and the individual stylistic development of each artist in the period 1898-1906 are traced. Works by Raoul Dufy, Othon Friesz, Georges Braque, Louis Valtat, and Kees van Dongen are also illustrated and analyzed.

1975, 10 April-
28 September

Sydney, Art Gallery of New South Wales. *Modern Masters: Manet to Matisse.* Also shown Melbourne, National Gallery of Victoria (28 May-22 June); New York, Museum of Modern Art (4 Aug.-28 Sept.). Edited by William S. Lieberman. 271 p., 131 illus., 16 col. 113 works shown. Included works by fifty-seven artists which traced the development of the modern tradition beginning with Manet's *A Boy with a Sword* (1861) and closing soon after the death of Matisse in 1954. Braque and Derain are represented by three or more works; Matisse by eleven. Reviews: J. Russell, *New York Times* (4 Aug. 1975):15; J. Canady, *New York Times* (17 Aug. 1975)I,21, sec. 2.

1975, 17 June-
17 September

La Roche-Jagu.

1975, 20 June-
24 August

Berlin, Staatliche Museen Preussischer Kulturbesitz, Kupferstichkabinett. *Druckgraphik der Gegenwart 1960-1975 im Berliner Kupferstichkabinett* [Contemporary Graphics 1960-1975 in the Berlin Kupferstichkabinett]. Katalog von Alexander Duckers. 167 p., 152 illus. 792 works shown. Works by over one hundred 20th century European and American artists, including Braque.

1975-76, 30 October-
31 January

Paris, Musée Jacquemart-André. *Le Bateau-Lavoir.* Catalogue par Jeanine Warnod. 163 p., 8 illus. ca. 200 works shown. Exhibition devoted to the Bateau-Lavoir, a building on top of Montmartre where Cubism was born and which became between 1900 and 1914 the abode or meeting place of artists and writers such as Picasso, Braque, Derain, Modigliani, van Dongen, Gris,

Max Jacob, and Guillaume Apollinaire. Includes paintings, prints, drawings and watercolors by these artists and others plus African masks and sculpture. Documentary material such as manuscripts, letters, catalogues, and photographs also included. Review: P. Schneider, *New York Times* (1 Dec. 1975):40.

1975-76, 30 October-
4 May

Minneapolis, Minneapolis Institute of Arts. *Picasso, Braque, Léger: Masterpieces from Swiss Collections.* Also shown Houston, University of Houston, Sarah Campbell Blaffer Gallery (17 Jan.-7 March 1976); San Francisco, San Francisco Museum of Modern Art (19 March-4 May 1976). 84 p., 56 illus., 53 col.
Exhibition of paintings and drawings devoted to three modern French masters drawn from the collections of Ernst Beyeler and other private collections in Switzerland. Sachs's introduction, Beyeler's remembrances of Picasso and Braque, and quotations by the artists illuminate the work as well as the personalities of these artists. Reviews: J. Butler, *Connoisseur* 191:768(Feb. 1976):139-41; F. Martin, *Art International* 20:6(Summer 1976):43-4.

1975

Brisbane, Queensland National Art Gallery. *Still Life from the Collection.* 15 p., 6 illus. Catalogue to this exhibition of forty-eight works by thirty-nine artists contains a brief history of the art of still-life painting which traces the genre from the Romans to the present, paying particular attention to Caravaggio and the 17th century Dutch painters, Chardin, Cézanne, Braque, Morandi, and Oldenburg.

1975

Paris, Musée National d'Art moderne. *Interprétations cézanniennes.*

1976, March-July

Cape Town, South African National Gallery. *Contemporary French Tapestries in South Africa. Hedendaagse Franse Wandtaptye in Suid-Afrika.* Also shown Johannesburg, Art Gallery (May-June); Pretoria, Art Museum (June-July). Foreword by C. J. Dury. Organized in association with the French Association for Artistic Action. 45 p., 23 illus., 3 col. In English and Afrikaans. 21 works shown. Exhibition of works by twenty-one painters, including Braque and Matisse, whose designs have been woven into tapestries.

1976, 14 May-
19 June

Saint-Omer, Musée Sandelin. *Cinquante années de lithographie: hommage à Fernand Mourlot.* Catalogue par P.-G. Chabert. 39 p., 8 illus. 40 works shown. Exhibition of forty lithographic prints dedicated to the Parisian master-lithographer and publisher, Fernand

Mourlot. Artists represented include Braque and Henri Matisse. Accompanying texts examine Mourlot's role in the achievements of 20th century French printmaking.

1976, 26 March-
31 October

New York, Museum of Modern Art. *The 'Wild Beasts': Fauvism and its Affinities.*

1976, 26 September-
28 November

Malines, Cultureel Centrum. *Kunst in Europa, 1920-1960.*

1976-77,
4 November-
2 January

Hamburg, Kunsthalle. *20 Jahre Stiftung zur Förderung der Hamburgischen Kunstsammlungen: Ausstellung einer Auswahl der Erwerbungen 1956-1975* [20 years of the Foundation for the Benefit of the Hamburg Kunstsammlungen; Exhibition of a Selection of the Acquisitions 1956-1975]. Redaktion und Vorwort: Alfred Hentzen. 117 p., 68 illus., 32 col. 303 works shown. Exhibition of works ranging from ancient Greek sculpture to 20th century paintings by Braque and others.

1976

Pasadena, Norton Simon Museum of Art. Review: D. Steadman, *Connoisseur* 193(Nov. 1976):227[+].

1976-77,
17 December-1 March

New York, Museum of Modern Art. *European Master Paintings from Swiss Collections: Post-Impressionism to World War II.* Foreword by William Rubin; Catalogue by John Elderfield. 172 p., 72 illus., 24 col. 72 works shown. Included paintings by Braque (mainly Cubist works). Matisse, and Rouault, among others.

1976

Bloomington, IN, Lilly Library, University of Indiana. *Beyond Illustration: The Livre d'artiste in the Twentieth Century.*

1977, January

Paris, Musée Jacquemart-André. *Oiseaux*. Review: Y. Bligne, *Peintre* 536(1 Jan. 1977):6-7.

1977, 25 February-
4 April

Paris, Centre Georges Pompidou, Bibliothèque publique d'information. *Francis Ponge*. Includes "Note sur le livre illustré à propos de *Cinq sapates*," an essay on Braque's illustrations for Ponge's book published in 1950.

1977, 29 April-
26 November

Buffalo, Albright-Knox Art Gallery. *The School of Paris: Drawing in France*. Also shown St. Louis, St. Louis Art Museum (30 June-21 Aug.); Seattle, Seattle Art Museum (25 Sept.-26 Nov.). Organized by The Museum of Modern Art, New York. Catalogue by William S. Lieberman, and R. T. Buck. 8 p., 7 illus. Brief catalogue introduces the largest exhibition of

drawings ever lent by New York's Museum of Modern Art. The exhibition mirrored the development of the modern movement in France, recording the innovations of collage, frottage, decalcomania, accident and collaboration, and the shattering of traditional attitudes towards draughtsmanship held by many artists including Archipenko, Braque, Gris, Ernst, and the Surrealists. Lieberman analyzes the reasons for the fact that more than half the artists represented were foreigners working in France.

1977	Paris, Galerie Jean Chauvelin. *Suprématisme*.
1978, 5 May- 1 September	Bordeaux, Galerie des Beaux-arts. *La Nature morte de Brueghel à Soutine*.
1977-78, 10 December- 29 January	Edinburgh, Scottish National Gallery of Modern Art. *Towards Abstract Art*. 31 p. 42 works shown. Included seven groups of works arranged to represent different types of abstraction. Aimed to demonstrate how certain visual themes or categories develop towards abstraction. Artists included Braque and Derain, among others.
1977	Cambridge, England, Kettle's Yard Gallery. *Simultaneity*. Edited by V. Spate. 24 p., 17 illus. This exhibition, created by members of the Faculty of Architecture and History of Art at Cambridge University, Homerton College, Cambridge, Kettle's Yard Gallery, and the Chelsea School of Art, consisted of multi-media installations in three sections: "The Passage," "Trans-Siberian Room," and "Invisible Energies, the Eiffel Tower." It centered on Parisian "Simultanism," but was concerned with the fundamental cosmopolitanism of the movement. The catalogue outlines the metaphysical precepts on which the exhibition is designed, and comments on the poetry, paintings and prose exhibited, which included works by Guillaume Apollinaire, Jules Romains, Robert and Sonia Delaunay, Blaise Cendrars, Chagall, Metzinger, and Braque. Also included is a "sequential essay," "Simultaneity and Painting," in which the attempts of the simultaneists to identify with "the collective energies and experiences of modern urban life" are analyzed.
1977	Gstaad, Palace Hotel. *Les Classiques du XX^e siècle*.
1978	London, Lumley Cazalet. Review: *Art & Artists* 12(Jan. 1978):40.

1978, 2-27 February

Oxford, Oxford University, Ashmolean Museum. *The Artist and the Book in France; Matisse to Vasarely: An Anthology from the Collection of W. J. Strachan.* Foreword by Kenneth J. Garlick; introduction by W. J. Strachan. 12 p., 1 illus. 64+ works shown.
Exhibited illustrations for books by Fermin Aguayo, Geneviève Asse, Mario Avati, André Beaudin, Hans Bellmer, Braque, Buffet, Serge Charchoune, Antonio Clavé, and Lucien Coutaud. Over sixty-eight artists were represented. Explanation of autographic processes and a glossary are included.

1978, 3 February-
24 April

Paris, Galeries Nationales du Grand Palais. *L'Art moderne dans les musées de province.*

1978, 1 April-
1 October

New York, Solomon R. Guggenheim Museum. *The Evelyn Sharp Collection.* Preface by Thomas M. Messer. Texts by Louise Averill Svendsen aided by Philip Verre and Hilarie Faberman. 96 p., 46 illus., 45 col. 45 works shown. Exhibition of paintings, sculptures and a few works in other media by eighteen major 20th century artists, including Braque, Dufy, Matisse, Rouault, van Dongen, and Vlaminck.

1978, 12 April-4 June

Cologne, Kunsthalle. *Fernand Léger: das figürliche Werk* [Fernand Léger; the Figurative Work]. Organisation und Durchführung der Ausstellung: Siegfried Gohr. (27 p., 128 illus., 17 col. 137 works shown. Included comparative works by Braque, Matisse, and Picasso. Reviews: E. Mai, *Kunstwerk* 31:3(June 1978):70-1; E. Mai, *Pantheon* 36:3(July-Sept. 1978):276-8.

1978, Spring-
31 December

Paris, Musée d'Art moderne de la Ville de Paris. *Paintings from Paris; Early 20th Century Paintings and Sculptures from the Musée d'Art moderne de la Ville de Paris.* Also shown Oxford, Museum of Modern Art (2 July-13 Aug.); Norwich, Castle Museum (19 Aug.-1 Oct.); Manchester, Whitworth Art Gallery (7 Oct.-11 Nov.); Coventry, Herbert Art Gallery and Museum (18 Nov.-31 Dec.). Preface by Joanna Drew and Michael Harrison; foreword by Jacques Lassaigne; introduction by Michael Harrison. 48 p., 74 illus., 4 col. 82 works shown. Exhibition aims to show the way in which Fauvism, Cubism, and the School of Paris are represented in the museum's collection. Catalogue includes an introduction on the development of early 20th century art in France, and a special section devoted to Marcel Gromaire who is strongly represented in the museum's holdings. Other artists shown include Braque, Delaunay, Derain, Dufy, La Freshaye, Léger, Lhote,

Lipchitz, Matisse, Metzinger, Pascin, Picasso, Rouault, Utrillo, Valadon, and van Dongen. Reviews: K. Roberts, *Burlington Magazine* 120:905(Aug. 1978):552; P. Macus, *Art & Artists* 13:5(Sept. 1978):18-21.

1978, 1 June-
4 September

Washington, D.C., National Gallery of Art. *Aspects of Twentieth-Century Art.*

1978, 8 June-
16 September

Bern, Kunstmuseum. *Sammlung Justin Thannhauser.* Redaktion des Kataloges: Jürgen Glaesemer, Betty Studer. Vorwort von Paul Rudolf Jolles und Beiträgen von Eberhard W. Kornfeld und Hans R. Hahnloser. 113 p., 79 illus., 15 col. 64 works shown. Review: C. Geelhaar, *Pantheon* 36:4(Oct.-Dec. 1978):386-7.

1978, 20 June-
10 September

Avignon, Palais des Papes. *Cinquante années de lithographie.* Catalogue par Pierre Cabanne. Fernand Mourlot. 5 p., 32 illus., 16 col. Lithographs by a number of artists including Braque, Chagall, Miró, and Picasso, all printed by Mourlot.

1978, 26 June

London, Sotheby's. *Collection Robert Von Hirsch.*

1978, 1 July-
18 September

Saint-Tropez Musée de l'Annonciade. *D'un espace à l'autre; la fenêtre œuvres du XXᵉ siècle.* [From One Space to Another; the Window Works of the 20th Century]. Catalogue établi par Alain Mousseigne. 166 p., 113 illus., 6 col. 47 works shown. Paintings, drawings and sculpture with windows as a major compositional feature by an international group of artists including Braque, Matisse, Picasso, Klee, Christo, and O'Keeffe. Catalogue includes the following essays: "D'un espace à l'autre: la fenêtre," by Alain Mousseigne; "Le Motif de la fenêtre d'Alberti à Cézanne," by Anne Marie Lecoq and Pierre Georgel; "La Transparence montrée," by Pierre Schneider; "Autour de la *Porte fenêtre à Collioure* de Matisse," by Jean Laude; "Picasso, la contagion des espaces et les montages du réel," by Denis Milhau; "Le Surréalisme et la fenêtre," by José Vovelle; "Le Ballon rouge et la fenêtre magique," by Jean Michel Royer. Full catalogue entries and reproductions of each object are included.

1978

Paris, Musée National du Louvre. *Donation Picasso: la collection personnelle de Picasso.* Introduction de Jean Leymarie. 120 p., 55 illus., 12 col. 51 works shown. Exhibition of thirty-eight paintings, mainly by 19th and 20th century French masters, including examples by Braque, Cézanne, Corot, Matisse, Miró, Renoir, and Rousseau, as well as a Cézanne watercolor, a Renoir drawing, and eleven Degas monotypes. The

works were given to France by the artist's widow Jacqueline and son Paolo and are currently housed at the Louvre. Reviews: J. Russell, *New York Times* (9 July 1978):D21; B. Scott, *Apollo* 108:198(Aug. 1978):127; X. Muratova, *Burlington Magazine* 120:905(Aug. 1978):559-60; R. Henry, *Du* 38:451(Sept. 1978):24; J.-P. Dauriac, *Pantheon* 36:4(Oct.-Dec. 1978):376; E. Hammer, *Art in America* 66:6(Nov.-Dec. 1978):163.

1978, 19 September– 29 October	Des Moines, Des Moines Art Center. *Art in Western Europe: The Post-War Years 1945-1955*. Sponsored by the Myron and Jacqueline Blank Charity Fund. Catalogue by L. Alloway. 133 p., 71 illus. Exhibition of works by nineteen artists in a wide range of media, representing the state of art in western Europe in the decade immediately following the Second World War. Alloway considers the isolating effect of the War on European artists, the initial rejuvenation of the School of Paris in the work of Braque, Matisse, Dufy, Ernst, Villon, and Picasso, and the later emergence of the revolutionary Informel painters, including Wols, Fautrier, Dubuffet, and Klee. A developing internationality is demonstrated in the work of Fontana and Tàpies and the legacy of war is reflected in the imagery of Bacon, Giacometti, and Picasso.
1978, 16 November– 21 December	London, Lefevre Gallery. *Les Fauves*. Catalogue by Denys Sutton. 30 p., 11 illus. In English. 11 works shown. In his brief introduction to this catalogue to an exhibition of eleven paintings by Braque, Derain, Matisse and Vlaminck, Sutton discusses the current state of information about the Fauves and suggests some of the avenues that remain to be explored.
1978	Lugano, Villa Malpensata. *Collezione Thyssen-Bornemisza. Arte Moderna.*
1978	Paris, Musée d'Art moderne de la Ville de Paris. *La Collection Thyssen-Bornemisza. Tableaux modernes.*
1978	Paris, Grand Palais. Société des Artistes Indépendant. *89ᵉ exposition.*
1978	Paris, Centre National d'Art et de culture Georges Pompidou. *Paris-Berlin: Rapports et contrastes France-Allemagne, 1900-1933.*
1978-79	Basel, Galerie Beyeler. *Das Stilleben im 20. Jahrhundert.*

1979, 11 March–
29 April

Bielefeld, Kunsthalle. *Zeichnungen und Collagen des Kubismus: Picasso, Braque, Gris.* Konzeption, Ulrich Weisner und Klaus Kowalski in Zusammenarbeit mit Erich Franz und Rüdiger Jörn. Katalog: Ulrich Weisner, Rolf P. Horstmann, Max Imdahl, Bernhard Kerber, Gundolf Winter. 393 p., 275 illus., 8 col. 57 works shown. Review: V. Bauermeister, *Pantheon* 37:39(July-Sept. 1979):197-8.

1979-80, 21 April–
20 April

Atlanta, High Museum of Art. *Corot to Braque; French Paintings from the Museum of Fine Arts, Boston.* Also shown Tokyo, Seibu Museum of Art (28 July-18 Sept. 1979): Nagoya, City Museum (29 Sept.-31 Oct. 1979); Kyoto, Kukuritsu Kindrai Bijutsukan (10 Nov.-1979-15 Jan. 1980); Denver, Denver Art Museum (13 Feb.-20 April 1980). Introduction and catalogue by Anne L. Poulet; essay by Alexandra R. Murphy. 148 p., 81 illus., 69 col. 69 works shown. Selected from the ca. 600 French paintings in the Boston Museum's collection, the sixty-nine works shown range in date from 1831 to 1927 and present examples by thirty-four artists, including Braque, Derain, and Matisse. Poulet's introductory essay discusses the history and crosscurrents of French paintings of the 19th and early 20th centuries with special reference to the importance of the exhibited works. Murphy's essay "French Paintings in Boston: 1800-1900," describes the history of collecting French paintings in Boston in the 19th century. Full catalogue entries with explanatory texts and color reproductions of each painting. A Japanese edition of the catalogue, printed in Tokyo, is available.

1979, 5 May–
1981

Washington, D.C., Phillips Collection. *The Phillips Collection in the Making, 1920-1930: An Exhibition.* Smithsonian Institution Traveling Exhibition Service. Catalogue by Kevin Grogan, Bess Hormats, and Sareen Gerson. 96 p., 111 illus., 37 col. 37 works shown.
Exhibition of thirty-seven paintings and watercolors acquired prior to 1930 explores the formative years of the oldest museum of modern art in the U.S. (it opened to the public in 1921), and examines the developing taste for modernism in America through the eyes of Duncan Phillips, the collection's founder. The exhibited works are each by a different artist, showing the diversity of the collection. Among the Europeans represented are Bonnard, Daumier, Klee, Braque, and Picasso; Americans include Ryder, Dove, Demuth, Sheeler, and O'Keefe. Catalogue contains selected writings by Phillips and a list of his published writings before 1930; appendices list selected acquisitions of the period and selected deaccessions of works acquired during the

period. Full catalogue entries and color reproductions of each work shown. Review: D. Tannous, *Art in America* 67:4(July-Aug. 1979):24-5.

1979, 31 May-
5 November

Paris, Musée National d'Art moderne, Centre Georges Pompidou. *Paris-Moscou 1900-1930.*

1979-80, Fall-
5 January

London, Arts Council of Great Britain. *Reality and Artifice.* Also shown Carlisle, Carlisle Museum and Art Gallery (8 Dec. 1979-5 Jan. 1980). Catalogue by Ian Jeffrey. 12 p., 31 illus. 27 works shown.
Twenty-two artists were represented, including Braque, whose work focuses both on the object illustrated and the means of creating illusion. Review: *Antiques* 115(May 1979):952+.

1979, 11 September-
December

Leningrad, Hermitage Museum. *Peinture française 1909-1939.* Collections du Musée National d'Art moderne, Paris. Also shown Moscow, Pushkin Institute and Museum (Nov.-Dec.).

1979, 1-30 November

New York, Acquavella Galleries. *XIX and XX Century Master Paintings.* 47 p., 22 illus. 22 works shown. Exhibition of twenty-two paintings by nineteen European and American artists, including Braque and Matisse. Lists of collections and exhibitions are included.

1979

Bern, Kunsthalle. *Bilder einer Ausstellung. Eine Ausstellung als Glückwunsch der Kunsthalle zum 100 jährigen Jubiläum des Kunstmuseums Bern.*

1979-80

Münster, Westfälisches Landesmuseum für Kunst und Kulturgeschichte. *Stilleben in Europa.*

1980, 16 January-
30 March

Paris, Bibliothèque nationale. *René Char; manuscrits enluminés par des peintres du XXᵉ siècle.* Rédacteur: Antoine Coron. 150 p., 89 illus., 15 col. 132 works shown. Catalogue describes Char's manuscripts (1948-78), which have been "illuminated" in a variety of media (gouache, watercolor, ink, colored pencil, etc.) by various artists including Arp, Braque, Brauner, Charbonnier, Ernst, Fernandez, Giacometti, Ghika, Hélion, Hugo, Lam, Laurens, Léger, Matisse, Miró, Picasso, Reichek, Sima, de Staël, Szenes, Vieira da Silva, and Villon. Accompanying texts describe each artist's relationship with Char and vice versa. Catalogue includes a list of poems contained in the illustrated manuscripts and appendices.

1980

London, Curwen Gallery. *Prints by Braque, Picasso and Motherwell*. Review: J. Burr, *Apollo* 111:215(Jan. 1980):2-5.

1980, 6 February-
13 April

London, Tate Gallery. *Abstraction: Towards a New Art; Painting 1910-20*. Introduction by Peter Vergo. 128 p., 470 illus., 17 col. 455 works shown.
Exhibition focused on the work of first-generation abstractionists in Europe and the U.S.; precursors and followers are not included. Malevich, Mondrian, and Kandinsky are given appropriate emphasis, but many lesser known artists are also included. The first section, "Pure Painting: Paris 1910-1922," with an essay by Christopher Green, emphasizes the Cubism of Picasso and Braque. Catalogue contains a chronology of artists and a chronology of artistic and historical events. Reviews: J. Taylor, *Times* (12 Feb. 1980):9; J. Hilton, *Times Literary Supplement* (15 Feb. 1980):174; F. Watson, *Arts Review* 32:3(15 Feb. 1980):59; C. Neve, *Country Life* 167:4311(21 Feb. 1980):494-5; R. Rushton, *Royal Society of Arts Journal* 128:5284(March 1980):234-6; R. Shone, *Burlington Magazine* 122:924(March 1980):2100-3; F. Roberts, *Connoisseur* 203:818(April 1980):298-9; G. von Gehren, *Weltkunstt* 50:7(1 April 1980):892-3; F. Crichton, *Pantheon* 38:3(July-Sept. 1980):222-4.

1980, 4 March-
11 April

Dallas, Pollock Galleries, Meadows School of the Arts, Southern Methodist University. *Livres d'artiste by Braque, Matisse and Picasso*. From the Collection of the Bridewell Library. Texts by William Jordan and Decherd Terner.

1980, 14 March-
25 May

Paris, Musée du Luxembourg. *Donation Geneviève et Jean Masurel à la Communauté urbaine de Lille*. Catalogue par Marie Anne Peneau, Jacques Jardez, Amaury Lefebure. Paris: Editions de la Réunion des Musées Nationaux, 1980. 135 p., 157 illus., 24 col. 132 works shown. Included many Cubist paintings, drawings, gouaches, prints, and sculptures, some by Georges Braque, André Derain, Georges Rouault, and Kees van Dongen.

1980, 19 August-
24 November

Tokyo, National Museum of Modern Art. *Le Musée National d'Art moderne, Centre Georges Pompidou—L'Art du XXe siècle*. Also shown Kyoto, National Museum of Modern Art (17 Oct.-24 Nov.).

1980, 22 September-
31 October

Chicago, Arts Club of Chicago. *Books Illustrated by Painters and Sculptors from 1900*. Catalogue by J. M. Wells. 42 p., 39 illus. Provides a brief history and

definition of artists' books and considers the extent to which artists' books, as they appeared in 1900, were revolutionary rather than merely part of the illuminated manuscript tradition. The exhibits displayed a wide range of printing techniques and included books illustrated by Arp, Braque, Ernst, Kandinsky, Matisse, Miró, and Picasso. Wells enumerates the multiple aspects of the artists' books and concludes that the most successful productions are those in which artist, craftsman and publisher have cooperated closely to create a work of art. The list of exhibits provides details of author, publisher, illustrator, binder and printer (where known) as well as dimensions and provenance.

1980-81, 2 December-
3 February

Dusseldorf, Kunstsammlung Nordrhein-Westfalen. *Wassily Kandinsky: drei Hauptwerke aus drei Jahrzehnten—eine didaktische Ausstellun: bilder, Fotos, Texte* [Wassily Kandinsky: Three Major Works Spanning Three Decades—A Didactic Exhibition of Paintings, Photographs and Texts]. Catalogue by W. Schmalenbach, and W. Kandinsky. 56 p., 130 illus. Exhibition structured around three major works by Kandinsky: *Komposition 4* (1911), *Durchgehender Strich* (1923), *Komposition X* (1939). The catalogue is divided into three sections documenting the background in which the works were created and confronting each of them with a painting by a contemporary artist in order to bring about a "dialogue between contemporaries": Georges Braque's *Still Life with Harp and Violin* (1912), Max Ernst's *The Tottering Woman* (1923), and Hans Hartung's *T.38-2* (1938). Werner Schmalenbach introduces the catalogue and discusses the didactic approach; notes by Kandinsky are also included in the publication together with detailed descriptions of the three major works and of the artistic movements of the period.

1980

Dallas, Meadows Museum & Sculpture Court. *Livres d'artiste by Braque, Matisse and Picasso from the collection of the Bridewell Library.* Dallas: Meadows Museum. Catalogue by William Jordan and Decherd Turner. 8 p., 9 illus.

1980-81,
30 November-
4 January

Rome, Valle giulia, Galleria Nazionale d'arte moderna. *Apollinare e l'avanguardia.*

1981, May-April

Cologne, Galerie Gmurzynska. *The Classical Moderns.* Catalogue by H. Jordan. 274 p., 285 illus. German and English editions. On the occasion of the

international exhibition *Weltkunst*, organized by the Museums of the City of Cologne, the Galerie Gmurzynska presented its own selection of classical moderns after 1939 as part of the supporting programme. The exhibition catalogue features the work of twenty-eight modern artists, including Georges Braque. Biographical information on each is provided together with an accompanying statement summarizing their career and achievement.

1981, May-June

Madrid, Galería Theo. *Picasso y sus amigos: 1881-1981 centario* [Picasso and His Friends: 1881-1981 Centenary]. Catalogue by E. Lafuente Ferrari. 80 p., 75 illus. Exhibition of five paintings by Picasso and works by fourteen of his contemporaries, including Braque, Pablo Gargallo, Juan Gris, Alberto Giacometti, Manolo Hugué, Fernand Léger, and Joan Miró. A brief introduction discusses the influence of Picasso on these artists.

1981

London, J. P. L. Fine Arts. *Georges Braque, Henri Braque*. Review: M. Beaumont, *Arts Review* 33:13(3 July 1981):291.

1981, 26 June-12 July

Spoleto, Chiesa della Manna d'Oro. *XXIV^e Festival dei due Mondi: Erik Satie e gli artisti del nostro tempo*.

1981, 27 June-
20 September

Florence, Palazzo Pitti. *Arte Maestra; da Monet a Picasso. Cento capolavori della Galleria Nazionale di Praga* [Art of the Masters; From Monet to Picasso. One Hundred Masterpieces from the Nàrodní Galerie, Prague]. Texts by Achille Bonito Oliva, and Jirí Kotalik. 163 p., 100 illus. In Italian and English. 100 works shown. Included works by Braque, Matisse, Derain, and others. Review: A. Mura, *Prospettiva* 27(Oct. 1981):103-6.

1981, 2 July-
27 September

Munich, Villa Stuck. *Maler machen Bücher: illustrierte Werke von Manet bis Picasso—Lithographien, Holzschnitte, Radierungen* [Artists Make Books: Illustrated Works from Manet to Picasso—Lithographs, Woodcuts, and Engravings]. Katalog von A. Ziersch und Erhart Kästner. 80 p., 27 illus. Exhibition devoted to the book illustrations of about thirty European artists, including Braque, André Derain, and Henri Matisse. Erhart Kästner traces the origins and development of 20th century book illustrations and describes in particular the contributions of Marc Chagall, Pablo Picasso, Georges Braque, Salvador Dalí, and Max Ernst to this genre.

1981-82, 4 July-
16 September

San Francisco, Fine Arts Museum of San Francisco. *Master Paintings from the Phillips Collection.* Also shown Dallas, Museum of Art (22 Nov.-16 Feb. 1982); Minneapolis, Institute of Arts (14 March-30 May 1982); Atlanta, High Museum of Art (24 June-16 Sept. 1982). Organized by the Phillips Collection, Washington, D.C. Text by Eleanor Green with twelve essays by Robert Cafritz. Introduction by Laughlin Phillips; foreword by Milton W. Broown. 224 p., 180 illus., 98 col. 75 works shown.

Presented seventy-five of the collection's finest paintings by sixty-three artists, focusing on Impressionist, Post-Impressionist, and modern American artists. Included Renoir, Monet, Bonnard, Cézanne, van Gogh, Marin, Dove, and Pollock. Also included a range of masterworks from El Greco, Goyá, and Daumier to Picasso and Braque. Brown's foreword describes 19th and 20th century collectors, placing Duncan Phillips among those patrons dedicated to educating the public to an appreciation of modern art, although essentially conservative in his taste. Descriptive entries with provenances and reproductions of each painting.

1981, 4 July-
23 December

Saint-Paul-de-Vence, Fondation Maeght. *Sculpture du XXe siècle 1900-1945: traditions et ruptures.* Also shown Madrid, Fundación Juan March (30 Oct.-23 Dec.). Exposition réalisée par Jean-Louis Prat. 234 p., 196 illus., 5 col. Included works by Braque and Matisse, among many other artists. Reviews: F. Le Targat, *Connaissance des arts* 354(Aug. 1981):48-55; M. Vaizey, *Sunday Times* (6 Sept. 1981):40.

1981, 20 September-
23 December

Purchase, NY, State University of New York, Neuberger Museum. *Soundings.* Curator of exhibition: Suzanne Delehanty. 96 p., 130 illus. Surveyed the use of sound and music in art since 1900. Included works by Georges Braque, among many other artists. Contains an introductory essay by Delehanty accompanying essays by Dore Ashton, Germano Celant, and Lucy Fischer. Reviews: J. Russell, *New York Times* (6 Dec. 1981):D33; A. Wooster, *Art in America* 70:2(Feb. 1982):116-25; P. Frank, *Art Journal* 42:1(Spring 1982):58-62; R. Flood, *Artforum* 20:9(May 1982):88-9.

1981-82,
28 September-
31 March

Wolfenbuttel, Herzog August Bibliothek. *Die Welt in Bücherrn* [The World in Books]. Also shown Wolfenbuttel, Zeughaus (28 Sept. 1981-31 March 1982). Konzeption der Ausstellung und Katalog: Paul Raabe. 99 p., illus. In German and English. 238 works shown. Two-part exhibition of works from the permanent collection: documents, medieval manuscripts,

incunabula, and 20th century artists' books at the Herzog
August Bibliothek, and 16th-18th century printed books
at the Zeughaus. Subjects of illustrated books include
geography, topography, travel, Bibles and other religious
texts, astronomy, medicine, physics, geometry, history
and literature. Artists' books are by Braque, Chagall,
Dali, Matisse, Miró, and Picasso.

1981-82, 18 October-
13 June

Washington, D.C., National Gallery of Art. *The Cubist
Print.* Also shown Santa Barbara, Art Museum,
University of California at Santa Barbara (17 Feb.-28
March 1982); Toledo, Ohio: Museum of Art (24 April-
13 June 1982). Sponsored by National Endowment for
the Arts, Washington D.C. Catalogue by Burr Wallen
and Donna Stein. Santa Barbara: University of
California, 1981. 219 p., 223 illus., 8 col. bibliog.
Exhibition of Cubist prints, arranged in three sections.
The first concentrates on work by Georges Braque and
Pablo Picasso from the period 1907-15, Jacques Villon,
Louis Marcoussis, and Jean-Emile Laboureur. The
second examines Cubist printmaking on a broader level
and includes sections on cityscapes, still lifes and prints
relating to Cubist sculpture. The concluding section
contains diverse prints and book illustrations tracing the
various directions taken by Cubism and its contribution
to printmaking. Reviews: D. Robbins, *PCN* 13(March-
April 1982):6-10; B. Wallen, *Art News* 81(April
1982):88-91.

1981-82,
11 December-
21 February

Hamburg, Kunsthalle. *Der zerbrochene Kopf: Picasso
zum 100. Geburtstag* [The Smashed Head: On the 100th
Anniversary of the Birth of Picasso]. Katalog von
Helmut R. Leppien, Pierre Daix. 135 p., 93 illus.
Partly in French. Catalogue to an exhibition presenting
a selection of paintings by Picasso and works by thirty-
seven other European artists executed in 1909 with the
aim of showing how artists were depicting the human
figure and head in the year when Picasso first "broke"
the head, as is explained in Leppien's text, "The
Smashed Head." In "1909 or Year 1 of Cubism," Pierre
Daix discusses the differences between the early Cubism
of Braque and Picasso. The catalogue entries, by
Helmut Leppien, contain detailed commentaries on the
composition and style of the work.

1981

Bochum, Haus Kemnade, Museum Bochum. *Kubismus
und Musik.* Texts by O. Pukl and P. Spielmann.

1982, 3 March-
22 August

London, Barbican Centre for Arts and Conferences, Art
Gallery. *Aftermath: France 1945-54: New Images of
Man.* Also shown Humlebaek, Denmark, Louisiana

Museum (26 June-22 Aug.). Notes by Germain Viatte and Sarah Wilson. Essays by Germain Viatte and Henry Claude Cousseau. Association française d'action artistique. 160 p., 228 illus., 32 col. 170 works shown. Examined how some of the artists working in the decade after World War II responded to the traumas they had witnessed during the Occupation in paintings, drawings, sculptures, and assemblages. While Picasso, Matisse, Braque, and Bonnard continued to make their individual contribution, other artists responded to the events of this time in other ways.

a. Danish ed.: *Paris efter Krigen, 1945-54: Mod et andet Menneskebillede* in *Louisiana Revy* 22:3(1982):1-66. 100 illus., 24 col. pl. 170 works shown. English and French summaries.

Reviews: M. Collings, *Artscribe* 34(9March 1982):62; P. Fuller, *Art Monthly* 55(April 1982):13-5; M. Vaizey, *Gazette des Beaux-arts* 100(July-Aug. 1982):18-9.

1982

Williamstown, MA, Sterling and Francine Clark Art Institute. *Extending Cubism; Cubism and American Photography, 1910-1930*. Review: D. Robbins, *PCN* 13(March-April 1982):6-10.

1982-83, 5 May-
27 November

Washington, D.C., National Gallery of Art. *20th Century Masters: The Thyssen-Bornemisza Collection*. Also shown Hartford, CT, Wadsworth Atheneum (1 Oct.-28 Nov. 1982); Toledo, Toledo Museum of Art (17 Dec. 1982-20 Feb. 1983); Seattle, Seattle Art Museum (15 March-15 May 1983); San Francisco, San Francisco Museum of Modern Art (2 June-31 July 1983); New York, Metropolitan Museum of Art (30 Aug.-27 Nov. 1983). Exhibition organized and circulated by the International Exhibitions Foundation, Washington, D.C. Catalogue by William S. Lieberman. 79 p., 66 illus., some col. 66 works shown. Paintings from the collection of Baron H. H. Thyssen-Bornemisza of Lugano, Switzerland, survey the development of modern art from the early 20th century to the period of American Abstract Expressionism and Photo Realism. Among the 20th century masters represented are Braque and Picasso. Reviews: N. Bremer, *Pantheon* 40:4(Oct.-Dec. 1982):346-7; C. Miedzinskyi, *Artweek* 14:25(16 July 1983):5-6.

1982, 26 May-25 July

Cologne, Josef-Haubrich-Kunsthalle. *Kubismus: Kunstler—Themen—Werke—1907-1920*. Konzept und Leitung: Siegfried Gohr. 263 p., 214 illus., 13 col. 137 works shown. Essays include Marianne Teuber on the origins of Cubism, postulating a connection with late-20th century findings concerning psychology of

perception; Leo Steinberg on Cézannisme and early
Cubism; Reinhold Hohl on appearance and illusion of
the content of Cubist paintings; Andreas Franzke on
landscape; Siegfried Gohr on still life and figure in the
Cubist painting of Picasso and Braque; Jens Kwasny on
Cubism and poetry in relation to the thought of Carl
Einstein; Manfred Brunner on Daniel-Henry
Kahnweiler's *Weg zum Kubismus* as an authority on
Cubist intentions. Reviews: H. Richter, *Weltkunst*
52:14(July 1982):1992; B. Catoir, *Pantheon* 40:3(July-
Sept. 1982):245-6; R. Puvogel, *Kunstwerk* 35:4(Aug.
1982):84-6.

1982, June-July

Cologne, Galerie Gmurzynska. *Masterpieces of the
Moderns.* Catalogue by K. Rubinger, H. Richter. 172
p., 88 illus. German and English versions.
Exhibition of works by eighteen modern artists including
Braque, containing biographical information on each.
Annotations provide details of title, size, date, signature,
provenance, previous exhibitions and, in some cases, a
descriptive commentary or previously published review.
The text of Gino Severini's contribution to the 1913
Futurist manifesto is appended.

1982, Fall

London, Waddington Galleries. *Sculpture.*
Included works by Braque, among others. Review: M.
Holman, *Artscribe* 38(Dec. 1982):55-6.

1982-82,
18 November-
13 March

New York, Solomon R. Guggenheim Museum. *60
Works: The Peggy Guggenheim Collection.* Foreword
and acknowledgements by Thomas M. Messer. 67 p.,
60 illus., some col. 60 works shown. Paintings and
works on paper including some by Braque, among other
artists.

1983, 27 April-9 July

London, Tate Gallery. *The Essential Cubism: Braque,
Picasso & Their Friends (1907-1920).* Catalogue by
Douglas Cooper and Gary Tinterow. 448 p., 233 illus.,
92 col. Exhibition of Cubist paintings, drawings, prints,
watercolors and sculpture by Braque, Gris, Léger,
Picasso, Laurens, Lipchitz, Robert Delaunay, Albert
Gleizes, Louis Marcoussis, Jean Metzinger, and Jacques
Villon, with an introduction in which the authors note
the recent growth in interest in Cubism and attempt to
define the true nature of Cubism. They assert that the
form of Cubism originally created and practiced by
Braque and Picasso between 1908 and 1911 was their
work alone and did not involve an artistic school,
although Gris's Cubist idiom was accepted by these two
artists as Cubist in their own sense of the term. They
see Cubism as a reaction against Impressionism and

compare the development of the two movements. They conclude that Cubism cannot be defined as a style any more than it can be identified by its subject matter; Cubist paintings are essentially personal in character. They quote Gris's comment that Cubism was "not a manner" but "a state of mind." In "The Early Purchasers of True Cubist Art," they examine the pioneering dealers and collectors and the later enthusiasts of Cubist art, to ascertain the sources of financial support available to Picasso and Braque. There are detailed analyses of all exhibited works. Reviews: F. Daix, *Connaissance des arts* 375(May 1983):94-7; F. Tempra, *Goyá* 1983):388-9; A. Phillips, *Times Literary Supplement* (27 May 1983):543; M. Beaumont, *Arts Review* 35:10(27 May 1983):286-7; D. Farr, *Apollo* 117:256(June 1983):508-9; H. Kramer, *New Criterion* 1:10(June 1983):63-7; R. Ayers, *Artscribe* 41(June 1983):59-61; C. Green, *Burlington Magazine* 125:964(July 1983):439-43; J. Wood, *Pantheon* 41(July-Sept. 1983):275-6; W. Feaver, *Art News* 82:8(Oct. 1983):159-60; J. McEwen, *Art in America* 70:9(Oct. 1983):32; N. Dimitrijevic, *Flash Art* 114(Nov. 1983):70; J. Adamson, *Art History* 7:1(March 1984):124-6; P. Flagg, *Revue d'Art Canadienne* 14:1-2(1987):175-6.

1983, 4 June-4 September

Martigny, Fondation Pierre Gianadda. *Manguin parmi les Fauves*. Introduction et catalogue par Pierre Gassier. Textes de Lucile Manguin et Marie Hahnloser. 175 p., illus. 105 works shown. Features twenty-four Fauvist canvases (1903-08) by Manguin shown with paintings of the same period by eleven other artists associated with Fauvism: Braque, Camoin, Derain, Dufy, Friesz, Marquet, Matisse, Puy, Valtat, van Dongen, and Vlaminck. Also presents twenty-five Manguin paintings, watercolors, and drawings executed after his Fauvist period (1908-49). A group of thirteen French posters of the period also shown. Catalogue contains an introductory essay by Gassier, an appreciation by the artist's daughter, Lucile Manguin, and an essay on Manguin in Switzerland by Maria Hahnloser.

1983-84, 30 September-1 January

Milwaukee, Milwaukee Art Museum. *Selections from the Hope and Abraham Melamed Collection*. Text by Russell Bowman and Verna Posever Curtis. 48 p., illus. 50 works shown. Representing just over one-half of the works in their collection, this selection features works on paper (prints, drawings, illustrated books, and collages) by 20th century European artists. Cubist prints are a special focus on the collection, including examples by Braque and Picasso.

1983

Little Rock, Arkansas Art Center. *Selections from the Permanent Collection of the Arkansas Art Center Foundation.* Text by Irma B. Jaffe and Yvonne Korshak. 175 p., 79 illus., 14 col.
Exhibition of 15th-20th century drawings, paintings, sculpture, and prints, including works by Braque. Collection emphasis is on works on paper.

1983-85

New York, New York State Council on the Arts. *Cubist Prints, Cubist Books.* Sponsored by the New York State Council on the Arts and the National Endowment for the Arts, Washington, D.C. Catalogue by R. Padgett, G. Peck; edited by Donna Stein. 128 p., 92 illus. The exhibition catalogue is also an issue of *Flue* 4:1-2(Fall 1983). Hailed as the first retrospective exhibition in New York entirely devoted to Cubist prints and illustrated books, it included examples of work by thirty-four European, Russian and American artists and twenty-two European, Russian and American writers. In her introductory essay, "Cubist Prints from the Weiss Collection," Stein emphasizes the artists' capacity for experimentation and originality. she discusses the sources of imagery in the work of many of the individuals concerned and states that the collection is significant for its concentration on prints by Braque, Picasso, Marcoussis, and Villon. Discussing the relationship between Cubist illustrated books and the revolutionary aesthetics of the early 20th century, she notes particularly the association between writers such as Blaise Cendrars, Max Jacob, Paul Reverdy, and Apollinaire and painters such as Delaunay, Léger, Picasso, and Braque. Padgett examines the links between the Cubist painters and poets in more detail, while Peck introduces Ernö Kállai's essay in the Hungarian magazine, *Ma*, entitled "Cubism and the Future of Art." The exhibition travelled to three other U.S. venues and to Paris after leaving New York.

1984, 5-24 May

Balingen, Stadthalle. *Europäische Keramik der Klassischen Moderne: Braque, Chagall, Miró, Picasso.* [European Ceramics in the Classic Modern Spirit: Braque, Chagall, Miró, Picasso]. Ausstellung und Katalog: Roland Doschka. 129 p., illus.

1984

San Antonio, Marian Koogler McNay Art Museum. Review: P. Larson, *Print Collector's Newslett* 15(July-Aug. 1984):96-7.

1984-85,
19 September-
15 January

New York, Museum of Modern Art. *'Primitivism' in Twentieth-Century Art: Affinity of the Tribal and the Modern.* Catalogue by William S. Rubin.

1984, 25 October- 30 December	Los Angeles, Los Angeles County Museum of Art. *In Honor of Ebria Feinblatt, Curator of Prints and Drawings*. Catalogue by Bruce Davis. Published in *Los Angeles County Museum of Art Bulletin* 28(1984):8-70. 79 illus. Tribute to Ebria Feinblatt, curator of the Los Angeles County Museum of Art's collection of prints and drawings from 1947 to 1985, comprising a summary of Feinblatt's acquisitions policy and the catalogue to an accompanying exhibition of the same title, showing 79 prints and drawings from the collection (25 Oct.-30 Dec. 1984). Davis discusses the historical significance of the works, which date from the 15th to the 20th centuries, and include prints by Andy Warhol, Jacques Villon, Karl Schmidt-Rottluff, Ed Ruscha, Picasso, Claes Oldenburg, Edvard Munch, Matisse, Jasper Johns, Sam Francis, Degas, Braque, and Pierre Bonnard. A list of exhibitions organized by Feinblatt is appended.
1984-85, 22 November- 28 January	Paris, Musée National d'Art moderne. Centre Georges Pompidou. *Donation Louis et Michel Leiris. Collection Kahnweiler-Leiris*. Introduction d'Isabelle Monod-Fontaine. Catalogue par Isabelle Monod-Fontaine, Agnès Angliviel de la Baumelle, Claude Laugier; assistées de Sylvie Warnier et Nadine Pouillon. 238 p., 260 illus., 38 col. 250 works shown. Exhibition of 20th century paintings, drawings, prints, and sculptures, donated to the museum in 1984 from the collection of Michel and Louise Leiris. The Leiris collection, formed with the assistance of Louise's brother-in-law, the dealer Daniel-Henry Kahnweiler, includes substantial holdings of works by Pablo Picasso, André Masson, Juan Gris, Georges Braque, and others. Catalogue contains introductory essays on each artist and his association with the Leiris's and Kahnweiler. Full catalogue entries with illustrations of all exhibited works. Review: M. Gee, *Burlington Magazine* 127:983(Feb. 1985):117-8.
1985	Amsterdam, Stedelijk Museum. *La Grande Parade: Highlights of Paintings After 1940*. Review: S. Morgan, *Artforum* 23(March 1985):82-6.
1985	Paris, Galerie Berggruen. *Cubisme*. Review: D. Picard, *Connaissance des arts* 397(March 1985):72-7.
1985, 20 March- 19 May	London, Victoria and Albert Museum. *From Manet to Hockney: Modern Artists' Illustrated Books*. Catalogue by Carol Hogben and Rowan Watson. 380 p., 429 illus., 36 col. Exhibition of printed book illustrations and illustrated books by 132 European, American and Russian artists of the last one hundred years, including Braque and Matisse. Watson discusses the history of

modern book illustration, describing the seminal roles played by Mallarmé and Vollard in the late 19th century, the importance of politically motivated art in the pamphlets and periodicals of early 20th century Europe and Russia, and the manner in which post-war artists have used illustration to expand their aesthetic vocabularies.

1985, 6 July-
22 September

Stüttgart, Staatsgalerie. *Vom Klang der Bilder: die Musik in der Kunst des 20. Jahrhunderts.* [On the Sound of the Picture: Music in 20th Century Art]. Edited by Karin von Maur. Munich: Prestel, 1985. 480 p., 832 illus., 223 col. Exhibition of 546 paintings, drawings and sculptures, showing a variety of manifestations of music in 20th century art. Artists represented include Picasso, Kandinsky, Klee, Man Ray, Braque, Beuys, Cage, Čiurlionis, the Delaunays, Itten, Léger, Marc, Miró, Mondrian, Paik, Poelzig, Schlemmer, and Gino Severini. The twenty essays explore the influence of musical themes, structures and rhythms of color and form in the work of specific artists and movements, and indicate the contributions of some major composers to the visual arts.

1985-86,
9 November-
10 February

Bologna, Galleria Comunale d'Art Moderna. *Morandi e il suo tempo* [Morandi and His Time]. Catalogue by Eugenio Riccomini, Franco Solmi, Silvia Evangelisti, Marilena Pasquali. Milan: Gabriele Mazzotta, 1985. 280 p., 336 illus., 88 col. Exhibition of paintings and drawings by Giorgio Morandi (1890-1964), together with paintings and drawings by some sixty artists whose work paralleled or influenced Morandi's style, including Cézanne, Rousseau, Braque, Picasso, de Chirico, Carrà, Licini, Sironi, Mafai, and Rosai.

1985, 13 November-
20 December

New York, Wildenstein Galleries. *Paris Cafés: Their Role in the Birth of Modern Art.* Review: G. Weisberg, *Arts Magazine* 60:5(Jan. 1986):90-1.

1985-86,
23 November-
12 January

Washington, D. C., Phillips Collection. *French Drawings from the Phillips Collection.* Sponsored by the National Endowment for the Arts, Washington, D. C. Catalogue by Sasha M. Newman. 8 p., 5 illus. Exhibition of drawings by French or French-based artists from the Phillips Collection, including works by Bonnard, Braque, Henri Edmond Cross, Degas, Derain, Charles Despiau, Dufy, Dunoyer de Segonzac, Fantin-Latour, Gaudier-Brzeska, van Gogh, Marcel Gromaire, Roger de La Fresnaye, Aristide Maillol, Matisse, Modigliani, Jules Pascin, Picasso, Renoir, Seurat, Nicolas de Staël, and Toulouse-Lautrec. In her

introduction Newman briefly describes the collection and analyzes some of the outstanding works it contains.

1986, 2 March-
25 May

Frankfurt am Main, Städtische Galerie im Städelschen Kunstinstitut. *Raumkonzepte: Konstruktivistische Tendenzzen in Bühnen- und Bildkunst 1910-1930* [Concepts of Space: Constructivist Tendencies in the Theatre and Art 1910-30]. Organized in cooperation with the Theatermuseum der Universität zu Köln, C. Hubertus Gassner, Hannelore Kersting, Helmut Grosse, Maria Porrmann, Maria Müller, Uwe Schareck. 329 p., 473 illus., 20 col. Catalogue to an exhibition of Constructivism in art and in the theater, divided into eight sections, with a general introduction to Constructivism by Gassner. Kersting discusses Russian Constructivists, focusing in particular on Liubov Popova and El Lissitzky, but including examples of work by twenty artists in all, among them Varvara Stepanova, Alexander Rodchenko, Aleksandr Vesnin, and Alexandra Exter. De Stijl and the work of Piet Mondrian, Theo van Doesburg, Sophie Täuber-Arp, Vilmos Huszár, and Bart van der Leck is introduced by Kerstitn, as are aspects of the Bauhaus, with examples of paintings by Lothar Schreyer, Wassily Kandinsky, Oskar Schlemmer, Roman Clemens, Andreas Weininger, and László Moholy-Nagy. Grosse provides an introduction to sixteen German Constructivists, including Erich Buchholz, George Grosz, and Gustav Singer. The role of the Constructivists in the political theater of socialist culture is explored by Porrmann, with the inclusion of work by Traugott Müller and Ernst Preusser, among others. The work of nineteen artists is featured in the section on collage and music theater introduced by Kersting. They include Ewald Dülberg, Kurt Schwitters, Hans Arp, and Georges Braque. Müller considers the relationship between Dada and Constructivism and Schareck comments on film, photomontage, and the avant-garde in the 1920s.

1986

Southport, England, Atkinson Art Gallery. *Illustrations to Apollinaire*. Review: M. Lothian, *Arts Review* 38(28 March 1986):174.

1986, April-August

Iowa City, University of Iowa Museum. *The University of Iowa Museum of Art: 101 Masterpieces*. Catalogue by Robert Hobbs. 224 p., 161 illus., 120 col. Exhibition of works selected from the holdings of the University of Iowa Museum of Art, Iowa City, Iowa. The European and American 20th century paintings and works on paper that made up the bulk of the exhibition included works by Munch, Braque, Matisse, Rouault, de

Chirico, Beckmann, Motherwell, and Morandi. There were also sculptures by Moore, Lipchitz, Nevelson, and Noguchi.

1986, 25 May-
17 August

Düren, Leopold-Hoesch-Museum. *1. International Biennale of Paper Art.* Sponsored by Föderverein Düren-Jülich-Euskirchener Papiergeschichte and Museums-verein Düren. 366 p., 187 illus. English and German versions. Showed work by paper artists from twenty-two countries. In "Papermaking: A New Language of Art—A Historical Excursion," Dorothea Eimert Briefly traces the history of paper and notes the new uses made by such artists as Picasso, Braque, Kurt Schwitters, and Oskar Holweck.

1986-87, 31 May-
18 January

Raleigh, North Carolina Museum of Art. *French Paintings from the Chrysler Museum of Art.* Also shown Birmingham, AL (6 Nov. 1986-18 Jan. 1987). Introduction by William J. Chiego; Catalogue by Jefferson C. Harrison. Norfolk, VA: Chrysler Museum, 1986. 139 p., 90 illus., 45 col. 45 works shown. Exhibition of French paintings from the Chrysler Museum, Norfolk, Virginia. They included works by Manet, Cézanne, Pissarro, Sisley, Renoir, Degas, Gauguin, Paul Signac, Matisse, Braque, and Rouault. There is a short essay on each by Harrison, and the annotations include exhibition histories. In his introduction, Chiego comments on the importance of the Chrysler Museum's collection and describes some of its highlights.

1986, 14 June-
9 November

Eindhoven, Netherlands, Van Abbemuseum. *Eye level/ooghoogt: Stedelijk Van Abbemuseum, 1936-1986.* Catalogue by Rudi H. Fuchs. 2 vols., 324 p., 340 p., 375 illus., 123 col. Exhibition celebrating the 50th anniversary of the museum established by the Dutch art collector Henri van Abbe, presenting paintings, sculptures, prints, installations, mixed-media works, photographs and neon pieces by modern and contemporary international artists. Works selected reflected the collection's main emphasis of Dutch art and international Expressionism, Cubism and geometric abstraction, and included works by Mondrian, van Doesburg, Heinrich Campendonk, Theo Kuypers, Karel Appel and Jan Schoonhoven, Barlach, Ernst, Beckmann, Kokoschka, Kiefer, Kirkeby, A. R. Penck, Clemente, Picasso, Miró, Chagall, Braque, Schwitters, Dubuffet, Tàpies, Gris, Baselitz, Zadkine and Warhol, among many others. The catalogue consisted of two volumes, with works arranged alphabetically by artist. Fuchs describes the difficulties of assessing the quality of art

works in an essay presented in the form of an imaginary debate.

1987, 16 April-
28 June

Los Angeles, Los Angeles County Museum of Art. *Degas to Picasso: Modern Masters from the Smooke Collection.* Catalogue by Carol S. Eliel. 144 p., 106 illus., 72 col. Exhibition of paintings and sculptures from the collection of late 19th and early 20th century European art assembled by Nathan and Marion Smooke. Although particularly strong in works by Degas, Matisse and Picasso, the selection also included important pieces by Vlaminck, Derain, Kandinsky, Kirchner, Gabo, Braque, and Gris. In her introduction Eliel discusses the avant-garde movements represented in the collection and describes its origins and expansion.

1987, 4 July-
4 October

Saint-Paul-de-Vence, Fondation Maeght. *A la rencontre de Jacques Prévert.* Catalogue par Jean-Louis Prat. 238 p., 288 illus., 114 col. Exhibition documenting the life and work of the poet and writer Jacques Prévert (1900-77), letters, poems, collages and drawings by Prévert, together with posters and stills from the cinema films on whose script Prévert collaborated. The exhibition also included paintings, drawings and sculptures by artists, most of them Surrealists, with whom he was primarily associated: Ernst, Tanguy, Magritte, Masson, Giacometti, Picasso, Léger, Henri Michaux, Asger Jorn, André Verdet, André François, Chagall, Braque, Emilienne Delacroix, Miró, Alexander Calder, Roland Topor, and Jean-Michel Folon. A catalogue to these works is included.

1987, 16 September-
8 November

Cleveland, Cleveland Museum of Art. *Creativity in Art and Science, 1860-1960.* Sponsored by Ohio Arts Council. Catalogue by Edward B. Henning. Bloomington, IN: Indiana University Press; in cooperation with the Cleveland Museum of Art, 1987. 143 p., 77 illus., 8 col. Exhibition which surveyed the parallel developments in science and the visual arts in the cited period. In his essay, Henning compares the ways in which creative scientists and artists articulate their experiences, in particular their use of imagery to express abstract concepts. The section on Cubism discusses Picasso and Braque, covering analytical Cubism, *papiers collés* and collages, and synthetic Cubism.

1987, 18 November-
19 December

Paris, Galerie Daniel Malingue. *Maîtres impressionnistes et modernes.* 72 p., 31 illus., 30 col. Exhibition of thirty paintings and one sculpture by predominantly French artists, including Pissarro,

Braque, Monet, Derain, Jean Dubuffet, Gauguin, Jean Hélion, Marie Laurencin, Matisse, Ben Nicholson, Yves Tanguy, and Auguste Herbin. Details of provenance are given for each of the paintings, accompanied by quotations by the artists or by critics.

1987-88, 22 November-4 April	Basel, Kunstmuseum. *Douglas Cooper und die Meister des Kubismus. Douglas Cooper and the Masters of Cubism.* Also shown London, Tate Gallery (3 Feb.-4 April 1988). Text und Katalog von Dorothy M. Kosinski; mit einem Beitrag von John Richardsonn. 231 p., 101 illus., 33 col. In German and English. 81 works shown. Exhibition of Cooper's collection of mainly Cubist watercolors, drawings, and prints. Catalogue contains chapters on Braque, Gris, Léger, and Picasso and Gaby Lespinasse, the artist's secret love.
1988, 23 April	Cologne, Galerie Orangerie-Reinz. *Ausgewaehlte Arbeiten von Georges Braque, Marc Chagall, Salvador Dalí, Joan Miró und Pablo Picasso.*
1988, 9 June- 15 August	New York, Brooklyn Museum. *Modern Masters: French Art from the Alex Hillman Family Foundation Collection.* Catalogue by Sarah France. 12 p., 8 illus. Exhibition of Impressionist, Post-Impressionist and early modern paintings and drawings from France from the Alex Hillman Family Foundation collection. France outlines the art scene in France in the latter part of the last century and briefly notes the work of the exhibited artists who include Renoir, Pissarro, Cézanne, Seurat, Toulouse-Lautrec, Picasso, Braque, Léger, and Juan Gris.
1988, 16 June- 30 October	Geneva, Musée d'Art et d'histoire. *Collection Berggruen.* Catalogue par Gary Tinterow, avec une contribution de John Rewald. 272 p., 120 illus., 114 col. 106 works shown. Exhibition of 106 works from the personal collection of Heinz Berggruen (1914-), including twelve paintings by Cézanne and works by Braque, Dufy, Matisse, and other artists.
1988, 19 June- 11 September	Lucerne, Kunstmuseum. *Von Matisse bis Picasso: Hommage an Siegfried Rosengart* [From Matisse to Picasso: Tribute to Siegfried Rosengart]. Sponsored by Schweizerischer Bankverein, Lucerne. Edited by Martin Kunz. Published in association with Gerd Hatje, Stuttgart, 1988. 200 p., 155 illus., 84 col. Exhibition of 20th century paintings and drawings collected by Siegfried Rosengart (1894-1985) and donated by him to museums in Europe and the U.S. with tributes to him by artists, collectors and curators, and a

profile of him by his daughter, Angela Rosengart. Particular attention is paid to his close friendship with Picasso, through which Rosengart gained an unusual insight into his art. Besides work by Picasso, the exhibition included paintings by Hodler, Bonnard, Matisse, Chagall, Klee, Miró, Léger, Gris, and Braque.

1988

New York, Sonnabend Gallery.
Review: S. Caley, *Flash Art* 141(Summer 1988):153.

1988, 9 September-
15 October

Philadelphia, Rosenwald-Wolf Gallery, Philadelphia College of Art. *The Arts of the Book.* Catalogue by Eleni Cocordas, Mary Phelan, and Clive Phillpot. 20 p., 10 illus., 8 col. Exhibition of 20th century book art which divided into three sections: "Five Years of New Bookworks"; "Limited Editions Featuring Artists and Writers in Collaboration and Response"; and "A Selection of Modern European Masterworks From the Collection of Arthur P. Williams." The works include artists's books, book illustrations and bookbinding. Phillpot considers methods of reading, focusing on artists' books. Artists exhibited included Jose Luis Cuevas, Georges Braque and Guillaume Apollinaire, K. K. Merker, Richard Minsky, Helen C. Frederick, Henry Morris, Romare Bearden, and Derek Wolcott, and Gary Link Frost.

1989, 18 April-
16 July

Hanover, Kestner-Gesellschaft. *Das Buch des Künstlers: die schönsten Malerbücher aus der Sammlung der Herzog August Bibliothek Wolfenbüttel* [The Artist's Book: The Most Beautiful Artists' Books from the Collection of the Herzog August Library in Wolfenbüttel]. Sponsored by Niedersächsische Sparkassenstiftung. Catalogue by Harriett Watts. 180 p., 72 illus., 31 col. Exhibition of the twenty-five "most beautiful" artist's books from the collection of the Herzog August Bibliothek in Wolfenbüttel. Watts provides a detailed commentary on each of the books, created by Georges Braque, Henri Matisse, and others.

1989, 18 May-8 July

Paris, Galerie Daniel Malingue. *Aspects de l'art moderne en France.* 88 p., 38 illus., 37 col.
Exhibition of paintings and sculptures by some twenty 20th century artists born or based in France, including Léger, Ernst, Metzinger, Braque, Laurens, Matta, Picasso, de Staël, and Vieira da Silva.

1989-90, 31 May-
4 November

Philadelphia, Philadelphia Museum of Art. *Masterpieces of Impressionism & Post-Impressionism: The Annenberg Collection.* Also shown Washington, D.C., National Gallery of Art (Summer 1990); Los Angeles, Los

Angeles County Museum of Art (16 Aug.-4 Nov. 1990).
Sponsored by Pennsylvania Historical and Museum
Commission, Pew Charitable Trusts, Florence Gould
Foundation, Bohen Foundation, CIGNA Foundation,
Philip and Muriel Berman, Ed and Martha Snider and
Women's Committee of the Philadelphia Museum of
Art. Catalogue by Colin B. Bailey, Joseph J. Rishe, and
Mark Rosenthal. 204 p., 243 illus., 49 col.
Exhibition of paintings from the collection assembled
since the early 1950s by Walter and Lee Annenberg. It
included works by Manet, Degas, Morisot, Fantin-
Latour, Renoir, Monet, Toulouse-Lautrec, Seurat,
Cézanne, Gauguin, van Gogh, Vuillard, Braque,
Bonnard, and Matisse.

1989, 4 July-
4 October

Saint-Paul-de Vence, Fondation Maeght. *De Cézanne à
Dubuffet, œuvres ultimes.* Review: V. Costa, *Beaux-
arts magazine* 70(July-Aug. 1989):74-9.

1989-90,
24 September-
16 January

New York, Museum of Modern Art. *Picasso and
Braque: Pioneering Cubism.* Also shown Basel,
Kunstmuseum (25 Feb.-4 June 1990). Catalogue by
William Rubin, assisted by Judith Cousins. Sponsored
by Philip Morris Companies Inc., National Endowment
for the Arts, Washington D.C., and Federal Council on
the Arts and Humanities. Exhibition examining Cubism
through the work of its prime inventors, Picasso and
Braque, and focusing on the core of the movement, the
work that they produced in dialogue with each other
between 1907 and the First World War. In a detailed
essay Rubin explores the work of each artist in the years
prior to this period before discussing the background to
this collaboration and comparing their work during the
years 1907-14. He pays particular attention to the
events of 1912, during the course of which the invention
of constructed sculpture, collage, and *papier collé* led
Picasso and Braque from Analytic to Synthetic Cubism,
and analyzes these developments in the light of the
dialogue between the two artists. His insights are drawn
in part from correspondence between Picasso and Braque
and from the testimonies of writers who had access to
the artists and their studios in the Cubist years. A
chronological anthology of documentary evidence that
bears directly on the interaction between Picasso and
Braque during the years 1907-14, compiled by Judith
Cousins, is appended. See also entry 210 for
information on a MOMA-sponsored symposium (1992).
a. French ed.: *Picasso et Braque: l'invention du
cubisme; suivi d'une chronologie documentaire.* Trans.
by Jeanne Bouniort. Paris: Flammarion, 1990. 422 p.,
illus.

b. German ed.: *Picasso und Braque: die Geburt des Kubismus*. Munich: Prestel, 1990. 424 p., 551 illus., 321 col.
Reviews: P. Daix, *Connaissance des arts* 451(Sept. 1989):92-101; D. Kuspit, *Artforum* 28:1(Sept. 1989):112-6; L. Zelevansky, *Beaux-arts magazine* 72(Oct. 1989):76-87; K. Levin, *Connoisseur* 219(Oct. 1989):40⁺; G. Galligan, *Art International* 9(Winter 1989):92-4; R. Wollheim, *Modern Painters* 2:4(Winter 1989-90):26-33; J. Flam, *Art News* 88:10(Dec. 1989):144-9; K. Wilkin, *New Criterion* 8:4(Dec. 1989):29-35; M. Beaumont, *Arts Review* 41(15 Dec. 1989):878-9; P. Matrick, *Arts Magazine* 64(Jan. 1990):78; D. Cottington, *Burlington Magazine* 132(Feb. 1990):160-1; J. Flam, *Art International* 10(Spring 1990):91-2; J. Golding, *New York Review of Books* 37:9(31 May 1990):8-11; J. Flam, *Art Journal* 49(Summer 1990):194-8, 49(Fall 1990):313-7; G. Regnier, *Journal of Art* 2:4(Jan. 1990):12-3; P. Mattick, *Arts Magazine* 64(Jan. 1990):78; D. Solomon, *Partisan Review* 57:2(Spring 1990):289-93.

1989-90,
12 December-1 April

New York, Metropolitan Museum of Art. *Twentieth-Century Modern Masters: Jacques and Natasha Gelman Collection*. Edited by William S. Lieberman. Foreword by Philippe de Montebello and Sabine Rewald. 355 p., 281 illus., 95 col. 81 works. Exhibition of the Jacques and Natasha Gelman Collection, shown in public for the first time. The collection comprises eighty-one masterpieces mainly of the art of the School of Paris by artists including Bonnard, Braque, Dali, Dubuffet, Matisse, Miró, and Picasso. The entries examine each work both individually and in its broader cultural context. Also included are essays on art currents such as Fauvism, Cubism, and Surrealism, and appreciations of artists considered to be among the main proponents of these major developments in the history of 20th century art. An illustrated checklist and an index are appended.

1989

London, Annely Juda Fine Art. *From Picasso to Abstraction*. 117 p., illus.

1990-91, 30 June-
April

Colmar, Musée d'Unterlinden. *Collages: collections des musées de province*. Also shown Villeneuve d'Ascq, Musée d'Art Moderne du nord (Sept. 1990-April 1991). Textes par Germain Viatte, Irène Elbaz, Sylvie Lecoq-Ramond, Marc Bormand, et Joëlle Pijaudier. 198 p., 205 illus., 69 col. Catalogue to an exhibition of collages from French provincial museums dating from 1912-86 including the work of seventy-six artists, among them Jean Arp, Georges Braque, Max Ernst, Henri Matisse,

and Kurt Schwitters. The catalogue contains five essays: "Notre avenir est dans l'air" by Germain Viatte; "Les Premiers collages. Les Premiers *papiers collés*" by Irène Elbaz; "Le Collage dadïste ou la peinture contestée" by Sylvie Lecoq-Ramond; "Aspects du collage dans les années soixante" by Marc Bormand; and "Années 80" by Joëlle Pijaudier.

1990-91, 4 October-1 September

Los Angeles, Los Angeles County Museum of Art. *The Fauve Landscape: Matisse, Derain, Braque, and Their Circle, 1904-1908.* Also shown New York, Metropolitan Museum of Art (19 Feb.-5 May 1991); London: Royal Academy of Arts (10 June-1 Sept. 1991). Catalogue by Judi Freeman with contributions by Roger Benjamin, James D. Herbert, John Klein, and Alvin Martin. 350 p., col. illus., col. pl. 345 works shown. Reviews: J. Pissarro, *Burlington Magazine* 133(Feb. 1991):144-6; J. Phillips *American Artist* 55(Oct. 1991):48-53[+].

1990, 14 October-30 December

Houston, Museum of Fine Arts. *Picasso, Braque, Gris, Léger: Douglas Cooper Collecting Cubism.* Sponsored by the Federal Council on the Arts and Humanities. Catalogue by Dorothy M. Kosinski and Alison de Lima Greene. 67 p., 39 illus., 14 col. Catalogue to an exhibition of eighty-five Cubist works by the four cited artists, together with two portraits of Douglas Cooper by Hockney and Sutherland. In her foreword, de Lima Greene stresses the nuanced understanding of Cubism that made Cooper a great collector. Kosinski's essay presents a detailed history of the formation of Douglas Cooper's collection in the 1930s, the period on which this exhibition concentrated.

1990

Liverpool, Walker Art Gallery.
Review: M. Lothian, *Arts Review* 42(5 Oct. 1990).

1990

Portland, Oregon Art Institute.
Review: C. Kelly-Zimmers, *Artweek* 21(6 Dec. 1990):15-6.

1990

Tokyo, Brigestone Museum of Art. *Masterworks: Paintings from the Bridgestone Museum of Art.* Catalogue by Yasuo Kamon. 102 p., illus. Catalogue to an exhibition of paintings from the holdings of the Bridgestone Museum of Art in Tokyo. Works by the following artists were on show: Camille Pissarro, Edouard Manet, Edgar Degas, Alfred Sisley, Paul Cézanne, Claude Monet, Pierre-Auguste Renoir, Henri Rousseau, Paul Gauguin, Vincent van Gogh, Paul Signac, Pierre Bonnard, Henri Matisse, Georges

Rouault, Raoul Dufy, Kees van Dongen, Pablo Picasso, Georges Braque, Maurice Utrillo, Marie Laurencin, Amedeo Modigliani, Giorgio de Chirico, and Chaim Soutine.

1991

London, National Gallery. *Van Gogh to Picasso. The Berggruen Collection at the National Gallery.* Essays by Lizzie Barker and Camilla Cazalet. Catalogue by Richard Kendall. 209 p., 150 illus., 88 col. Exhibition based on the personal collection of Heinz Berggruen. Artists represented include van Gogh, Seurat, Cézanne, Miró, Braque, and Picasso. Each work is reproduced in color.

1992, 19 January-
12 April

's-Hertogenbosch, Netherlands, Het Kruithuis Museum. *Terra scultura, terra pictura: keramiek van de 'klassieke modernen' George Braque, Marc Chagall, Jean Cocteau, Joan Miró, Pablo Picasso* [Sculpted Clay, Painted Clay: Ceramics from the 'Classical Modernists' Georges Braque, Marc Chagall, Jean Cocteau, Raoul Dufy, Joan Miró, Pablo Picasso]. Preface by Yvonne G. J. M. Joris, Roland Doschka, and François Mathey. 220 p., 99 illus., 82 col. In Dutch, summary in English and French. Catalogue issued on the occasion of an exhibition with the same title shown at the Museum Het Kruithuis in s'-Hertogenbosch, Netherlands. In the preface Joris analyzes how the "classical modernists" such as Braque, Chagall, Miró, Picasso, Cocteau and Dufy looked to the past, drawing on past images as well as experimenting with new materials in their exploration of the sculptural and pictorial possibilities of clay. Doschka, in an essay titled "Art Cannot be Made with Theory," discusses the versatility of the Fauves and Cubists who combined skills in both the sculptural and painted medium. The cooperation between painters and sculptors and the life and work of French ceramicist André Metthey, Catalan ceramicist Llorens Artigas, and Chagall's ceramic œuvre are examined. Mathey, in "But this is another story . . . ," traces the attitude of various artists towards ceramics, particularly Picasso and Miró.

1992

Paris, Galerie 10. Review: *l'Œil* 446(Nov. 1992):83.

1992

New York, Curt Marcus Gallery. Review: *Art News* 91(Oct. 1992):121.

1993, 23 May

Brooklyn, Brooklyn Museum of Art. *Manet to Picasso.* 35 prints and drawings created in France between 1870 and 1940 by, among others, Braque, Matisse, Degas, Renoir, Cézanne, and Morisot.

1993, 6 July

New York, Museum of Modern Art. *Reading Prints*. Exhibition focusing on the use of language and printed elements in 20th century art, from Cubist drypoints by Braque to works by the Dadaists, Léger, and Sonia Delaunay.

Art Works Index

Includes the titles of art works by Georges Braque in all media, as referred to in the entries and annotations.

Aegle (oil) 432
L'Arlequin (oil) 434
Atelier IX (oil) 435, 497
Ateliers series (oils, 1949-56) 497

Bass (engraving) 496
Le Billard (oil) 436
Black Rose (oil) 863
The Blue Mandolin (oil) 425,431
Boats on the Beach, L'Estaque (oil) 437
Bottle, Glass and Fruit (oil) 428
Bouteille de marc (oil) 438
Bouteille de rhum (oil, 1912) 502, 507

Cahiers 527
Casas en el Estaque (oil) 439
The Castle (oil, 1909) 499
Le Char (color lithograph) 540
The Checkerboard (oil, 1910) 440
Le Chevalet (oil) 441
Compotier, bouteille et verre (oil) 442
The Crystal Vase (oil, 1929) 493, 504

Femme au torse nu (oil) 443
Femme lisant (oil) 444
Fox (etching) 559, 563

Girl with a Cross (oil, 1911) 474
The Great Nude (oil, 1908) 398, 512
Guitar and Bottle of Marc on a Table (oil, 1930) 490, 493
Guitare (le petit éclaireur) (oil) 445

Henri II salle, Louvre (oils, 1952-53) 478, 483, 511
L'Homme à la guitare (oil, 1911) 494
House on the Hill, La Ciolat (oil) 501

Instrument de musique et journal (oil) 446

Job (drypoint etching, 1911) 447, 571
Le Journal (oil) 509

Lady with a Mandolin (oil) 763
La Lampe sur la table (oil) 486

Maisons et arbres (oil, 1909) 433, 488
Mantel (oil) 473, 476
La Monacre (oil) 502
The Musician (oil) 427

Naturaleza muetta: Gillette (oil) 448
Nature morte (oil) 454
Nature morte à la guitare (oil) 449, 516
Nature morte au gúeridon (oil, 1918) 510
Nature morte au verre et au journal (oil) 451, 506
Nature morte aux cerises (oil) 450
Nature morte aux pêches (oil) 452
Nature morte II: cubiste (oil) 453
Nu (oil) 455

Odalisque in Red (oil, 1925) 517

L'Oiseau blanc (oil) 456
L'Olivier (oil) 457

Palette and Flowers (oil, 1954) 517
Paysage à L'Estaque (oil) 458
Paysage de la Roche-Guyon (oil, 1909)
 503
Le Piège de Méduse (oil) 459
Pipe, verre et journal (collage, 1914)
 477
Platter of fruit (oil, 1925) 423
Les Poissons noirs (oil) 485
Le Portugais (oil, 1911-12) 481

Le Quotidien du midi (oil) 460

La Roche-Guyon Bridge (oil, 1909) 398
The Round Table (oil) 461

The Shower (oil) 462
Stilleben mit Harfe und Violine (oil,
 1911) 466
Still Life (oil, 1927) 498
Still Life (oil, 1952) 505
Still Life, Sorgues (oil) 462
Still Life with Fish (oil) 513
Still Life with Glass (oil, 1931) 482, 514
*Still Life with Jug, Pomegranate and
 Pears* (oil) 464
Still Life with Violin (oil, 1911) 465
Still Life with Violin and Pitcher (oil,
 1909-10) 487

La Table de toilette (oil) 467
Terrace of the Hôtel Mistral (oil) 501
Theogonie (prints, 1912-50) 531, 572,
 594
[Two Birds] (oil) 468

Vase, Palette, and Mandolin (oil) 469
Viaduct at L'Estaque (oil, 1908) 501,
 515
View of L'Estaque (oil) 501
Le Violin (oil, 1914) 470
Violin and Jug (oil, 1910) 495
Le Violoncelle (cutout) 645

[Wine Bottle Label] 471
Woman with a Book 973
Woman with a Mandolin (oil, 1910) 479,
 495

Yellow Cloth (oil, 1936) 520, 521

Personal Names Index

Abadie, Daniel 709
Abtal, Kampis 283
Adema, Pierre Marcel 743
Adrian, Dennis 324
Agar, Eunice 726
Alberts, Edouard 500
Allard, Roger 247, 803
Allendy, R. 935
Alphand, Hervé 293
Alvard, Julien 80, 936
Ambler, Jaquelin 425
Ampatzē Kōdōna, Rania 937
Anfam, David 727
Angiolini, Gerard 744
Anthelme, Gille 660
Apollinaire, Guillaume 134, 147, 198, 215, 216, 249, 325-327, 622, 670, 716, 717, 743, 745, 746, 803, 906, 938, 939, 1057, 1072
Apolonio, Umbro 284, 288, 747
Appebaum, Stanley 2
Appel, Karel 902
Aragon, Louis 731
Archipenko, Alexander 570, 746, 939
Argan, Giulio Carlo 748, 749
Arland, Marcel 81, 940
Arnason, Hjorvardur Harvard 750
Arnaudet, D. 427
Arnoson, Henry 839b
Arp, Hans (Jean) 715, 720, 804
Ashton, Dore 199
Aspel, Paulène 534
Assouline, Pierre 751
Astier, Colette 428
Astier, Pierre 41, 811

Aubry, G. 805
August, Marilyn 943
Auric, Georges 752, 944
Avedon, Richard 161
Avery, Milton 828
Ayers, R. 329

Babelon, J. 330
Bach, Johann Sebastian 688, 696
Bacon, Francis 773, 877, 949, 966
Bacot, Jacques 588
Baker, Sarah 331
Balla, Giacomo 861
Ballinger, James K. 714
Balthus 705, 1035
Bann, S. 753
Barbaud, Pierre 692
Bargellini, Piero 736
Barker, Michael 945
Barr, Alfred H., Jr. 254, 863
Barr, Pamela 282b
Barriere, Gérard 332
Barrows, Clyde 82
Barsky, Vivianne 429
Barthel, Gustav 754
Bartsch, Ingo 946
Baskt, Léon 664
Basler, Adolphe 755, 805
Battisini, Yves 584, 947
Bauer, Helmut 948
Bazaine, Jacques 333
Bazin, Germain 83, 293, 334, 335, 831
Beaudin, André 909
Beaufret, Jean 613
Beaumont, Etienne de 579

Beaumont, Mary Rose 949
Beloubek-Hammer, Anita 728
Beněs, Vincenc 1042
Benincasa, Carmine 285
Benito, Aurelio Martinez 775a
Benoit, Pierre-André 553, 591, 593, 600, 608-610, 612, 620, 623, 633-635, 686
Bensusan-Butt, John 756
Berckelauers, F. L. see Michel Seuphor
Berger, Jean-Claude 36, 53c
Berger, John 757
Berger, R. 950
Bergson, Henri 232, 715, 717, 1046
Bernard, Jean-Claude 690
Bernheim-Jeune 805
Bernier, Rosamond 795
Bernsmeier, U. 946
Bertholle, J. 952
Beuchey, Maurice 694
Beuys, Joseph 269, 1058
Bill, Max 216, 638
Bille, Ejler 217
Billot, Marcel 953
Bissière, Roger 84, 286, 336, 337, 670, 686, 709, 954
Blake, William 756, 773
Blanchard, Maria 1086
Blass, Bill 972
Blázque-Miguel, Juan 338
Bligne, Yves 430
Blin, Georges 535, 630
Blunt, Anthony 200
Boatto, A. 339
Boccioni, Umberto 653, 1059
Boddington, J. 729
Bodino, Maristella 218
Boe, Alf 955
Boissonnas, Edith 602
Bokanowski, Hélèna 1097
Bompart, Malvina 219
Bonet, J. M. 730
Bonfante, Egidio 85
Bonjean, Jacques 86
Bonnard, Pierre 539, 583, 722, 758, 760, 772, 773, 909, 910, 916, 943
Bonnefoy, Yves 201
Bononno, Robert 282b
Borsi 684
Bosquet, Alain 87, 340
Bouché, Louis 165

Boudin, Eugène 760
Bouillier, Renée 341
Bouillon, J.-P. 220, 779
Bouisset, Maïten 433
Bouquet, Michel 692
Bouret, Jean 342
Boutang, Pierre-André 705
Bove, E. 88
Bozo, Dominique 710
Brancusi, Constantin 50, 796, 920
Brandt, Bill 89
Brassaï, Jules 93, 686, 7858
Bresson, H. Cartier 166
Breton, André 759, 804, 877
Brettell, Richard R. 760
Breunig, Lloyd C. 745
Brion, Marcel 55
Brion-Guerry, Liliane 761
Brookner, Anita 94
Broos, Kees 957
Brown, Robert K. 711
Brunet, Christian 292
Bruno, R. 957
Buchheim, Lothar Günther 531, 958
Buchner, Joachim 477
Buffet-Picabia, G. 959
Bulliet, Clarence Joseph 762
Bureau, André 688
Burger, Fritz 763
Burgess, Gelett 735
Burollet, Thérèse 832
Bütler, Sonja 36
Büttner, Werner 742

Cabanne, Pierre 538, 684, 764
Cabutti, Lucio 221, 960
Caby, Robert 961
Cachons, Jacques 962
Cafritz, Robert C. 56, 346
Cain, Jean 347, 954
Calabrese, Omar 712
Calder, Alexander 266, 638, 877
Calvo, Serraller F. 95
Camoin, Charles 931
Campagne, Jean-Marc 963
Campano 730
Cantù, Arnoldo 957
Carandante, Giovanni 786
Carey, Francis 964
Carmeau, E. A. 639
Caroli, Flavio 765

Carr, Jeffrey 726
Carrà, Carlo 733
Carrà, Massimo 237, 280
Cartier, Jean-Albert 348
Carzou, Jean 684
Cassandre, A. M. 711
Cassou, Jean 57, 63, 96-98, 349, 350,
 670, 686, 766-768, 965
Cembalest, Robin 966
Cendrars, Blaise 99, 670, 717
Cepe, P. 100
Cézanne, Paul 52, 78, 110, 147, 224,
 241, 256, 304, 323, 380, 386, 393,
 394, 406, 427, 493, 494, 501, 714,
 723, 727, 730, 735, 738, 740, 746,
 756, 763, 773, 789, 799, 879, 892,
 910, 946, 974, 1004, 1065, 1083, 1085
Chabert, Philippe 713
Chagall, Mark 638, 684, 686, 693, 699,
 720, 772, 805, 864, 900, 911, 945,
 948, 966, 1035, 1073
Chalumeau, Jean -Luc. 731
Chapon, Francis 539, 682
Char, René 103, 276, 351, 352, 534,
 543, 551, 558, 584, 586, 590, 593,
 597, 598, 6700, 604, 613, 624, 627,
 629, 630, 633, 637, 671, 672, 686,
 717
Charbonnier, Georges 353, 541, 680
Chardin, Jean-Baptiste-Simeon 1065
Charensol, Georges 967
Chastel, André 201, 222, 478, 542, 686
Chavenon, Roland 968
Cheney, Sheldon 769
Chevalier, Denys 104
Chillida, Eduardo 686
Chipp, Herschel Browning 202
Chirico, Giorgio de 725, 804, 960
Cinotti, Mia 969
Ciry, Michel 684
Clair, René 717
Clarboust, Jean 739
Clark, E. 479
Clark, T. 639
Claudel, Paul 130
Clayman, Andrew S. 707
Cloonan, William 481
Cloquet, Ghislain 692
Cocteau, Jean 717, 945, 948
Cogniat, Raymond 44, 354, 661, 770,
 771

Cohen, J. 355
Collaer, Paul 970
Collamarini 690
Colles, Baxter 772
Collet, Henri 971
Collin, Philippe 705
Collins, Amy Fine 972
Collins, Judith 773
Columbier, Pierre du 774, 991
Conover, Carl 973
Constable, John 756
Cooper, Douglas 45, 106-108, 218, 227,
 294, 686, 775, 840
Coquiot, Gustave 776
Corot, Camille 730, 756, 1035, 1060
Costa, Vanina 974
Courbet, Gustave 946
Courthion, Pierre 777, 975
Cousins, Judith 209
Couturier, Pierre 953
Cowart, Jack 482
Cranshaw, Roger 976
Cranston, Mechthild 543
Craven, John 655
Creixhams 690
Crémieux, Francis 841
Crespelle, Jean-Paul 778
Crevel, René 977
Cruz-Diez, Carlos 517
Csaky, Joseph 1080
Cummings, Nathan 760
Cuttoli, Raphaël de 293
Czwiklitzer, Christoph 948

Dahlin, Bernard 356
Daix, Pierre 224, 225, 641, 705, 780
Dale, Chester 1049
Daleveze, Jacques 978
Dalí, Salvatore 656, 758, 773, 804, 916,
 949, 1073
Damase, Jacques 59
Daniele, S. 544
Dargent, G. 779
Darses, Simon 280a
Daucher, Hans 781
Daumier, Honoré de 552, 653, 738
Dauriac, Jacques-Pierre 109
Davay, P. 357
Décaudin, Michel 134
Degand, Léon 979, 980

Degas, Hilaire-Germain-Edgar 653, 760, 1096
De Kooning, Wilhelm 771, 850
Delacroix, Edgar 730, 1061
Delaunay, Robert 254, 720, 779, 861, 907, 939, 1072, 1073
Delaunay, Sonia 539, 684, 720, 721, 861, 1072
Delvaux, Paul 804
Denis, Maurice 1086
Depero, Fortunato 861
Derain, André 539, 653, 664, 751, 773, 783, 805, 808, 844, 861, 878, 924, 931, 978, 1019, 1042, 1050
Desailly, Jean 688
Descargues, Pierre 74, 110, 280a, 484, 782
Deschamps, Henri 1095
Desfons, Pierre 697
D'Espardès 690
Despiau, Charles 758, 1080
Desvallières, Georges 1086
Dethlefs, Hans Joachim 358
Dexter, R. F. M. 780a
Diaghilev, Serge 660, 664-666, 720
Diehl, Gaston 18, 60, 784
Dine, Jim 956
Dior, Christian 666
Dorival, Bernard 61, 111, 333, 485, 651, 766, 779, 784-788, 981-989
Dorr, G. H. III 990
Doucet, Jean 805
Dreuzy, Miriam de 939
Dubois, A. 779
Dubuffet, Jean 773, 781, 916, 956, 974
Duchamp, Marcel 253, 721, 773, 805, 807, 939, 1014, 1025, 1057, 1058, 1060
Duchamp-Villon, Raymond 939
Düchting, Hajo 746
Dufour, P. 992, 993
Dufy, Raoul 60, 304, 724, 758, 760, 772, 783, 805, 808, 828, 844, 845, 864, 878, 889, 926, 931, 1019
Dunlop, Lane 74a
Dunoyer de Segonzac, André 684, 755, 772, 805, 994
Dupin, Jacques 678, 995
Duthuit, Georges 997
Dutilleul, Roger 433, 1070
Duval, Jean-Luc 789

Duval, Rémy 112

Earp, Thomas Wade 790
Eddy, Arthur Jerome 791
Edlich, Stephen 753
Einstein, Carl 113, 226, 358, 359, 580, 670, 792, 998
Eisendrath, W. N., Jr. 1000
El Greco 227, 714, 738
Elgar, Frank 295, 573, 605, 642, 686
Elliot, J. H. 1001
Eluard, Paul 114, 599, 715, 804, 805
Emmons, James 66a
Enckell, Rabbe 1002
Engelberts, Edwin 276
Ernould-Gandouet, Marielle 658
Ernst, Max 638, 653, 664, 715, 804, 805, 861, 877, 1073
Erving, Selma 772
Escholier, Raymond 793
Escobar, Marisol 517

Fabiani, Enzo 1004
Fagus, Félicien 360
Fandsen, Jan Würtz 715
Farrell, Michael 902
Fauchereau, Serge 62, 203
Favela, Ramón 714
Feavier, W. 227
Feito, M. 739
Fels, Florent 794
Fermigier, André 841
Fernandez, Justino 228
Fertey, Jean-Marie 706
Fierens, Paul 115
Filla, Emil 738
Fini, Leonor 804
Finn, David 760
Fitzgerald, Robert 626a
Flam, Jack Donald 116
Flanner, Janet Hobhouse 117, 795, 1020
Flon, Suzanne 702
Folliot, Denise 743
Fontana, Lucio 638
Fortunescu, Irina 47, 296
Fosca, François 796
Fourcade, Dominique 613
Foye, Edward 487
Francastel, Pierre 229, 797
Frasnay, Daniel 796
Frechtman, Bernard 53b

Free, R. 488
Freeman, Judi 151
Freige, Simon 705
Fresnaye, Roger de la 805, 907, 939
Freud, Sigmund 715
Fried, Anny 361
Friesz, Othon 304, 783, 808, 931
Frochot 690
Frost, Rosamund 799
Fry, Edward F. 800, 1005
Fry, Roger 254, 1006
Füglister, Robert L. 362
Fumet, Stanislas 230, 297-299, 333, 363, 649, 675, 682, 683, 688, 689, 1007

Gabo, Naum 801
Gachons, Jacques des 1008
Galassi, J. 153
Gallatin, Albert Eugene 300, 802
Gamwell, Lynn 803
Garvey, Eleanor W. 545
Gasch, Sebastia 364
Gasser M. 546, 547
Gateau, Jean-Charles 804
Gatellier, G. 365
Gauguin, Paul 227, 653, 746, 760, 789, 946, 974, 1019
Gauthier, Maximilien 119
Gauthier, P. 732
Gavronsky, Serge 366
Gee, Malcolm 805
Gehry, Frank 707
Gelman, Jacques 916
Gelman, Natasha 916
Gener, Charlotte 716
George, Waldemar 367-369, 805
Gera, György 806
Gerson, Mark 1009
Giacometti, Alberto 539, 558, 621, 673, 686, 756, 773, 789, 878, 966, 1010
Gieure, Maurice 301, 522
Gilbert, Stuart 54
Gilmour, P. 122
Gilot, Françoise 807
Gimond, Marcel 1080
Giroud, M. 231
Giry, Marcel 123, 779, 808
Gleizes, Albert 247, 254, 395, 569, 721, 809, 810, 939, 1057
Goethe, Johann Wolfgang von 1101

Goldaine, Louis 41, 811
Golding, John 124, 254, 812
Goldwater, Robert John 4b, 813
Gómez de la Serna, Rámon 814
Gonzáles 736
Goodwin, Richard La Barre 495
Gordon, A. 125
Gordon, Jan 815
Gorky, Arshile 722, 727, 740
Gottlieb, Aurélie 1011
Gouk, Alan 718, 1012
Gourgaud 988
Gowing, Lawrence 126
Goyá y Lucientes, Francisco José de 552
Grand, P. M. 652
Grandrieux, Philippe 703
Gray, Christopher 816
Green, Christopher 717, 817
Greenberg, Clement 127, 643
Greenspan, Joanne 58a
Grenier, Jean 289, 374, 673, 686, 708, 818
Grieshaber, Hap 948
Grigorescu, Dan 47, 296
Gris, Juan 97, 167, 206, 218, 220, 226, 227, 231, 237, 244, 260, 265, 267, 303, 433, 665, 673, 703, 714, 717, 751, 780, 803, 805, 807, 812, 840, 844, 850, 861, 891, 900, 907, 924, 939, 960, 978, 1010, 1018, 1070, 1073, 1076
Grohmann, Gertrud 872b
Grohmann, Will 54, 128, 526, 677
Gross, Lori 490, 493
Grossi, Paolo 765
Gueguen, Pierre 129, 1013
Guggenheim, Marguerite 819
Guggenheim, Peggy 4b, 819
Guillaume, Paul 805
Guiney, Mortimer 820
Guth, Paul 26
Gysbrecht, Norbertus 495

Haas, I. 548, 549
Habasque, Guy 821
Hachuel, Jacquer 966
Hachuel, Marta 966
Haftmann, Werner 822
Halpern, Daniel 823
Halvorsen, Walther 375
Hamilton, George Heard 824

Hanna, Leonard 1017
Harnett, Michael 495
Hartung, Hans 638
Hatfield, Hurd 688, 689
Hauert, Roger 320b, 321
Heartfield, John 269
Heckel, Erich 960
Heidegger, Martin 686
Heinrichs, Hans-Jürgen 312
Hélion, Jean 802, 878
Hellerstein, Nina 130
Henderson, Linda Dalrymple 1014
Hennessy, Eileen B. 44a, 58b, 645, 646
Henning, Edward B. 492, 493, 1015-1018
Hering, George 1101
Heron, Patrick 131, 302, 718, 1012
Herrigel, E. 617
Hertz, Henri 377
Hesiod 594, 676
Hessens, Robert 692
Heversy, Ivan 825
Higgins, Ian 826
Hildebrandt, Hans 827
Hines, T. J. 551
Hirsh, Sharon Latchaw 733
Hitchcock, Henry-Russell 863
Hobbes, Robert Carleton 828
Hobhouse, Janet 117, 795, 1020
Hochfield, Sylvia 1021
Hockney, David 707, 773, 900, 902
Hodin, J. P. 1022
Hodler, Phillip 763
Hoeree, Arthur 1023
Hoffman, E. 378
Hoffmann, Gabriele 232
Hofmann, Hans 1012, 1032
Hofmann, Werner 532
Hogarth, William 749
Holzer, Jenny 269
Home, C. G. 790
Homolle, Geneviève 766
Hoog, Michel 779, 1024
Hope, Henry Radford 63
Hoppe-Sailer, Richard 1025
Horter, Earl 379
Hourcade, Olivier 247
Howard, Richard 74a
Howe, R. W. 25
Huber, C. 1026
Hubert, Etienne-Alain 134, 233

Huggler, M. 1027
Hugo, Victor 804
Humbert, Agnès 1028
Hüneke, Anne 653
Huser, France 135
Hüsserl 487
Huyghe, René 798, 830-832, 1029

Ikhlef, Roger 705
Ilíázd 621, 833
Imaizumi, A. 27, 674
Imdahl, M. 380
Ingres, Jean-Auguste-Dominique 227
Inoue, Yasushi 204
Isarlov, Georges 64, 275, 381
Ivey, William 722

Jacob, Max 924, 978
Jacoupy, Jacqueline 692
Jakovski, Anatole 136, 234
Janneau, Guillaume 254, 834
Jardot, Maurice 836
Jarry, Alfred 906
Jeanneret, Charles-Etienne 871, 1051
Jeanneret, Pierre 803
Jedlika, Gotthard 10, 137, 235, 837
Jennings 804
Jochems, Herbert 656
Johns, Jasper 773, 850
Johnson, Robert Stanley 838
Jouffroy, Alain 382, 654
Jouffroy, Jean-Pierre 138
Jouhandeau, Marcel 619, 686
Jouhannot, Jean 693
Joyce, James 487, 737
Joyce, Sonia 40
Judkins, Winthrop 303, 1031
Jullian, René 236, 779, 808

Kachur, Lewis 237
Kahane, Roger 696
Kahn, Alphonse 1097
Kahn, Wolf 1032
Kahnweiler, Daniel-Henry 3, 4, 139, 220, 221, 238-240, 247, 254, 383, 433, 577, 686, 751, 803, 805, 839-842, 1057, 1076
Kallaï, Ernö 384
Kamon, Yasuo 843
Kandinsky, Wassily 140, 433, 552, 715, 960, 974, 1025, 1073

Kanoldt, Alexander 734
Kar, Ida 1009
Karmel, Pepe 707
Käsebier, Gertrude 729
Kay 1101
Keen, G. 494
Kelder, Diane 844, 845
Kenner, Hugh 141
Kersting-Bleyl, Hannelore 495
Kim, Youngna 304
Kippenberger, Martin 742
Kirchner, Ernst Ludwig 960
Kisling, Moïse 805
Klee, Paul 218, 552, 719, 751, 781,
 804, 948, 956, 966, 1025
Klimt, Gustav 1097
Klyun 477
Knight, Vivien 718
Kober, Jacques 583, 671
Koch, Michael 734
Kohán, György 723
Kohler, A. 142
Kokoschka, Oskar 338, 758, 900
Kolle, Helmut 713
Kollwitz, Käthe 653
Kootz, Samuel M. 1055
Kornfeld, Eberhard W. 552
Kosuth 953
Kowzan, Tadeusz 1033
Kramer, Hilton A. 143, 828, 846
Krauss, Rosalind 241
Kuhn, Walt 879
Kunstler, Charles 755
Kuntzel, Thierry 703
Kupka, Frank 1014
Kurt, Martin 836
Kuspit, Donald Burton 144, 242
Kysela, Joseph 1042

La Furetière 1034
Lacambre, Jean 939
Lacasse, Joseph 1086
Lachaud, Mariette 686, 702, 708
Laforgue 380
Laloy, L. 145
Lancaster, Jan 56
Lancaster, John 772
Land, John R. 735
Langsner, Johannes 385, 1035
Langui, Emile 768
Lanllier, Jan 656

Larinov, Mikhail 666
Larrieux, J.-M. 386
Larson, Philip 496
Lasker, Albert D. 1047
Lassaigne, Jacques 46
Laude, Jean 213, 277, 278, 387, 779,
 848, 1036
Laufer, Fritz 305
Laugier, Henri 934
Laurencin, Marie 258, 716, 805
Laurens, Claude 1, 110, 282, 329, 686,
 702
Laurens, Henri 710, 728, 758, 779
Lawless, Catherine 497
Le Bon, Gustav 1046
Le Bot, M. 779
Le Brocquy, Louis 902
Le Buhan, D. 527
Le Corbusier 711, 717, 758, 873, 907,
 945, 953, 969
Le Fauconnier, Henri 254, 721, 939
Lebenstejn, Jean-Claude 1037
Lefèvre, André 805, 986
LeFrak, Ethel 845
LeFrak, Samuel J. 845
Léger, Fernand 49, 50, 167, 212, 218,
 220, 223, 227, 254, 271, 433, 690,
 692, 711, 717, 721, 751, 758, 760,
 805, 844, 850, 861, 864, 878, 907,
 920, 945, 953, 960, 969, 1002, 1070,
 1073, 1086
Lehni, Nadine 706
Lejard, André 306
Lemaître, Georges Edouard 849
Leroy, Claude 146
Lescure, Jean 702
Lespinasse, Gaby 218
Levêque, Jean-Jacque 147, 553
Levine, Edward 850
Lévy, Pierre 1080
LeWitt, Sol 773
Leyhausen, Karl 498
Leymarie, Jean 66, 147, 388, 686, 702,
 706, 851, 852, 1038
Lhote, André 233, 264, 389, 390, 395,
 670, 853-855, 1091
Liberman, Alexander 148, 149, 856
Lichtenstein, Roy 773, 902, 946, 964,
 1097
Lieberman, William S. 554, 916

Limbour, Georges 30, 51, 68, 150, 363, 555, 676
Lionel-Marie, Annick 939, 953
Lipchitz, Jacques 329, 477, 758, 1017, 1035, 1070
Lissitzky, El 552, 665
Little, Roger 391
Llopès, M.-C. 953
Lloyd, Christopher H. 499, 1039
Loeb, Pierre 857
Loewenfeld, Baron Heger de 293
Loos, Irma 243
Lórándírta, Hegyi 810b
Lorenz, G. W. 888
Louis, Morris 773
Loving, F. M. 211
Lowenfeld, Hegier de 657
Lurçat, Jean 271, 684
Lynch, James B., Jr. 719
Lyons, Kenneth 62a

Maar, D. 804
Macke, August 665
Mackintosh, Charles Rennie 1097
Madden, Anne 902
Madsen, Alex 720
Maeght, Adrien 607, 684, 943
Maeght, Aimé 572, 943
Maeght, Marguerite 943
Magnelli, Alberto 638, 684
Magritte, René 269, 638, 804, 956, 1073
Maillol, Aristide 758, 760, 772, 873
Makoviski, Sergei 1040
Maldiney, Henri 672
Malevich, Kasimir 665, 715, 858, 956, 1101
Malraux, Andre 74
Manessier, Alfred 952
Manet, Edouard 52, 539, 722, 746, 789
Mangin, Nicole S. see Worms de Romilly, Nicole S. Mangin
Manguin, Henrri 931
Manuel, Roland 774
Marc, Franz 960
Marchiori, Giuseppe 859
Marcoussis, Louis 97, 574
Marcus, Susan 1041
Maren-Grisebach, Manon 759b
Marey, Etienne Jules 1060
Marini, Marino 736

Marquet, Albert 772, 783, 808, 931
Marrey, Bernard 500
Marsans 910
Martin, Alvin Randolph III 151, 284, 307, 501
Martin, Robert 69
Masaryková, Anna 1042
Masini, Lara Vinca 70, 205
Massine, Léonide 660
Masson, André 539, 751, 789, 804
Mastai, M. L. D. 152
Masurel, Jean 433
Mathey, François 244, 860, 1043
Matisse, Henri 49, 212, 271, 395, 517, 539, 583, 653, 718, 720, 724, 726, 731, 735, 746, 755, 758, 760, 772, 773, 780, 783, 789, 804, 805, 808, 823, 828, 844, 845, 861, 864, 869, 878, 907, 910, 916, 931, 943, 944, 946, 949, 953, 957, 972, 1040, 1050, 1076
Mattick, Paul 245
Mauthner, M. 197
Max, Karl 392
McEwen, John 556
McGarry, S. H. 393
McMillan, Putnam Dana 990
McMullin, R. 394
McQuillan, Melissa Ann 861
Meistermann, Georg 911
Melegari, Ulisse 732
Méliès, Georges 261
Mellon, Paul 869
Mellon, Rachel 869
Mellow, James R. 862
Melot, Michel 557
Menier, M. 779
Metzinger, Jean 233, 247, 254, 721, 760, 803, 805, 809, 1045, 1057, 1070
Meurice, Jean-Michel 699, 704
Milgate, R. 395, 779
Milhaud, Daniel 395, 779
Miller, Jane 208b
Miller, Richard 758a
Minkoff, Burton S. 707
Miró, Joan 50, 218, 433, 558, 638, 664, 686, 758, 789, 804, 807, 861, 864, 877, 916, 920, 966, 1073
Mitchell, T. 1046
Mjöberg, Jöran 246
Modigliani, Amedeo 433, 653, 805

Moe, H. 396
Molesworth, A. H. N. 55a
Mondrian, Piet 714, 779, 780, 956, 966, 1025, 1073, 1083
Monet, Claude 789
Monod-Fontaine, Isabelle 4, 281, 311, 639, 710
Montaigne, Nicole 24
Montale, E. 153
Montebello, Philippe de 916
Moore, Henry 638, 742, 877
Morandi, Giorgio 732, 737, 910, 946
Morice, Charles 397
Morisot, Berthe 760
Morris, Georges L. K. 802
Mortensen, Richard 715
Mortimer, Ruth 772
Mosele, Franz 206
Moser, Koloman 665
Moskowitz, Peta 504
Moskowitz, Peter 493
Motherwell, Robert 753
Mourlot, Fernand 279, 631, 864, 865
Mourlot, frères 538
Mousseigne, Alain 866
Moutard-Uldry, R. 659
Mugot, Hélène 731
Muller, Joseph-Emile 867
Müller, Otto 960
Mullins, Edwin B. 71
Munch, Edvard 552, 665, 1083
Mundinger, Hugo 207
Murphy, Gerald 711
Murray, Elizabeth 707
Muybridge, Eadweard 1060
Myers, B. 1048

Nash, John Malcolm 247, 756, 868
Naumann, Francis M. 1050
Near, Pinkney Y. 869
Newman, Isaac 1101
Nogacki, Edmond 558
Nolde, Emil 653, 960
Novarina, Maurice 944
Nye, Simon 78a, 323a

Ochse, M. 155
Oehlen, Albert 742
Oehlen, Markus 742
Olivetti, Calendrier 72
Olivier, Fernande 208, 248

Olivier, G. 398
Oppler, Ellen Charlotte 870
Orsi, Donatella 737
Ozenfant, Amédée 803, 871, 872, 907, 1051

Paflik, Hannelore 232
Pallucchini, Rodolfo 72
Pallut, Pierre 686
Pankol, Otto 653
Papathanassioiu, B. Vangelis 702
Parinaud, Alain 249, 700
Paris, I. Mark 44b, 58a
Parménide 947
Pasch 926
Pasotti, Silvio 712
Pássuth, Krisztina 873
Paul, Gen 690
Paulhan, Jean 17, 147, 156-60, 399, 581, 595, 625, 686, 703, 874, 875, 1052
Payró, Julio E. 876
Payson, John W. 879
Pearson, R. M. 400
Peillex, Guy 1053
Penrose, Roland 804, 877
Perate, André 1054
Peret, Benjamin 1055
Perl, Jed 401, 878
Perlman, Bernard B. 879
Perrett, August 944
Perrone, Jeff 402
Perruchot, Henri 1056
Perse, Saint-John 430, 518, 561, 567, 626, 686
Petrová, Eva 738
Pevsner, Nikolaus 768
Phillips, Duncan 56
Picabia, Francis 721, 789, 804, 861, 939
Picard, D. 1057
Picasso, Pablo 49, 110, 116, 144, 147, 167, 185, 198-274, 303, 323, 329, 380, 386, 387, 393-395, 398, 402, 403, 406, 492, 493, 516, 517, 538, 539, 552, 558, 569, 570, 574, 638, 641, 664-666, 686, 692, 703, 707, 710, 711-717, 719-721, 725, 728, 729, 733-735, 737, 738, 740-742, 746, 748, 751, 756, 758, 772, 773, 779, 781, 789, 803-805, 807, 812, 828, 850, 861, 864, 877-879, 891, 899, 900,

910, 916, 920, 924-926, 933, 937, 939, 946, 948, 949, 953, 957, 960, 964, 969, 974, 976, 978, 1002, 1004, 1014-1019, 1021, 1024, 1025, 1035, 1042, 1057-1060, 1065, 1070, 1072, 1073, 1076, 1083, 1085, 1091, 1100, 1101
Picon, G. 162
Pierre, J. 880
Pindar 613
Pini, Marie-Anne 656
Pissarro, Camille 756, 760
Pleynet, Marcelin 403
Pocar, Ervino 305a
Podesta, Attilo 404
Poiret, Paul 805
Poirier, Patrick 739
Poliakoff, Serge 638
Pollock, Jackson 773, 789, 1083
Ponce de Leon, Arolina 1058
Ponge, Francis 48, 74, 163, 279, 308-310, 631, 686, 706, 826
Pontiggia, Elena 1059
Pool, Phoebe 200, 251
Porter, Allan 1060
Pouillon, Nadine 75, 281, 311
Poussin, Nicolas 730, 756
Presler, G. 167
Prevert, Jacques 636
Prowse, Philip 666
Puy, Michel 169, 247, 881

Quaytman, H. 740

Racine, Daniel 567
Ragghianti, Carlo R. 736
Ragon, M. 171
Raphael, Max 312
Rauch, Nicholas 882
Rauchenberg, Robert 731, 773, 933
Raun, Eva Epp 1050
Ravenna, Juti 85
Ray, Man 686, 804, 877, 1035
Raynal, Maurice 247, 313, 803, 805, 883-885, 1061
Read, Herbert Edward 886, 887
Reboux, Paul 926
Redon, Odilon 539, 772
Reff, Theodore 210, 892
Regnier, Gérard 253
Reichel, Hans 758

Reinhardt, Max 665
Reinhold, Susan 711
Renoir, Auguste 760
Restany, Pierre 41, 811, 1062
Reuillard, Gabriel 172
Reverdy, Pierre 42, 230, 233, 573, 575, 576, 582, 587, 592, 627, 682, 699
Revol, Jean 173, 314
Rewald, John 869, 1063
Rewald, Sabine 916
Rey, Robert 744
Ribemont-Dessaignes, Georges 29, 363, 560, 615, 675, 686, 1064
Rich, D. C. 508
Richardson, Frances 320b
Richardson, John 344, 35, 38, 76, 174-177
Richier, Germaine 758
Rivera, Diego 233, 714, 805, 1019
Rivers, Larry 902
Rivière, Jacques 247
Robbins, Daniel 254, 721
Robinson, Keith 1065
Robus, Hugo 741
Roché, Henri-Pierre 33, 1066
Roeder, Ralph 883a
Roger-Marx, Claude 889
Roh, Franz 289b
Roseet, David 859a
Rosenberg, C. 1067
Rosenberg, Léonce 6, 286, 389, 670, 1068-1070
Rosenberg, Paul 390, 493, 504, 1071
Rosenblum, Robert 890
Rosenthal, Gertrude 509
Roskill, Mark Wentworth 891
Rossif, Frédéric 702
Rothko, Mark 789, 1012, 1083
Rotzler, Willy 1072, 1073
Rouan, François 241
Rouault, Georges 664, 758, 760, 772, 845
Rousseau, Henri (Le Douannier) 713, 725, 906, 1019
Routhier 686
Roux, Jean-Paul 764
Rubin, William Stanley 209, 224, 255-257, 260, 262, 707, 892, 1021, 1074
Rupf, Hermann 1027
Rupf, Margrit 1027
Ruskin, John 380

Russell, John 315
Rutten, Pierre van 561
Rutter, Frank Vane Phipson 893
Ryndel, Nils 894, 929

Saidenberg, Nina 1076
Saint Laurent, Yves 972
Saint-Pol, Roux 606
Sallebert, Jacques 695
Salles, Georges 686, 1077
Salmon, André 670, 805, 895-897,
 1078, 1079
San Lazzaro, Gualtieri di 638, 770
Sarane, Alexandrian 898
Sarkis, Robert 722
Sarraut, Martin 700
Satie, Erik Alfred Leslie 577, 601, 616,
 907, 971
Saulnier, Adam 697
Saure, Wolfgang 1080, 1081
Schaarschmidt-Richter, Irmtraud 800b
Schaffrath, Ludwig 911
Schlemmer, Oskar 960
Schmidt, Georg 510
Schmidt-Rottluff, Karl 653, 960
Schneider, Pierre 178, 644
Schnunck, Volker 899
Schulumberger, E. 539
Schulz, Gisela 900
Schürer, Oskar 258
Schwabsky, Barry 179
Schwartz, Paul Waldo 901
Schwitters, Kurt 269, 653, 722
Scott, David 902
Segal, George 737
Segui, Schinichi 316
Selz, Jean 317, 562
Serre, Henri 706
Serullaz, Maurice 903
Seuphor, Michael 511, 533, 904, 905
Seurat, Georges 1019
Severini, Gino 773, 805, 907, 1059
Sharp, E. 563
Shattuck, Roger W. 528, 1082
Shih, Su 756
Shlemmer 653
Signovert, Jean 564
Silva, Vierra de 558
Sima, Michel 908
Simpson, I. 1083
Sitwell, Sachaverell 1087

Skira, Albert 909
Skira, Pierre 910
Soffici, Ardenzo 259, 670, 957
Solier, René de 565, 566
Solomon, Deborah 260
Soos, Emèse 567
Sowers, Robert 911
Spies, Werner 222a
Staël, Nicholas de 789, 911, 1012
Stahly, F. 568
Staller, Natasha 261
Stalter, Marcel-André 835
Stefani, Alessandro de 512
Stein, Donna M. 569, 560
Stein, Gertrude 11, 220, 249, 862, 949,
 1076
Stein, Leo 255, 949
Steinberg, Leo 180, 255, 262, 402, 1085
Steinberg, Mrs. Mark C. 1000
Stella, Joseph 773, 850
Stemp, Robin 263, 406
Stewart, Ian 664
Stieglitz, Alfred 729, 1050
Strachan, Walter John 912
Strand, Paul 729
Stravinsky, Igor 487, 715
Süe, Louis 994
Suleiman, Susan 745a
Sumner, Maud 1086
Supka, Magdolna B. 723
Sussan, René Ben 315
Sutherland, Graham 638
Sutton, Denys 1087
Suzuki, Daisetz Teitaro 617
Sweeney, James Johnson 913

Tadashi, Miyagawa 318
Takashina, Shuji 204
Tal-Coat, Pierre 686
Tamayo, Rufino 719
Tanguy, Yves 804
Tarbell, Roberta K. 741
Tassi, Roberto 914
Taylor, Simon Watson 759c
Temple, Charles de 656
Terenzio, Stephanie 571
Teriade, Emmanuel 8, 9, 28, 182, 407,
 529, 556, 1069, 1088, 1089
Terrasse, Antoine 1090
Thomas, M. 953
Thorstenson, Inger Johanne 264, 1091

Tinterow, Gary 227, 408
Tono, Yoshiaky 319
Torres-García, Joaquin 409
Torroella, R. S. 57b
Toulouse-Lautrec, Henri 539, 552
Treves, Marco 4b
Tschechne, Martin 742
Tudal, Antoine 54, 526, 582, 607, 677, 686
Turin, Louis 702
Turr, Karina 915
Tzanck, D. 805
Tzara, Tristan 596, 647

Ubac, Raoul 686
Uhde, Wilhelm 211, 410, 805
Uscatescu, J. 183
Utrillo, Maurice 433, 805, 949

Vallery, Jean 917
Vallier, Dora 32, 36, 40, 43, 50, 184, 282, 411, 572, 918-920
Vallotton, Félix 1096
Valsecchi, Marco 280
Van Dongen, Kees 783, 808, 845, 924, 978
Van Eyck, Jan 789
van Gogh, Vincent 725, 910, 946, 972, 1083
Van Rutten, Pierre 1092
Vaneck, Pierre 702
Varnedoe, Kirk 210
Vasarely, Victor 500
Vauxcelles, Louis 412, 413, 805
Vecchis, M. de 185
Veillard, Roger 607
Venturi, Lionello 423, 921
Verdet, André 49, 186, 187, 212, 290, 293, 320, 321, 414, 611
Verlaine, Paul 772
Veronesi, Giulio 188, 266
Victor, Eliane 698, 699
Vieira, J. G. 189
Vierny, Sacha 692
Vildrac, Charles 922
Villon, Jacques 50, 173, 574, 721, 758, 772, 920, 939, 1057, 1086
Vlaminck, Maurice de 751, 760, 783, 845, 924, 931, 978, 1050, 1093
Volboudt, Pierre 190, 573, 638
Vollard, Ambroise 594, 772

Voster, Hans 665
Vuillard, Edouard 760

Wagner, Anni 516, 517
Walker, James Faure 718
Wallard, Daniel 191
Walle, Odile van de 1095
Wallen, B. 574
Warhol, Andy 773, 933
Warnod, André 20, 22, 192, 193, 923
Warnod, Jeaninne 924, 978
Waroquier, Henri 684
Watt, André 194, 195
Weaver, Helen 841b
Weber, Gerhard 240
Weber, Max 141, 735, 879, 1019
Wechsler, Herman Joel 925
Weill, Berthe 926
Weiner 956
Weisberg, Gabriel P. 1096
Wen, George 1097
Wentinck, Charles 196
Werner, Alfred 724
Werner, Klaus 725
Werth, Léon 247
Wescher, Herta 927
West, Rebecca 54, 526, 677
Westheim, Paul 267, 928
Westhold, Alfred 929
Wheeler, Monroe 63, 930
White, Clarence 729
White, Tony 59a
Whitfield, Sarah 931
Wilenski, Reginald Howard 932
Wilhelm 666
Wilkin, Karen 77, 268, 322
Wilkinson, Norman 666
Will-Levaillant, Françoise 1099
Winspur, Steven 518
Wolfgang, Max Faust 269
Wolfram, Eddie 933
Wollheim, Richard 270
Woodcock, Sara 666
Woodruff, H. A. 415
Woolf, Virginia 487
Worms de Romilly, Nicole S. Mangin 213, 277
Wou-Ki, Zao 638

Yavorskaya, N. 271

Zadkine, O. 684
Zahar, Marcel 416
Zárraga, Angel 714
Zayas, Marius de 1050
Zborowski, W. 805
Zelevansky, Lynn 210, 272
Zervos, Christian 15, 197, 273, 274,
 417, 421, 618, 650, 670, 686, 934,
 1100
Zervos, Yvonne 829
Zipruth, M. E. 580b
Zollinger, Heinrich 1101
Zurcher, Bernard 78, 323

Subject Index

Subjects referred to by entry numbers.

Archival Materials 1-3
Audiovisual Materials 688-708

Biography and Career 55-197
Braque and Picasso 49, 110, 116, 144,
 167, 185, 198-274, 303, 323, 386,
 387, 393-395, 398, 402, 403, 406,
 545, 779, 780, 803, 807, 933, 937

Catalogues Raisonnés 275-282
Correspondence 4-52
Cubism 78, 110, 116, 141, 143, 144,
 147, 167, 173, 179, 183, 198-274,
 304, 323, 329, 332, 380, 386, 393-
 395, 398, 403, 406, 433, 477, 487,
 499, 501, 512, 557, 574, 641, 707,
 709, 710, 714, 721, 723, 727, 728,
 733, 735, 747, 751, 757, 764, 765,
 775, 778, 779, 780, 782, 785, 795,
 800, 803, 809, 810, 811, 814, 816,
 817, 820, 821, 825, 834, 838, 839,
 845, 846, 848, 850, 860, 868, 876,
 868, 875, 880, 890, 891, 898, 899-
 901, 903, 907, 933, 957, 960, 969,
 976, 980-982, 989, 992, 998, 1004,
 1005, 1014, 1017, 1018, 1031, 1033,
 1035, 1041, 1043, 1046, 1052, 1057-
 1059, 1067, 1070, 1072, 1074, 1076,
 1081, 1085, 1088, 1091, 1093, 1094,
 1099, 1101
Cutouts (*Papiers découpés*) 219, 408,
 639-648

Drawings 522-529

Graphic Arts 276, 279, 282, 530-574

Illustrated Books 545, 550, 551, 555,
 574-638, 754, 882, 912
Individual Paintings 442-521
Influence on Other Artists 709-742

Mentions of Georges Braque 743-1101

Obituaries 154
Œuvre in General 283-421

Paintings 277, 422-521
Papiers découpés (Cutouts) 219, 408,
 639-648
Portfolios 575-638
Prints 276, 279, 282, 530-574

Sculptures 649-654
Sketchbooks 2, 53, 54, 527
Special Issues Devoted to Braque 42,
 133, 318, 345, 370, 371, 373, 667-
 687

Theatre Designs 660-666, 771, 772

Writings, Statements and Interviews 4-52

About the Author

RUSSELL T. CLEMENT is Fine Arts Librarian at the Harold B. Lee Library, Brigham Young University. His previous books include *Paul Gauguin: A Bio-Bibliography* (Greenwood, 1991), *Henri Matisse: A Bio-Bibliography* (Greenwood, 1993), and *Les Fauves: A Bio-Critical Sourcebook* (forthcoming from Greenwood). He also has written extensively for professional journals and is the adviser for Reference Books in Art and Architecture for Greenwood.